RANDOM HOUSE NEW YORK

PHOTOGRAPHS
BY
ANNIE
LEIBOVITZ
ESSAY
BY
SUSAN
SONTAG

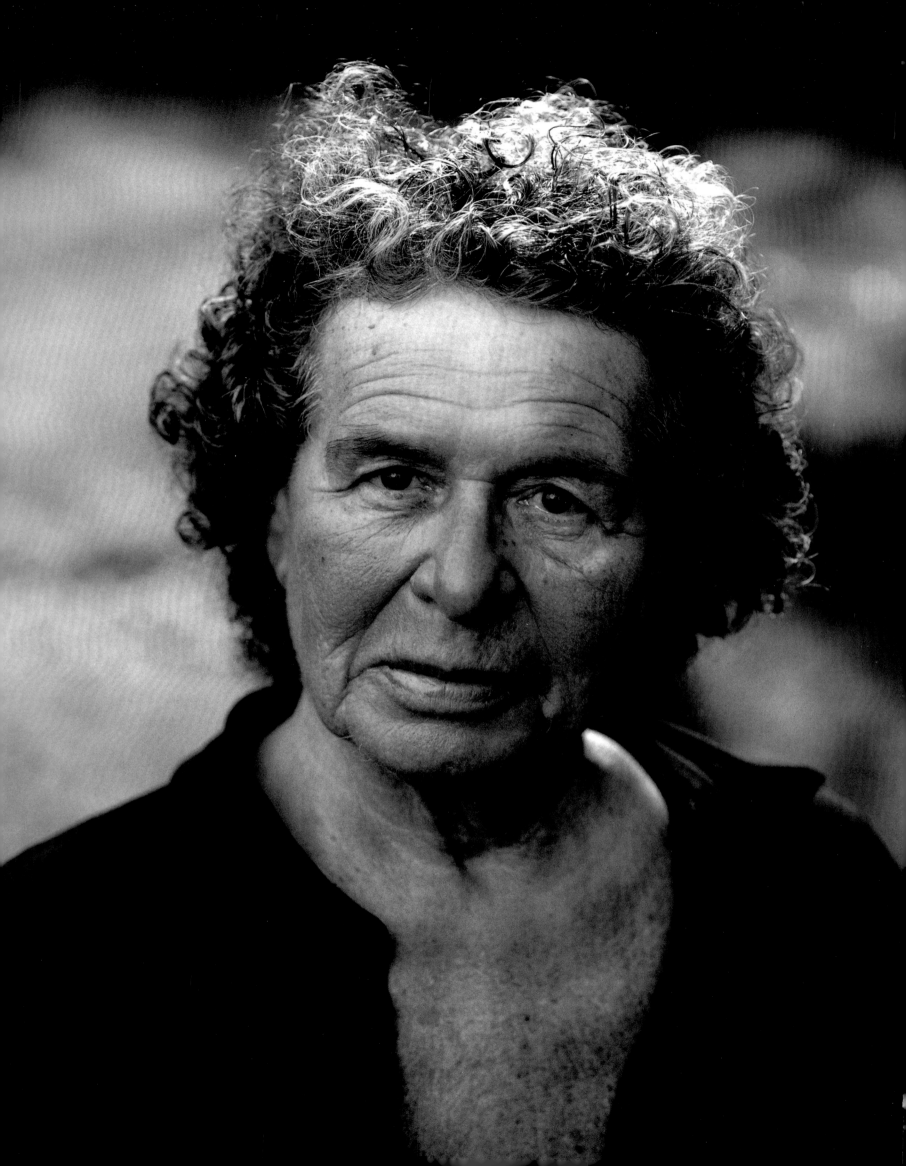

WOMEN

Trini Campbell and Cassidy Campbell Mueller
Farmer and her daughter
Riverdog Farm, Guinda, California

Preceding page:

Marilyn Leibovitz
Photographer's mother
Clifton Point, Rhinebeck, New York

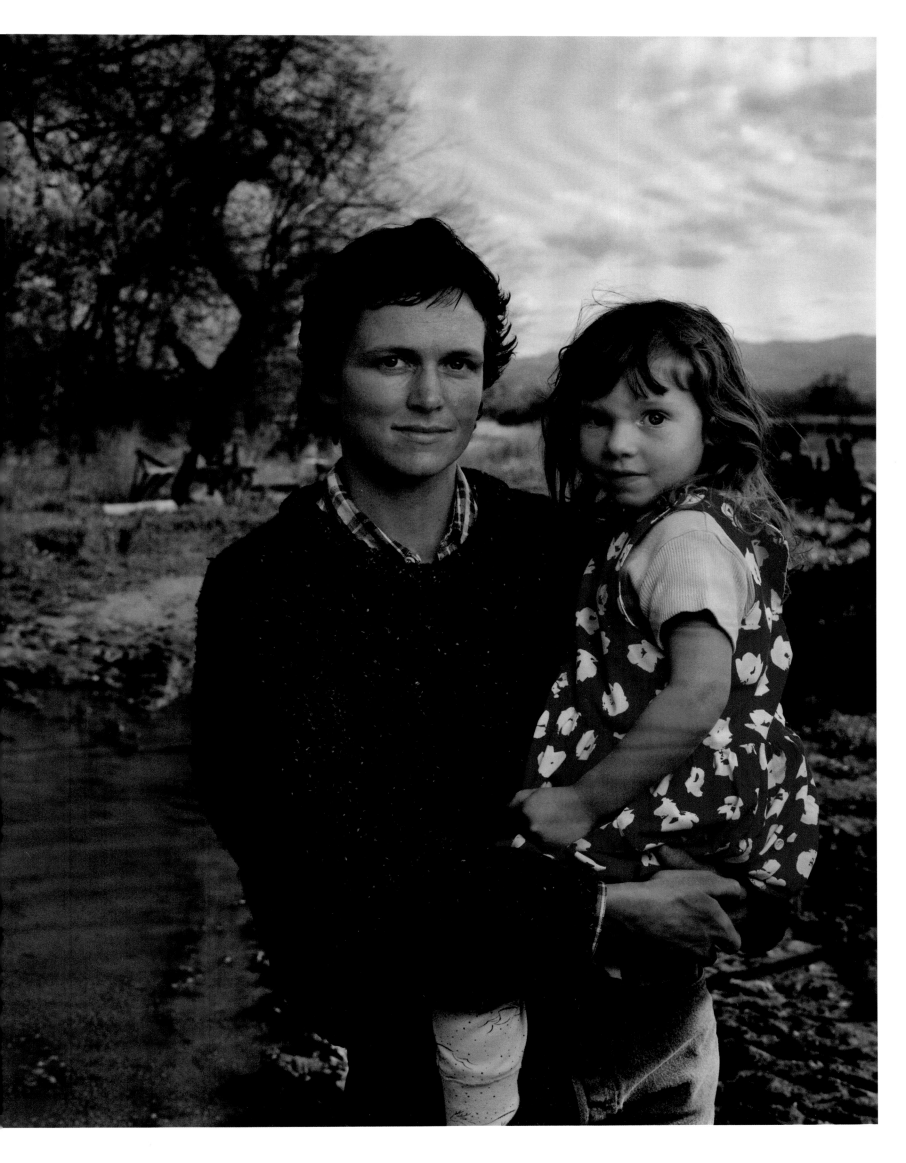

Eileen Collins
Space Shuttle commander
Johnson Space Center, Houston, Texas

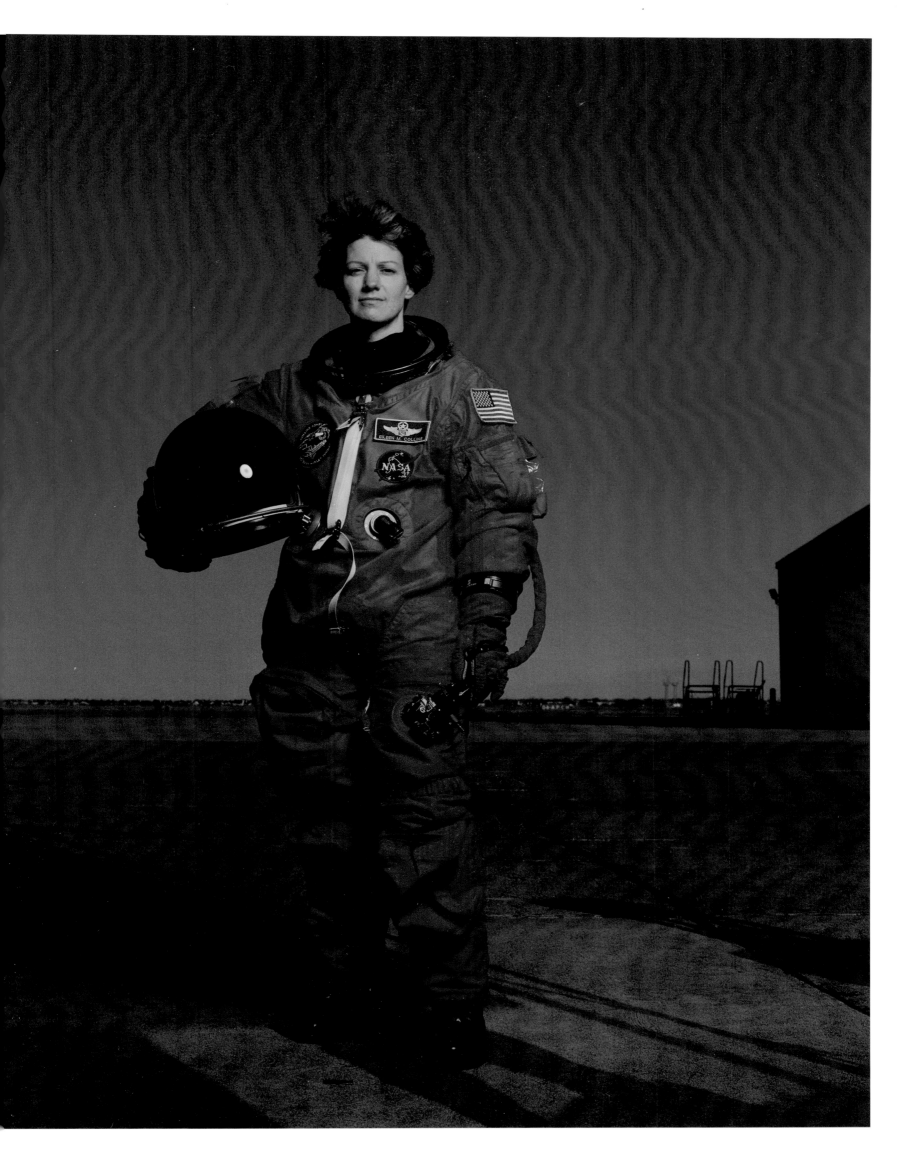

Morgan W. Kelly
Teacher
Junior High School 145, South Bronx, New York

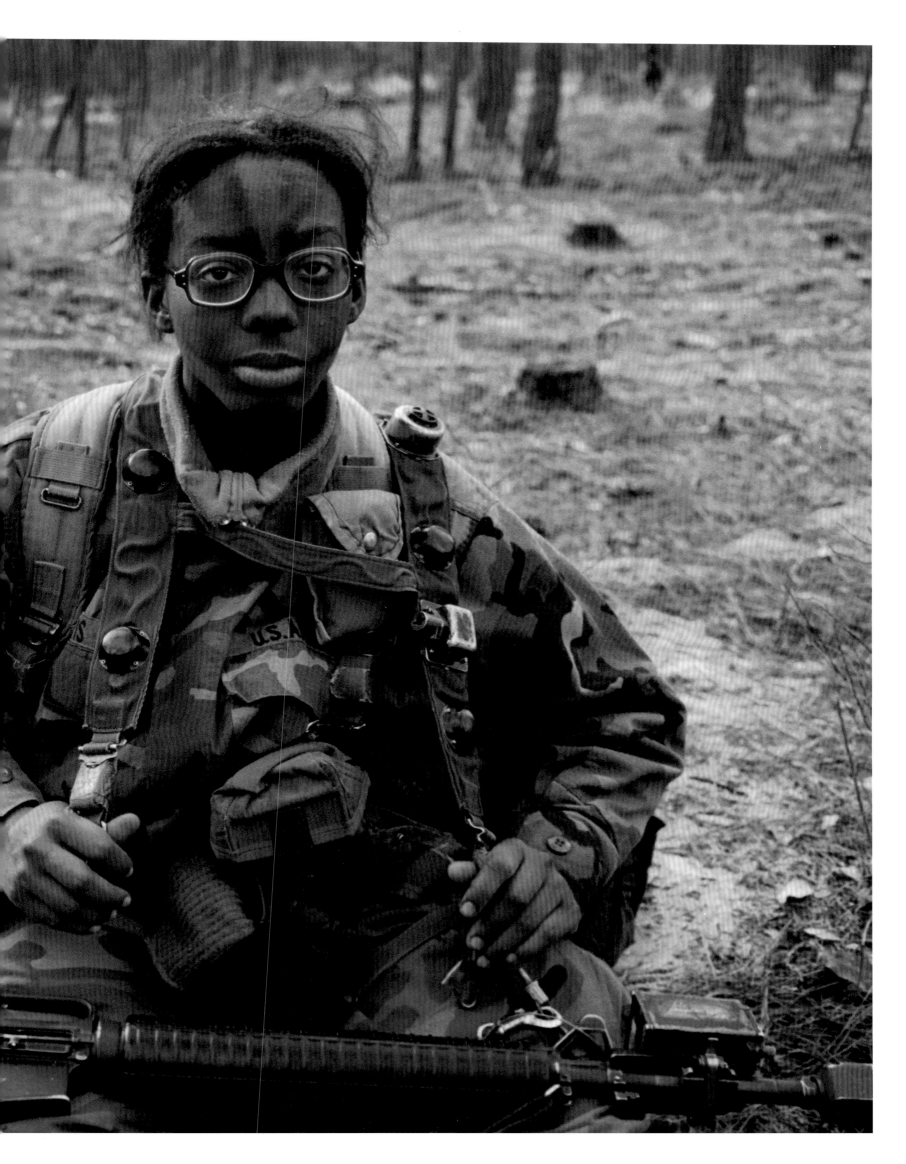

Polly Weydener
Retired chiropractor's assistant
Beach Patrol headquarters public restroom, Miami Beach, Florida

Preceding page:

Raymonda Davis
Soldier
Basic training, Fort Jackson, Columbia, South Carolina

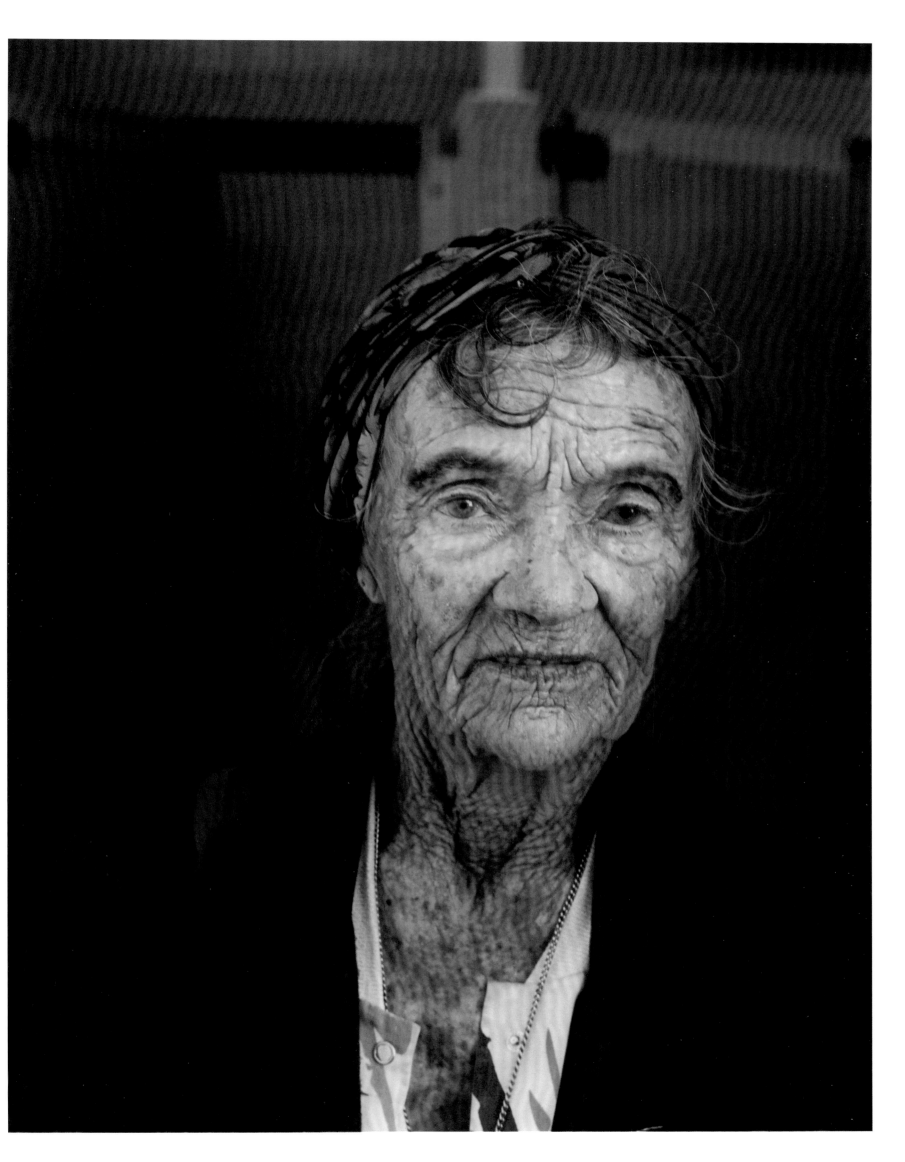

Lil' Kim
Rap artist
New York City

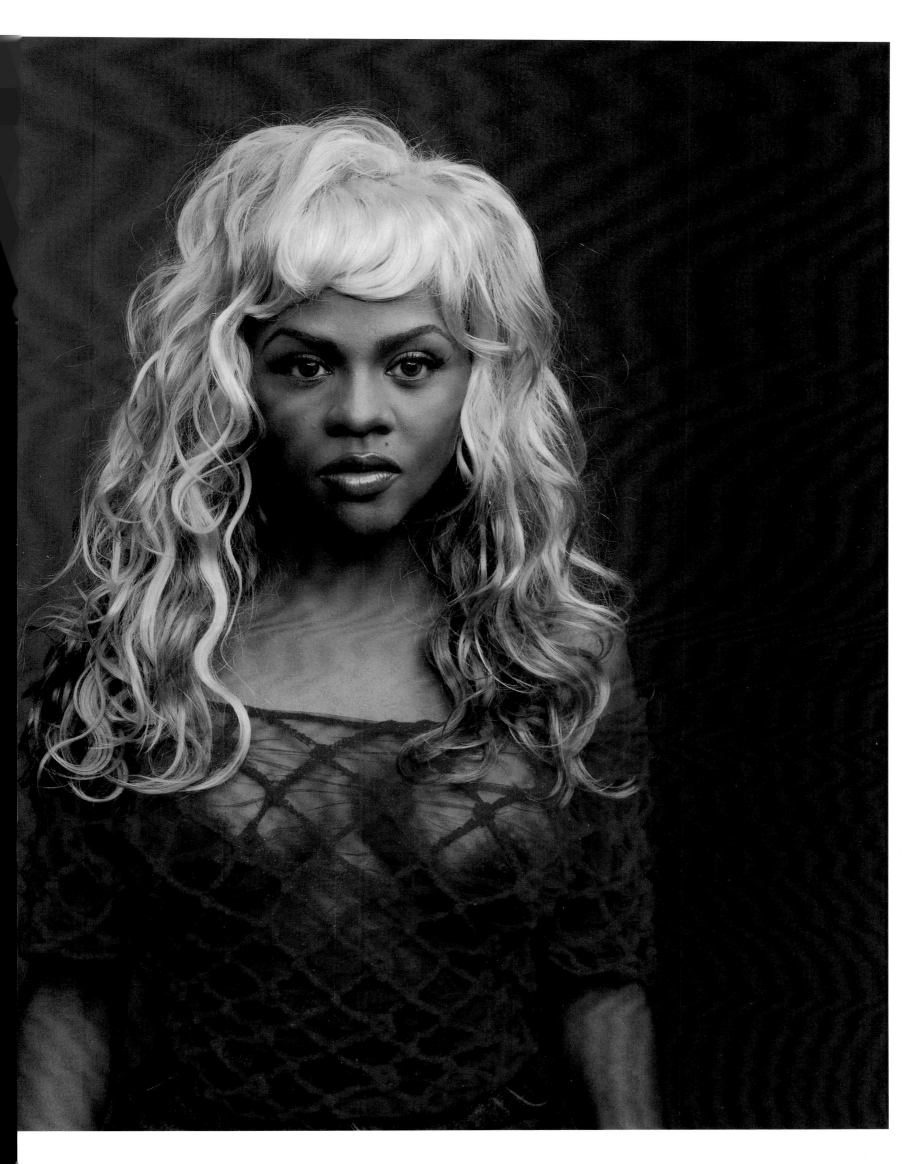

A PHOTOGRAPH IS NOT AN OPINION. OR IS IT?

Undertake to do a book of photographs of people with nothing more in common than that they are women (and living in America at the end of the twentieth century), all—well, almost all—fully clothed, therefore not the *other* kind of all-women picture book . . .

Start with no more than a commanding notion of the sheer interestingness of the subject, especially in view of the unprecedented changes in the consciousness of many women in these last decades, and a resolve to stay open to whim and opportunity . . .

Sample, explore, revisit, choose, arrange, without claiming to have brought to the page a representative miscellany . . .

Even so, a large number of pictures of what is, nominally, a single subject will inevitably be felt to be representative in *some* sense. How much more so with this subject, with this book, an anthology of destinies and disabilities and new possibilities; a book that invites the sympathetic responses we bring to the depiction of a minority (for that is what women are, by every criterion except the numerical), featuring many portraits of those who are a credit to their sex. Such a book has to feel instructive, even if it tells us what we think we already know about the overcoming of perennial impediments and prejudices and cultural handicaps, the conquest of new zones of achievement. Of course, such a book would be misleading if it did not touch on the bad news as well: the continuing authority of demeaning stereotypes, the continuing violence (domestic assault is the leading cause of injuries to American women). Any large-scale

picturing of women belongs to the ongoing story of how women are presented, and how they are invited to think of themselves. A book of photographs of women must, whether it intends to or not, raise the question of women—there is no equivalent "question of men." Men, unlike women, are not a work in progress.

Each of these pictures must stand on its own. But the ensemble says, So this is what women are now—as different, as varied, as heroic, as forlorn, as conventional, as unconventional as *this*. Nobody scrutinizing the book will fail to note the confirmation of stereotypes of what women are like and the challenge to those stereotypes. Whether well-known or obscure, each of the nearly one hundred and seventy women in this album will be looked at (especially by other women) as models: models of beauty, models of self-esteem, models of strength, models of transgressiveness, models of victimhood, models of false consciousness, models of successful aging.

No book of photographs of men would be interrogated in the same way.

But then a book of photographs of men would not be undertaken in the same spirit. How could there be any interest in asserting that a man can be a stockbroker or a farmer or an astronaut or a miner? A book of photographs of men with sundry occupations, men only (without any additional label), would probably be a book about the beauty of men, men as objects of lustful imaginings to women and to other men.

But when men are viewed as sex objects, that is not their primary identity.

The traditions of regarding men as, at least potentially, the creators and curators of their own destinies and women as objects of male emotions and fantasies (lust, tenderness, fear, condescension, scorn, dependence), of regarding an individual man as an instance of humankind and an individual woman as an instance of . . . women, are still largely intact, deeply rooted in language, narrative, group arrangements, and family customs. In no language does the pronoun "she" stand for human beings of both sexes. Women and men are differently weighted, physically and culturally, with different contours of selfhood, all presumptively favoring those born male.

I do this, I endure this, I want this . . . because I am a woman. I do that, I endure that, I want that . . . even though I'm a woman. Because of the mandated inferiority of women, their condition as a cultural minority, there continues to be a debate about what women are, can be, should want to be. Freud is famously supposed to have asked, "Lord, what do women want?" Imagine a world in which it seems normal to inquire, "Lord, what do men want?" . . . but who can imagine such a world?

No one thinks the Great Duality is symmetrical—even in America, noted since the nineteenth century by foreign travelers as a paradise for uppity women. Feminine and masculine are a tilted polarity. Equal rights for men has never inspired a march or a hunger strike. In no country are men legal minors, as women were until well into the twentieth century in many European countries, and are still in many Muslim countries, from Morocco to Afghanistan.

No country gave women the right to vote before giving it to men. Nobody ever thought of men as the second sex.

And yet, and yet: there is something new in the world, starting with the revoking of age-old legal shackles regarding suffrage, divorce, property rights. It seems almost inconceivable now that the enfranchisement of women happened as recently as it did: that, for instance, women in France and Italy had to wait until 1945 and 1946 to be able to vote. There have been tremendous changes in women's consciousness, transforming the inner life of everyone: the sallying forth of women from women's worlds into the world at large, the arrival of women's *ambitions*. Ambition is what women have been schooled to stifle in themselves, and what is celebrated in a book of photographs that emphasizes the variety of women's lives today.

Such a book, however much it attends to women's activeness, is also about women's attractiveness.

Nobody looks through a book of pictures of women without noticing whether the women are attractive or not.

To be feminine, in one commonly felt definition, *is* to be attractive, or to do one's best to be attractive; to attract. (As being masculine is being strong.) While it is perfectly possible to defy this imperative, it is not possible for any woman to be unaware of it. As it is thought a weakness in a man to care a great deal about how he looks, it is a moral fault in a woman not to care "enough."

Women are judged by their appearance as men are not, and women are punished more than men are by the changes brought about by aging. Ideals of appearance such as youthfulness and slimness are in large part now created and enforced by photographic images. And, of course, a primary interest in having photographs of well-known beauties to look at over the years is seeing just how well or badly they negotiate the shame of aging.

In advanced consumer societies, it is said, these "narcissistic" values are more and more the concern of men as well. But male primping never loosens the male lock on initiative taking. Indeed, glorying in one's appearance is an ancient warrior's pleasure, an expression of power, an instrument of dominance. Anxiety about personal attractiveness could never be thought defining of a man: a man can always be seen. Women are looked at.

We assume a world with a boundless appetite for images, in which people, women and men, are eager to surrender themselves to the camera. But it is worth recalling that there are parts of the world where being photographed is something off-limits to women. In a few countries, where men have been mobilized for a veritable war against women, women scarcely *appear* at all. The imperial rights of the camera—to gaze at, to record, to exhibit anyone, anything—are an exemplary feature of modern life, as is the emancipation of women. And just as the granting of more and more rights and choices to women is a measure of a society's embrace of modernity, so the revolt against modernity initiates a rush to rescind the meager gains toward participation in

society on equal terms with men won by women, mostly urban, educated women, in previous decades. In many countries struggling with failed or discredited attempts to modernize, there are more and more *covered* women.

The traditional unity of a book of photographs of women is some ideal of female essence: women gaily displaying their sexual charms, women veiling themselves behind a look of soulfulness or primness.

Portraits of women featured their beauty; portraits of men their "character." Beauty (the province of women) was smooth; character (the province of men) was rugged. Feminine was yielding, placid, or plaintive; masculine was forceful, piercing. Men didn't look wistful. Women, ideally, didn't look forceful.

When in the early 1860s a well-connected, exuberant, middle-aged Englishwoman named Julia Margaret Cameron took up the camera as a vocation, she usually photographed men differently than she photographed women. The men, who included some of the most eminent poets, sages, and scientists of the Victorian era, were posed for their portraits. The women—somebody's wife, daughter, sister, niece—served mostly as models for "fancy subjects" (Cameron's label). Women were used to personify ideals of womanliness drawn from literature or mythology: the vulnerability and pathos of Ophelia; the tenderness of the Madonna with her Child. Almost all the sitters were relatives and friends—or her parlormaid, who, suitably reclothed, incarnated several exalted icons of femininity. Only Julia

Jackson, Cameron's niece (and the future mother of the future Virginia Woolf), was, in homage to her exceptional beauty, never posed as anyone but herself.

What qualified the women as sitters was precisely their beauty, as fame and achievement qualified the men. The beauty of women made them ideal subjects. (Notably, there was no role for picturesque or exotic beauty, so that when Cameron and her husband moved to Ceylon, she virtually stopped taking pictures.) Indeed, Cameron defined photography as a quest for the beautiful. And quest it was: "Why does not Mrs. Smith come to be photographed?" she wrote to a friend about a lady in London whom she had never met. "I hear she is Beautiful. Bid her come, and she shall be made Immortal."

Imagine a book of pictures of women in which none of the women could be identified as beautiful. Wouldn't we feel that the photographer had made some kind of mistake? Was being mean-spirited? Misogynistic? Was depriving us of something that we had a right to see? No one would say the same thing of a book of portraits of men.

There were always several kinds of beauty: imperious beauty, voluptuous beauty, beauty signifying the character traits that fitted a woman for the confines of genteel domesticity—docility, pliancy, serenity. Beauty was not just

loveliness of feature and expression, an aesthetic ideal. It also spoke to the eye about the virtues deemed essential in women.

For a woman to be intelligent was not essential, not even particularly appropriate. It was in fact considered disabling, and likely to be inscribed in her appearance. Such is the fate of a principal character in *The Woman in White,* Wilkie Collins's robustly, enthrallingly clever bestseller, which appeared in 1860, just before Cameron started making her portraits. Here is how this woman is introduced, early in the novel, in the voice of its young hero:

> . . . I looked from the table to the window farthest from me, and saw a lady standing at it, with her back turned towards me. The instant my eyes rested on her, I was struck by the rare beauty of her form, and by the unaffected grace of her attitude. Her figure was tall, yet not too tall; comely and well-developed, yet not fat; her head set on her shoulders with an easy, pliant firmness; her waist, perfection in the eyes of a man, for it occupied its natural place, it filled out its natural circle, it was visibly and delightfully unde-formed by stays. She had not heard my entrance into the room; and I allowed myself the luxury of admiring her for a few moments, before I moved one of the chairs near me, as the least embarrassing means of attracting her attention. She turned towards me immediately. The easy elegance of every movement of her limbs and body as soon as she began to advance from the far end of the room set me in a flutter of expectation to see her face clearly. She

left the window—and I said to myself, The lady is dark. She moved forward a few steps—and I said to myself, The lady is young. She approached nearer—and I said to myself (with a sense of surprise which words fail me to express), The lady is ugly!

Reveling in the presumptions and delights of the appraising male gaze, the narrator has noted that, seen from behind and in long shot, the lady satisfies all the criteria of female desirability. Hence his acute surprise, when she turns and comes toward him, at her "ugly" face (it is not allowed to be just plain or homely), which, he explains, is a kind of paradox:

> Never was the old conventional maxim, that Nature cannot err, more flatly contradicted—never was the fair promise of a lovely figure more strangely and startlingly belied by the face and head that crowned it. The lady's complexion was almost swarthy, and the dark down on her upper lip was almost a moustache. She had a large, firm, masculine mouth and jaw; prominent, piercing, resolute brown eyes; and thick, coal-black hair, growing unusually low down on her forehead. Her expression—bright, frank, and intelligent—appeared, while she was silent, to be altogether wanting in those feminine attractions of gentleness and pliability, without which the beauty of the handsomest woman alive is beauty incomplete.

Marian Halcombe will turn out to be the most admirable character in Collins's

novel, awarded every virtue except the capacity to inspire desire. Moved only by generous, noble sentiments, she has a near angelic, that is, archetypally feminine, temperament—except for the troubling matter of her uncommon intelligence, her frankness, her want of "pliability." Marian Halcombe's body, so ideally feminine that it is judged ripe for appropriation by a (presumably male) artist, conveys "modest graces of action." Her head, her face, signifies something more concentrated, exacting—unfeminine. The body gives one message, the face another. And face trumps body—as intelligence, to the detriment of female sexual attractiveness, trumps beauty. The narrator concludes:

> To see such a face as this set on shoulders that a sculptor would have longed to model—to be charmed by the modest graces of action through which the symmetrical limbs betrayed their beauty when they moved, and then to be almost repelled by the masculine form and masculine look of the features in which the perfectly shaped figure ended—was to feel a sensation oddly akin to the helpless discomfort familiar to us all in sleep, when we recognise yet cannot reconcile the anomalies and contradictions of a dream.

Collins's male narrator is touching a gender faultline, which typically arouses anxieties and feelings of discomfort. The contradiction in the order of sexual stereotypes may seem dreamlike to a well-adjusted inhabitant of an era in which action, enterprise, artistic creativity, and intellectual innovation are understood to be masculine, fraternal orders. For a long time the beauty of

a woman seemed incompatible, or at least oddly matched, with intelligence and assertiveness. (A far greater novelist, Henry James, in the preface to *The Portrait of a Lady,* speaks of the challenge of filling the "frail vessel" of a female protagonist with all the richness of an independent consciousness.) To be sure, no novelist today would find it implausible to award good looks to a woman who is cerebral and self-assertive. But in real life it's still common to begrudge a woman who has both beauty and intellectual brilliance—one would never say there was something odd or intimidating or "unfair" about a man who was so fortunate—as if beauty, the ultimate enabler of feminine charm, should by rights have barred other kinds of excellence.

In a woman beauty is something total. It is what stands, in a woman, for character. It is also, of course, a performance; something willed, designed, obtained. Looking through an old family photograph album, the Russian-born French writer Andreï Makine recalls a trick used to get the particular glow of beauty he saw in some of the women's faces:

> . . . these women knew that in order to be beautiful, what they must do several seconds before the flash blinded them was to articulate the following mysterious syllables in French, of which few understood the meaning: "*pe-tite-pomme.*" As if by magic, the mouth, instead of being extended in counterfeit bliss, or contracting into an anxious grin, would form a gracious round. . . . The eyebrows

arched slightly, the oval of the cheeks was elongated. You said "*petite pomme,*" and the shadow of a distant and dreamy sweetness veiled your gaze, refined your features . . .

A woman being photographed aspired to a standardized look that signified an ideal refinement of "feminine" traits, as conveyed *through* beauty; and beauty was understood to be a distancing from the ordinary; as photographed, it projected something enigmatic, dreamy, inaccessible. Now, idiosyncrasy and forthrightness of expression are what make a photographic portrait interesting. And refinement is passé, and seems pretentious or phony.

Beauty—as photographed in the mainstream tradition that prevailed until recently—blurred women's sexuality. And even in photographs that were frankly erotic, the body might be telling one story and the face another: a naked woman lying in a strenuously indecent position, spread-eagled or presenting her rump, with the face turned toward the viewer wearing the vapidly amiable expression of respectable photographic portraiture. Newer ways of photographing women are less concealing of women's sexuality, though the display of once forbidden female flesh or carnal posturing is still fraught as a subject, so inveterate are responses that reassert male condescensions to women in the guise of lecherous appreciation. Women's libidinousness is always being repressed or held against them.

The identification of women with beauty was a way of immobilizing women. While character evolves, reveals, beauty is static, a mask, a magnet for

projection. In the legendary final shot of *Queen Christina,* the Queen—Greta Garbo—having abdicated the Swedish throne, renouncing the masculinizing prerogatives of a monarch for the modesty of a woman's happiness, and boarded the ship to join her foreign lover and depart with him into exile only to find him mortally wounded by a vengeful rejected suitor from her court, stands at the ship's prow with the wind in her face, a monument of heartbreak. While the lighting for the shot was being prepared, Garbo asked the director, Rouben Mamoulian, what she should be thinking during the take. Nothing, he famously replied. Don't think of anything. Go blank. His instruction produced one of the most emotion-charged images in movie history: as the camera moves in and holds on a long close-up, the spectator has no choice but to read mounting despair on that incomparably beautiful, dry-eyed, vacant face. The face that is a mask on which one can project whatever is desired is the consummate perfection of the looked-at-ness of women.

The identification of beauty as the ideal condition of a woman is, if anything, more powerful than ever, although today's hugely complex fashion-and-photography system sponsors norms of beauty that are far less provincial, more diverse, and favor brazen rather than demure ways of facing the camera. The downcast gaze, a staple of the presentation of women to the camera, should have a touch of sullennness if it is not to seem insipid. Ideas of beauty are less immobilizing now. But beauty itself is an ideal of a stable, unchanging appearance, a commitment to staving off or disguising the marks of time. The

norms of sexual attractiveness for women are an index of their vulnerability. A man ages into his powers. A woman ages into being no longer desired.

Forever young, forever good-looking, forever sexy—beauty is still a construction, a transformation, a masquerade. We shouldn't be surprised—though of course we are—that in real life, when she is not decked out as a cliché of desirability, the flamboyant, bespangled, semi-nude Las Vegas showgirl can be a mature woman of unremarkable features and sober presence. The eternal feminine project of self-embellishment has always been able to pull off such triumphs.

Since to be feminine is to have qualities which are the opposite, or negation, of ideal masculine qualities, for a long time it was hard to elaborate the attractiveness of the strong woman in other than mythic or allegorical guise. The heroic woman was an allegorical fantasy in nineteenth-century painting and sculpture: Liberty leading the People. The large-gestured, imperiously draped, convulsively powerful woman danced by Martha Graham in the works she created for her all-women troupe in the 1930s—a turning point in the history of how women's strength, women's anger have been represented—was a mythic archetype (priestess, rebel, mourning daimon, quester) presiding over a community of women, not a real woman compromising and cohabiting with and working alongside men.

Dentist, orchestra conductor, commercial pilot, rabbi, lawyer, astronaut, film director, professional boxer, law-school dean, three-star general . . .

no doubt about it, ideas about what women can *do,* and do well, have changed. And what women *mind* has changed. Male behavior, from the caddish to the outright violent, that until recently was accepted without demurral is seen today as outrageous by many women who not so long ago were putting up with it themselves and who would still protest indignantly if someone described them as feminists. To be sure, what has done most to change the stereotypes of frivolity and fecklessness afflicting women are not the labors of the various feminisms, indispensable as these have been. It is the new economic realities that oblige most American women (including most women with small children) to work outside their homes. The measure of how much things have *not* changed is that women earn between one half and three fourths of what men earn in the same jobs. And virtually all occupations are still gender-labeled: with the exception of a few occupations (prostitute, nurse, secretary) where the reverse is true and it needs to be specified if the person is a man, one has to put "woman" in front of most job titles when it's a woman doing them; otherwise the presumption will always be that one is referring to a man.

Any woman of accomplishment becomes more acceptable if she can be seen as pursuing her ambitions, exercising her competence, in a feminine (wily, nonconfrontational) way. "No harsh feminist, Ms. X has attained . . ." begins the reassuring accolade to a woman in a job with executive responsibilities. That women are the equals of men—the new idea—continues to collide with the age-old presumption of female inferiority and serviceability: that it is

normal for a woman to be in an essentially dependent or self-sacrificingly supportive relation to at least one man.

So ingrained is the presupposition that the man will be taller, older, richer, more successful than the woman with whom he mates that the exceptions, of which there are now many, never fail to seem noteworthy. It seems normal for a journalist to ask the husband of a woman more famous than himself if he feels "threatened" by his wife's eminence. No one would dream of wondering if the nonfamous wife of an important industrialist, surgeon, writer, politician, actor, feels threatened by her husband's eminence. And it is still thought that the ultimate act of love for a woman is to efface her own identity—a loving wife in a two-career marriage having every cause for anguish should her success overtake and surpass her husband's. ("Hello, everybody. This is Mrs. Norman Maine.") Accomplished women, except for those in the performing professions, continue to be regarded as an anomaly. It appears to make sense, for many reasons, to have anthologies of women writers or exhibits of women photographers; it would seem very odd to propose an anthology of writers or an exhibit of photographers who had nothing in common except that they were men.

We want photography to be unmythic, full of concrete information. We are more comfortable with photographs that are ironic, unidealizing. Decorum is now understood as concealment. We expect the photographer to be bold, even insolent. We hope that subjects will be candid, or naïvely revealing.

Of course, subjects who are accustomed to posing—women of achievement, women of notoriety—will offer something more guarded, or defiant.

And the way women and men really look (or allow themselves to appear) is not identical with how it is thought appropriate to appear to the camera. What looks right, or attractive, in a photograph is often no more than what illustrates the felt "naturalness" of the unequal distribution of powers conventionally accorded women and men.

Just as photography has done so much to confirm these stereotypes, it can engage in complicating and undermining them. In this collection, we see women catering to the imperatives of looked-at-ness. We see women for whom, because of age or because they're preoccupied by the duties and pleasures of raising children, the rules of ostentatiously feminine performance are irrelevant. There are many portraits of women defined by the new kinds of work now open to them. There are strong women, some of them doing "men's jobs," some of them dancers and athletes with the powerful musculature that only recently began to be visible when such champion female bodies were photographed.

One of the tasks of photography is to disclose, and shape our sense of, the variety of the world. It is not to present ideals. There is no agenda except diversity and interestingness. There are no judgments, which of course is itself a judgment.

And that variety is itself an ideal. We want now to know that for every *this* there is a *that*. We want to have a plurality of models.

Photography is in the service of the postjudgmental ethos gaining ascendancy in societies whose norms are drawn from the practices of consumerism. The camera shows us many worlds, and the point is that all the images are valid. A woman may be a cop or a beauty queen or an architect or a housewife or a physicist. Diversity is an end in itself—much celebrated in today's America. There is the very American, very modern faith in the possibility of continuous self-transformation. A life, after all, is commonly referred to as a *lifestyle*. Styles change. This celebration of variety, of individuality, of individuality as style, saps the authority of gender stereotypes, and has become an inexorable counterforce to the bigotry that still denies women more than token access to many occupations and experiences.

That women, in the same measure as men, should be able to fulfill their individuality is, of course, a radical idea. It is in this form, for better and for worse, that the traditional feminist call for *justice* for women has come to seem most plausible.

A book of photographs; a book about women; a very American project: generous, ardent, inventive, open-ended. It's for us to decide what to make of these pictures. After all, a photograph is not an opinion. Or is it?

SUSAN SONTAG

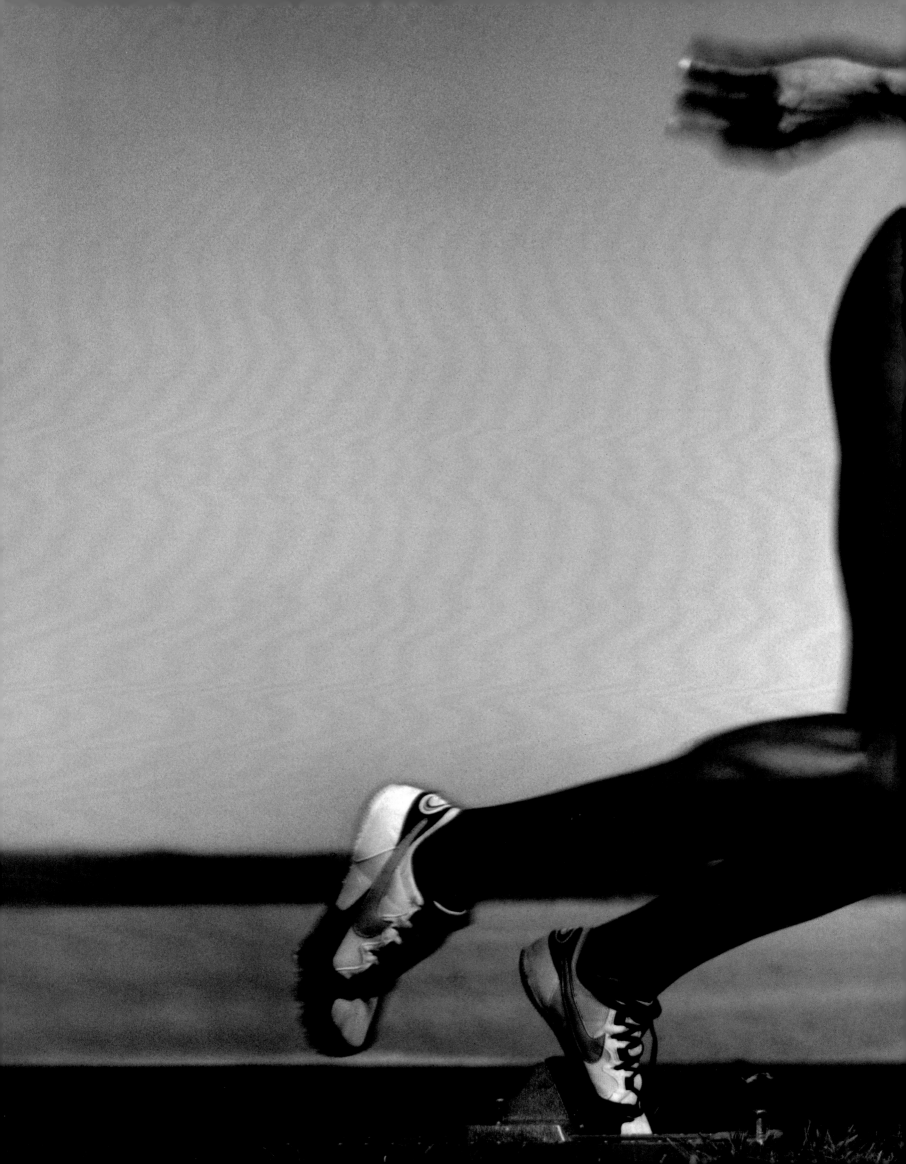

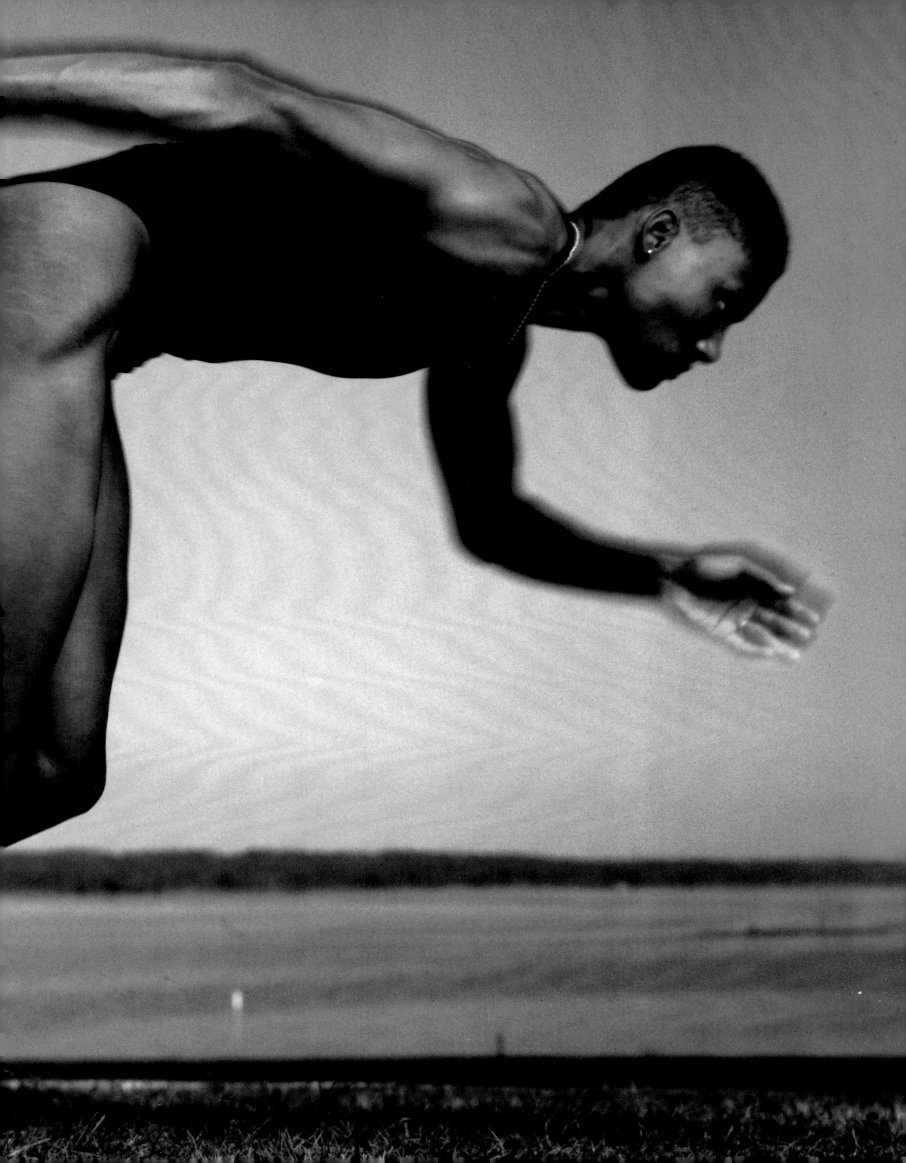

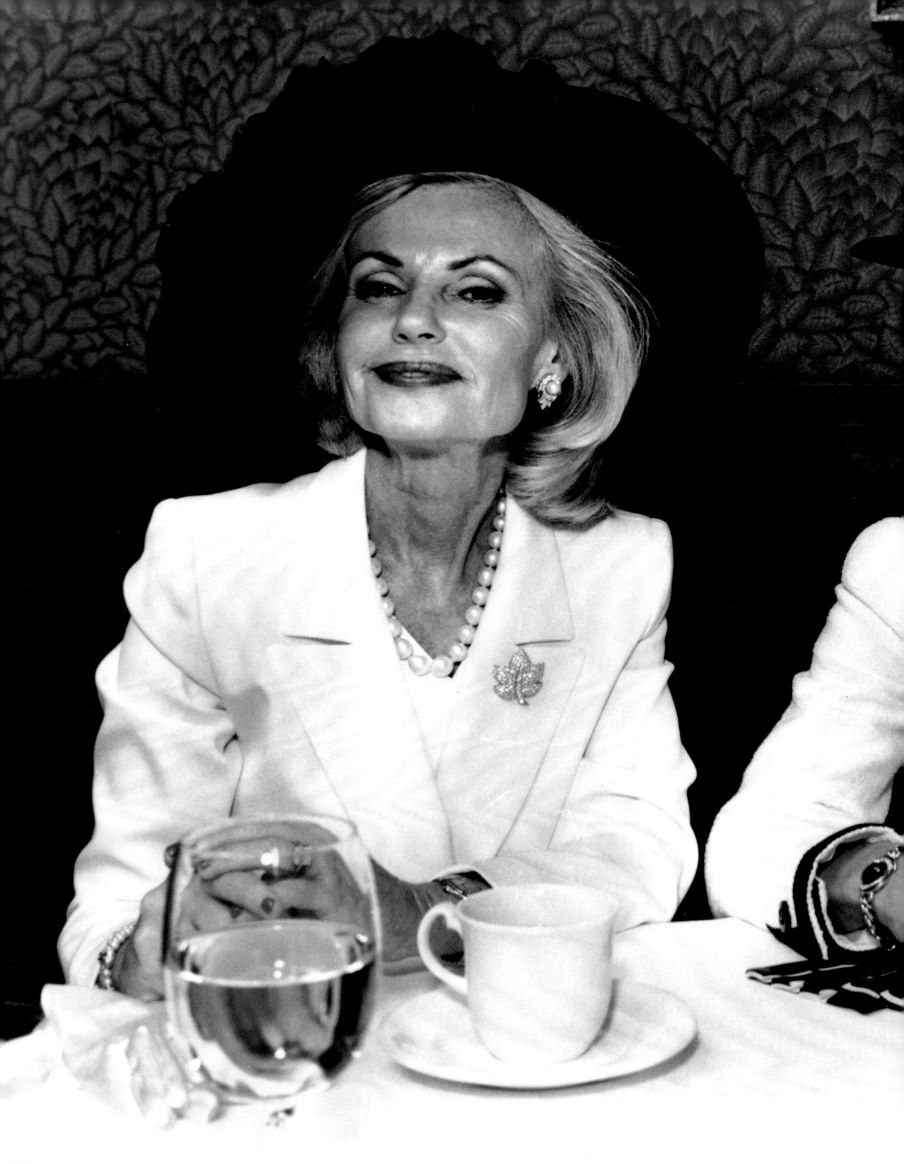

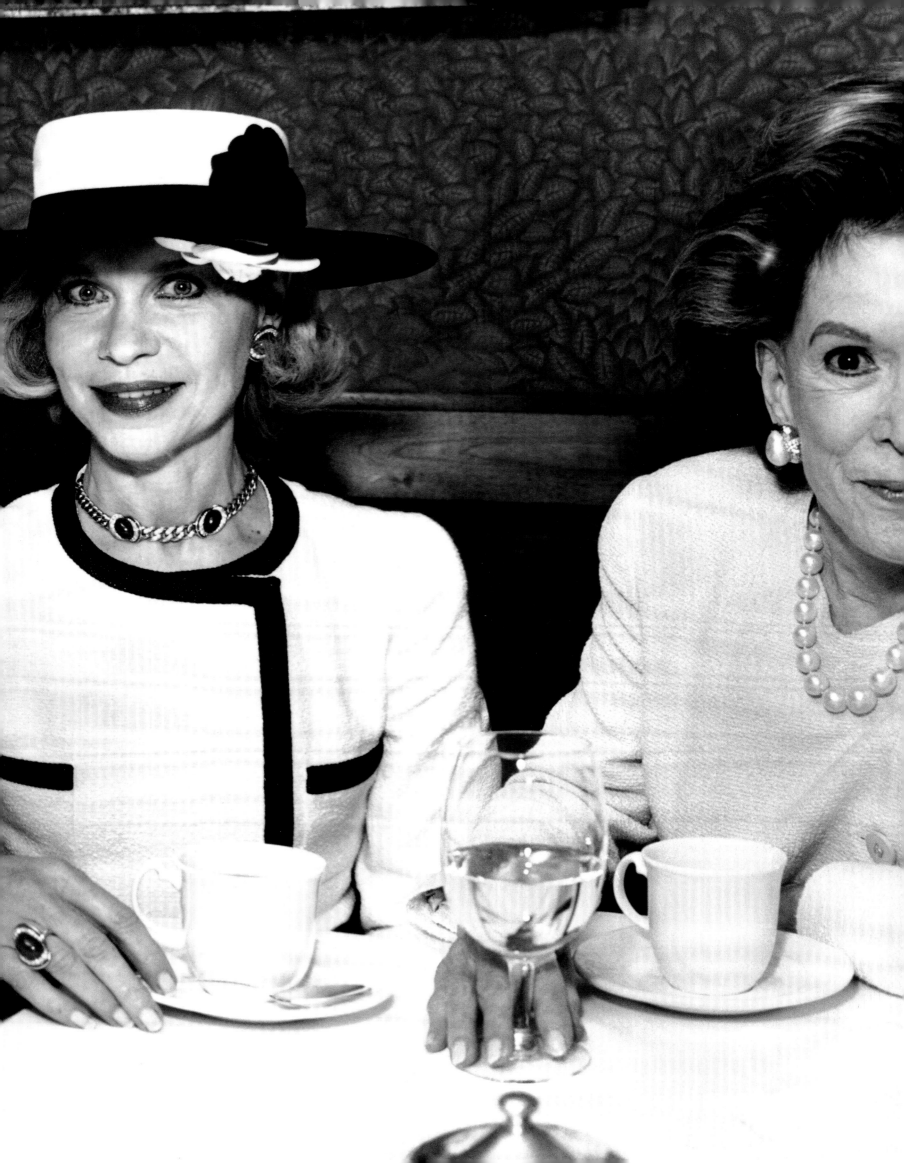

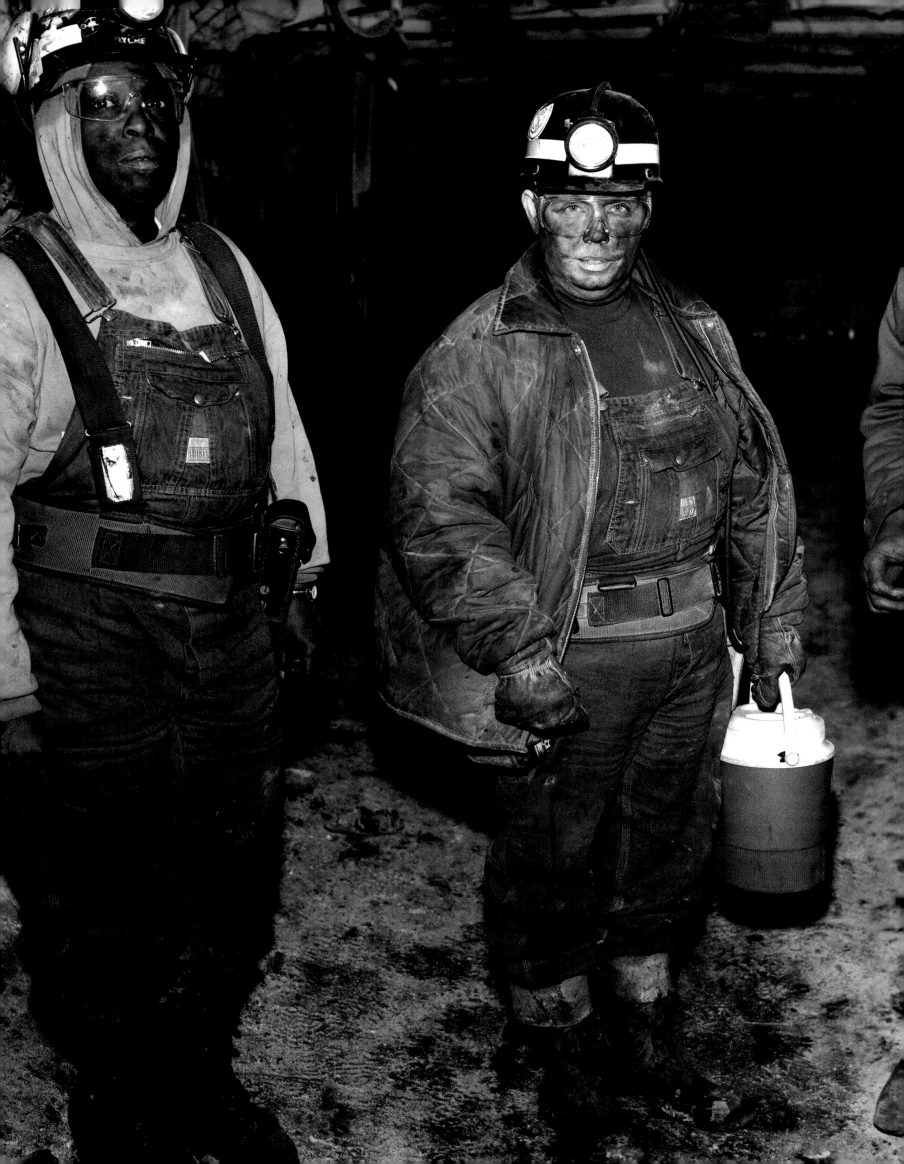

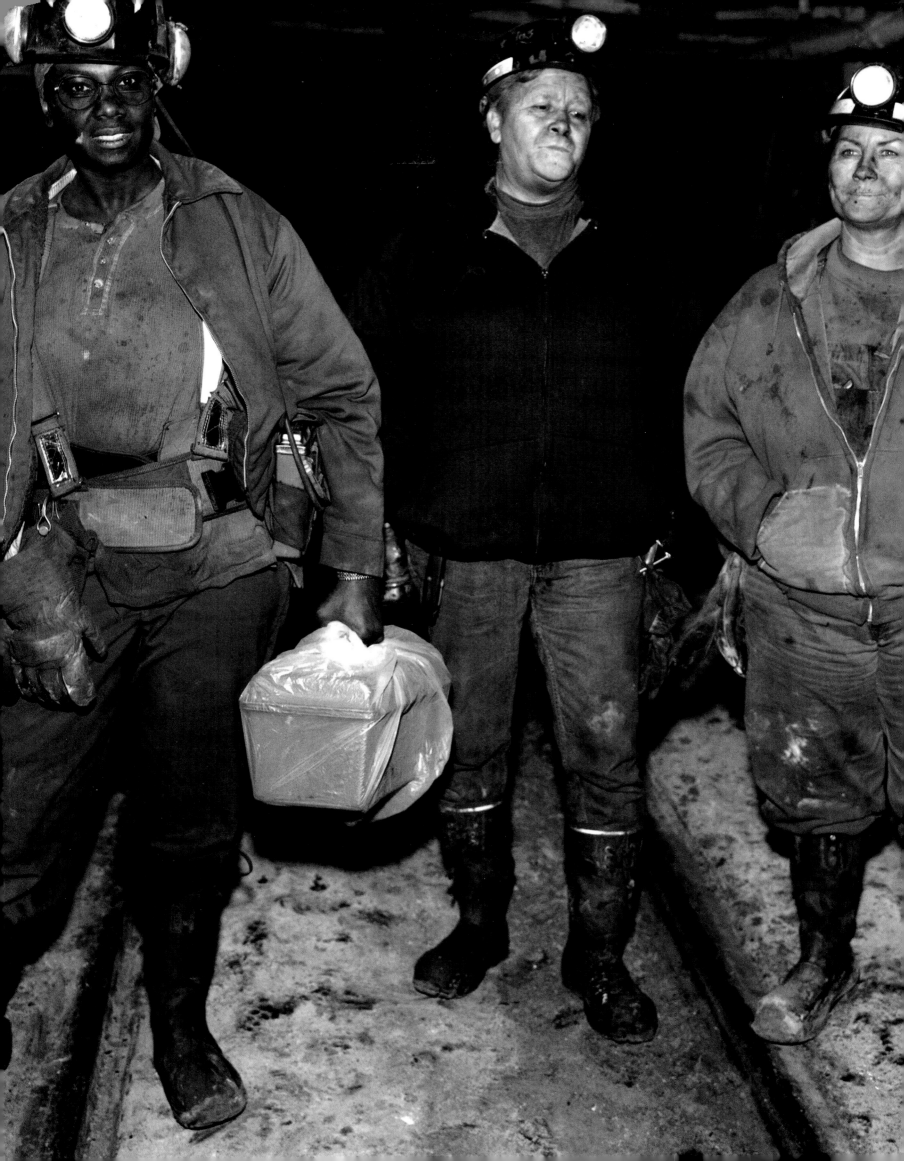

Jennifer Miller
Performance artist
New York City

Preceding pages:

Marion Jones
Sprinter
Raleigh, North Carolina

Pat Breen, Lynn Wyatt, and Caroline Wiess Law
Tony's Restaurant, Houston, Texas

**Shirley Hyche, Jean McCrary,
Johnnie Simon, Nell Cooley, and Linda Hosmer**
Coal miners
Jim Walter No. 5 Mine, Brookwood, Alabama

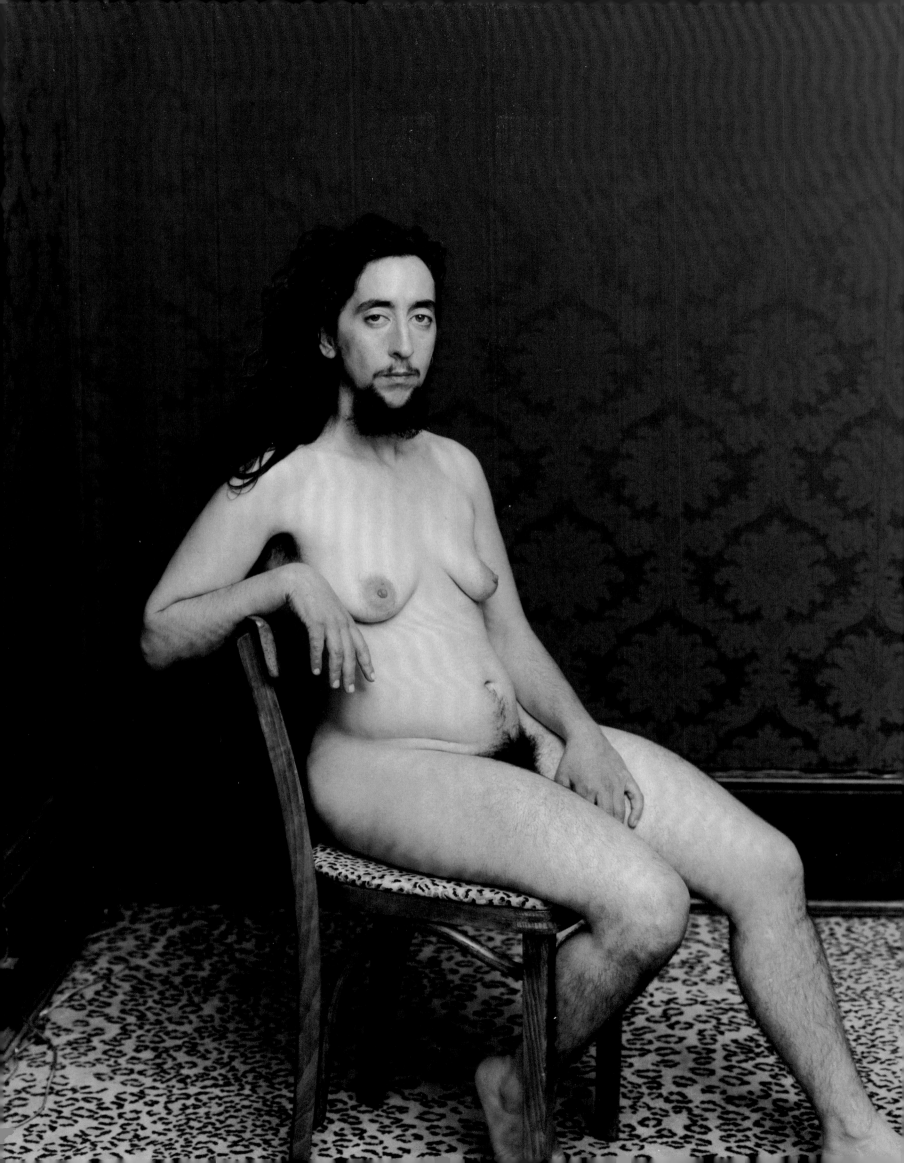

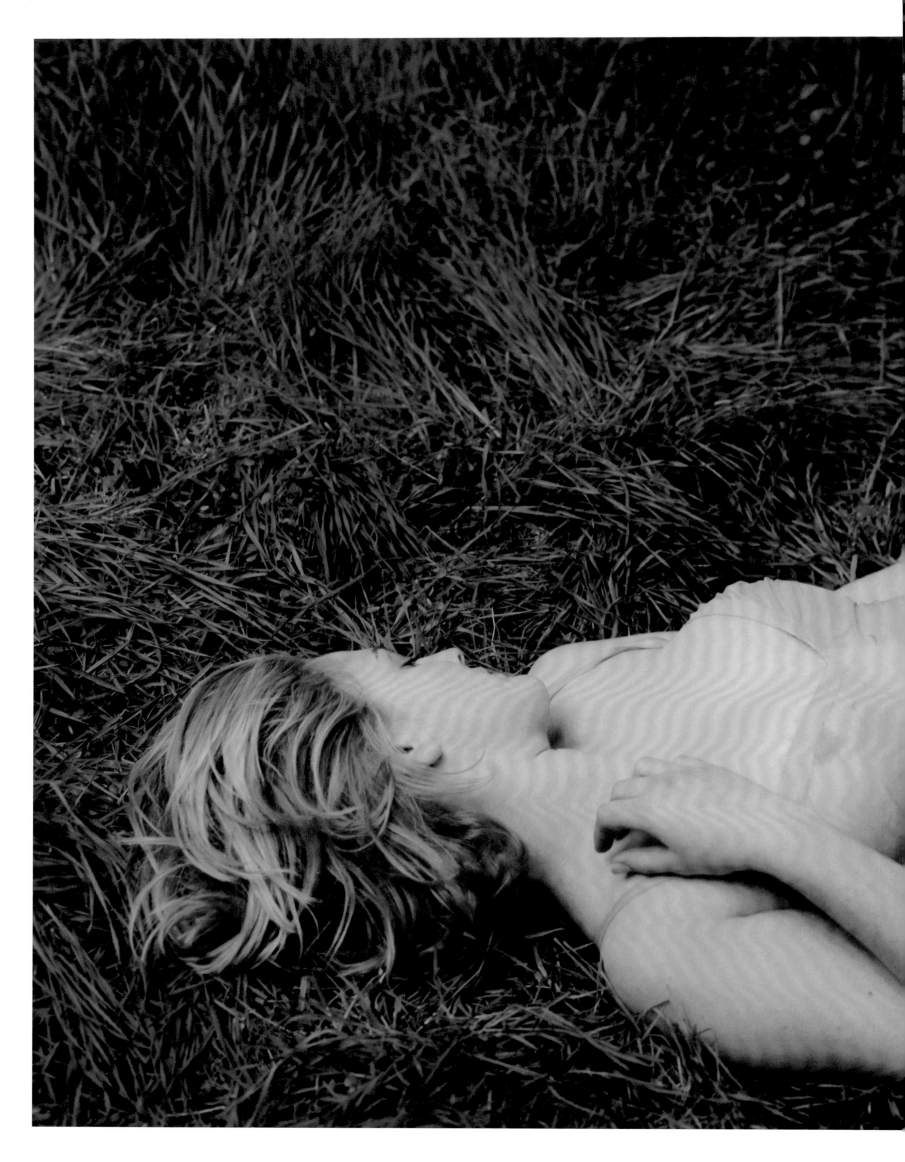

Drew Barrymore
Actress
Los Angeles, California

47

Lamis Srour
Teacher
East Dearborn International Arab-American Festival, East Dearborn, Michigan

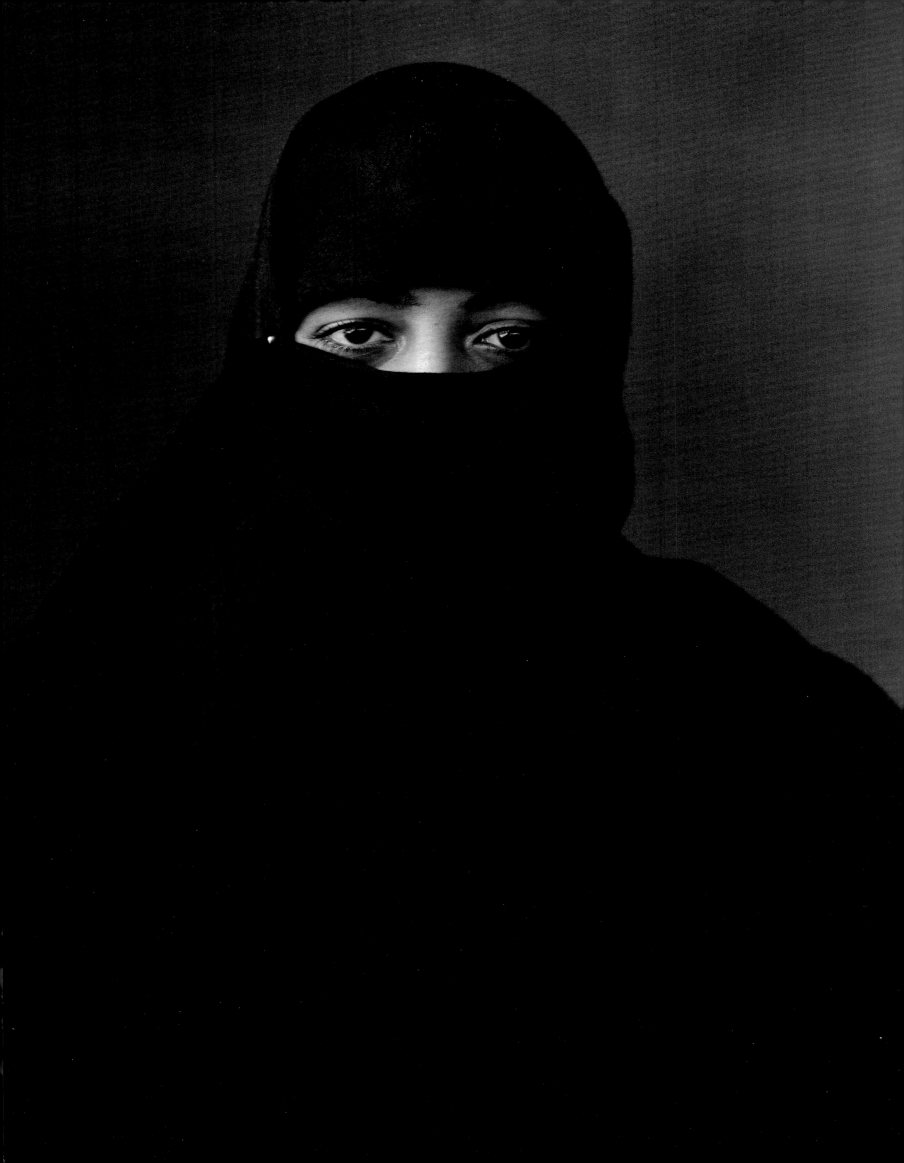

Jorie Graham
Poet
New York City

Following pages:

Margaret Minges, Chastity Maxwell, and Patricia Black
Soldiers
Basic training, Fort McClellan, Anniston, Alabama

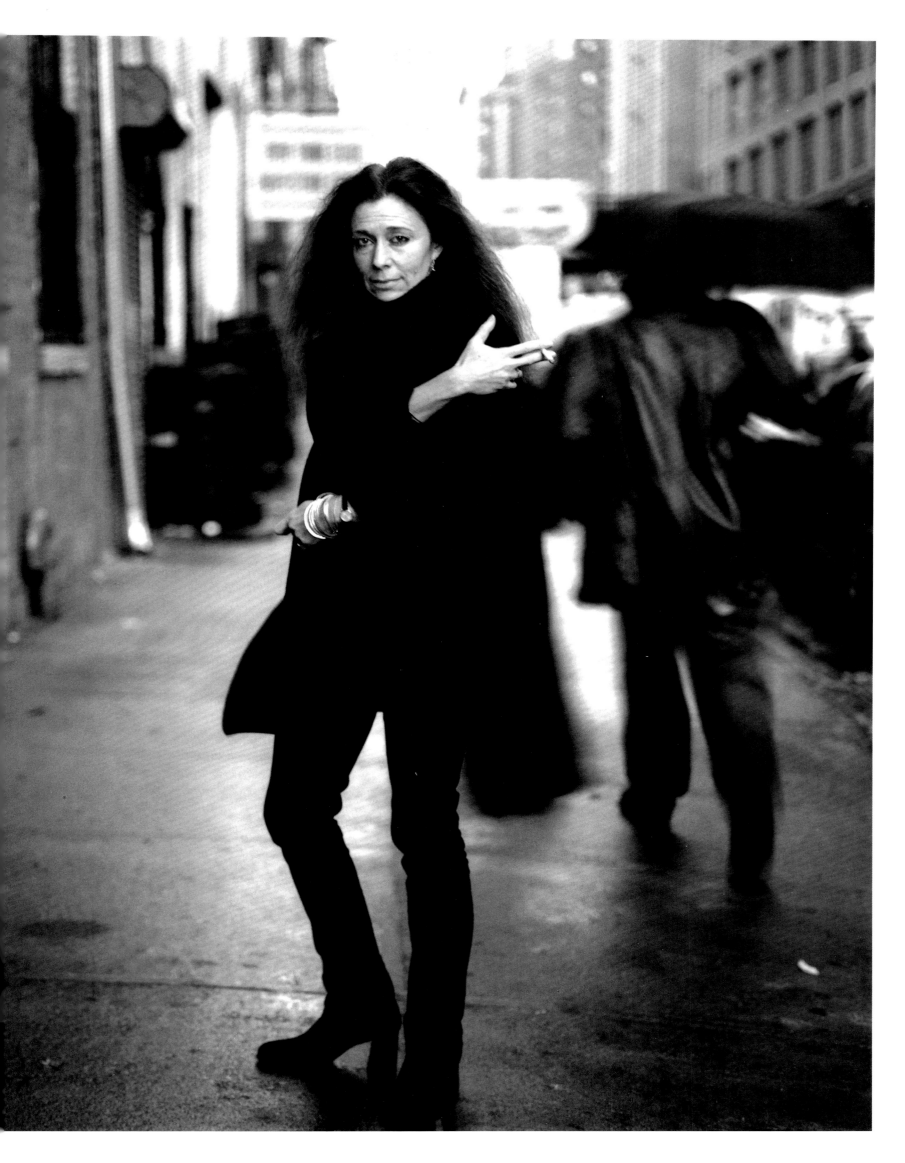

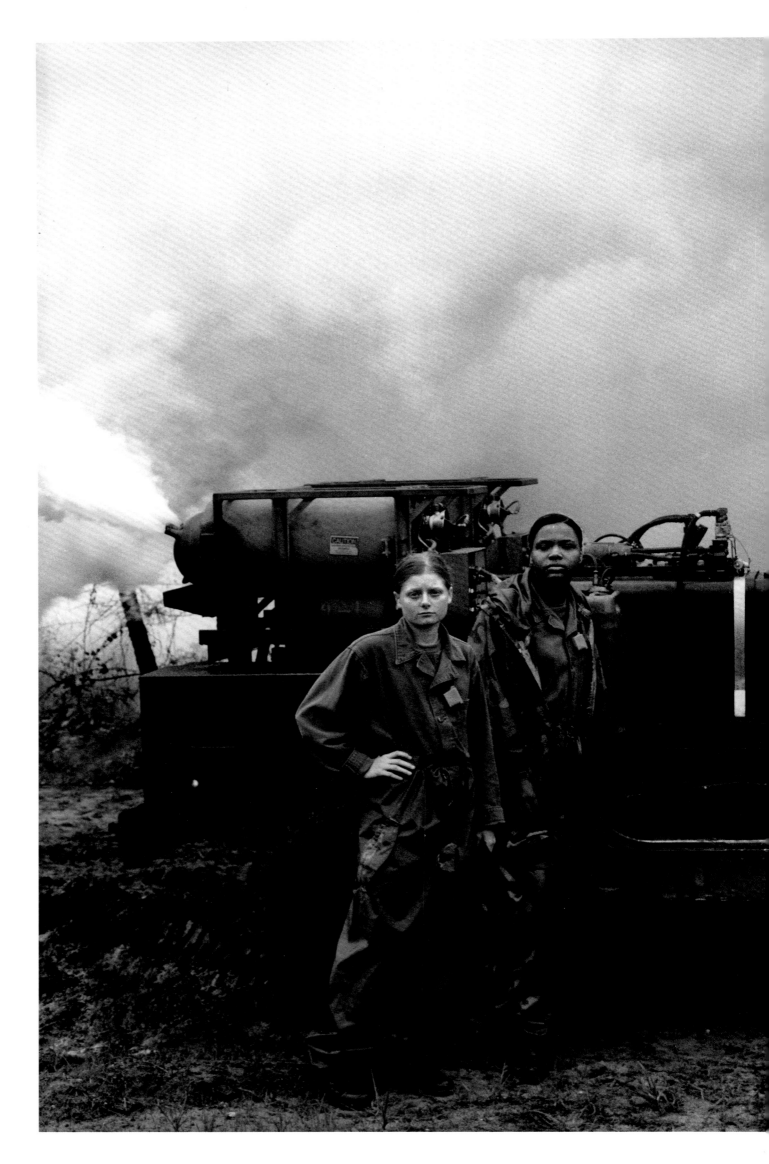

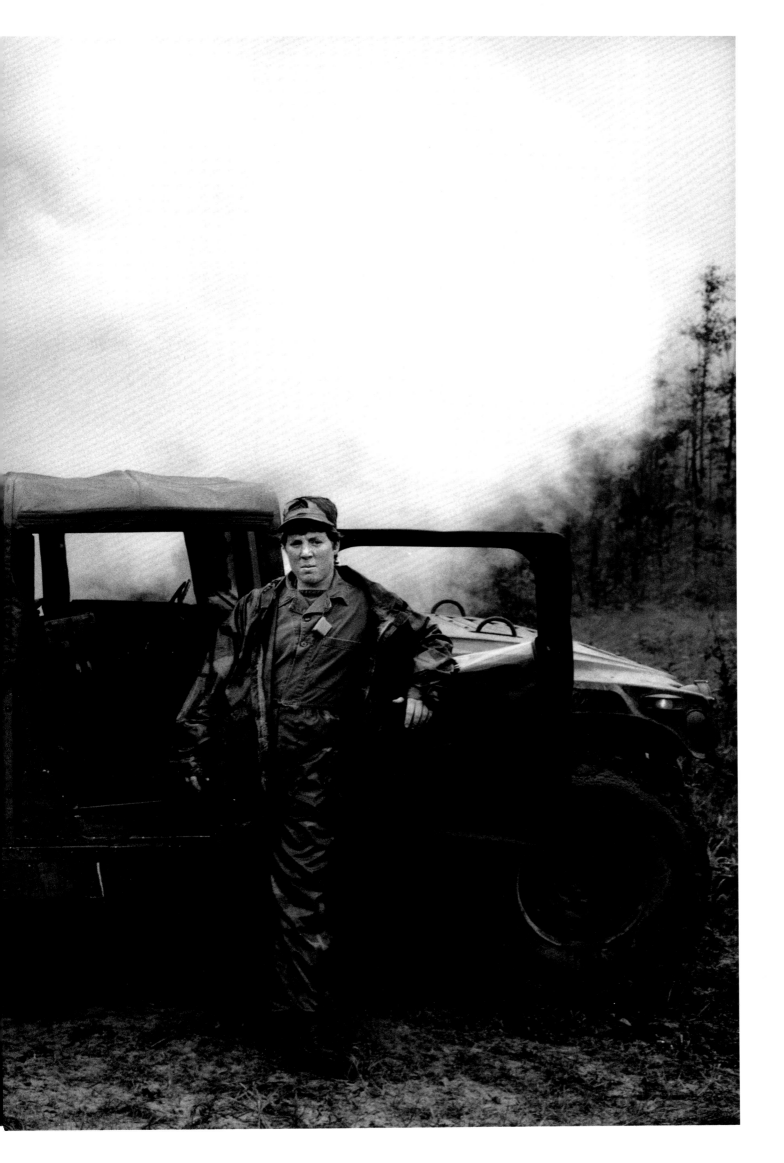

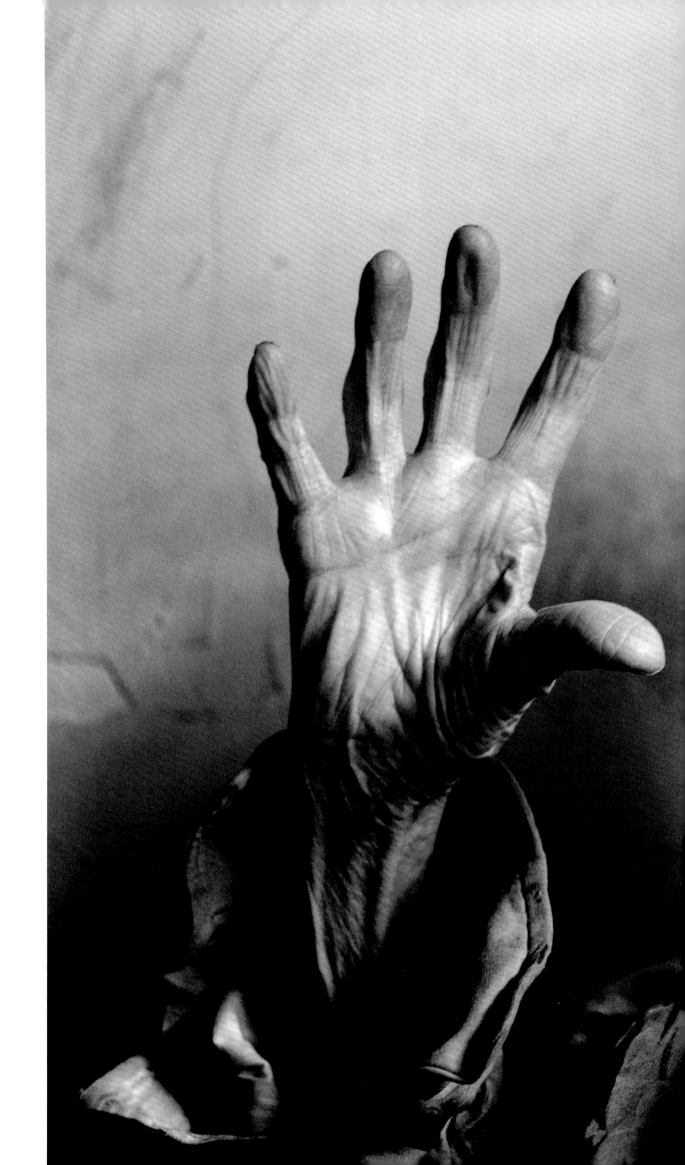

Louise Bourgeois
Sculptor
New York City

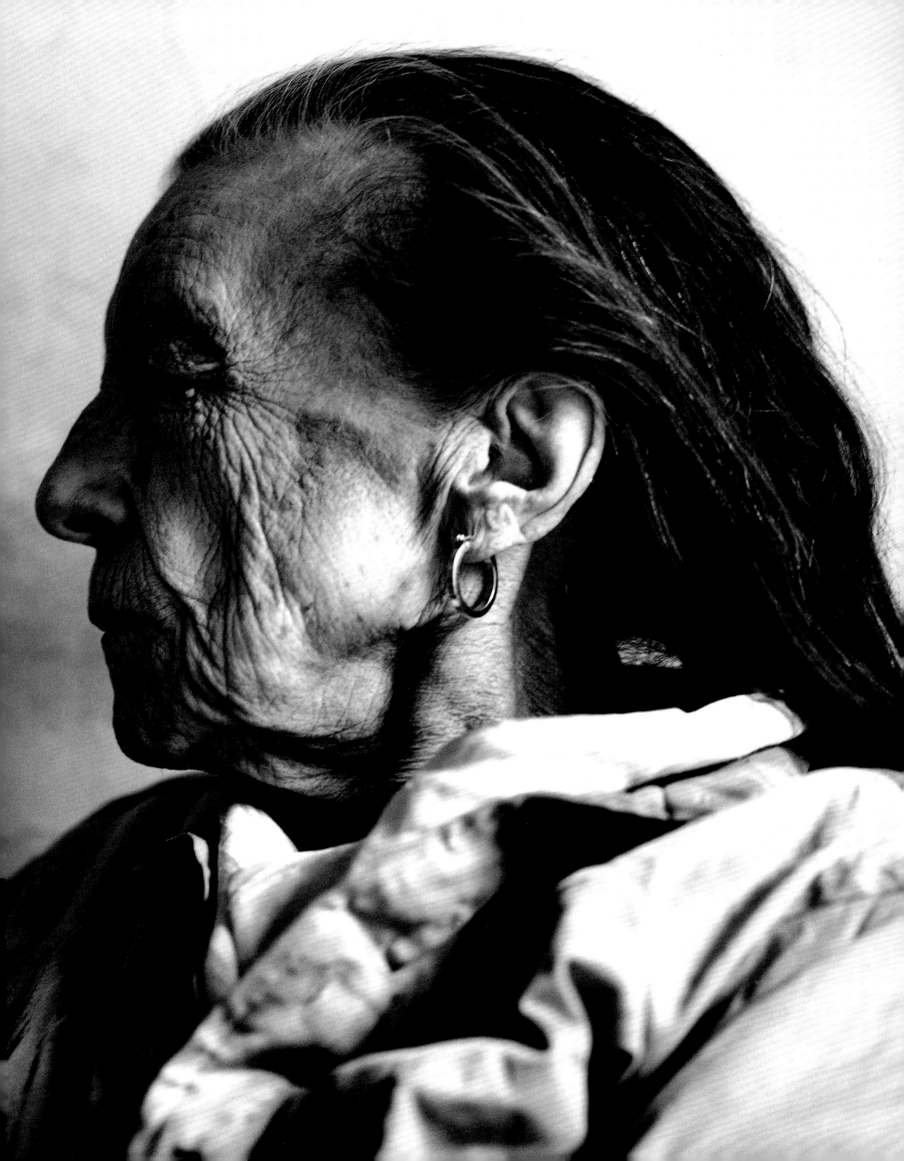

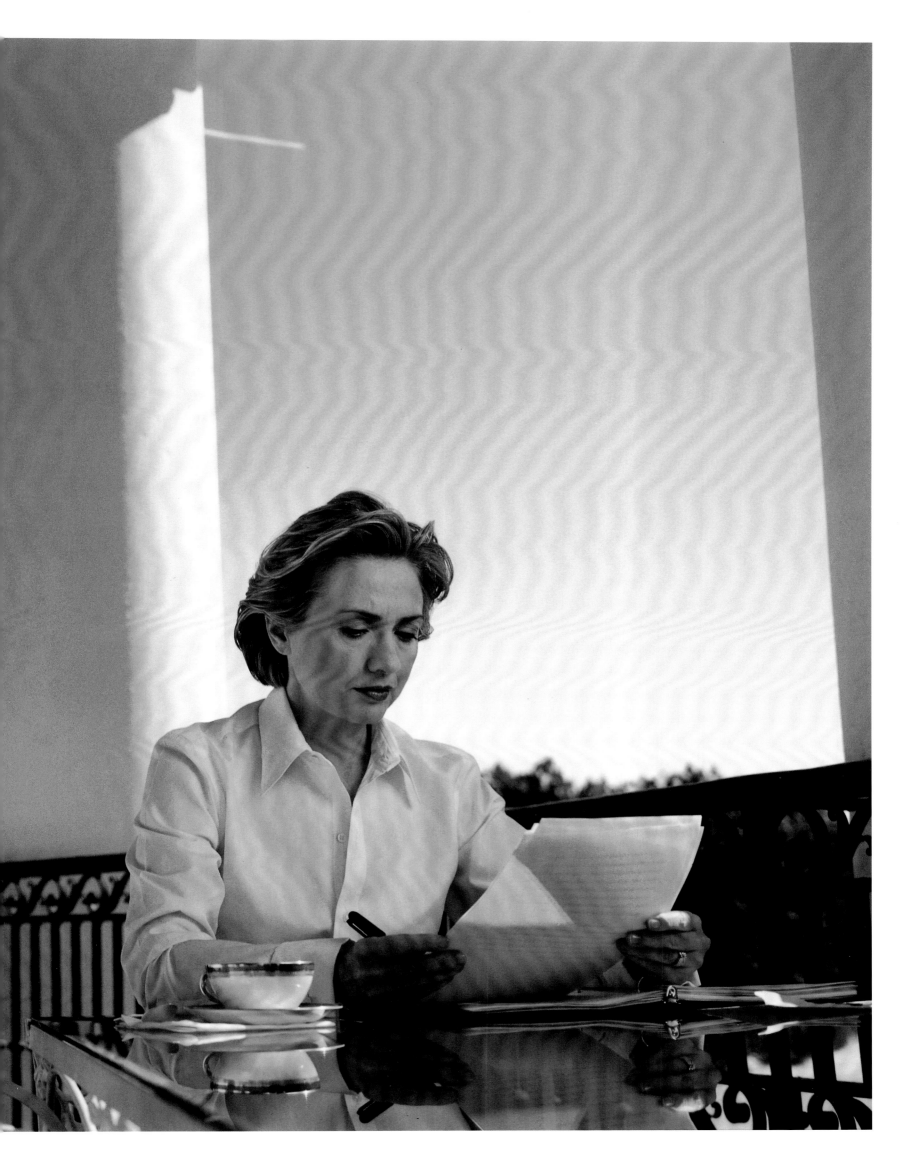

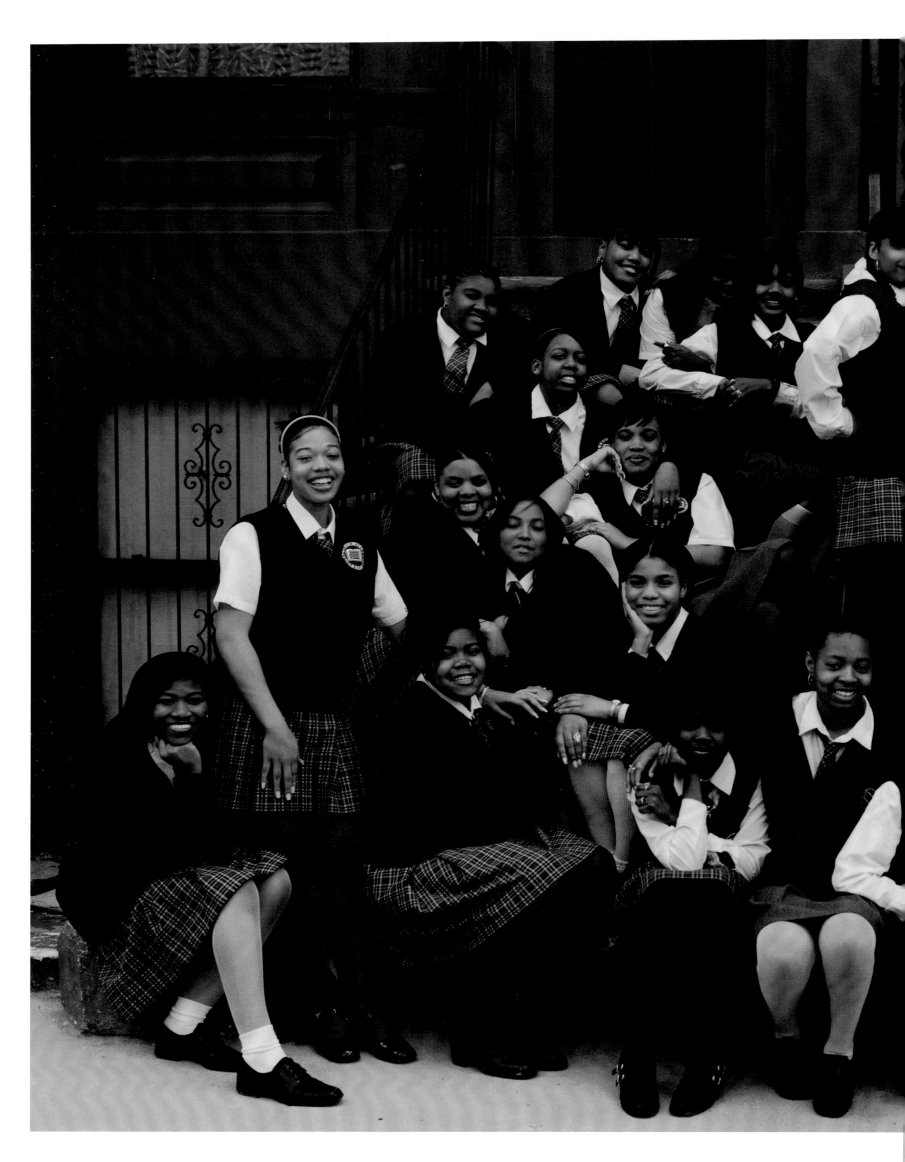

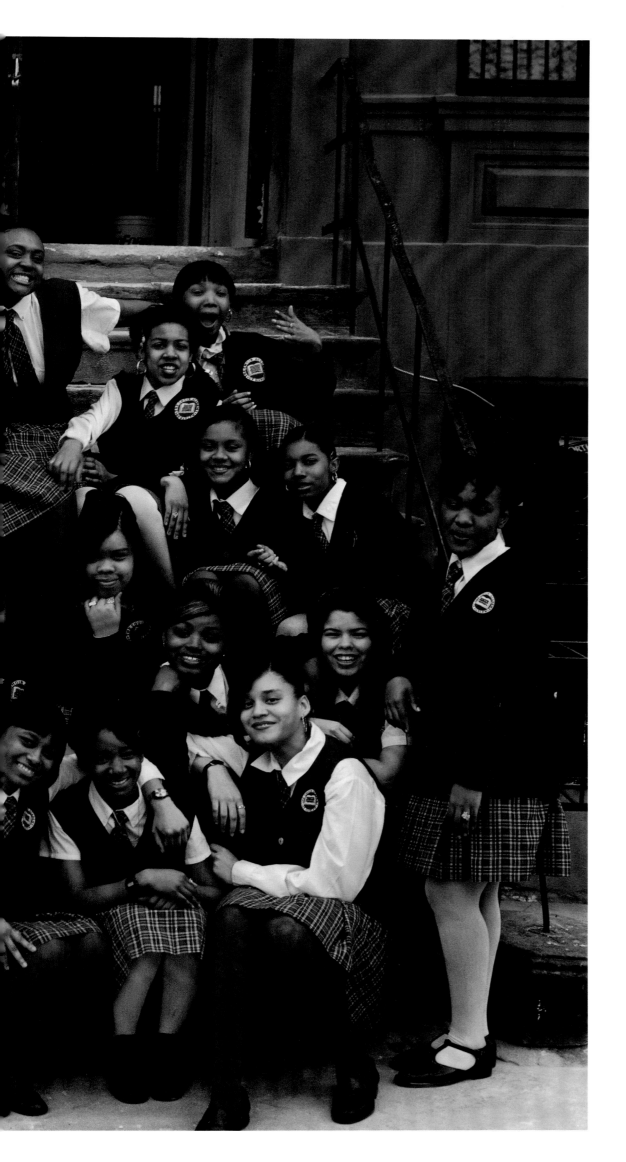

Girls Choir of Harlem
New York City

Preceding page:

Hillary Rodham Clinton
The White House, Washington, D.C.

Patti Smith
Musician, poet
New York City

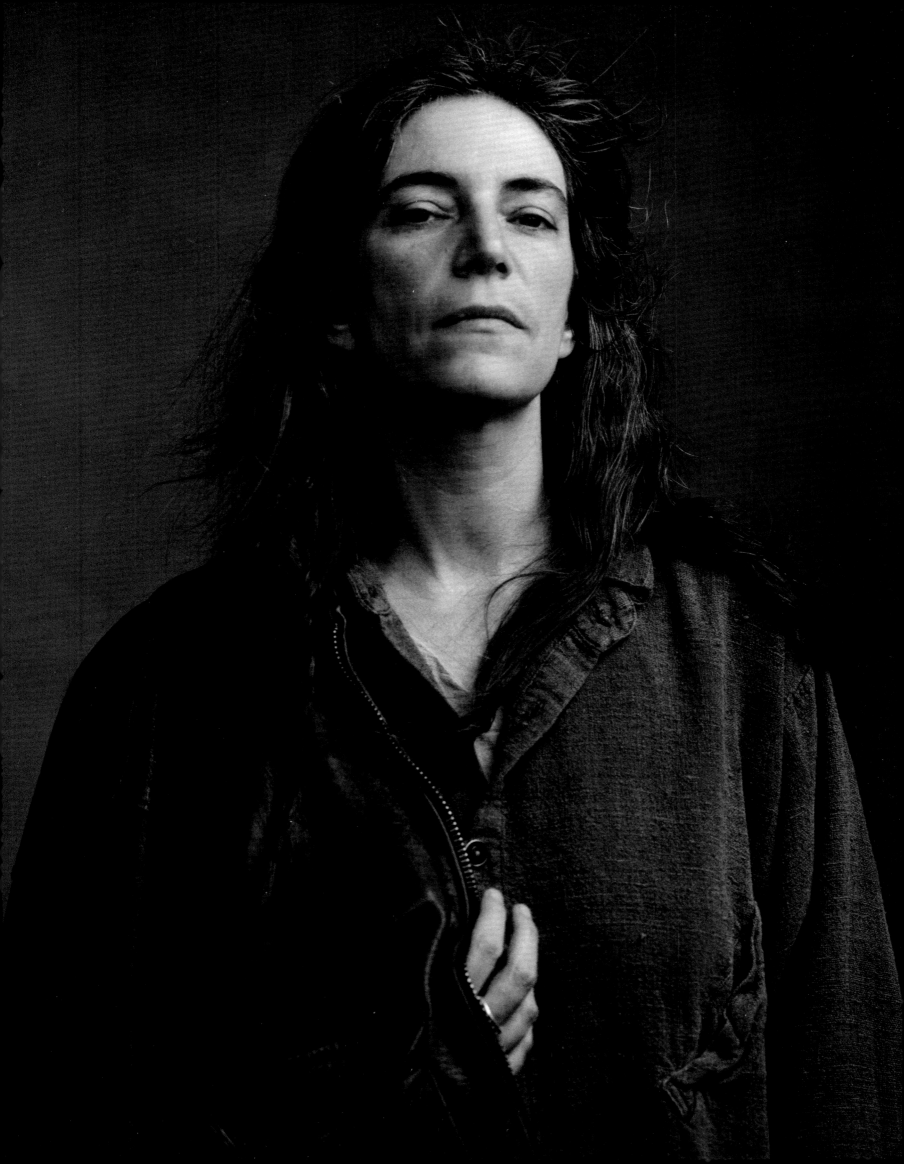

Missy Giove
Mountain biker
Durango, Colorado

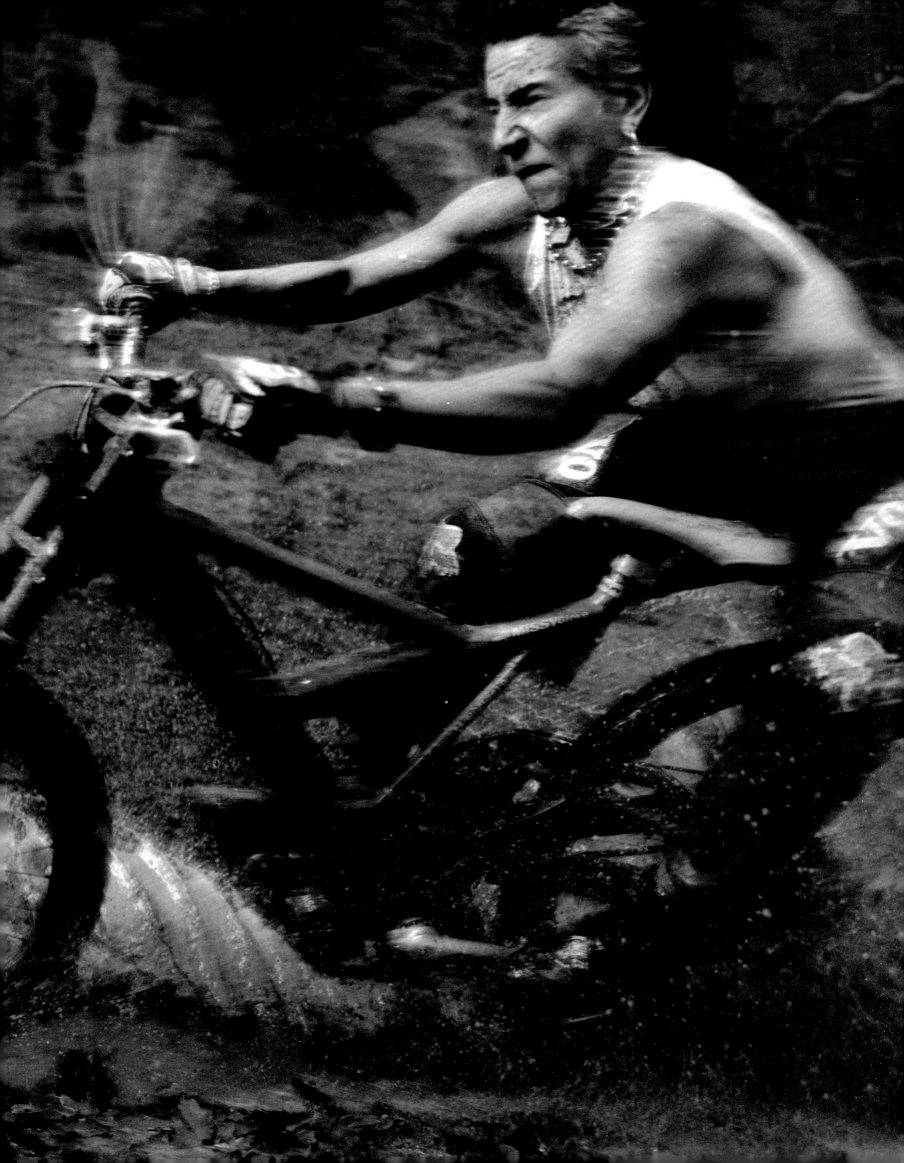

Jennifer Jackson
San Antonio, Texas

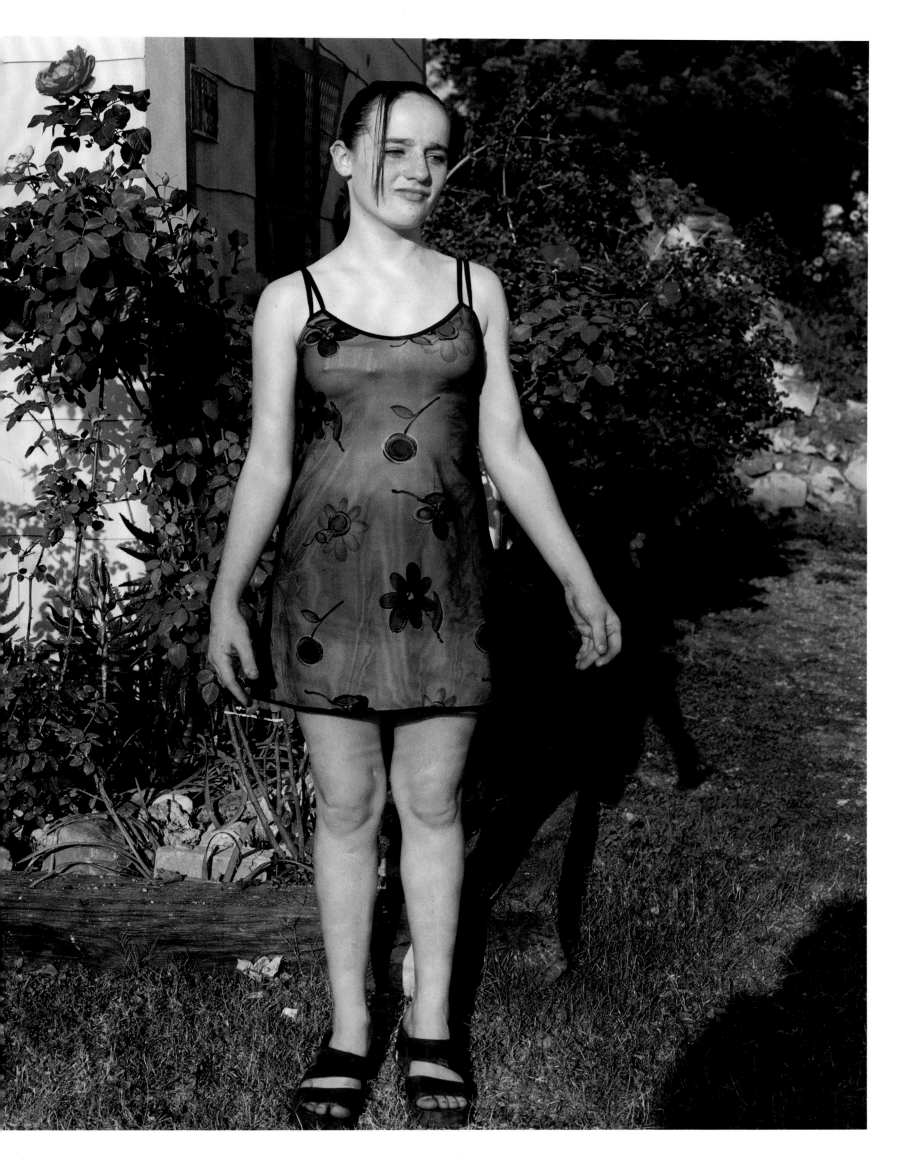

Terese Capucilli
Dancer, Martha Graham Dance Company
New York City

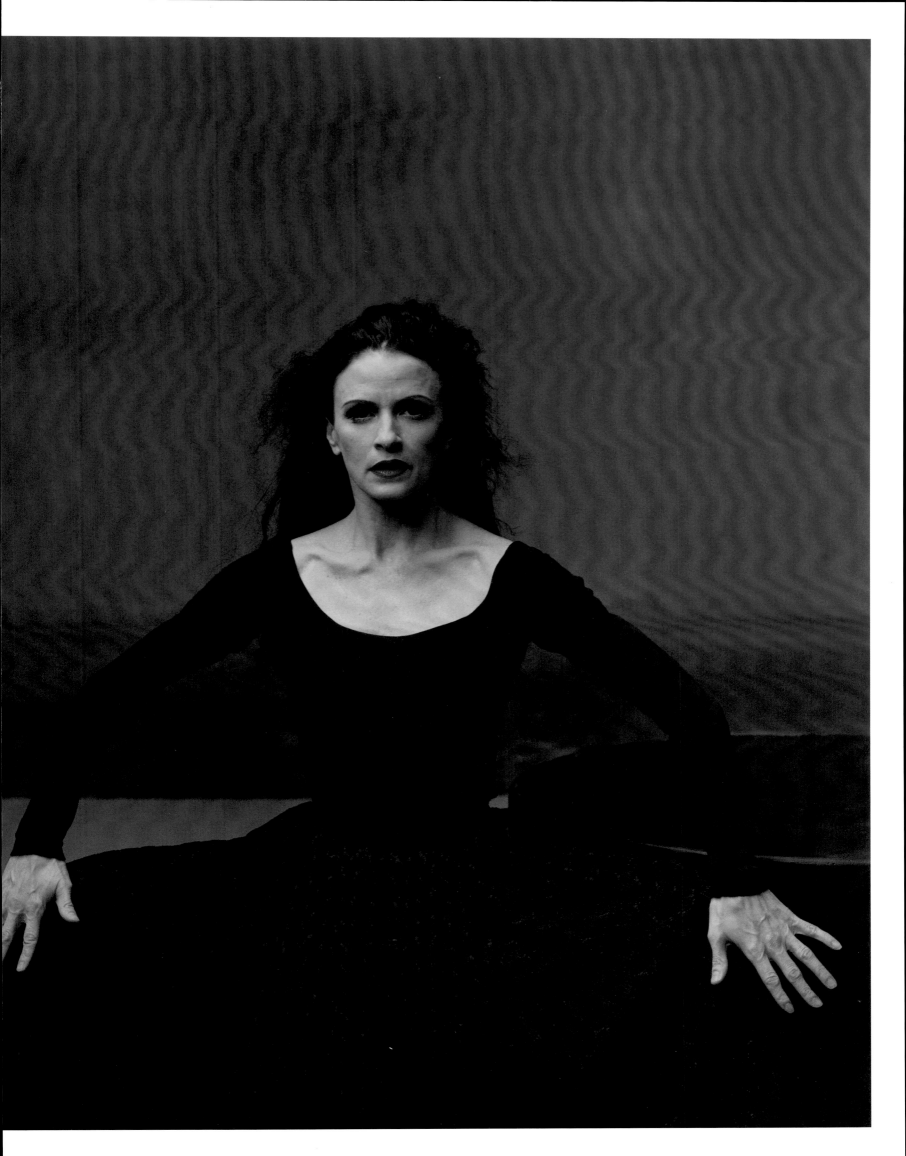

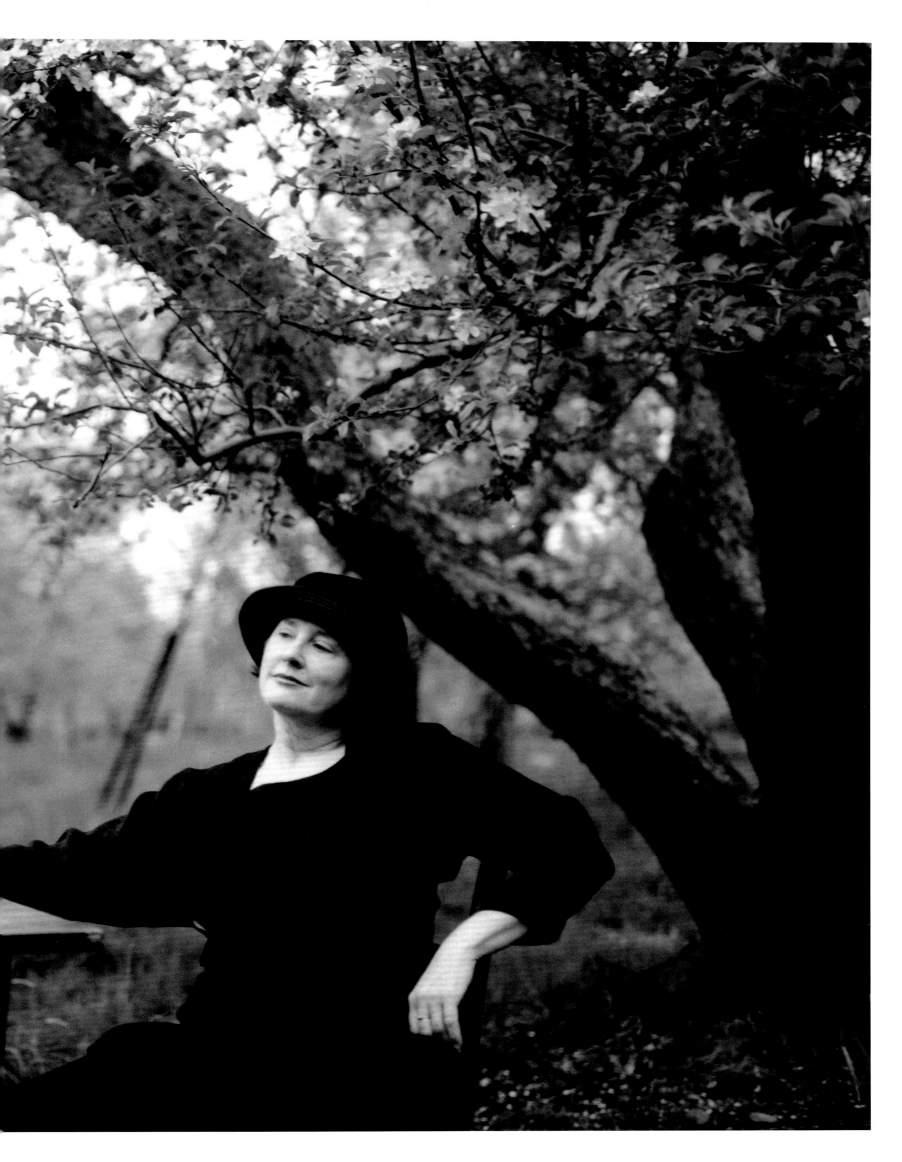

Waris Dirie
Model
New York City

Preceding page:

Alice Waters
Restaurateur, chef
Rocktown Apple Orchard, New Jersey

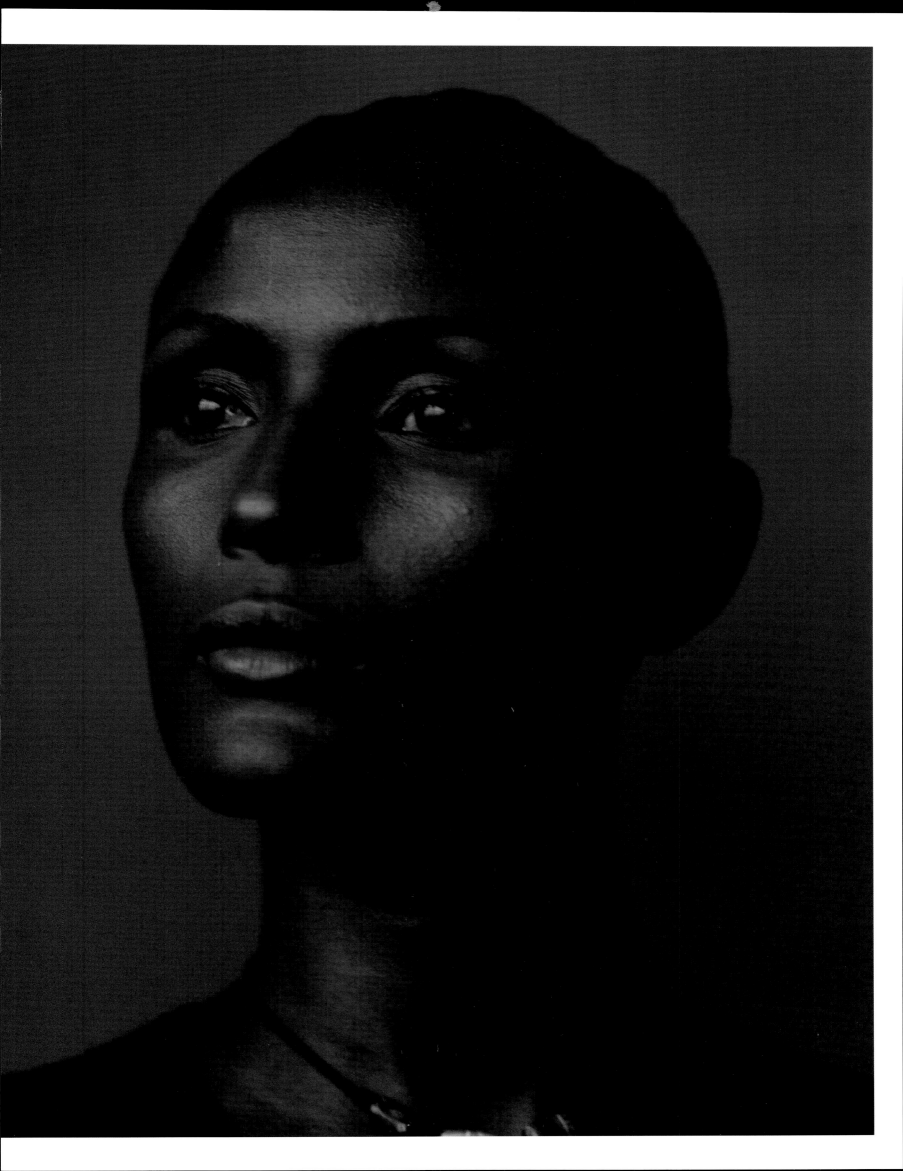

Madeleine Albright
U.S. secretary of state
State Department, Washington, D.C.

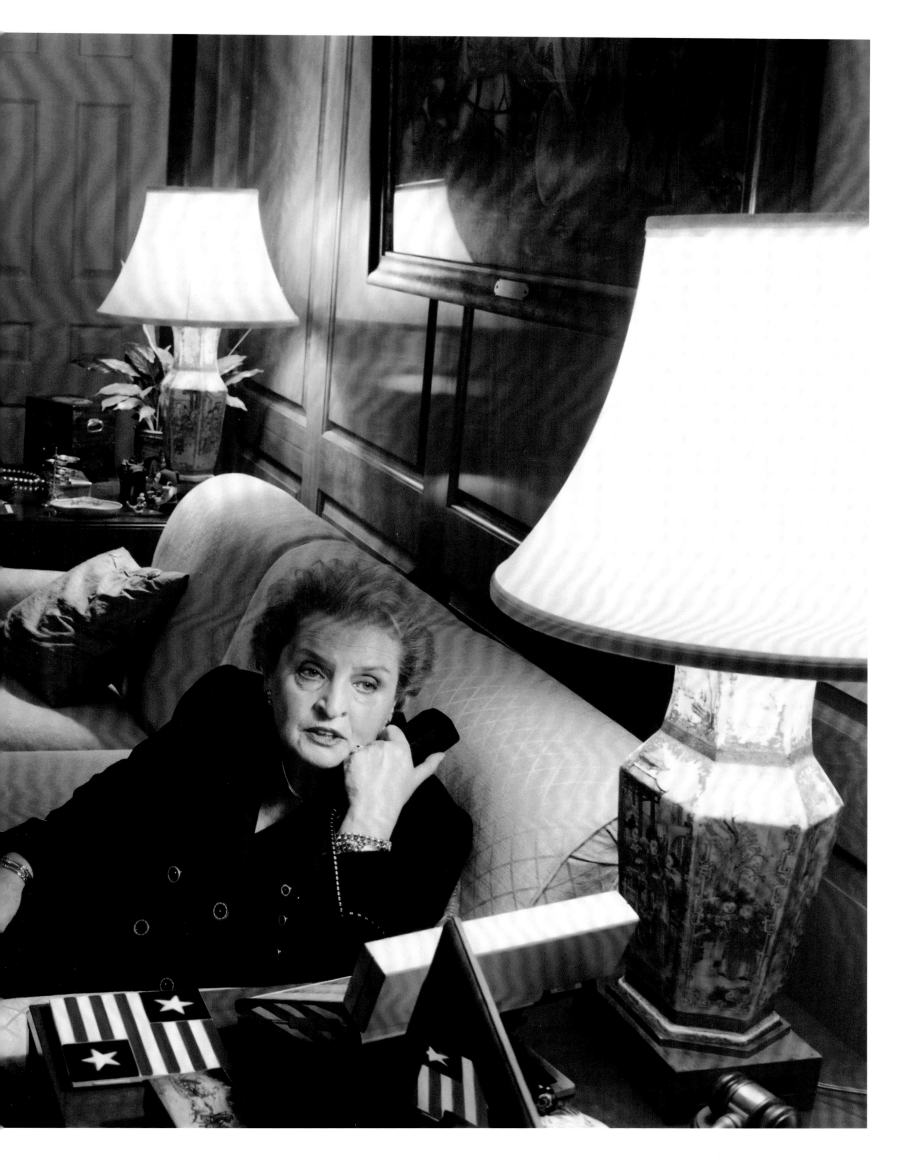

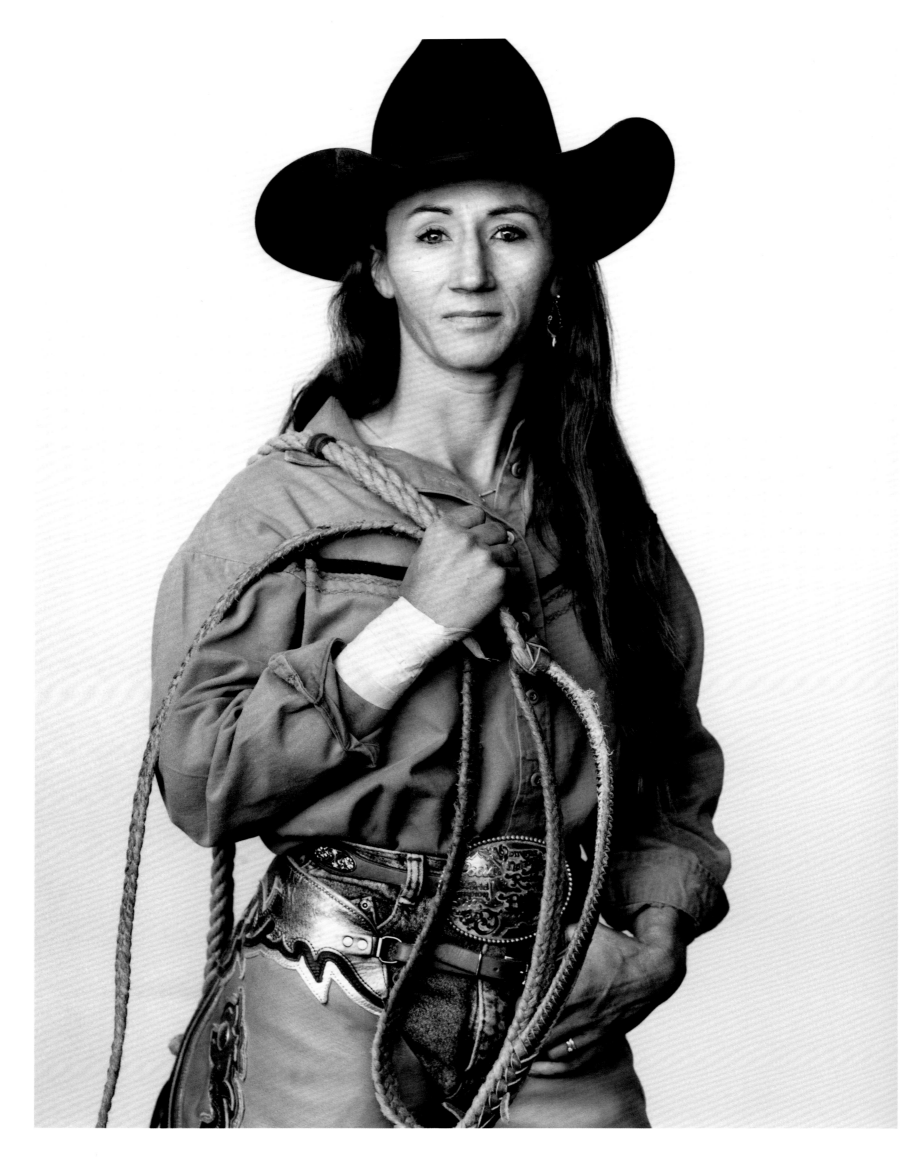

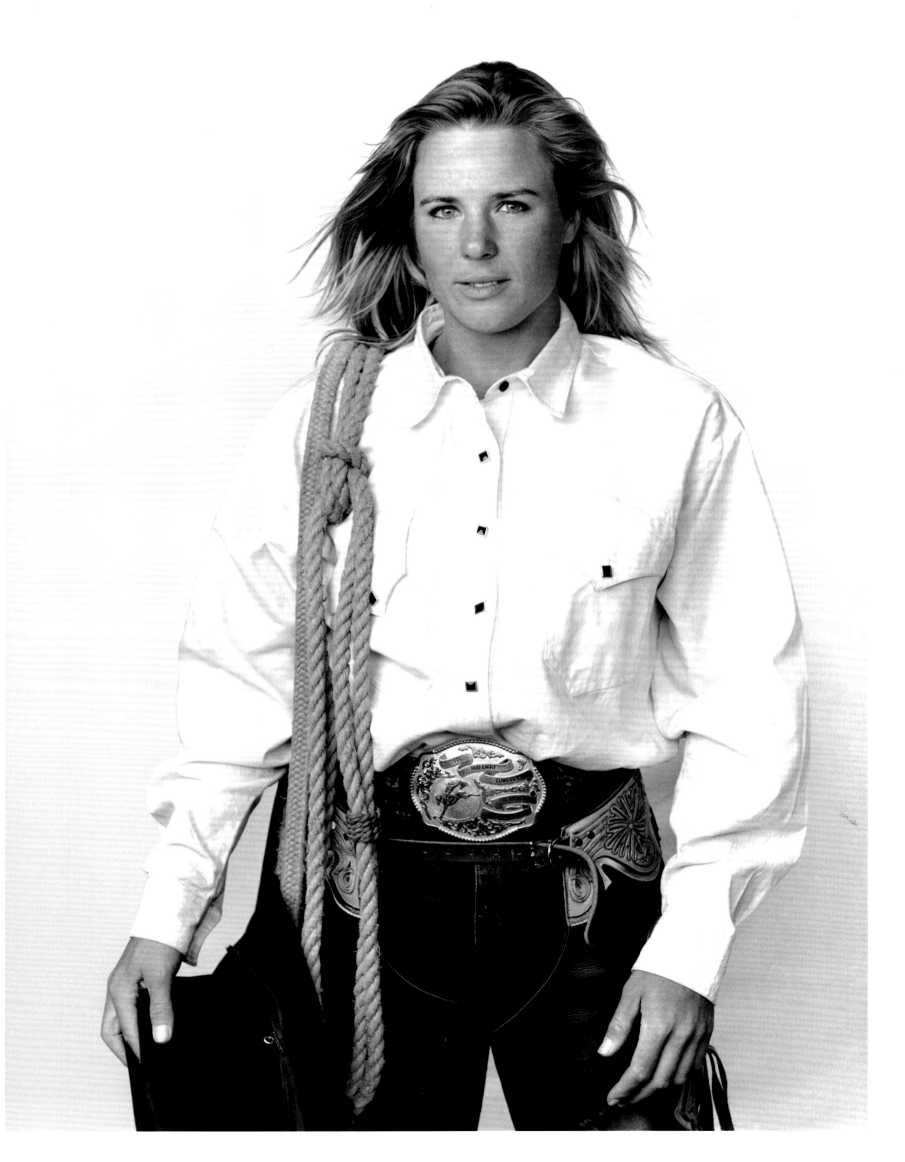

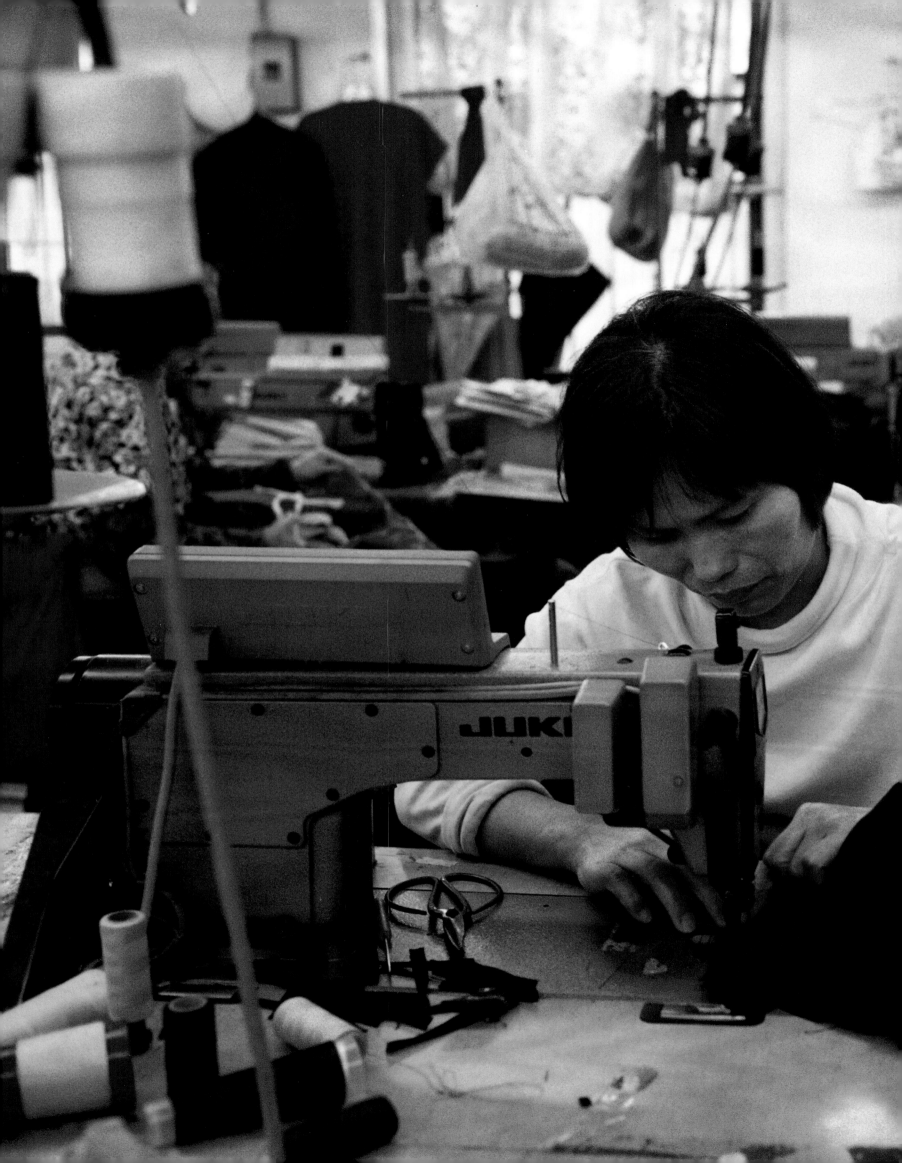

Elizabeth Taylor and Sugar
Actress
Bel Air, California

Preceding pages:

Tammy Kelly
Bull rider
Alamosa All-Girl Rodeo, Alamosa, Colorado

Joy Gordon
Bull rider
Alamosa All-Girl Rodeo, Alamosa, Colorado

Shen Chu
Sewing machine operator
Four Maples Ladies' Blouse Company,
Chinatown, New York City

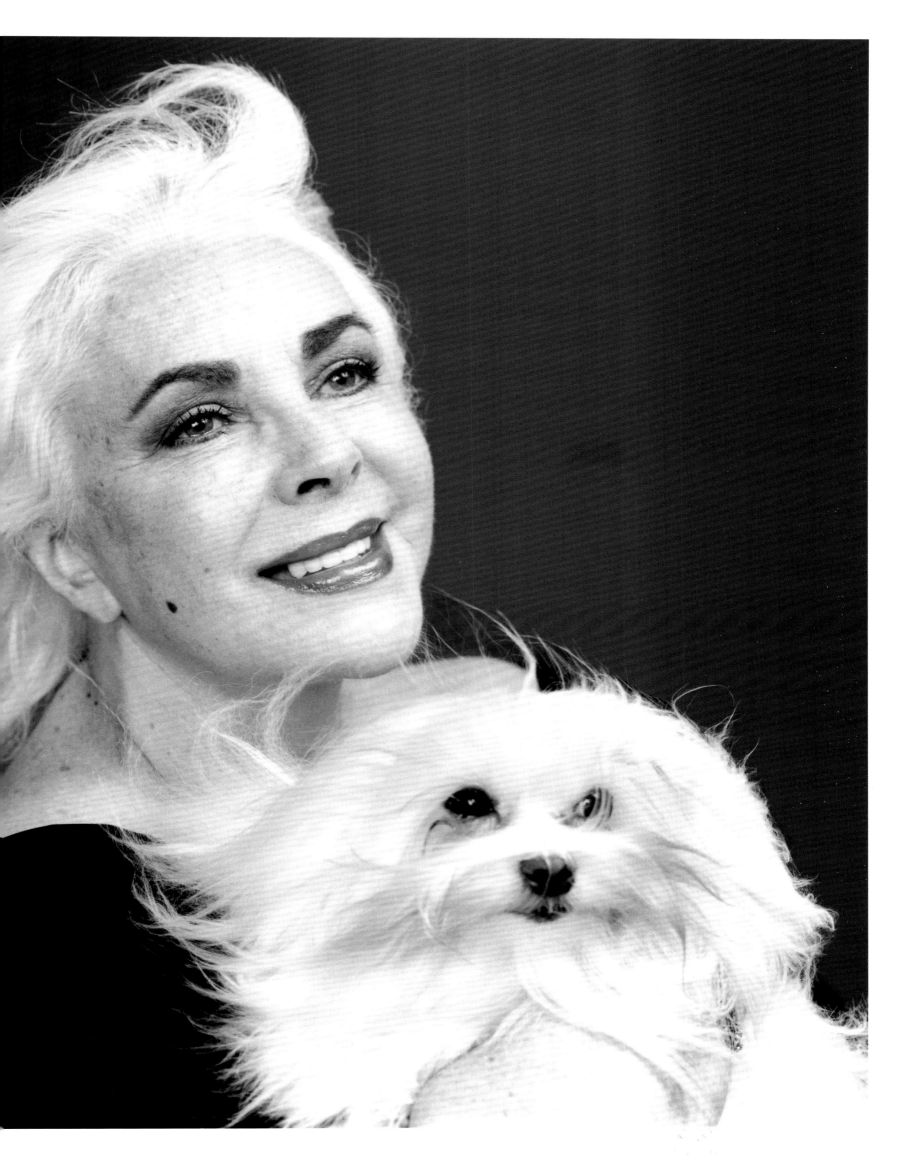

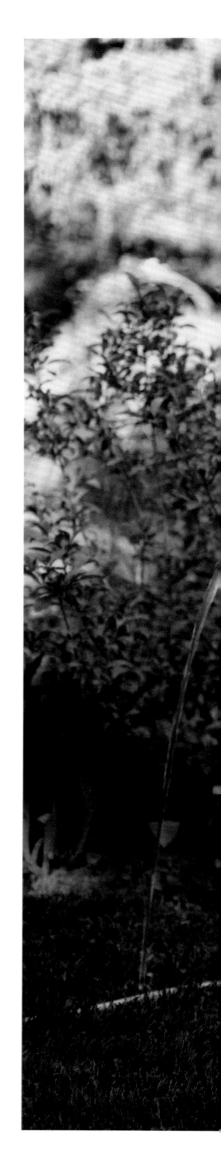

Jamaica Kincaid
Writer
Bennington, Vermont

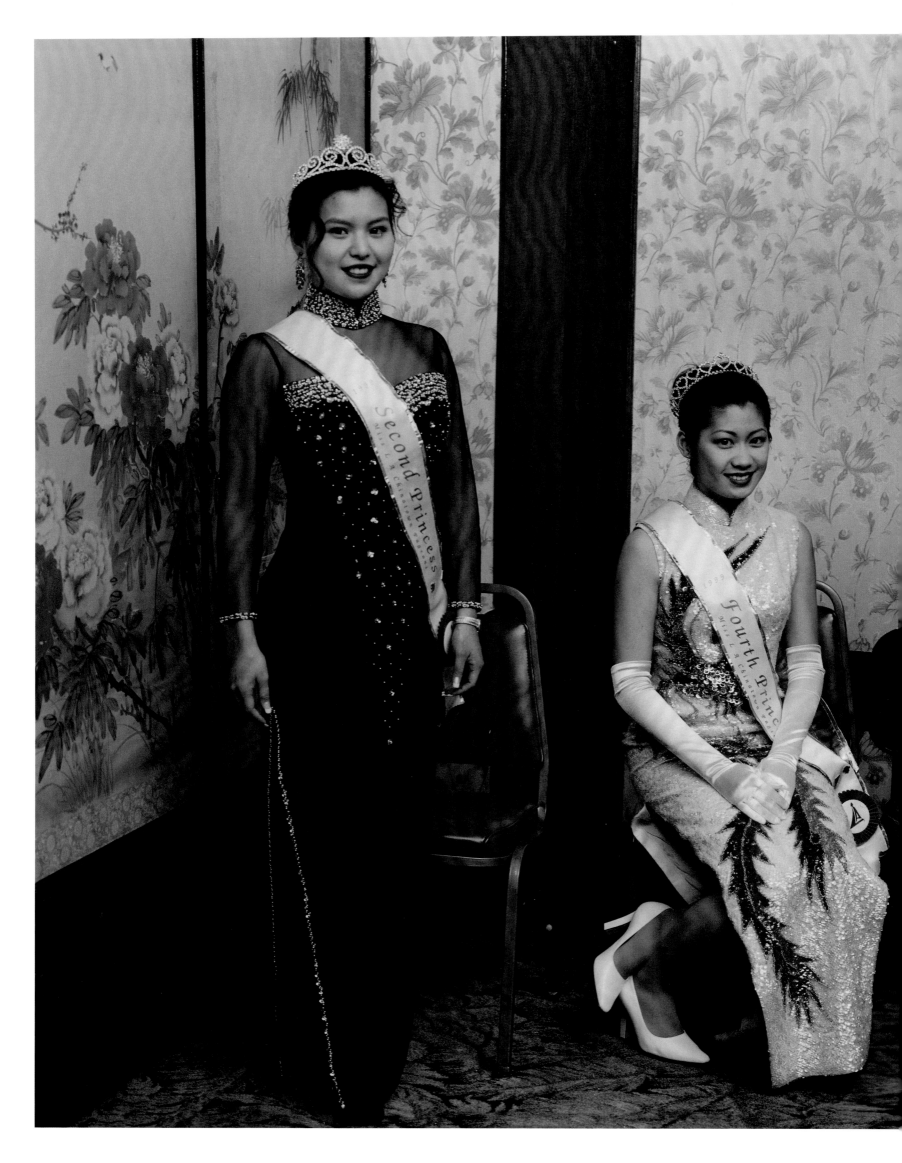

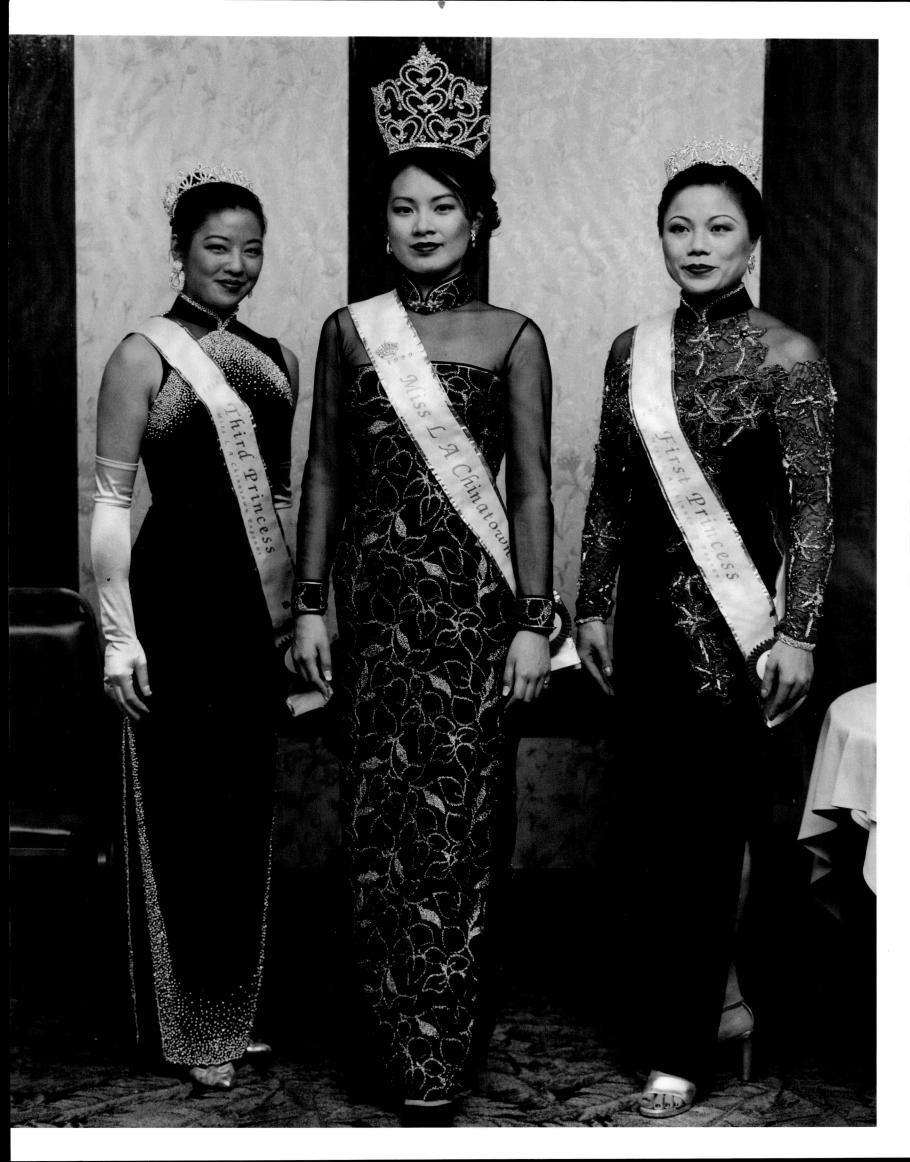

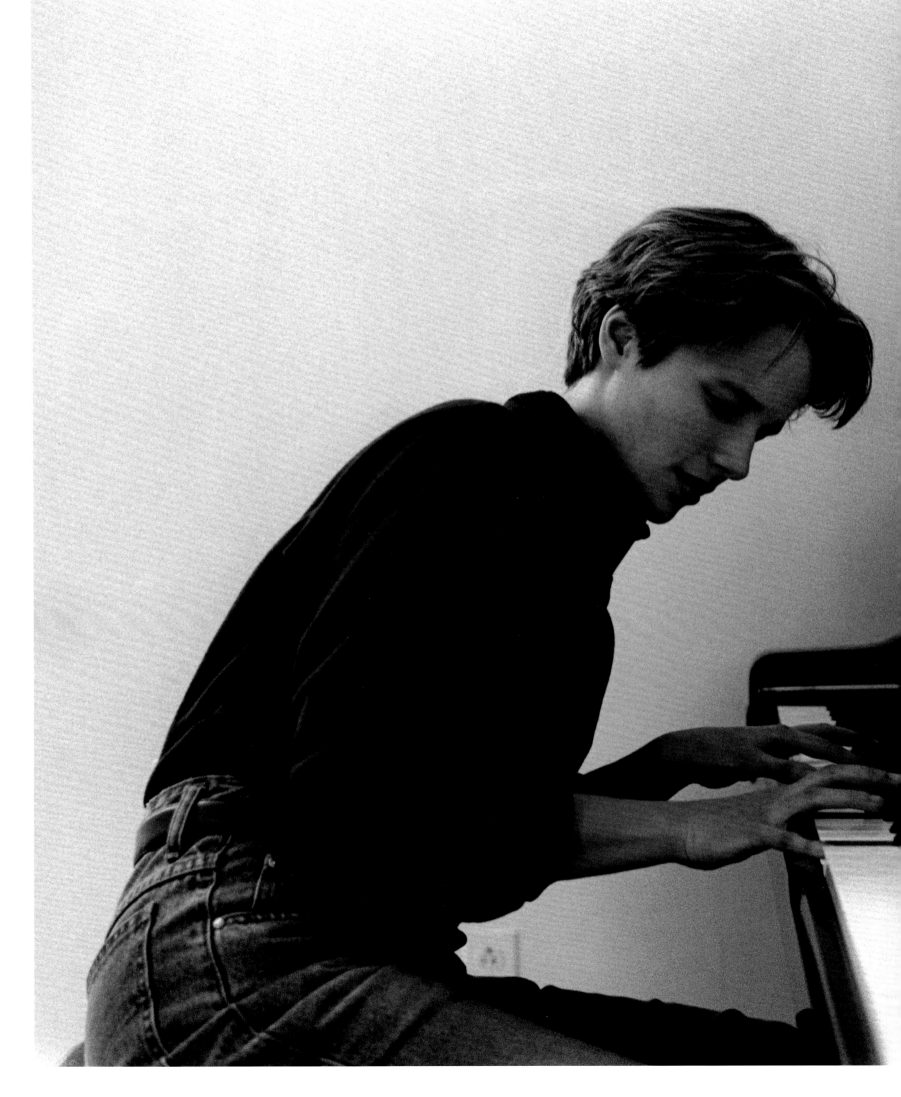

Serena and Venus Williams
Tennis players
West Palm Beach, Florida

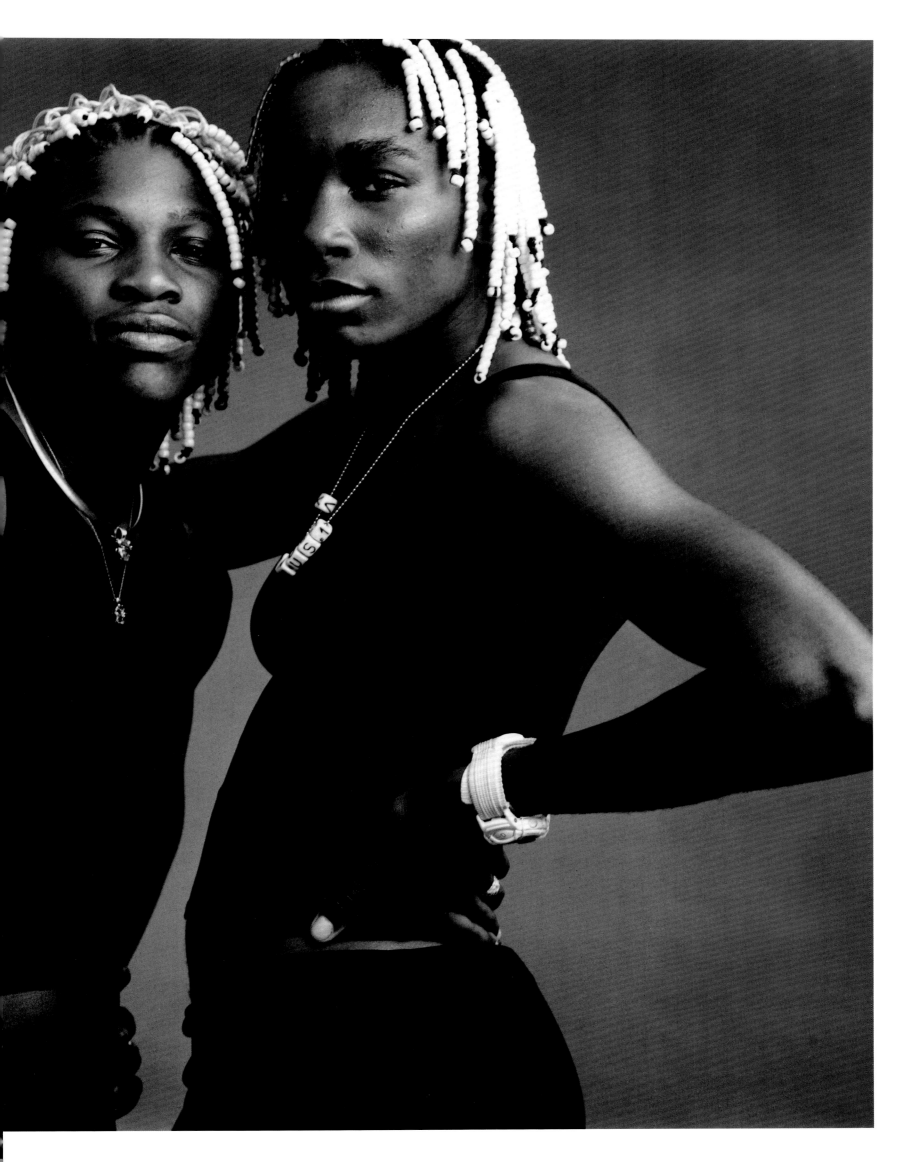

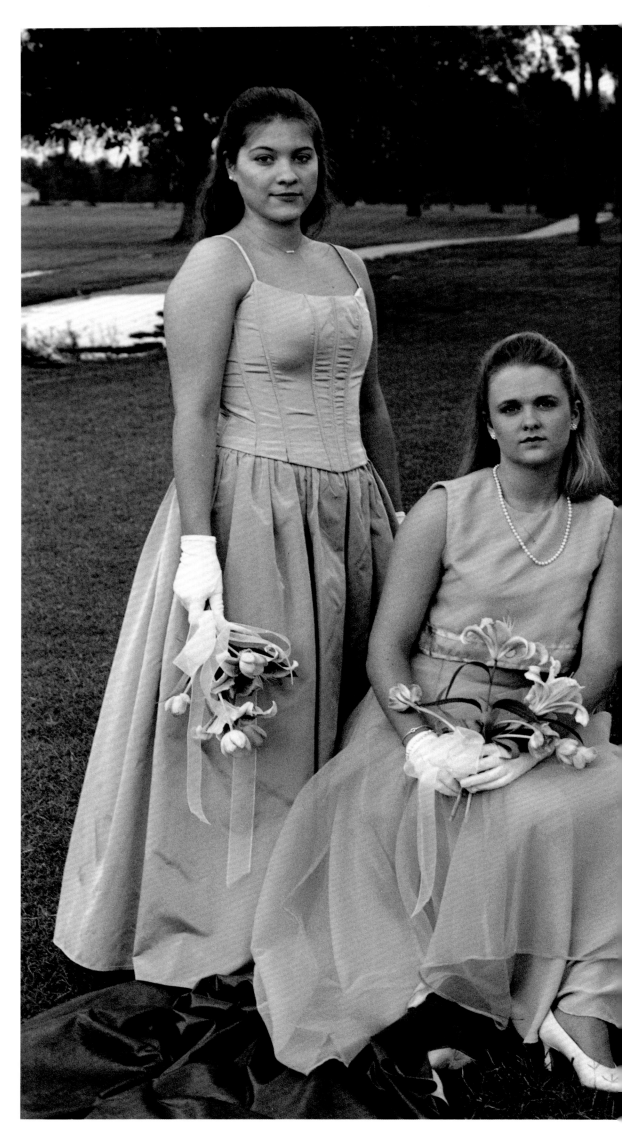

Jane Britt, Leathe Maxwell, Meg Goodman,
Marie Newcome, Crocker Lee, and Jane Hall
Delta Debutante Club
Greenville, Mississippi

Preceding page:

Carly Fiorina
President and chief executive officer
Hewlett-Packard Company
Teterboro Airport, Teterboro, New Jersey

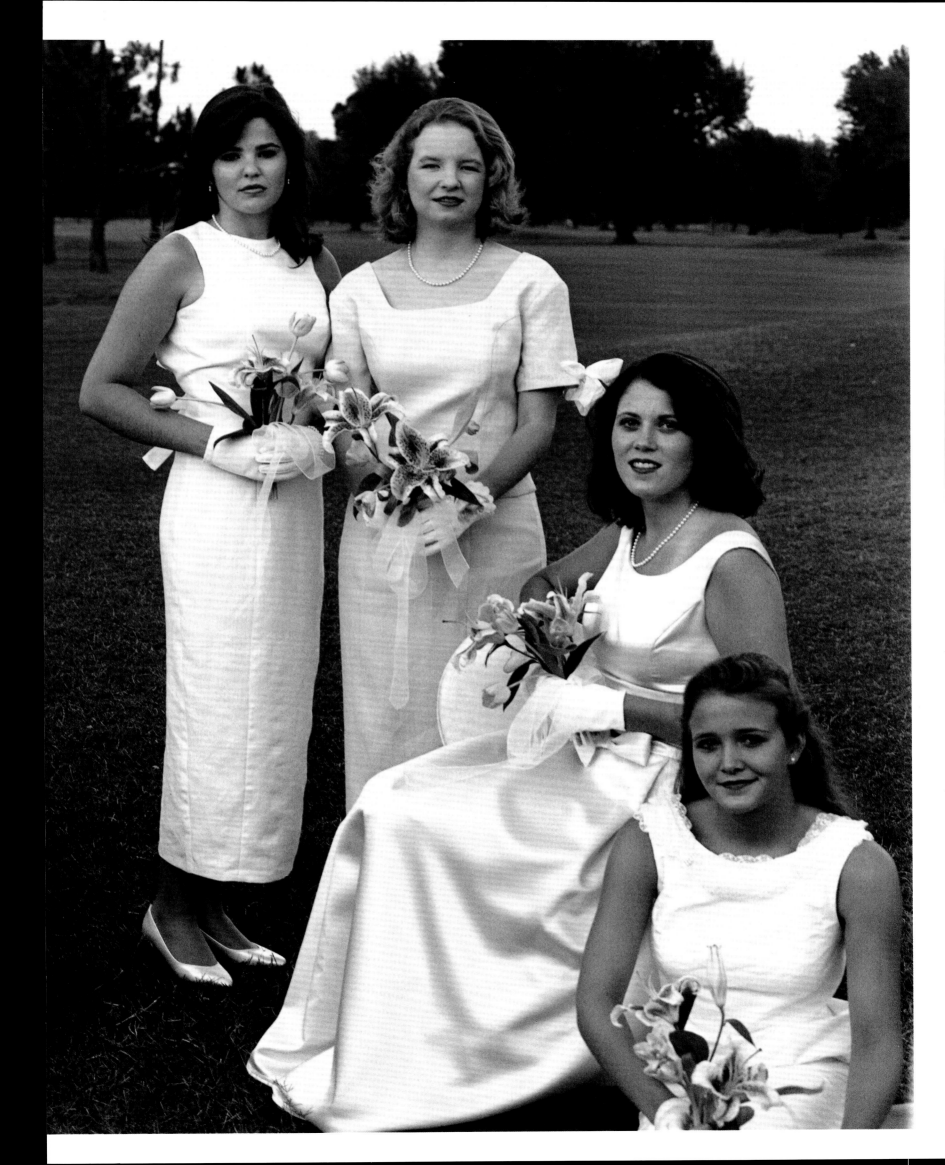

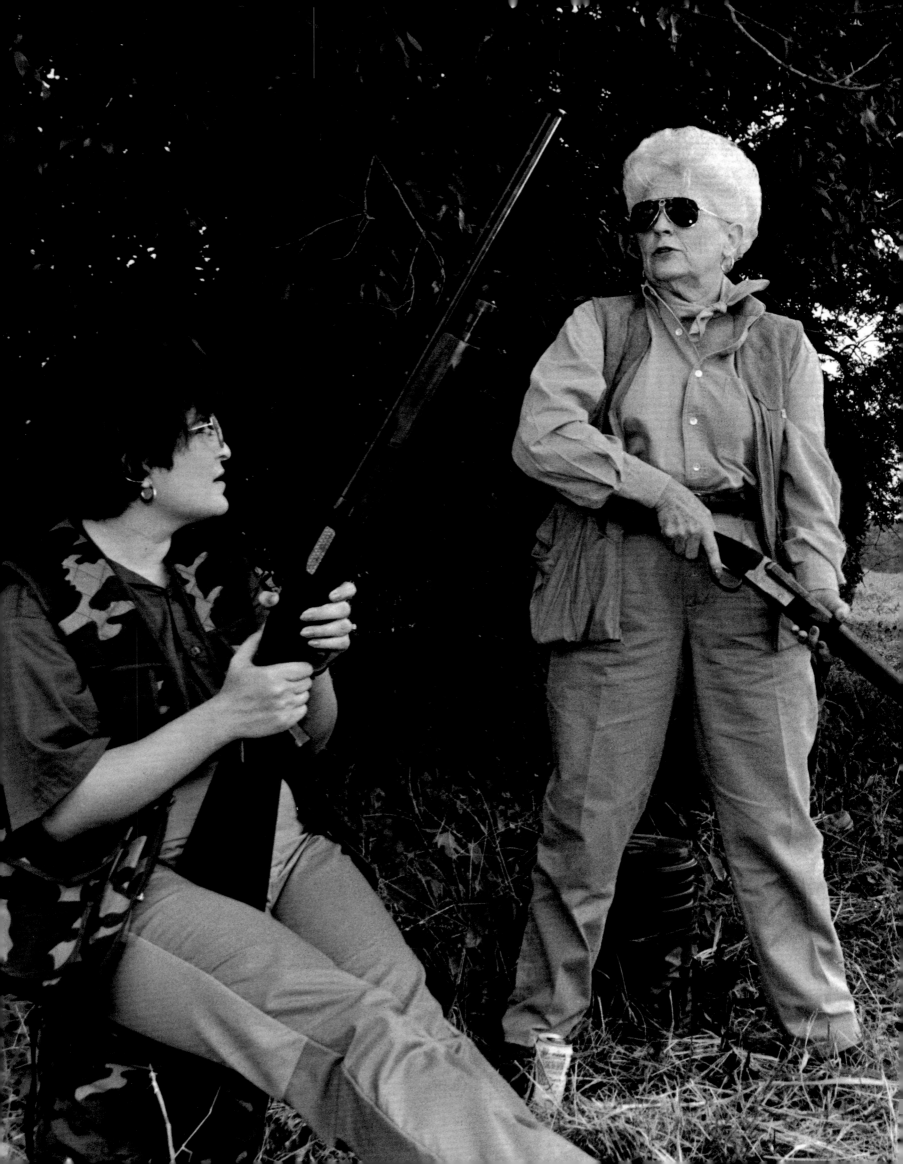

Ann Richards
and Lena Guerrero (left)
Former governor of Texas and
former Texas state representative
Honey Grove, Texas

Jody Williams
Activist,
International Campaign to Ban Landmines
New York City

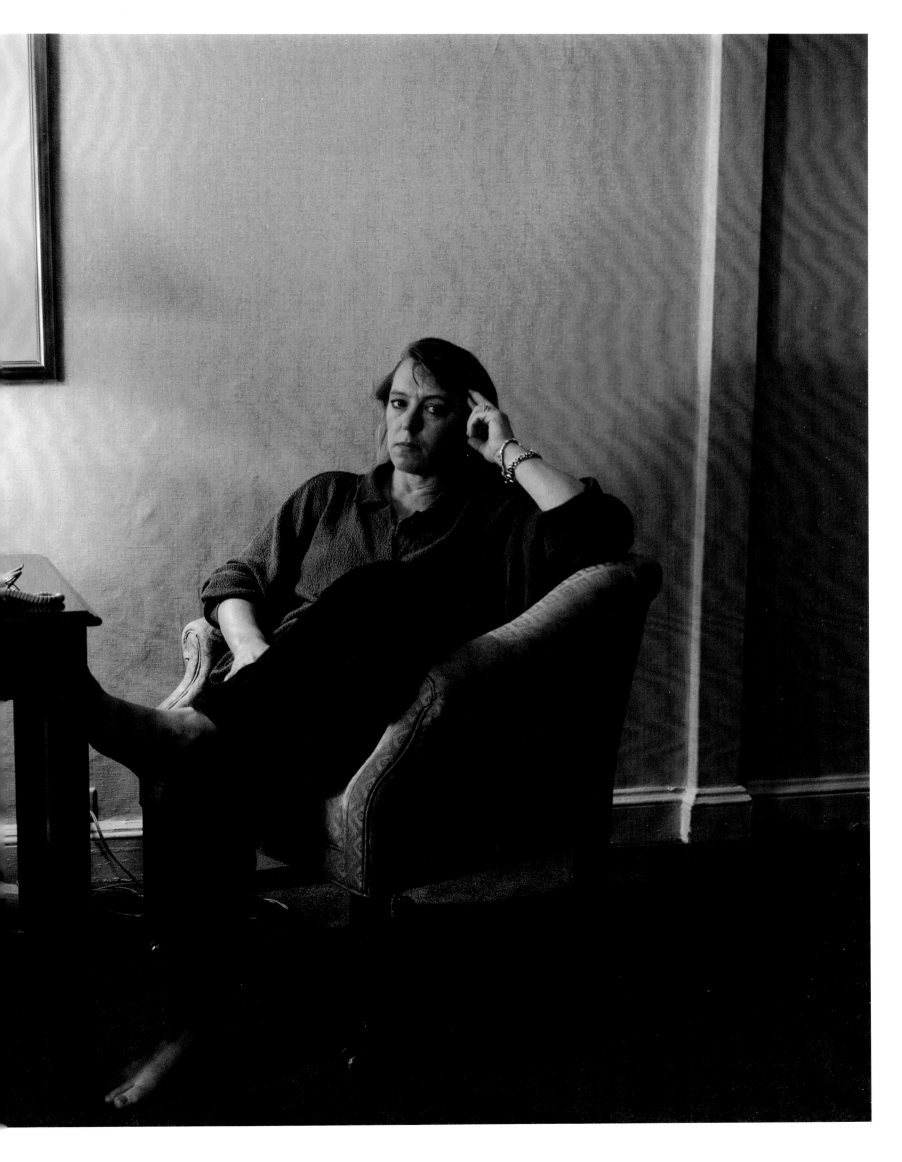

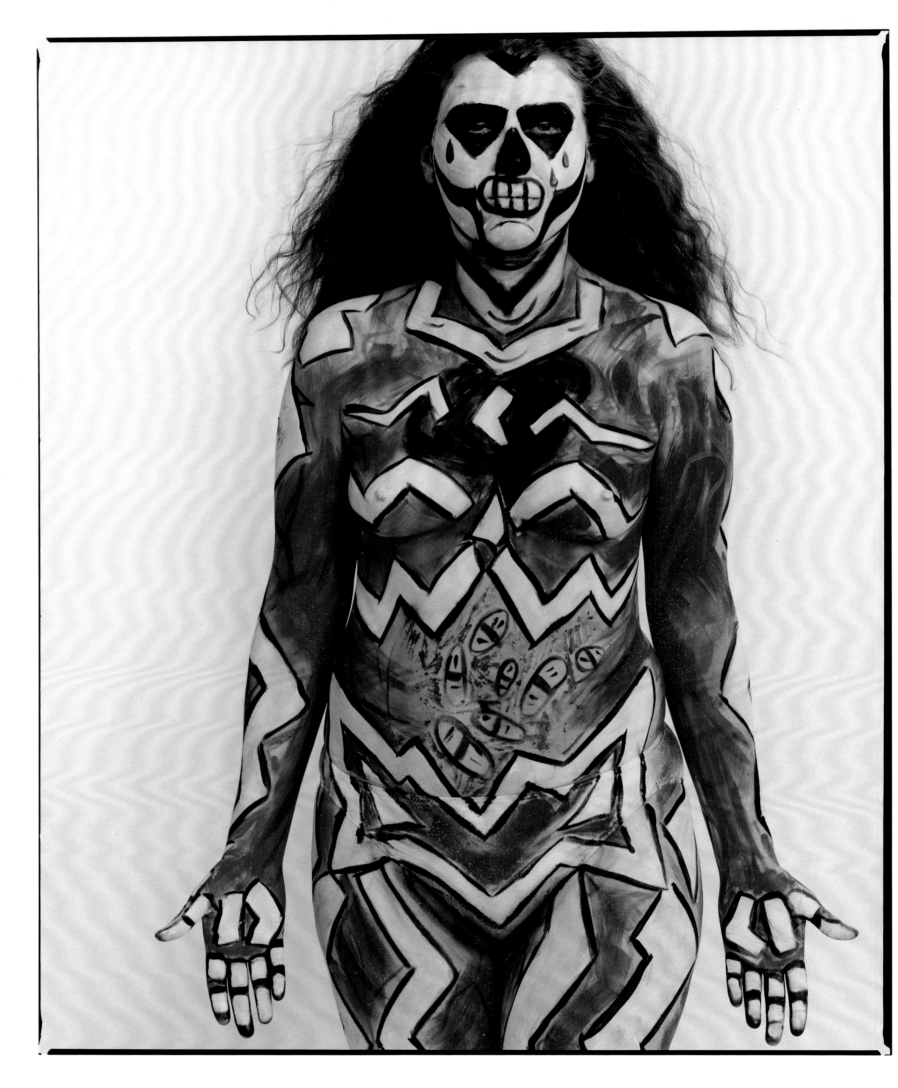

Kerie Campbell, member of organization of women with AIDS, San Francisco, California

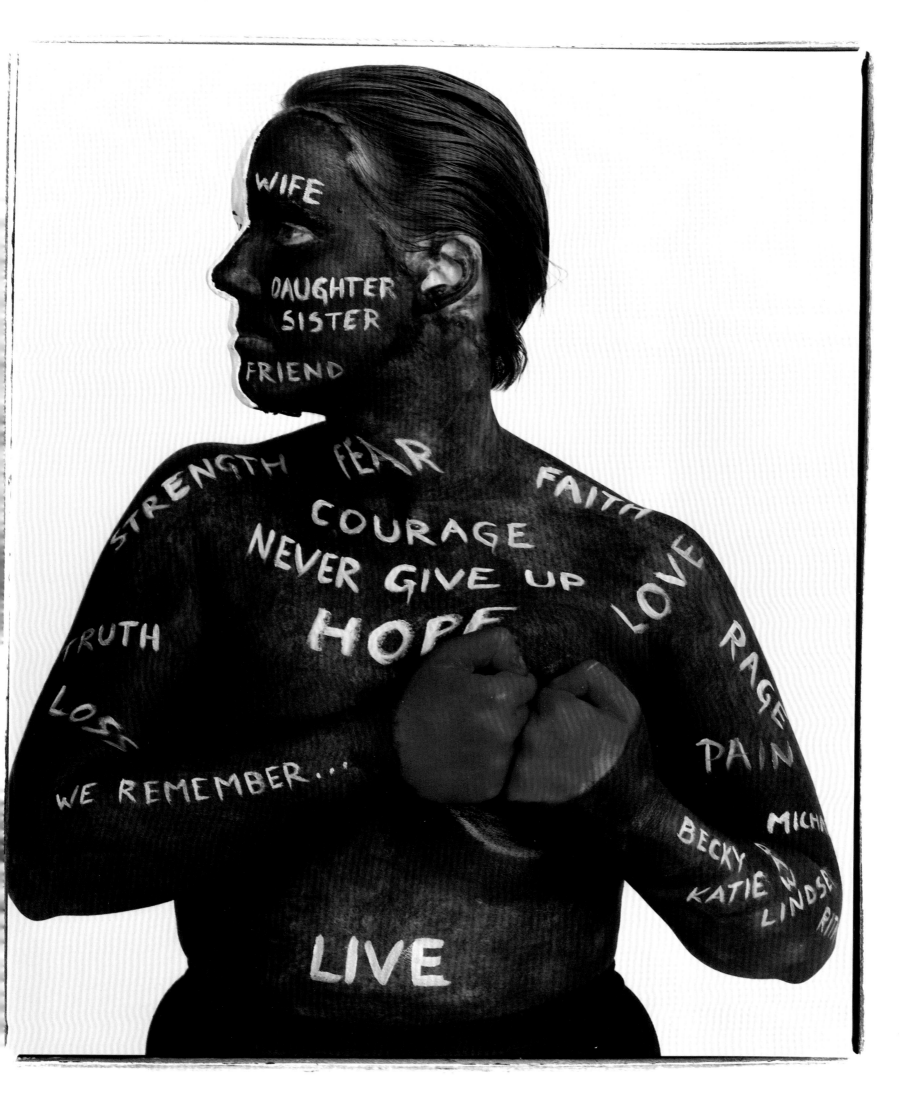

Rebecca Denison, executive director of organization of women with AIDS, San Francisco, California

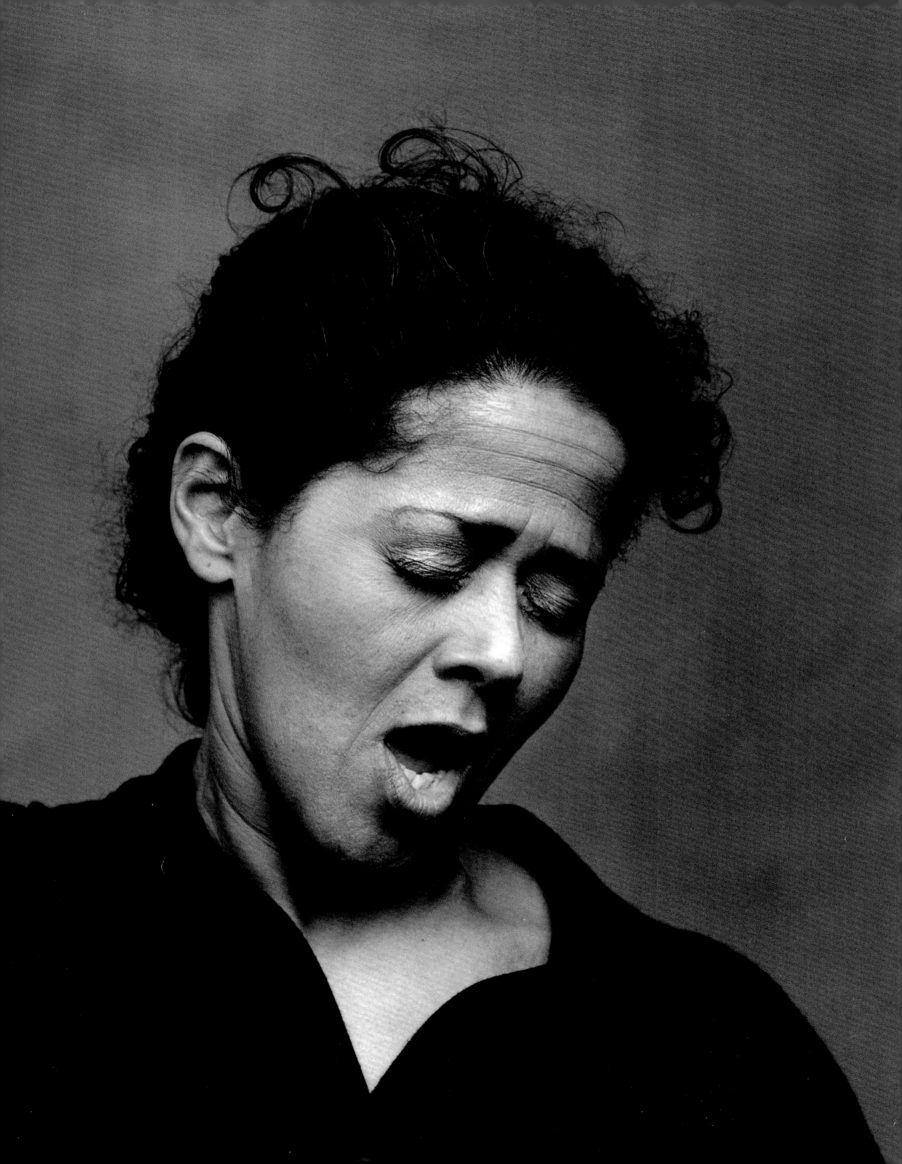

Karen Fedrau
Farmer
Fedrau Family Farm, Newcastle, California

Preceding page:

Anna Deavere Smith
Playwright, performer
New York City

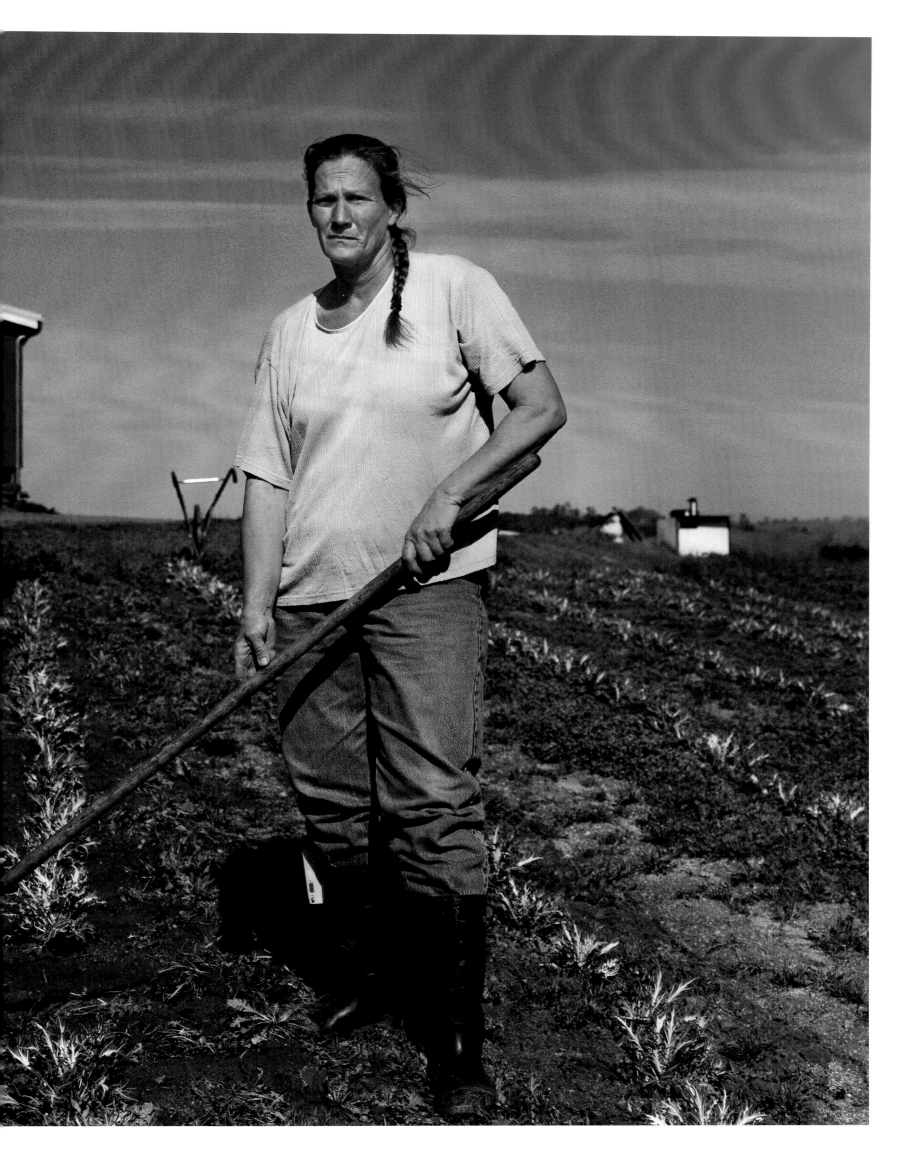

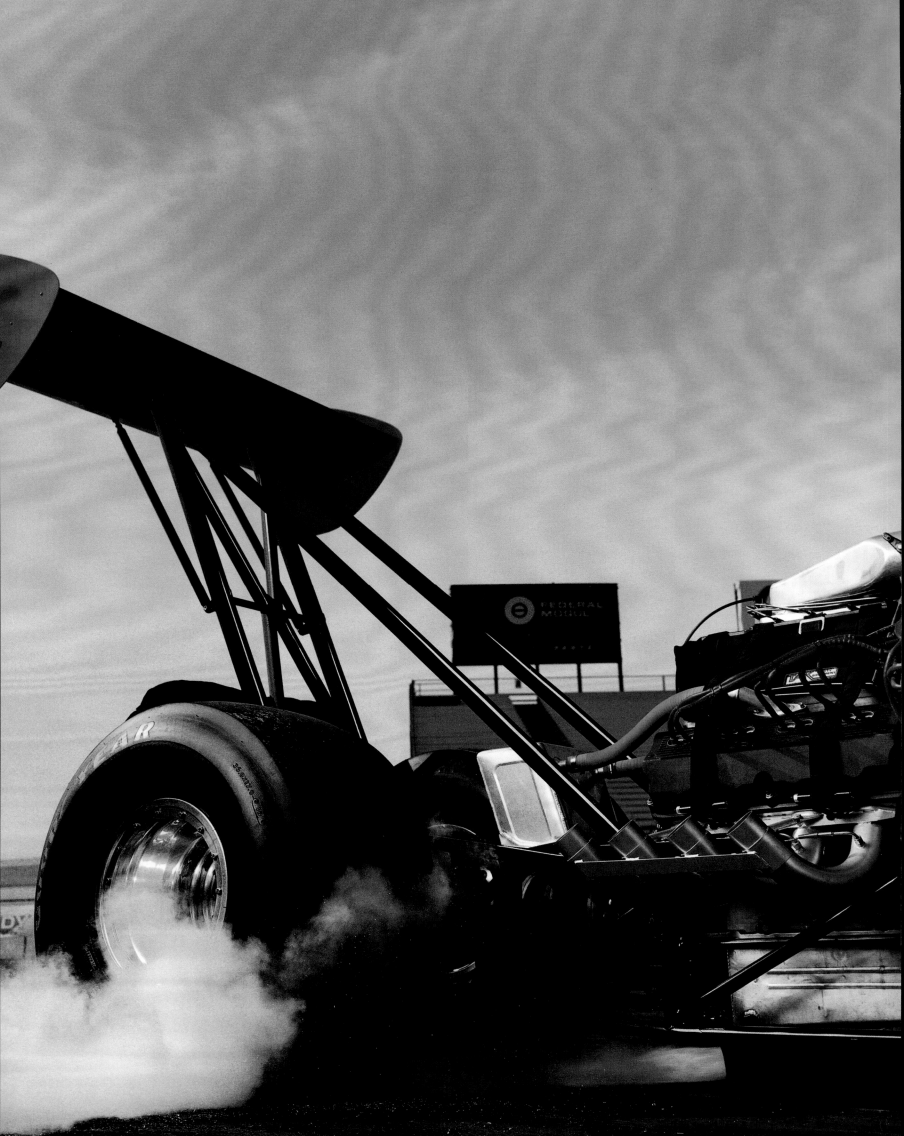

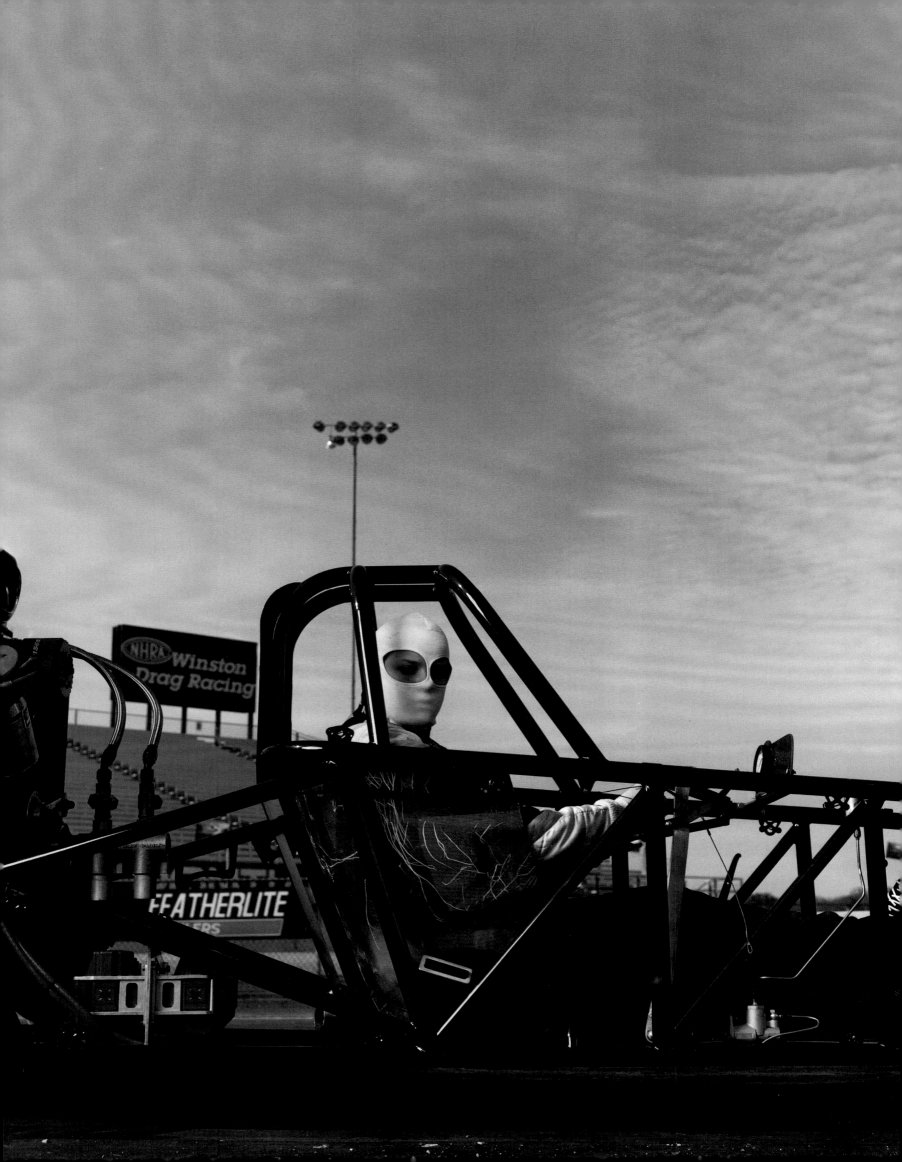

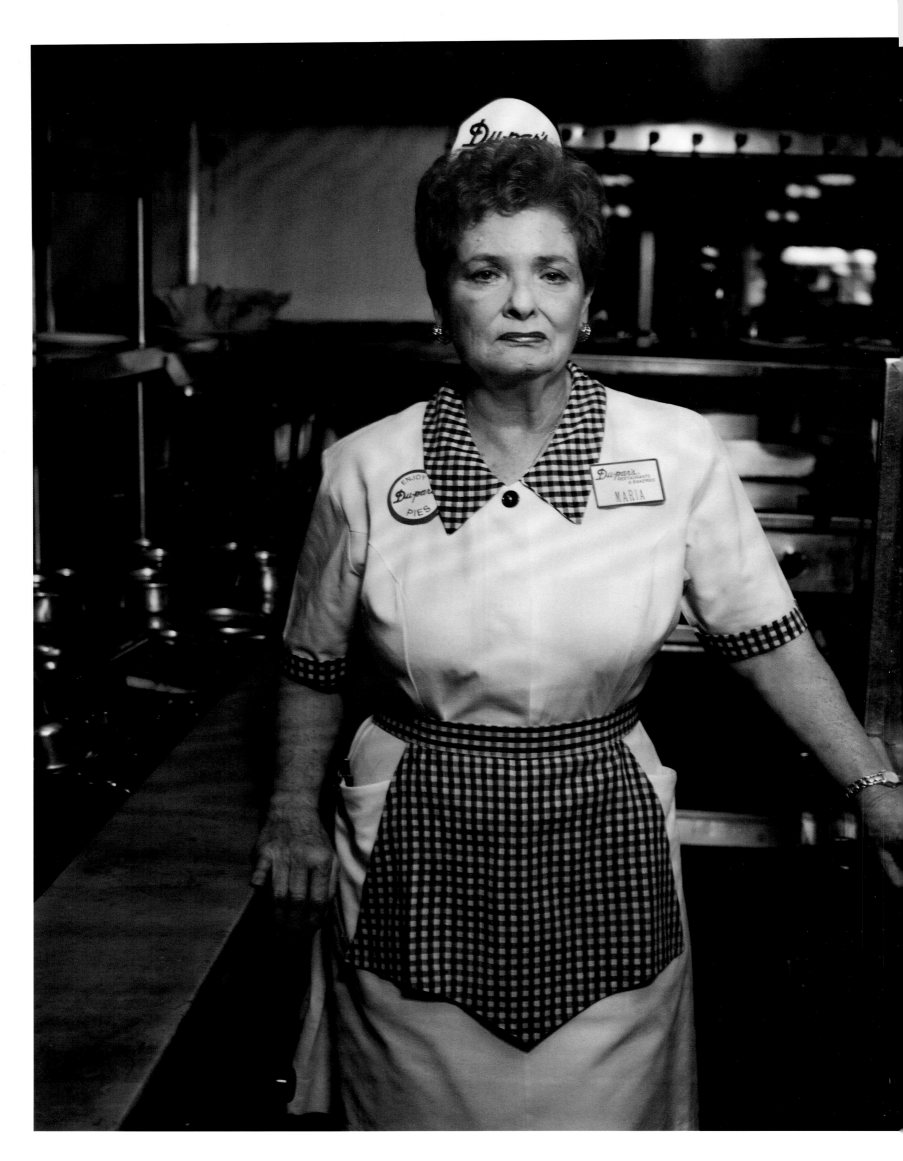

Maria Eugenia Ponce
Waitress
Dupar's Restaurant, Los Angeles, California

Preceding page:

Cristen Powell
Drag car racer
Indianapolis Speedway, Indianapolis, Indiana

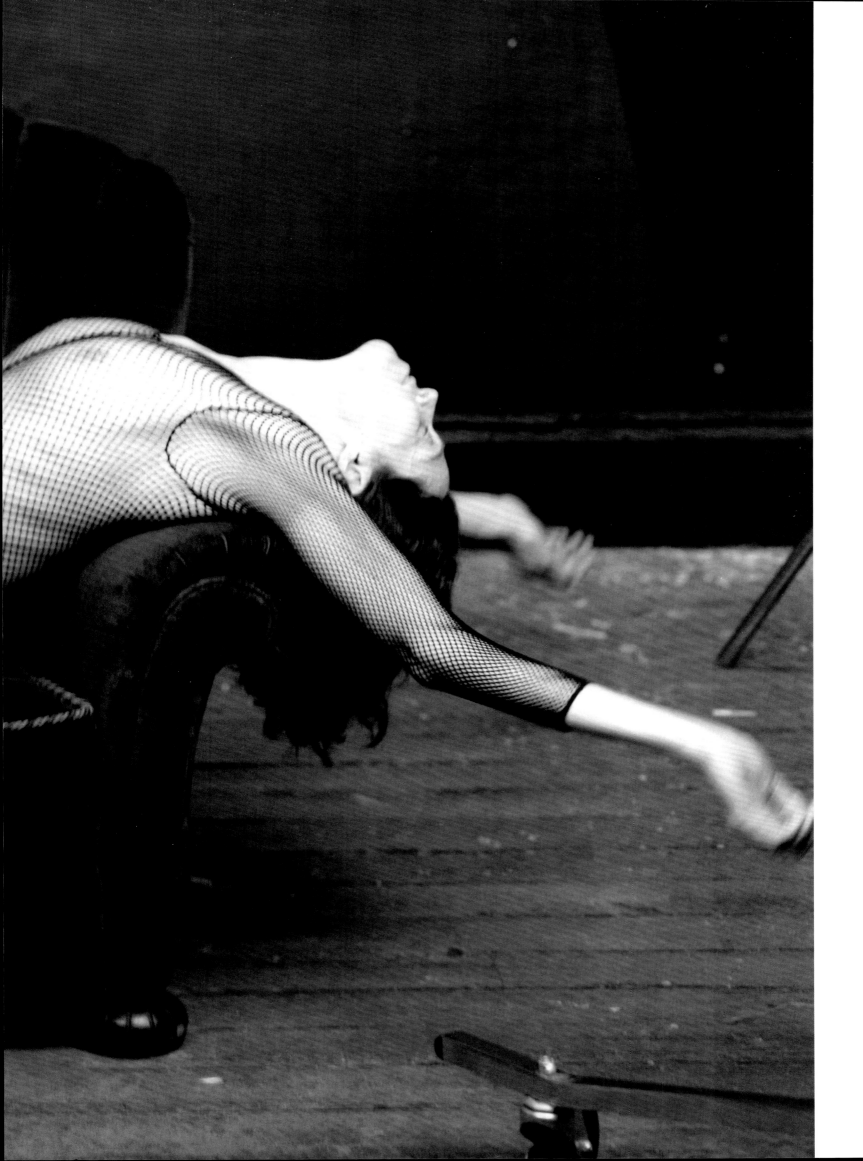

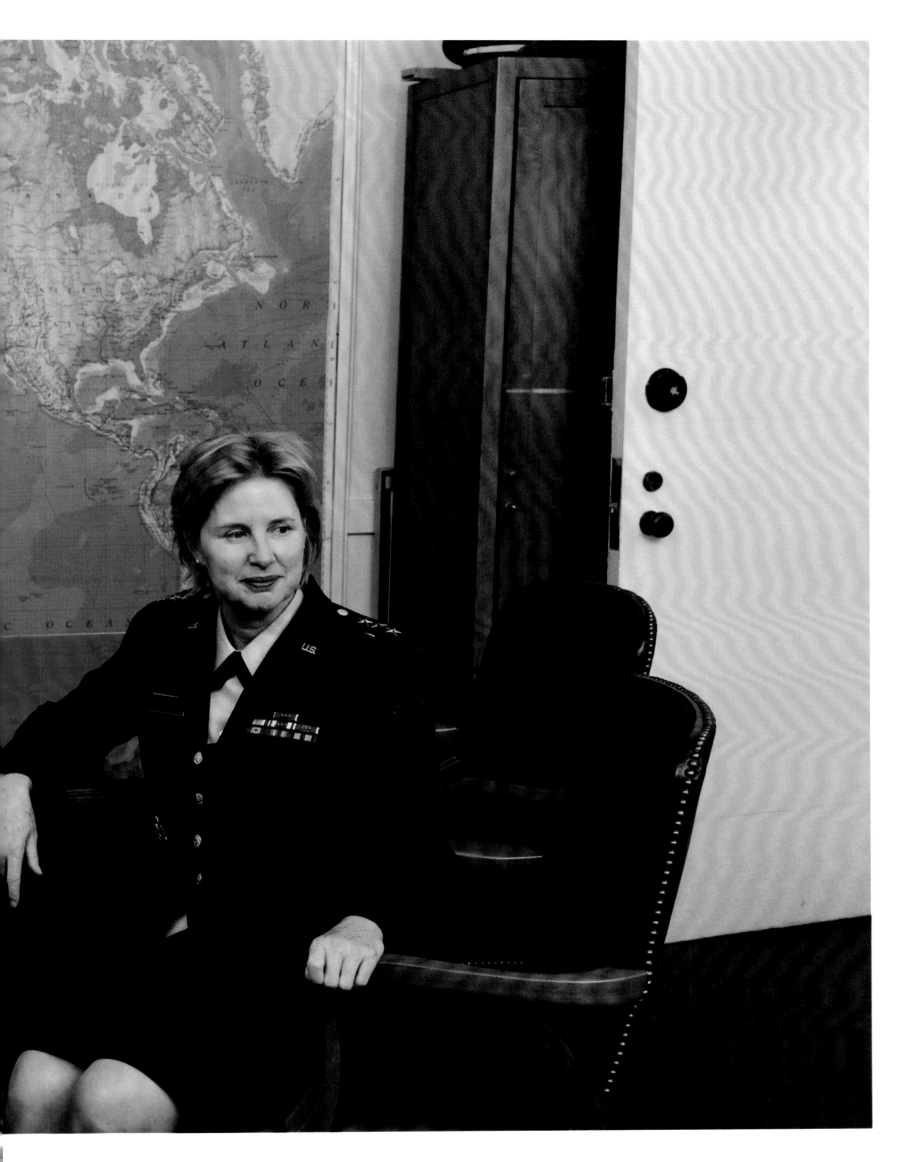

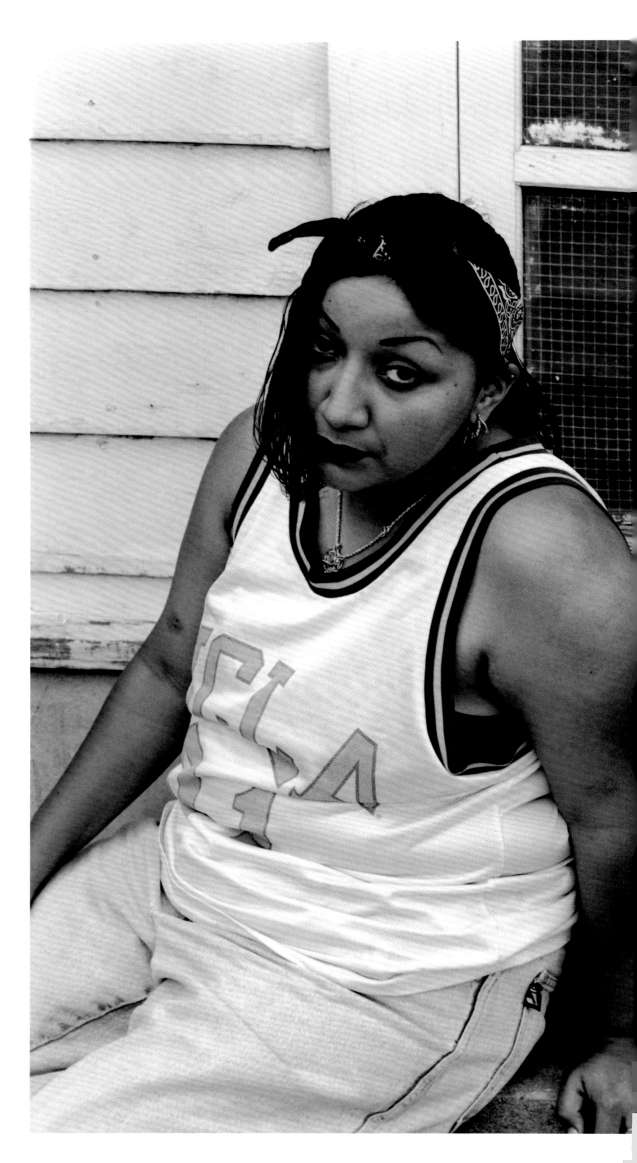

**Janie Martinez, Angie Idrogo,
and Jackie Constancio**
Members of the West Side Crips all-girl gang
San Antonio, Texas

Preceding pages:

Sigourney Weaver
Actress
New York City

Claudia J. Kennedy
Lieutenant General, U.S. Army
Deputy chief of staff for intelligence
The Pentagon, Washington, D.C.

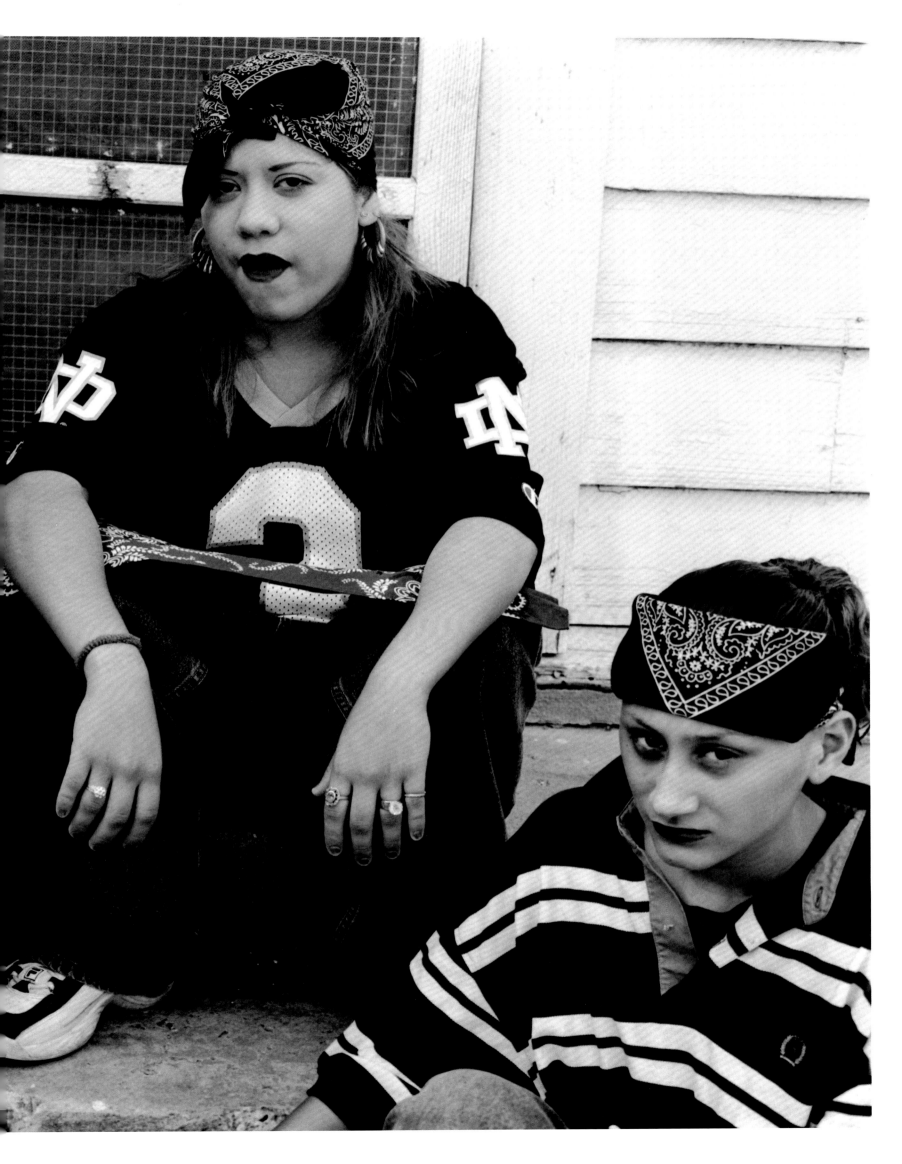

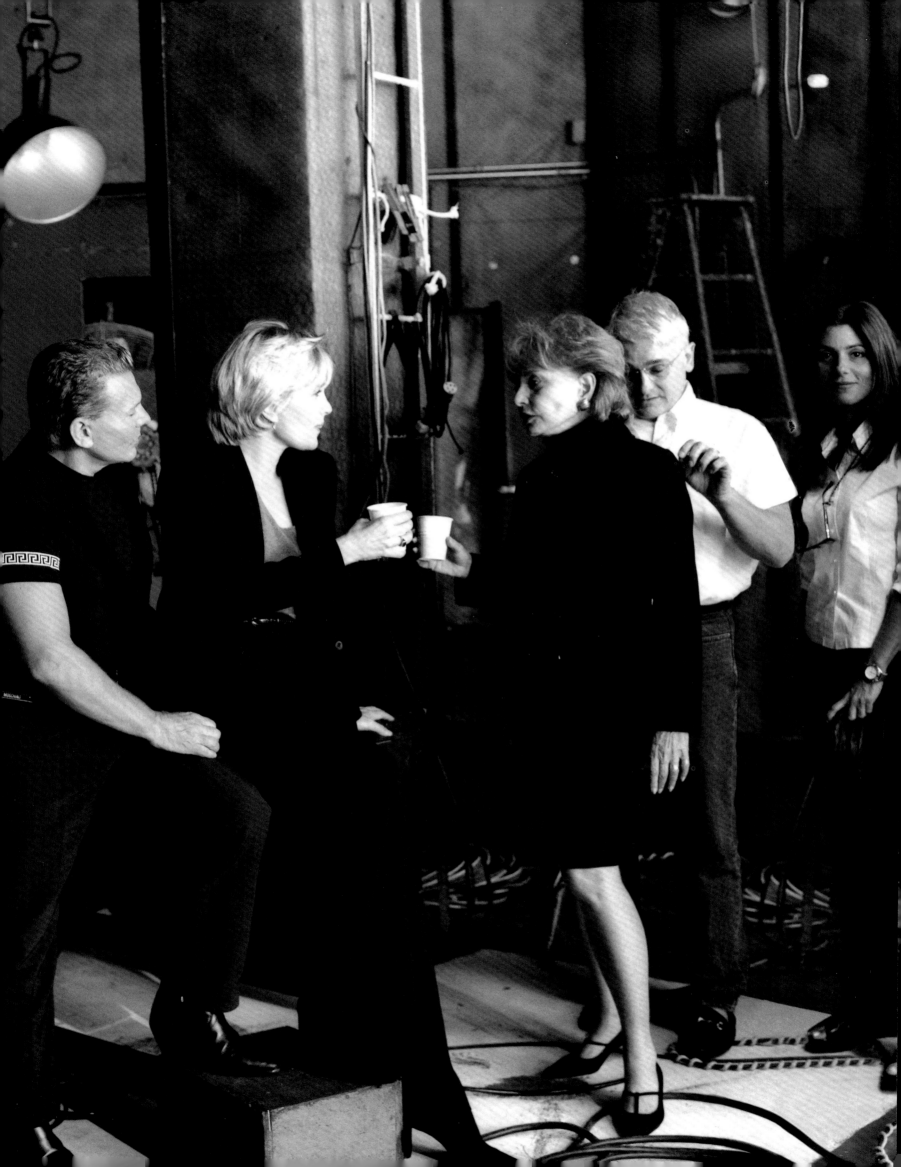

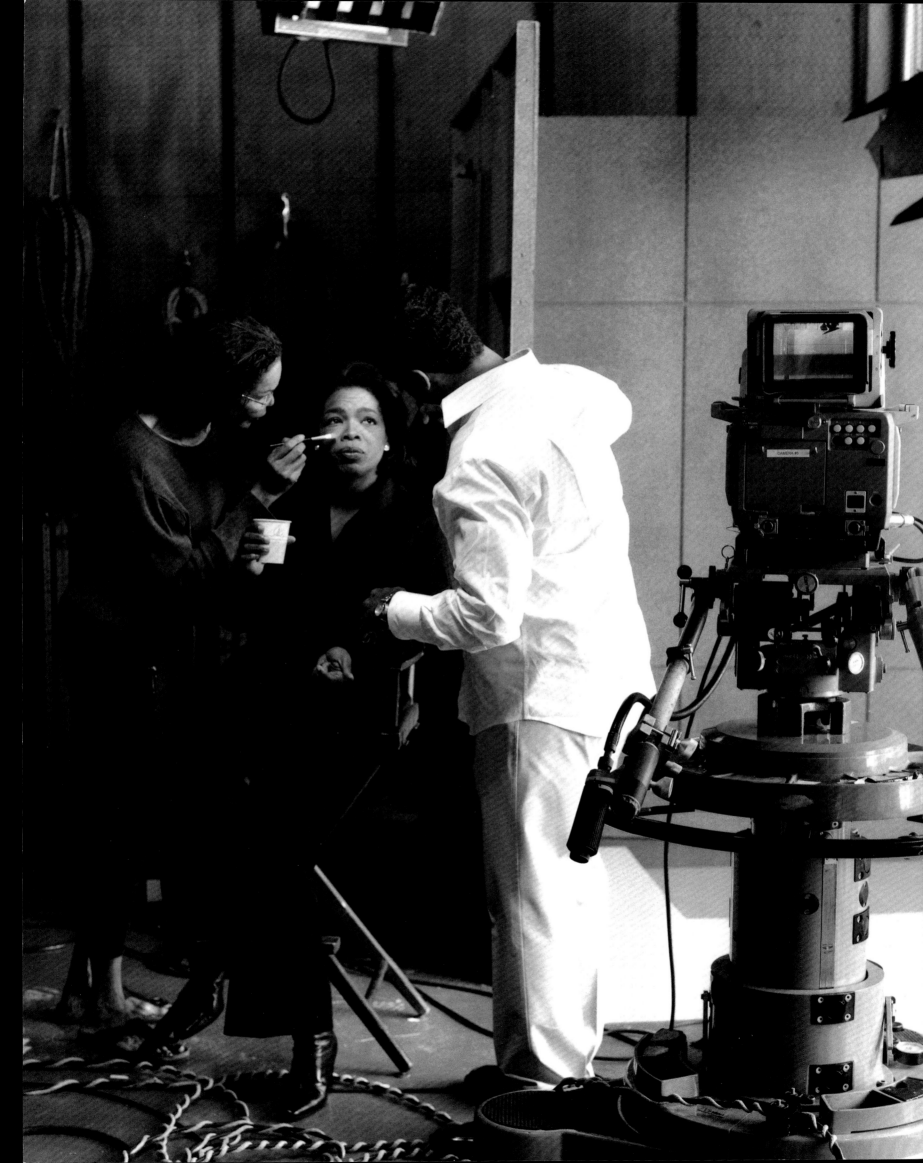

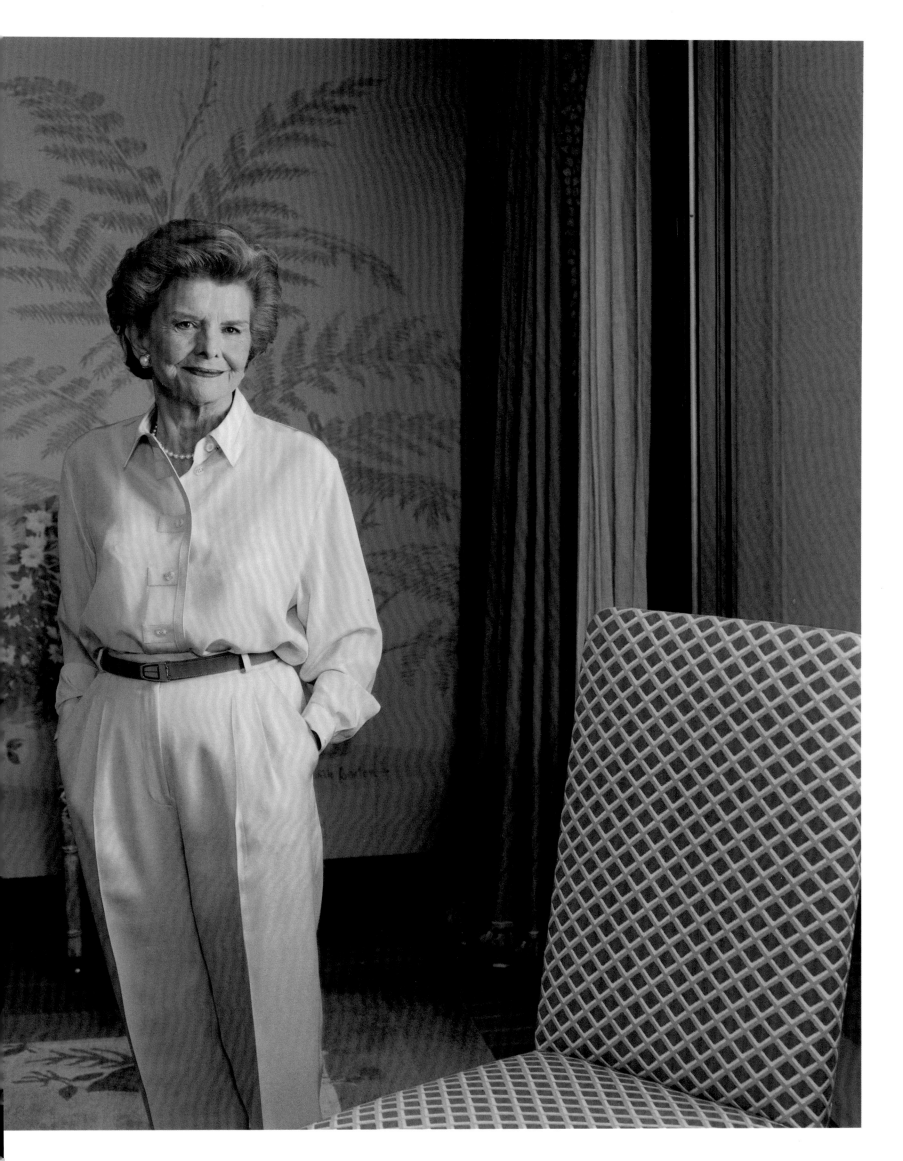

Jackie Joyner-Kersee
Track and field athlete
Floyd Bennett Field, Brooklyn, New York

Preceding pages:

Diane Sawyer, Barbara Walters, and Oprah Winfrey
Television journalists and talk-show host
Chelsea Television Studios, New York City

Betty Ford
Chairman of the board of directors, The Betty Ford Center
Palm Springs, California

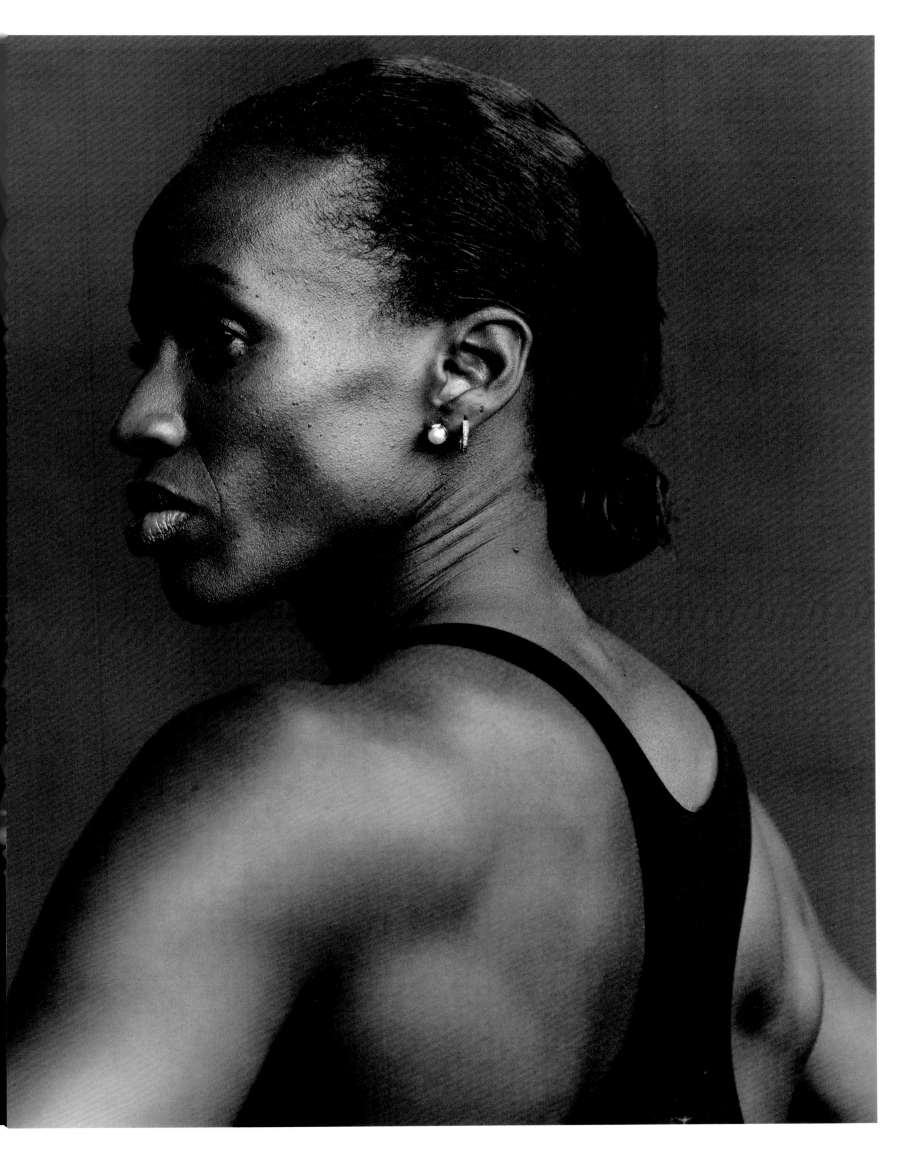

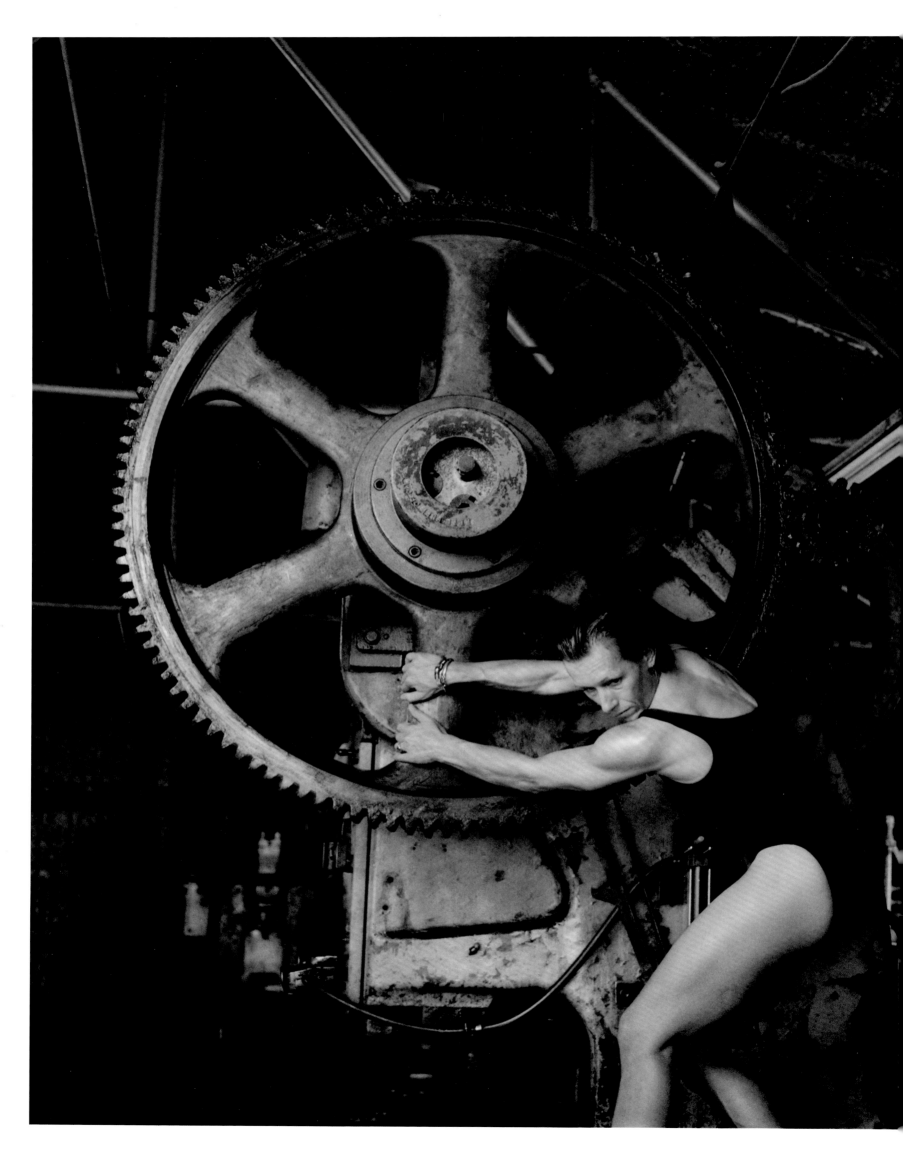

Martina Navratilova
Tennis player
Dallas, Texas

Courtney Love
Musician, actress
Los Angeles, California

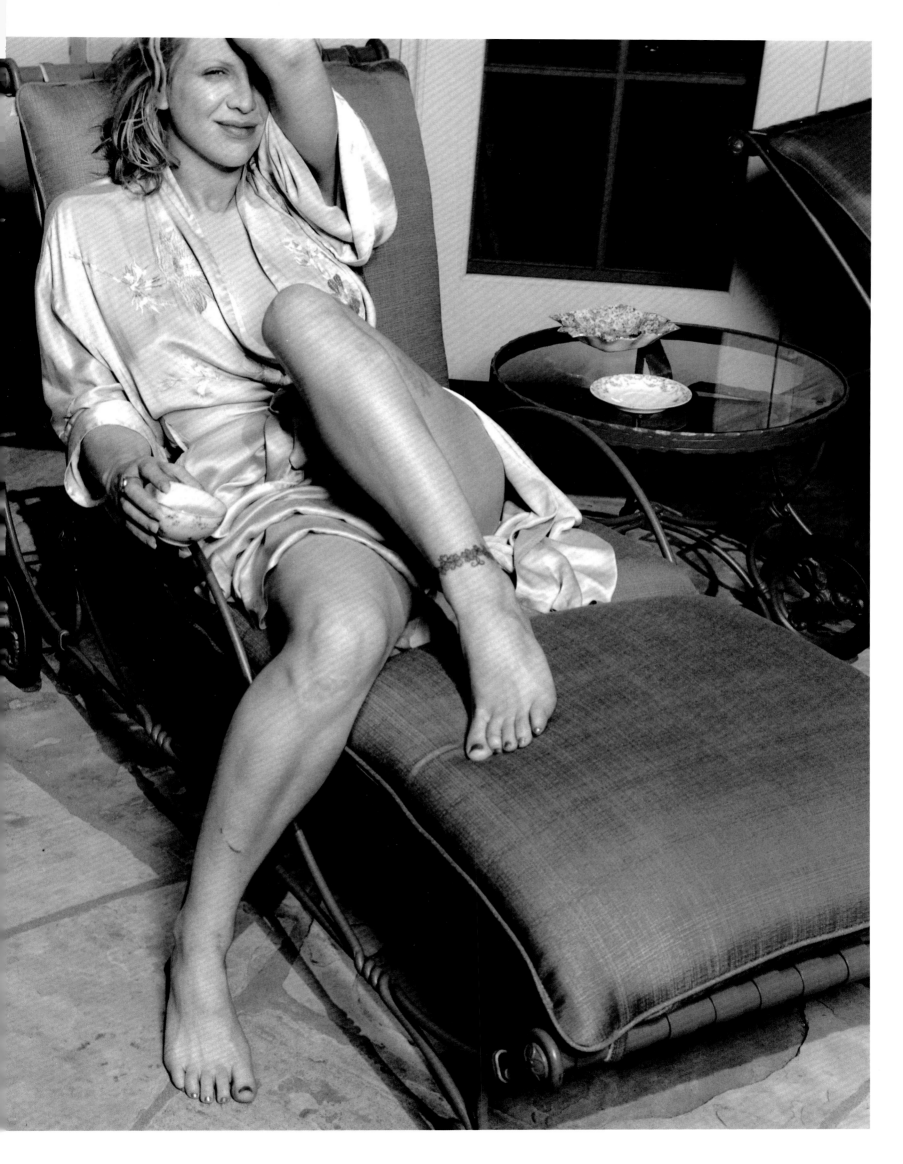

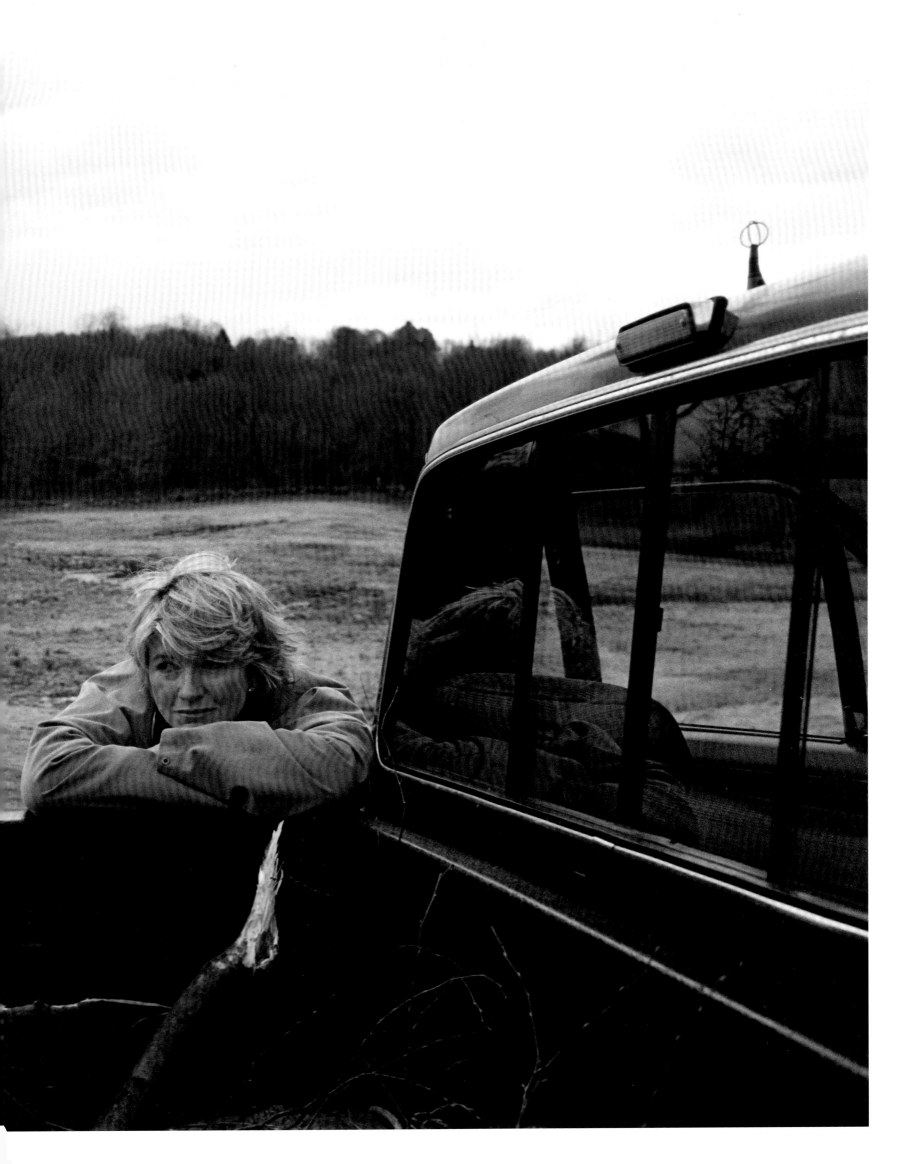

Dorothy A. Richman
Rabbinical student
Jewish Theological Seminary, New York City

Preceding page:

Martha Stewart
CEO, Martha Stewart Living Omnimedia
Bronson Road, Fairfield, Connecticut

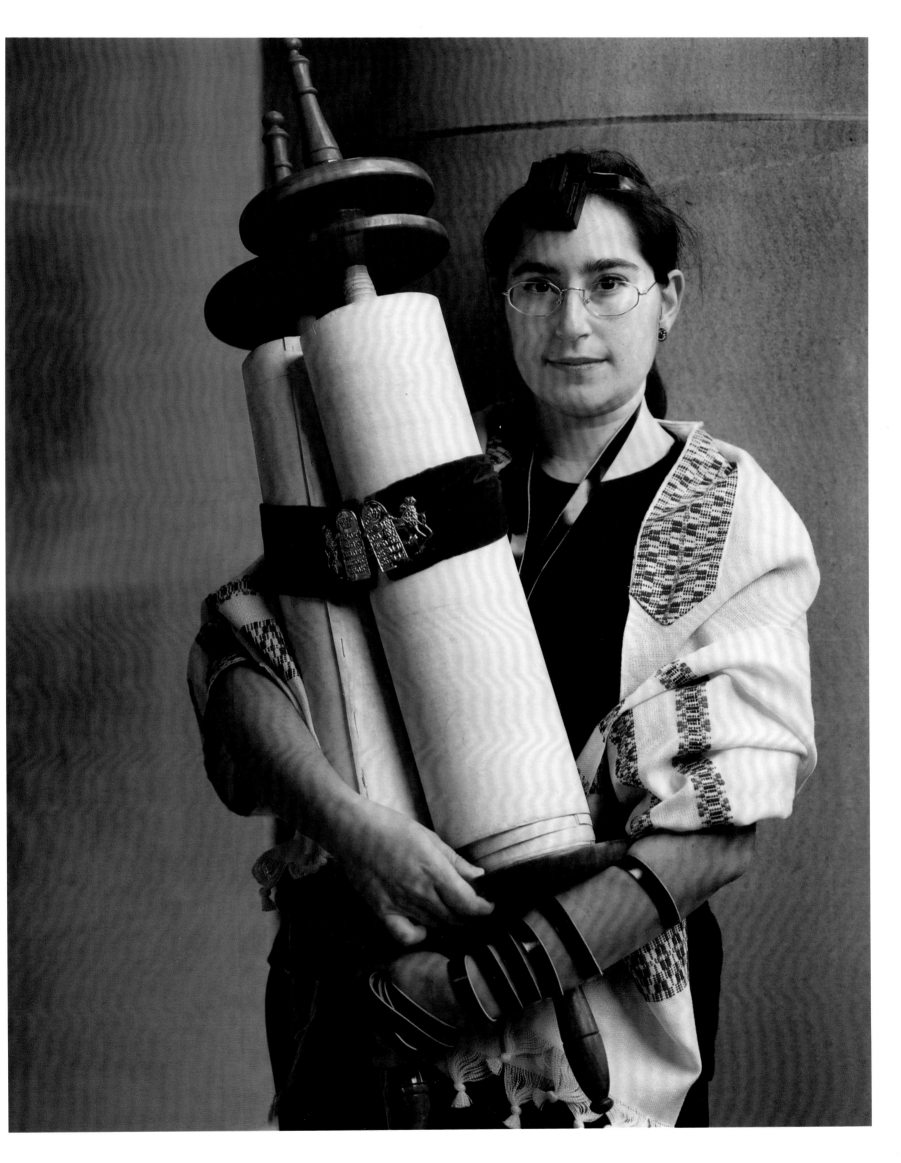

Katharine Graham
Chairman of the executive committee of
The Washington Post Company
Washington, D.C.

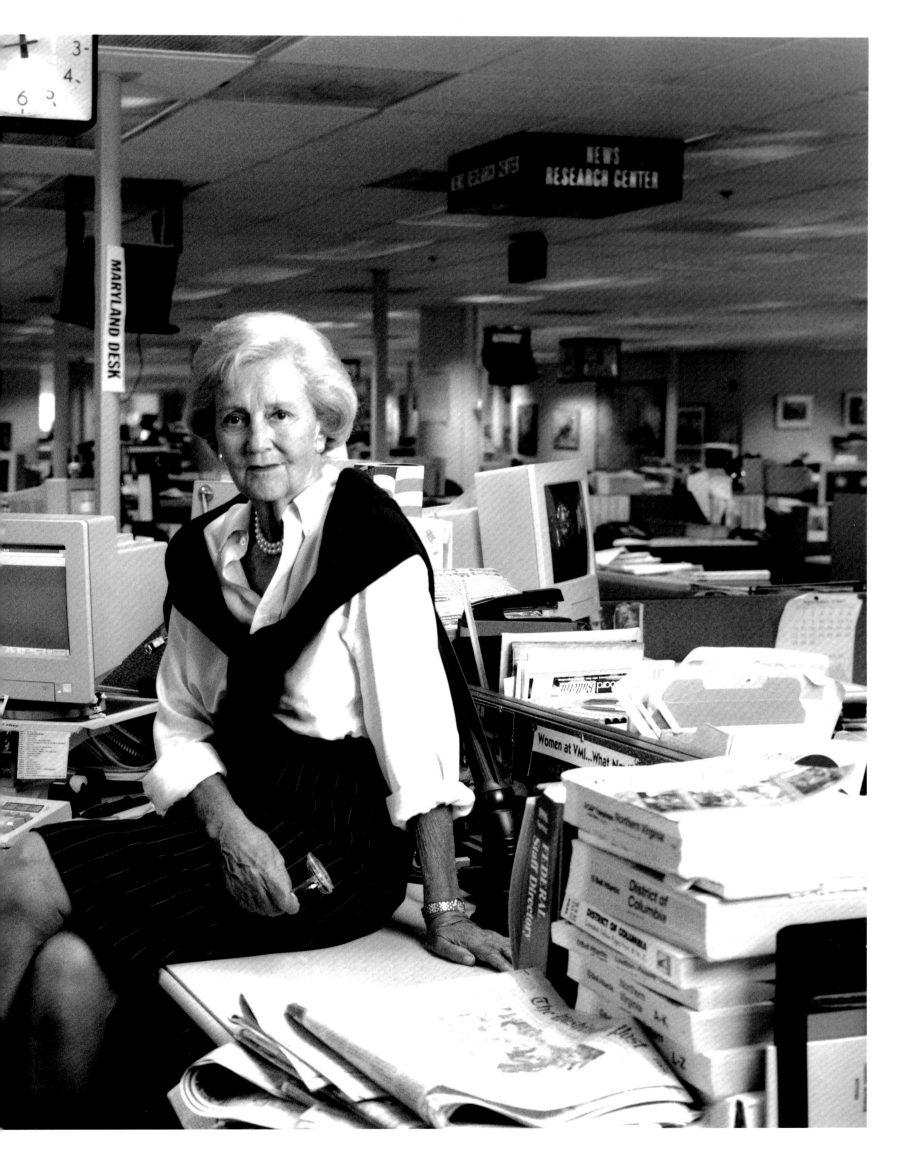

Judy Mayfield and Japohni Gibson
Home-care attendant and her sister
Circle K convenience store, Rockdale, Texas

Following pages:

Candy Haney and Tommye Lynn
Circle K convenience store, Rockdale, Texas

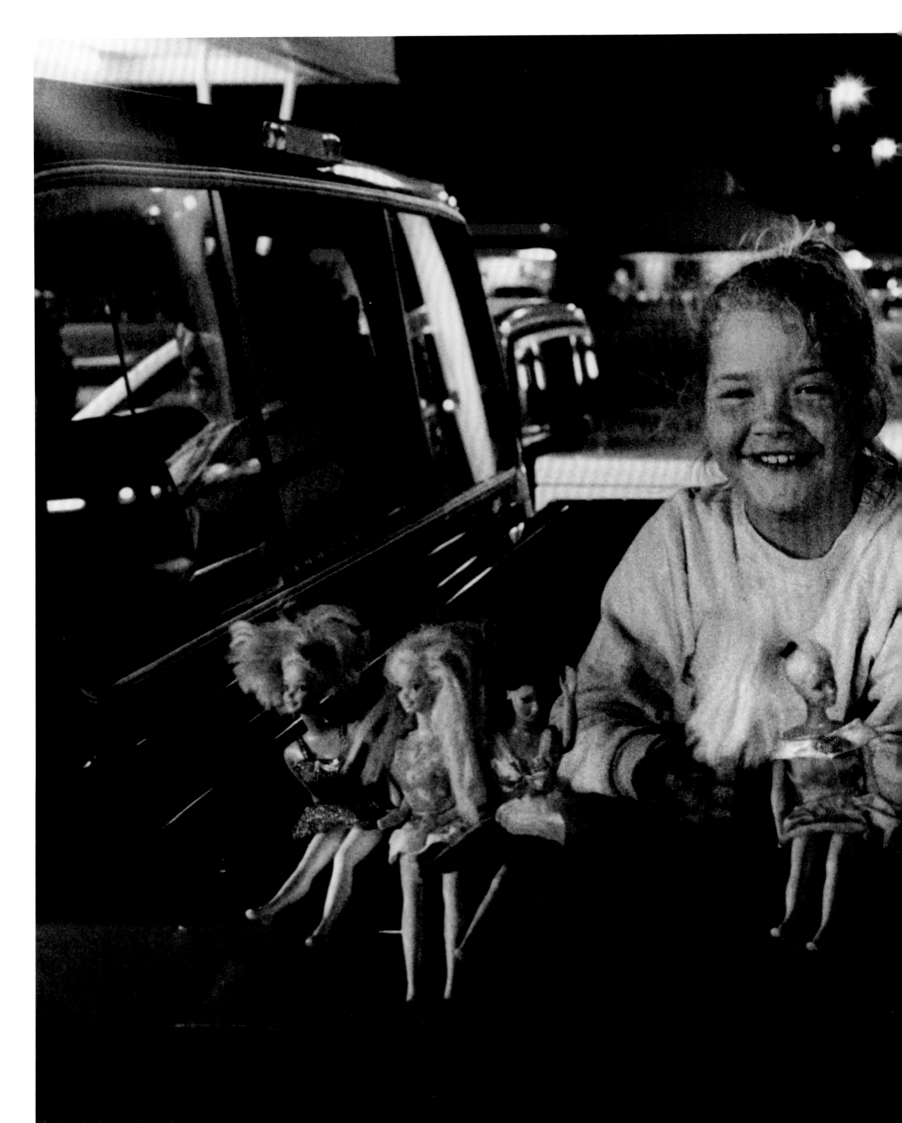

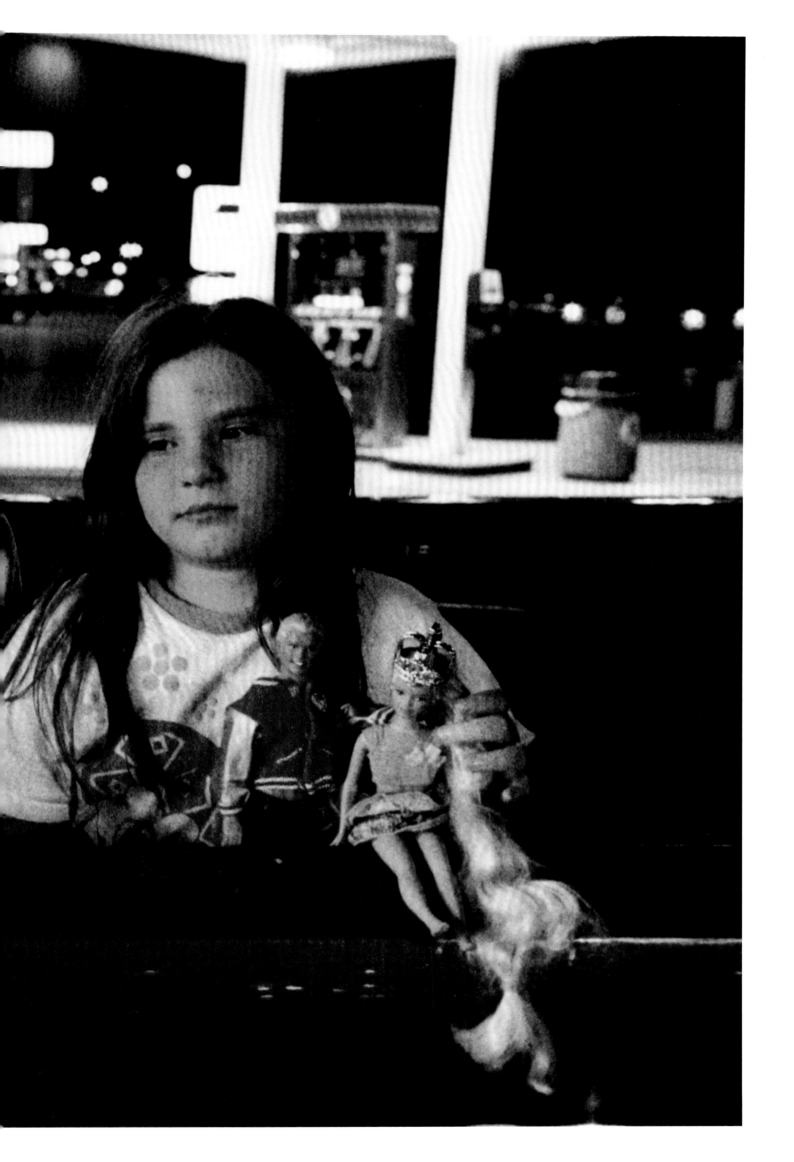

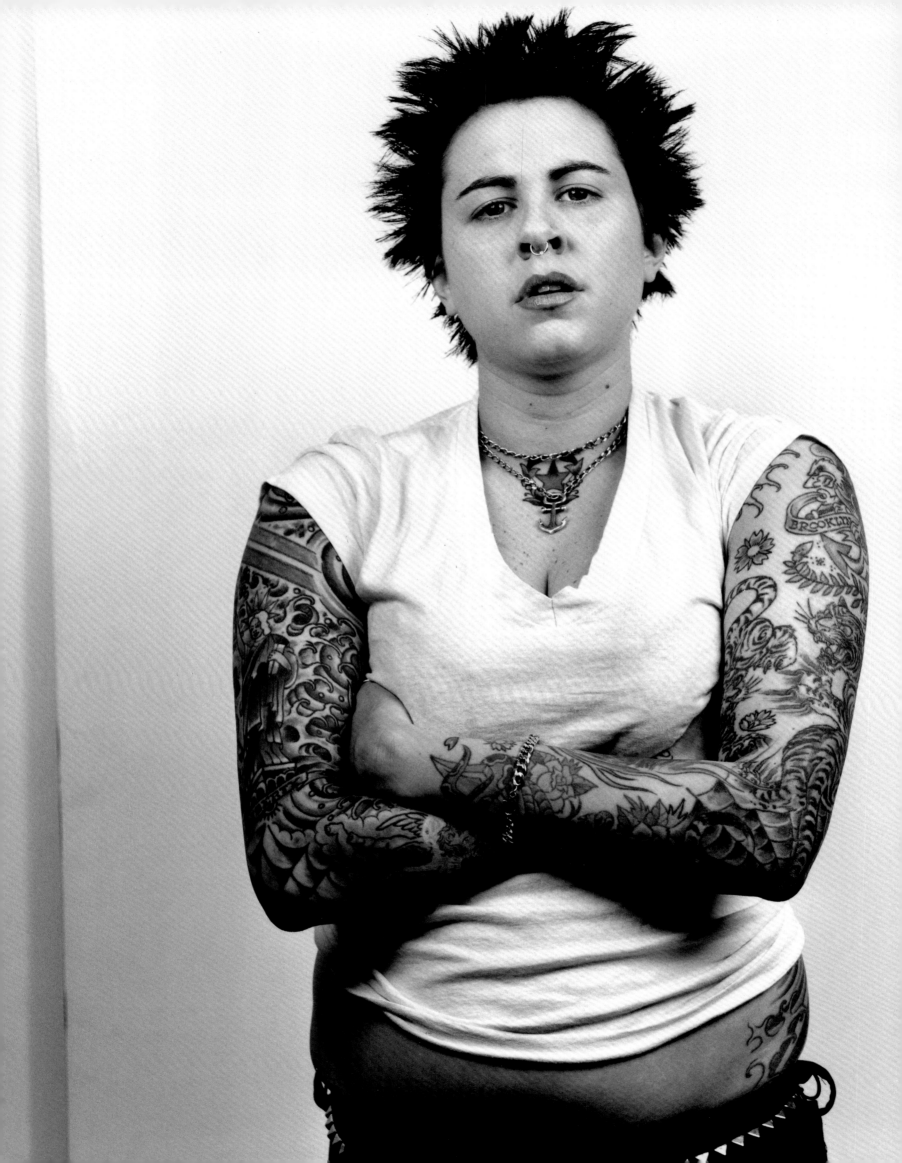

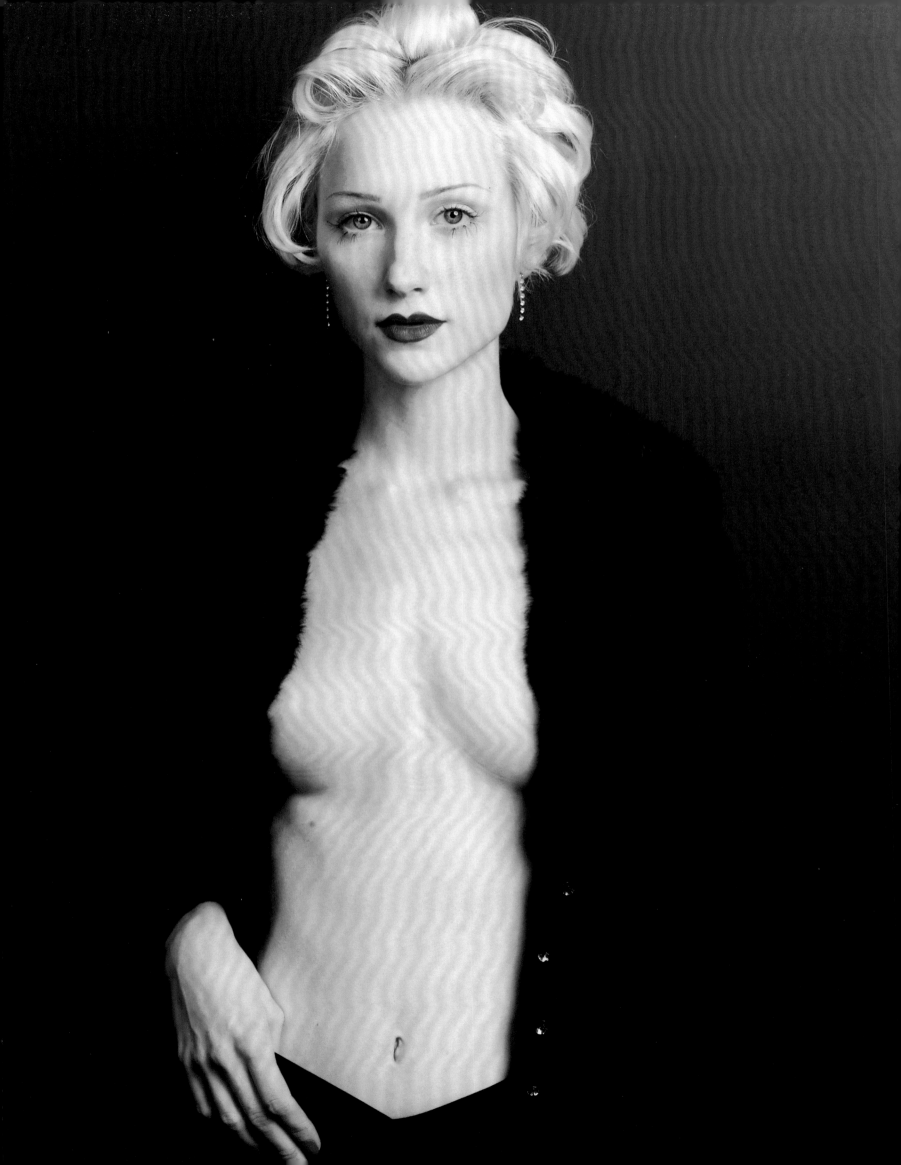

Barbara Bush
Former First Lady of the United States
Houston, Texas

Preceding pages:

Sidney Silver
Bass player for the Lunachicks
Coney Island High nightclub, New York City

Penelope Tuesdae
Go-go dancer, singer, nightclubber
Coney Island High nightclub, New York City

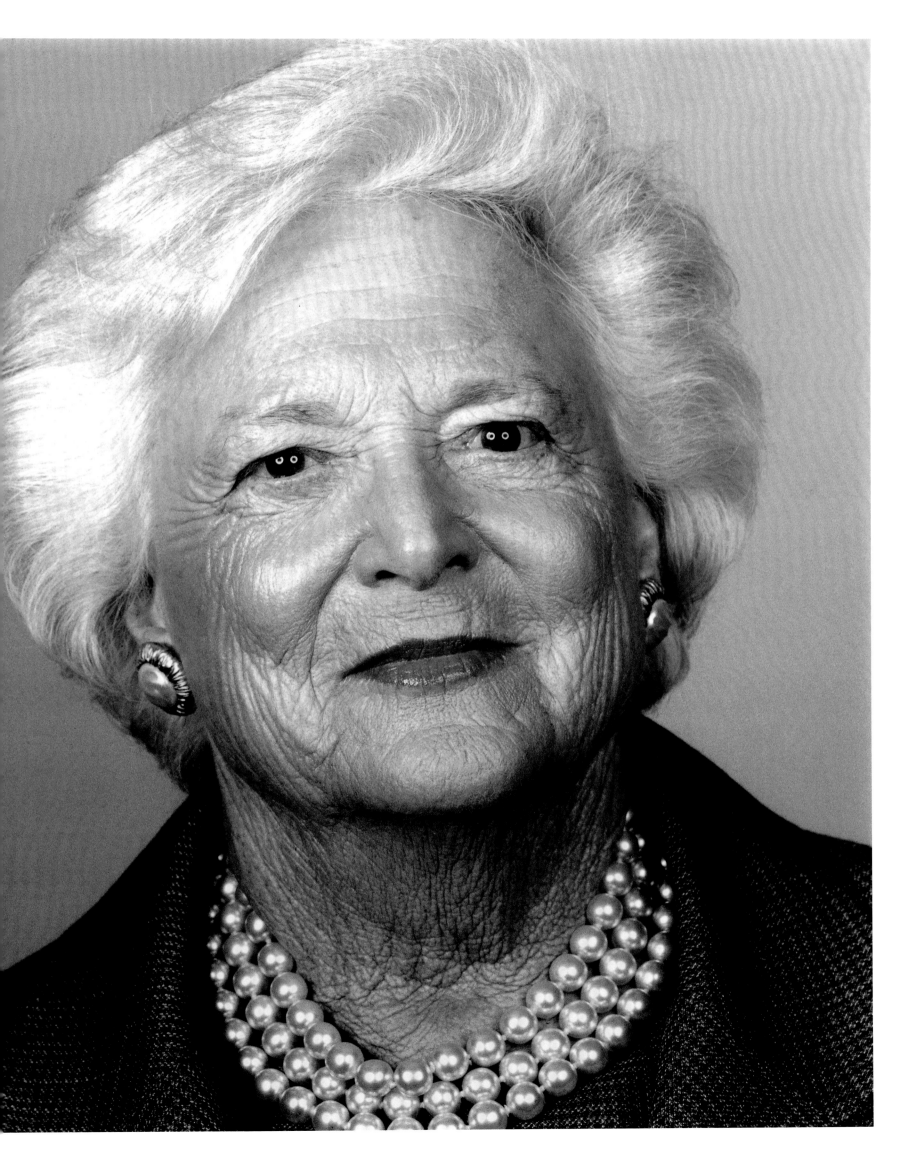

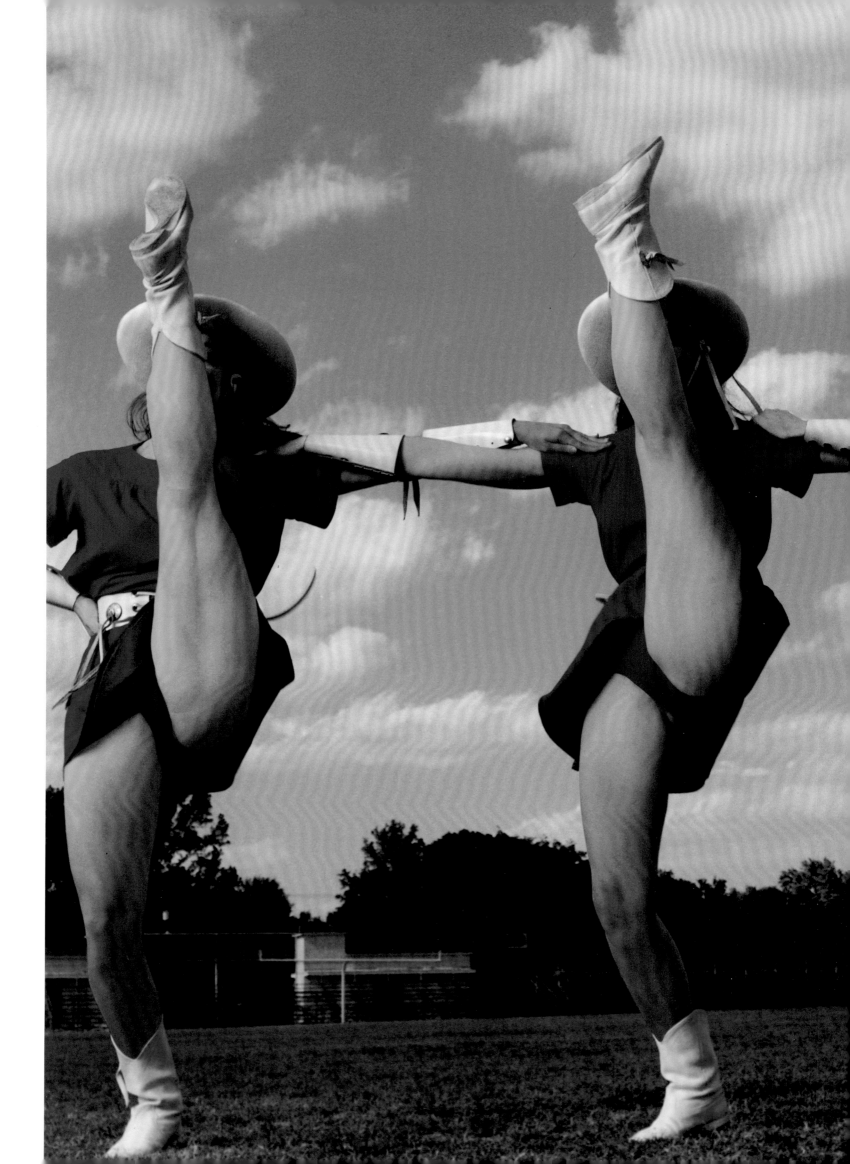

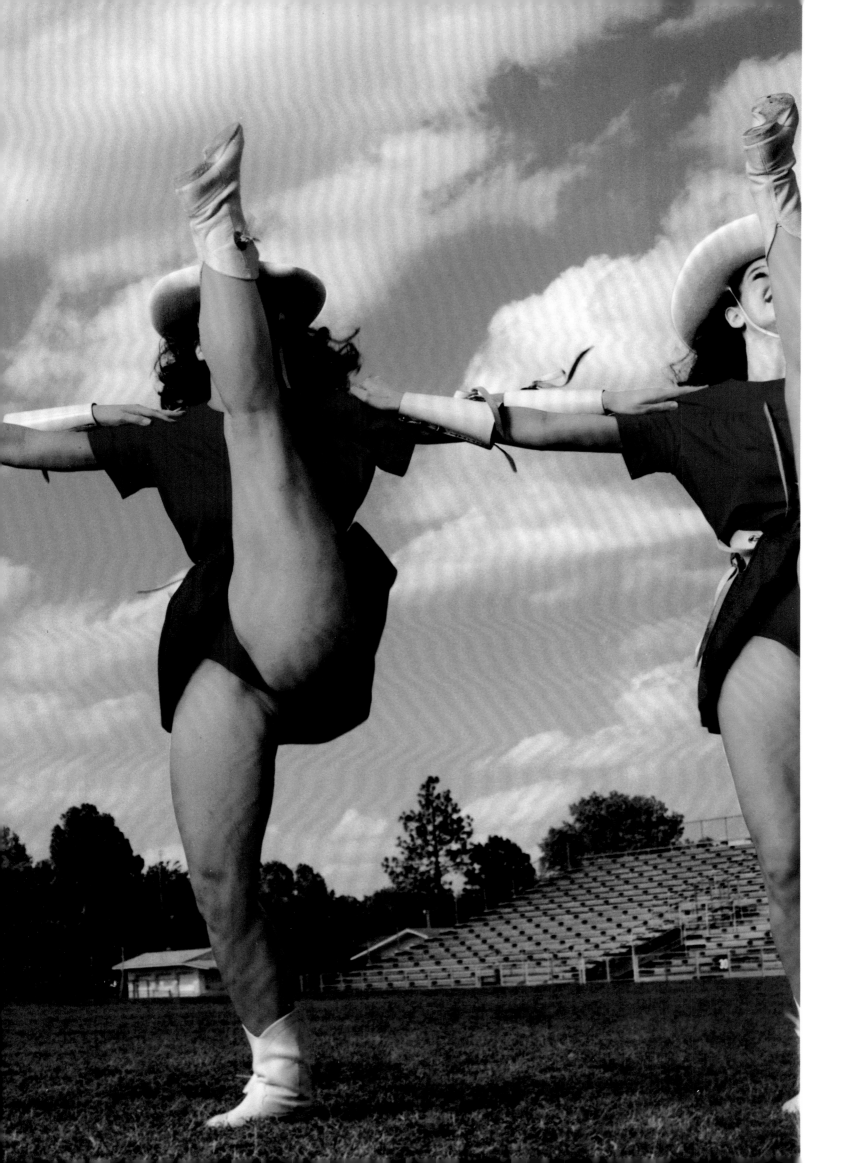

Norma McCorvey
a.k.a. Jane Roe, now an antiabortion activist
Dallas, Texas

Preceding pages:

Kilgore College Rangerettes
Kilgore, Texas

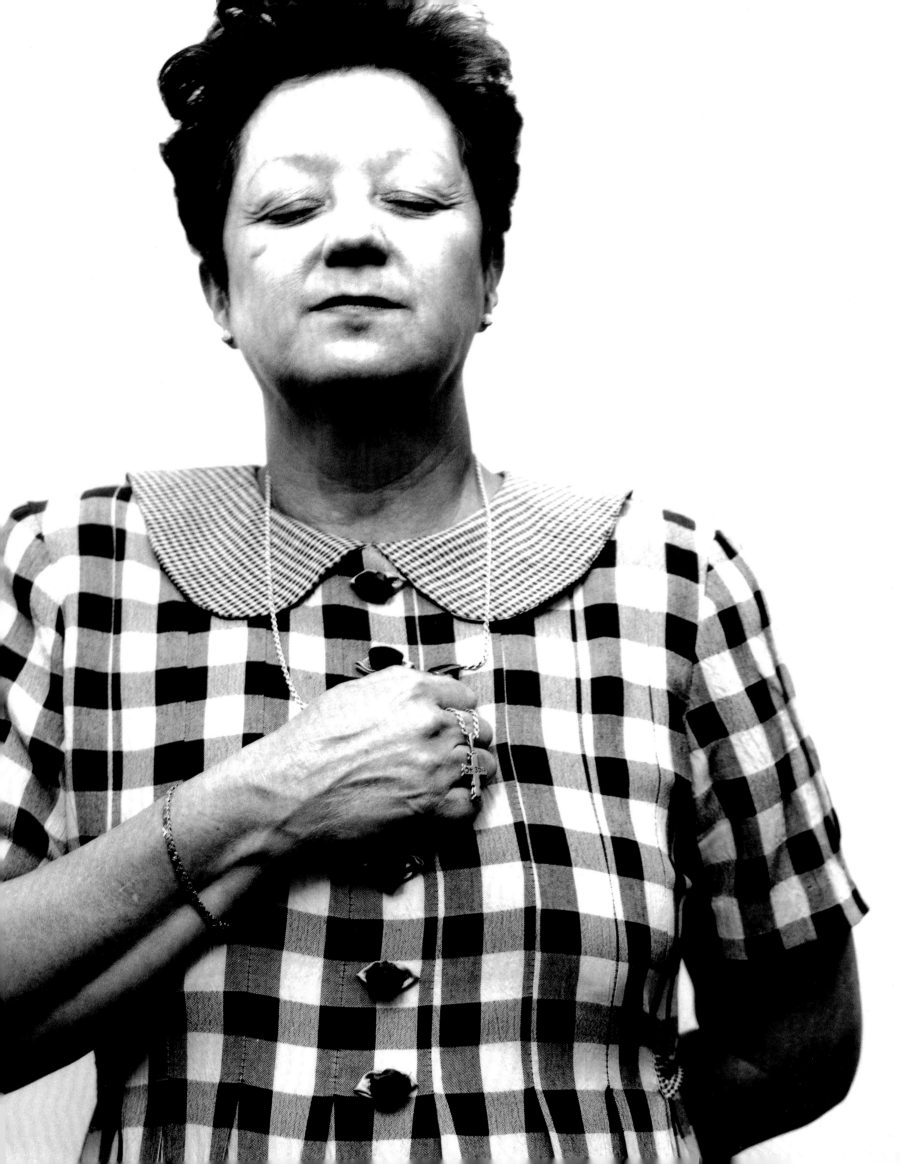

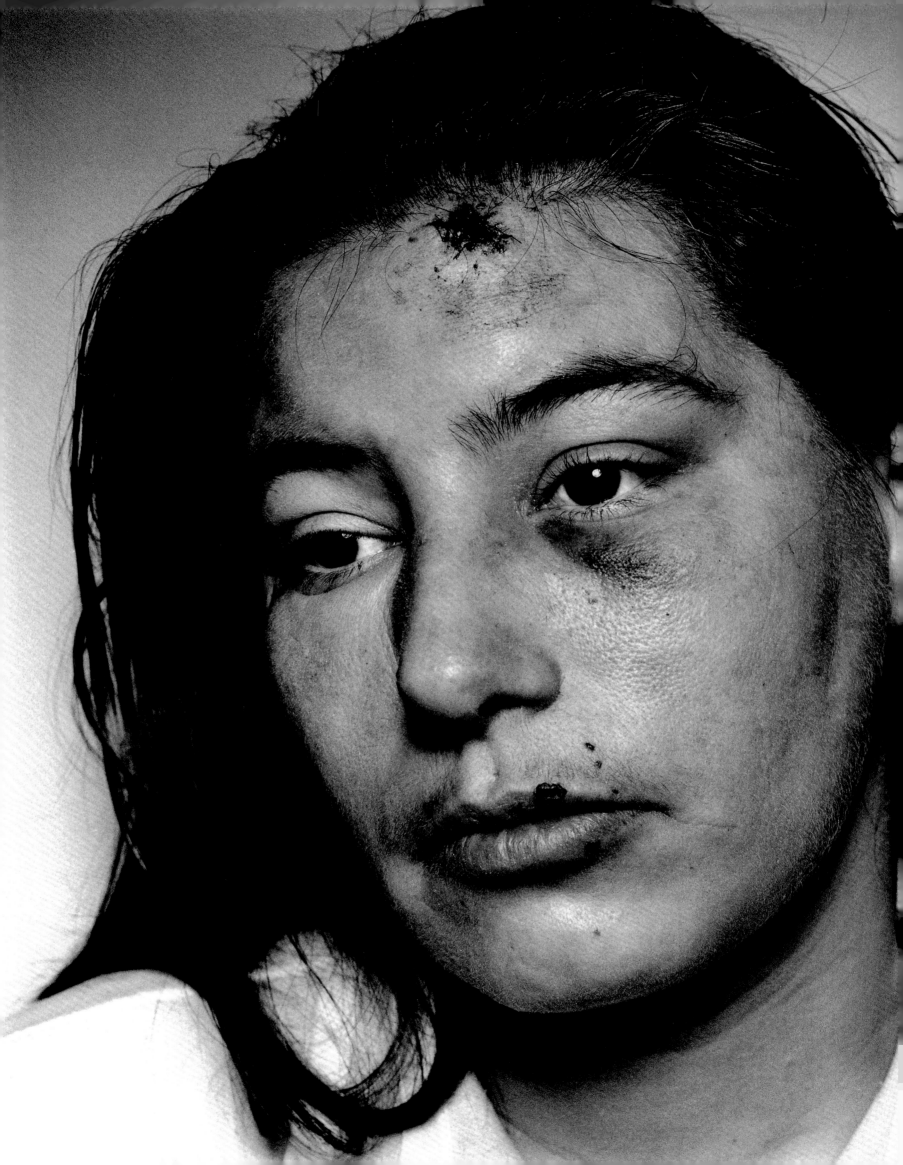

Barbara Anne Smith
Victim of domestic violence
YWCA Women's Shelter, Bridgeport, Connecticut

Tammie Winfield
Victim of domestic violence
Crime Victim's Center, St. Luke's–Roosevelt Hospital, New York City

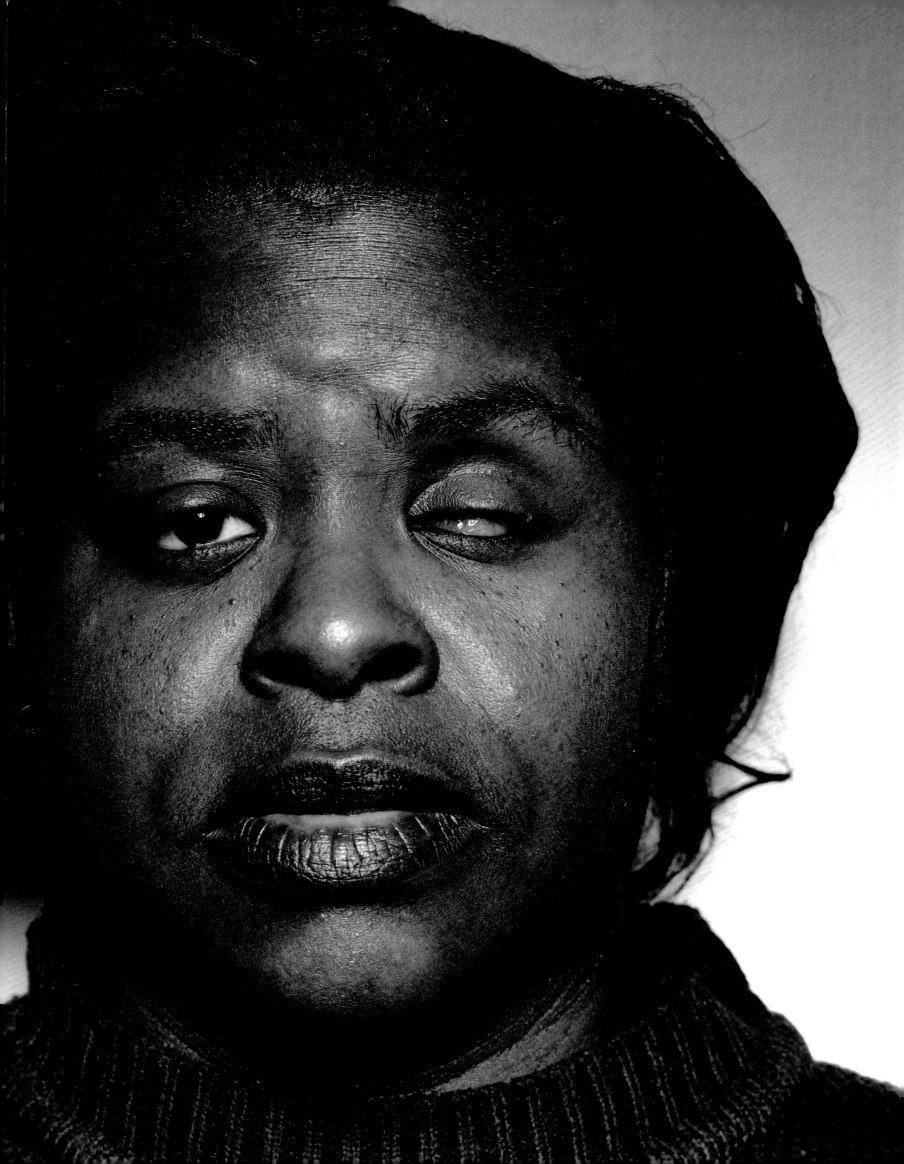

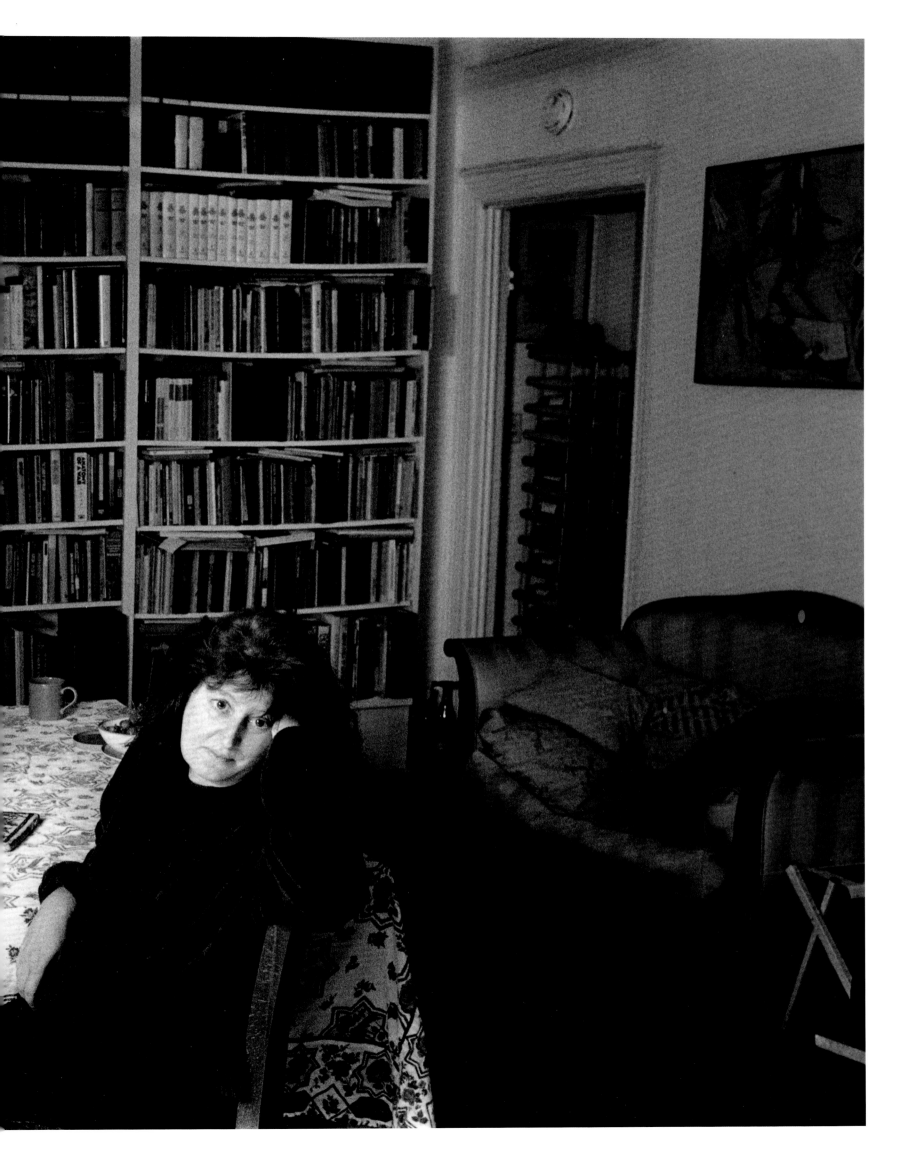

Josephine Barlow
Maid
Golden Nugget, Las Vegas, Nevada

Preceding page:

Katha Pollitt
Writer
New York City

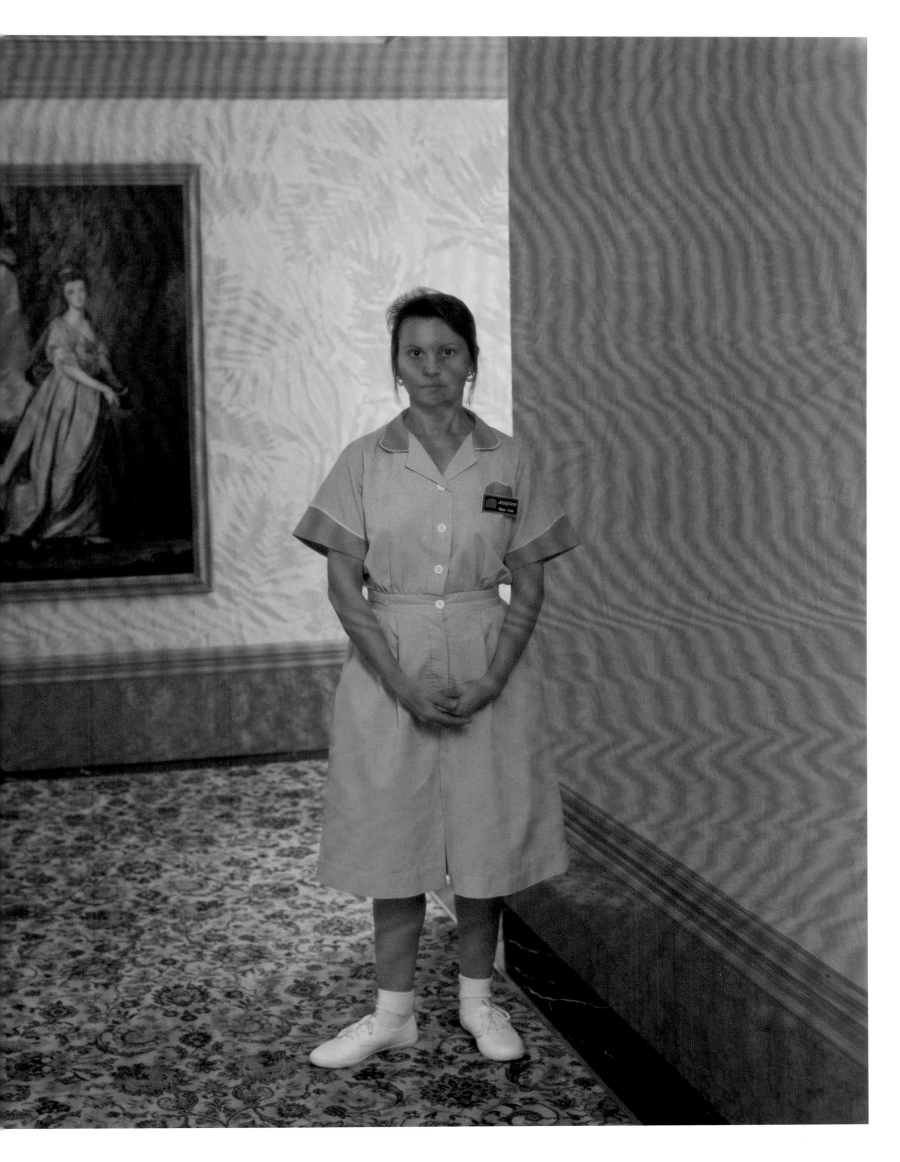

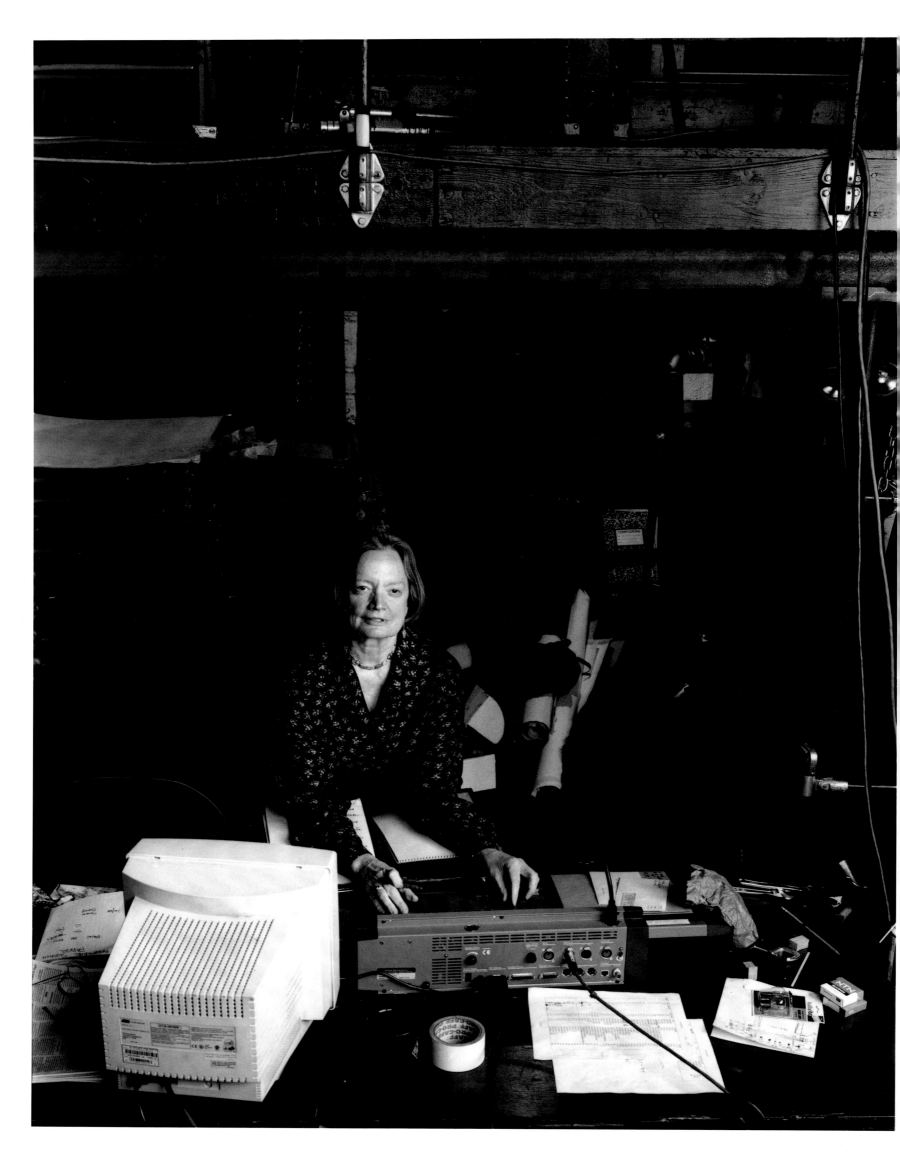

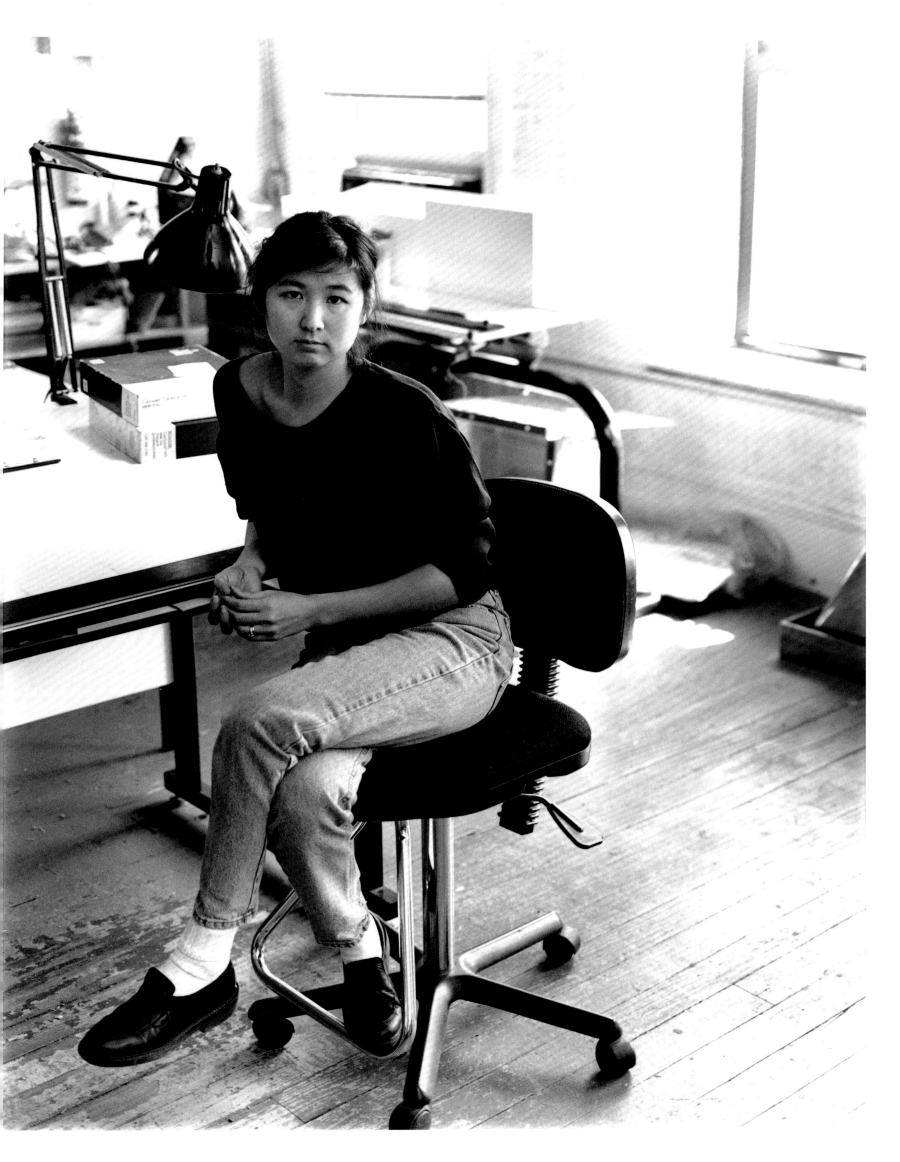

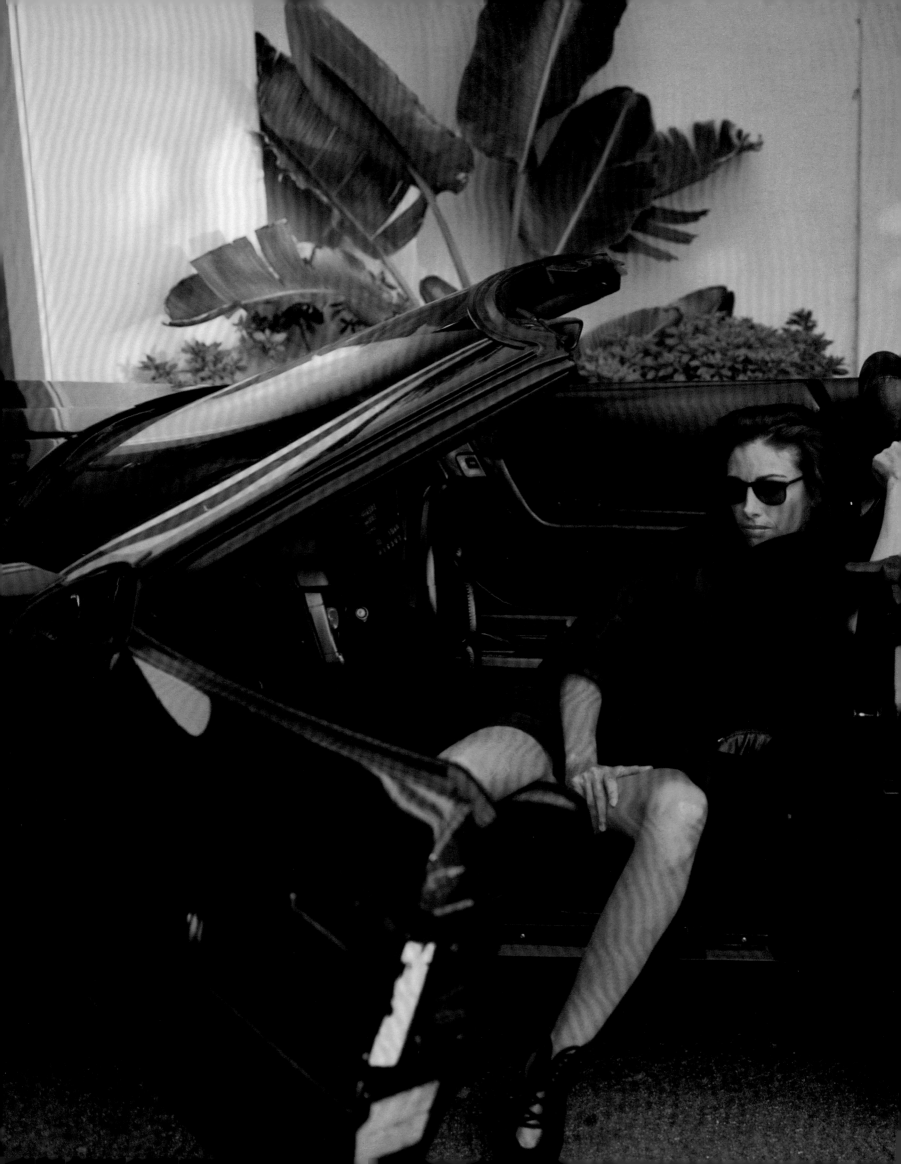

Janet Aiello
Police officer
Hoboken, New Jersey

Preceding pages:

Jennifer Tipton
Lighting designer
The Performance Garage, New York City

Maya Lin
Architect
New York City

Heidi Fleiss
Sex entrepreneur
Los Angeles, California

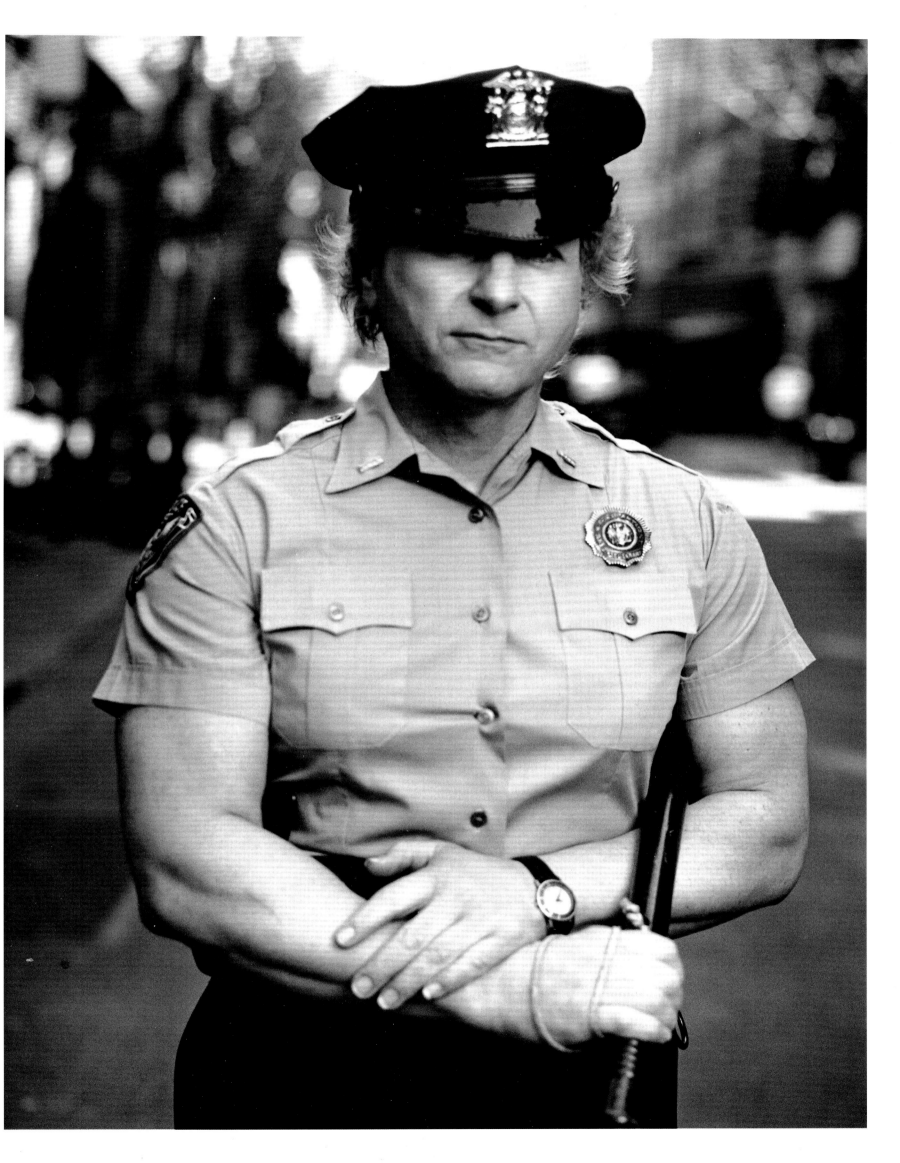

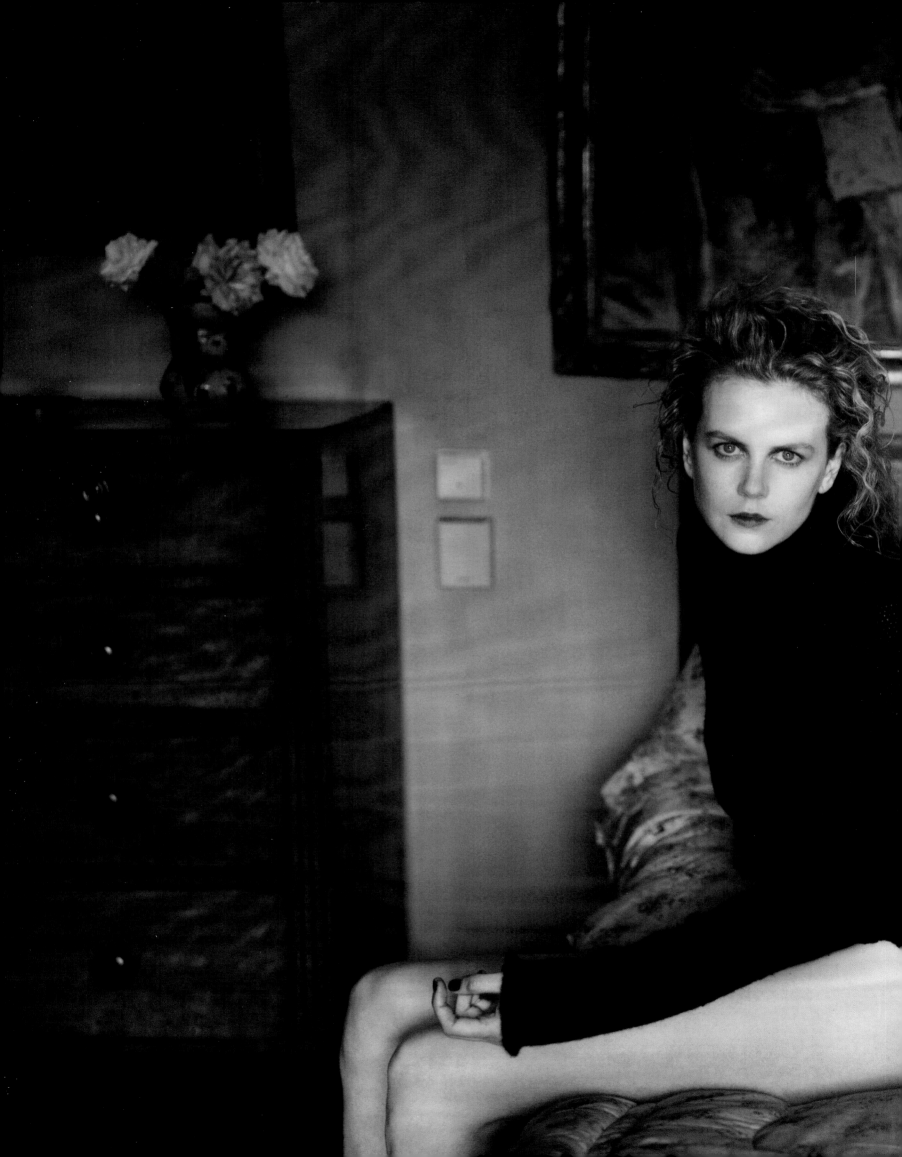

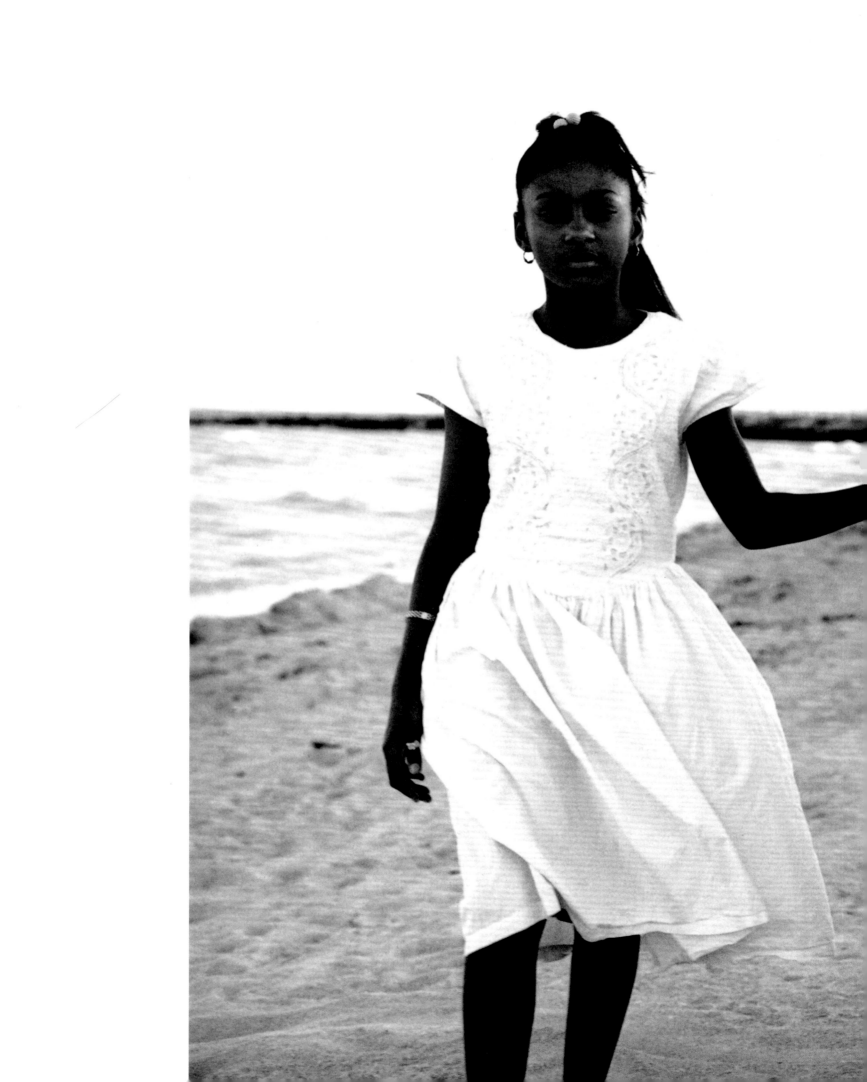

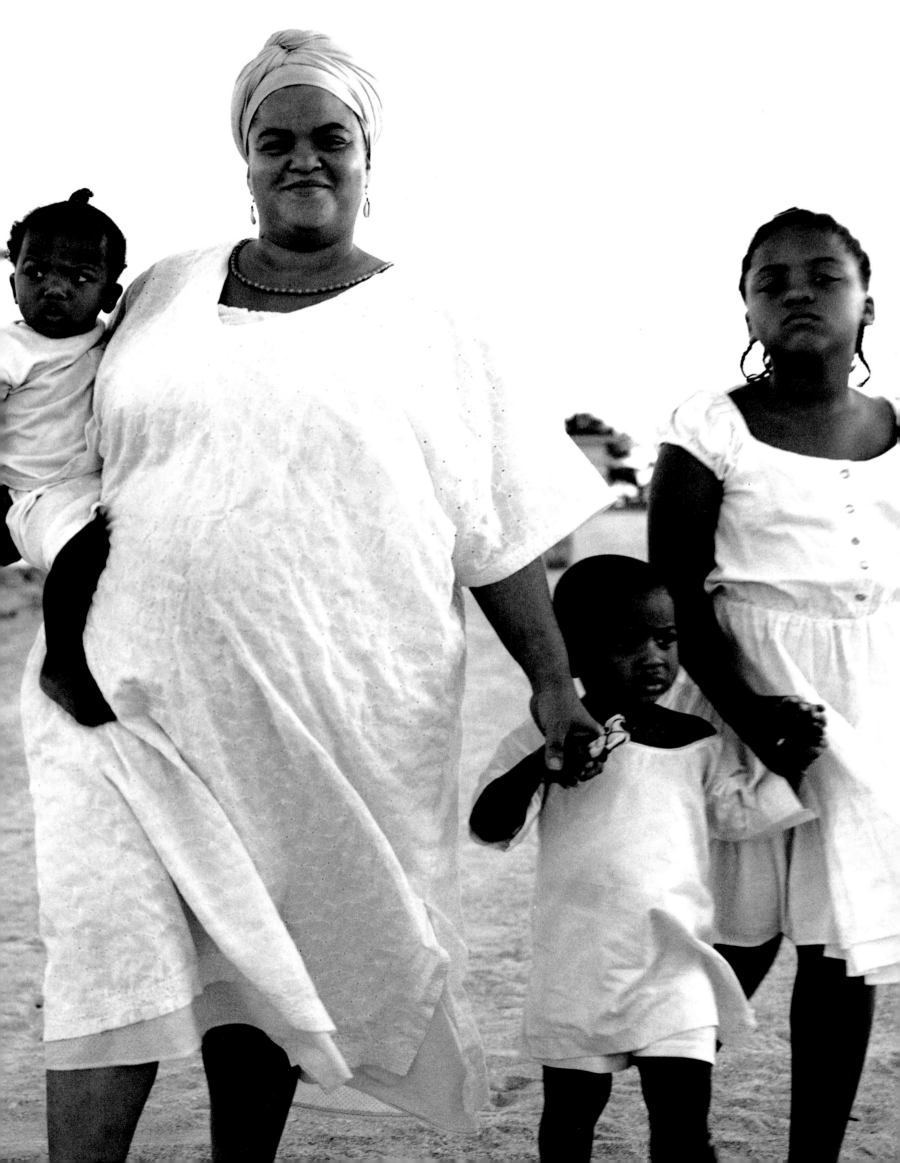

Eudora Welty
Writer
Jackson, Mississippi

Preceding pages:

Nicole Kidman
Actress
East Sussex, England

**Asabi Romera, Ajiki, Adeniyin,
Ogunlana, and Omudunbi Henderson**
Follower of Yoruba religion and her family
Miami, Florida

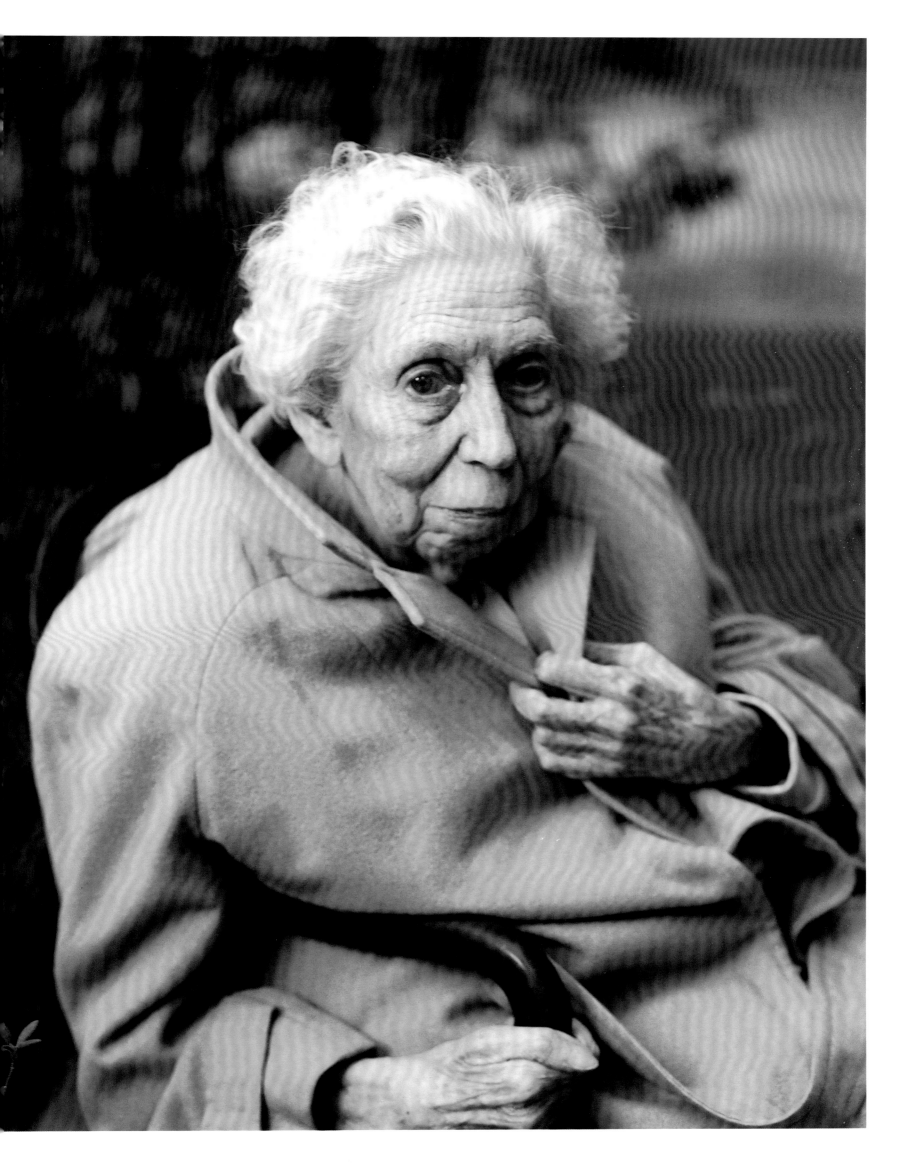

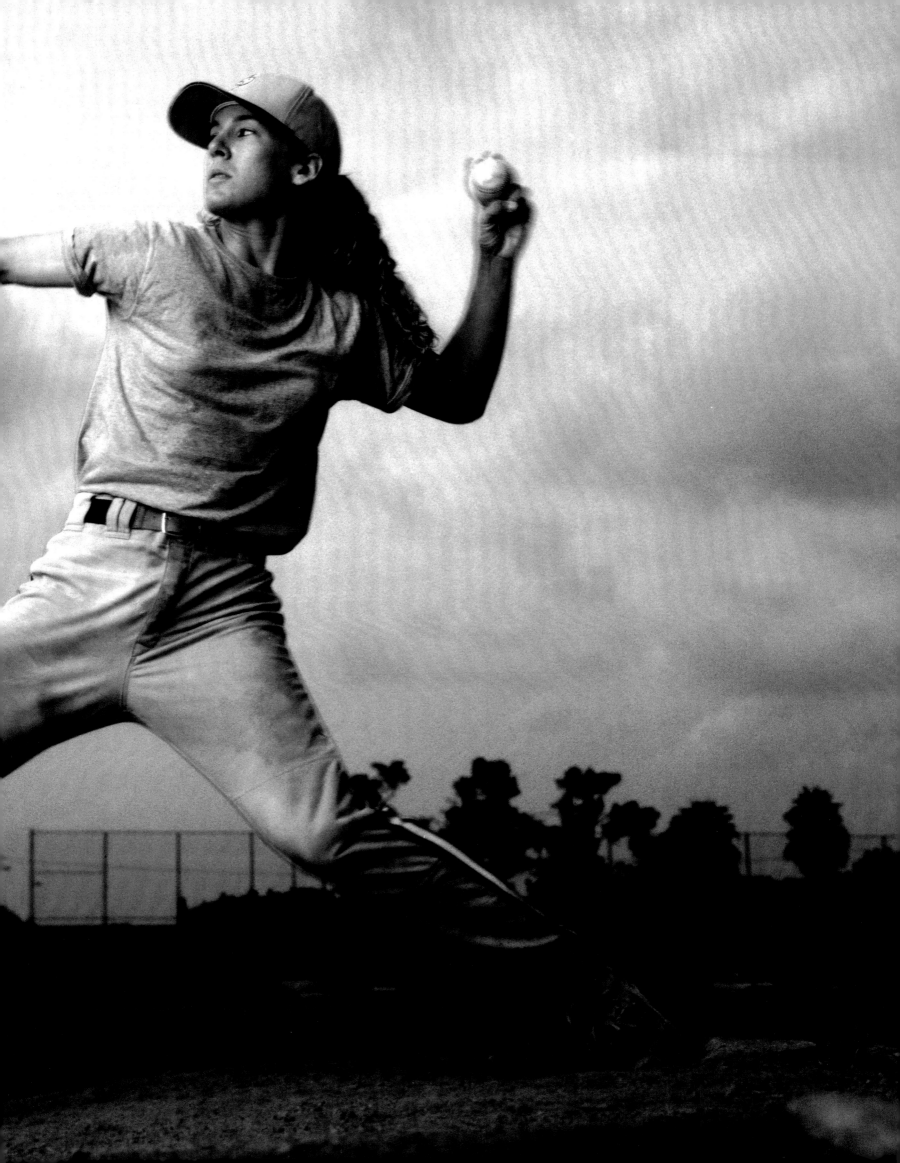

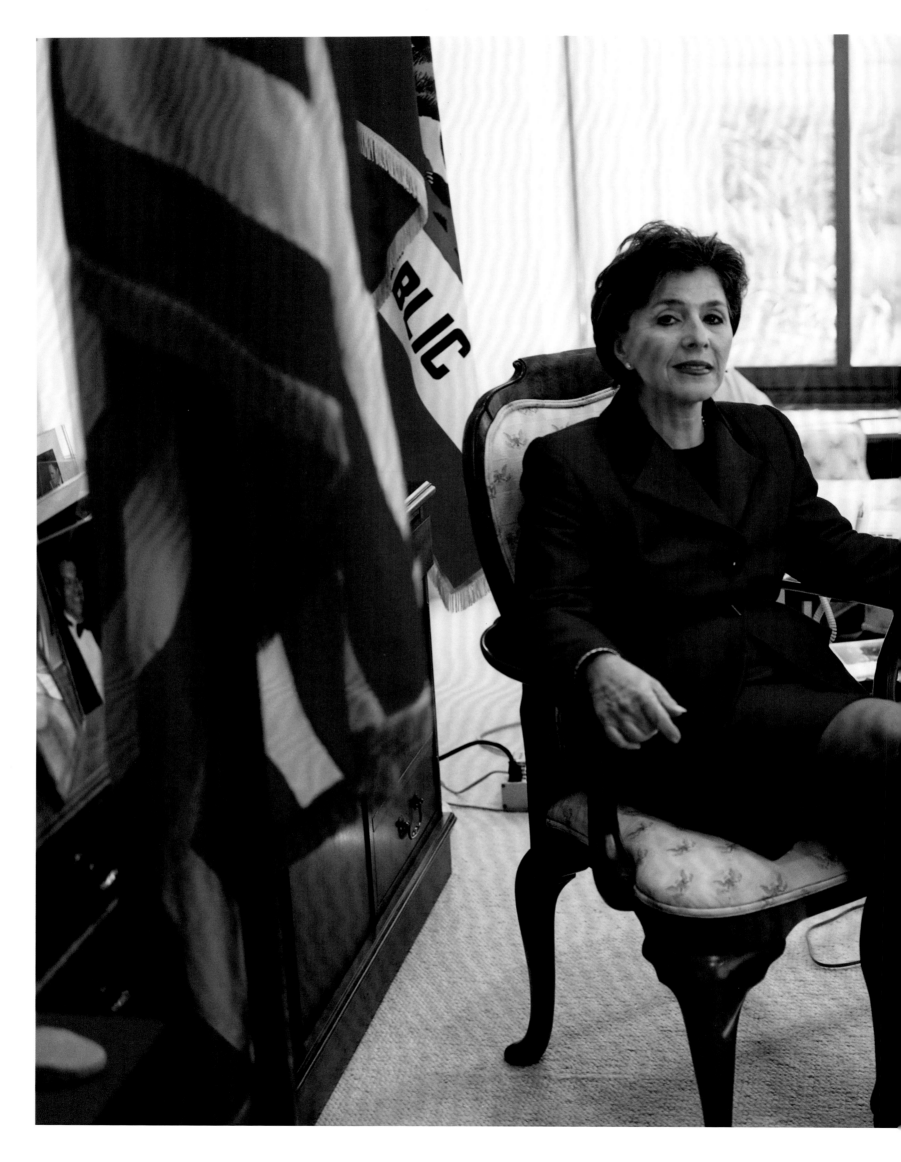

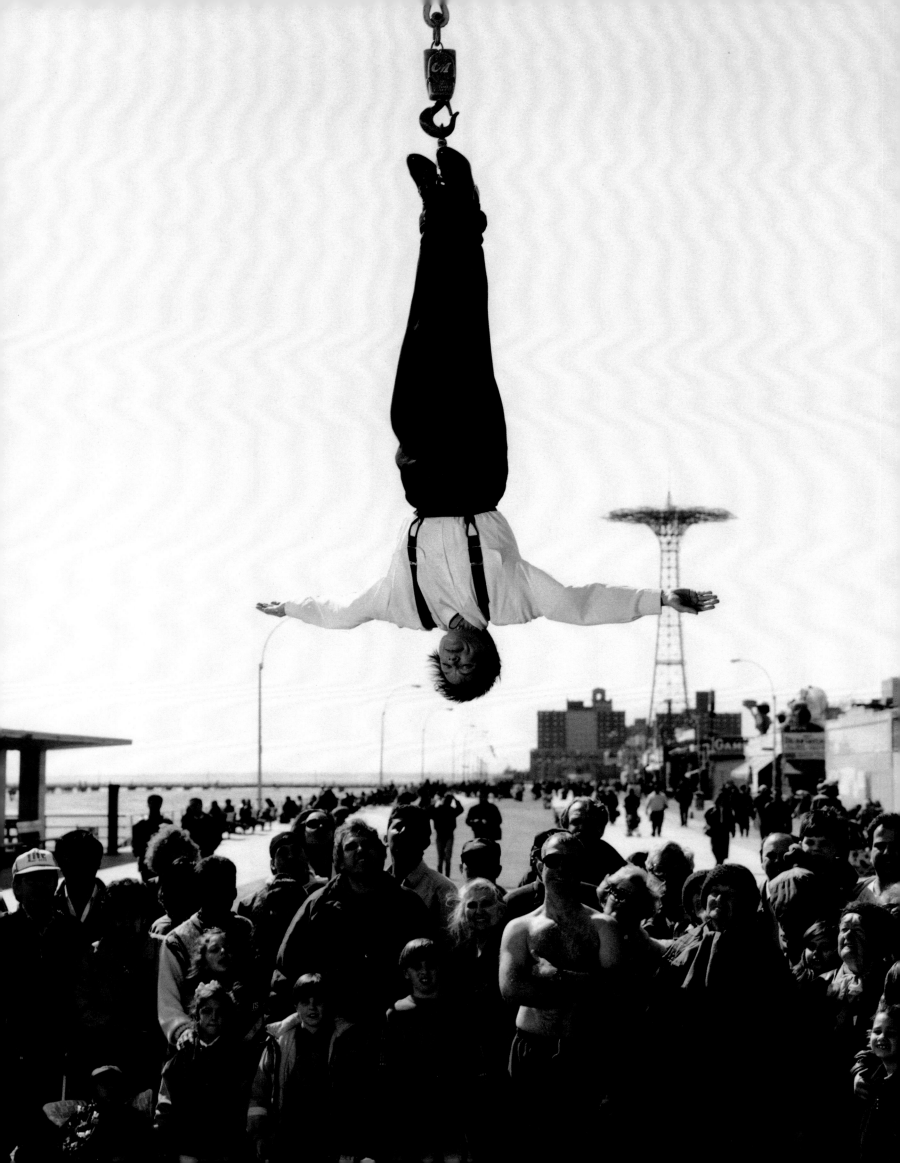

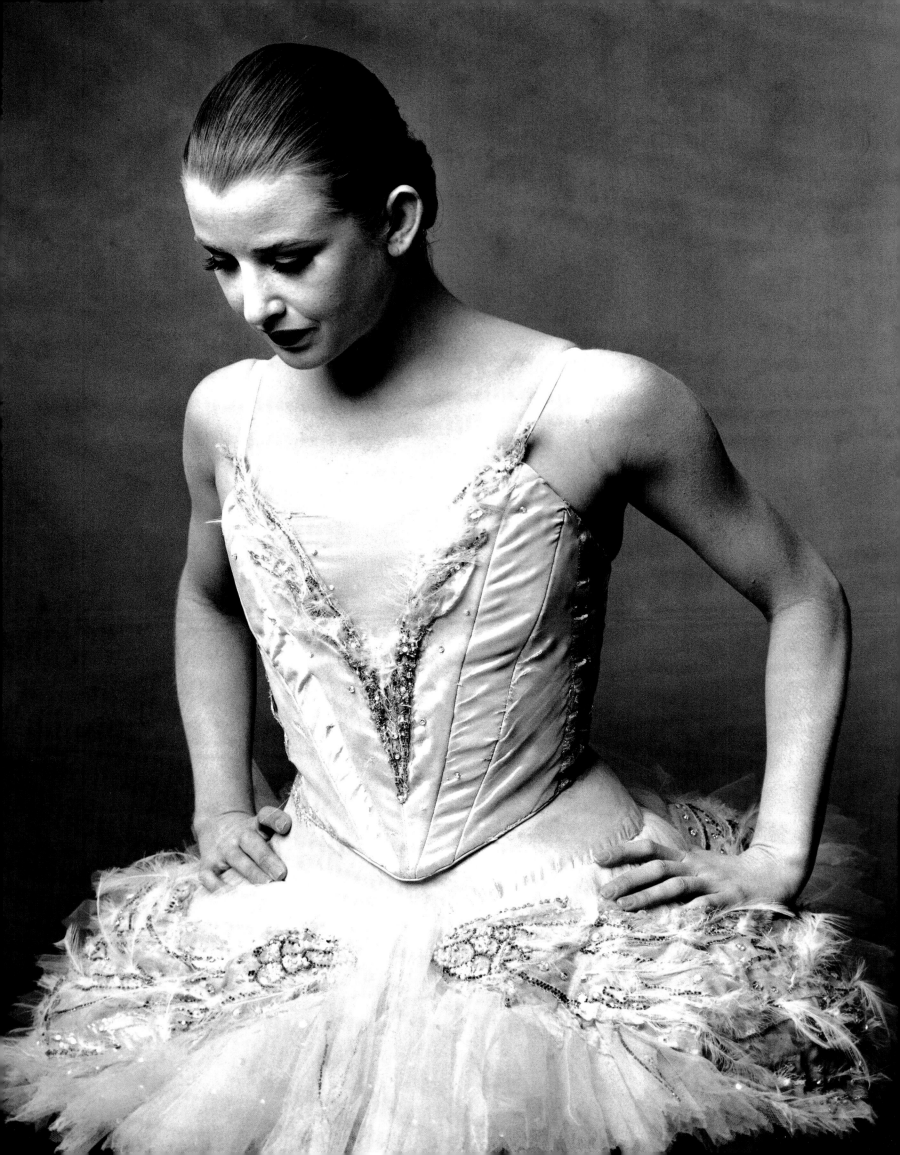

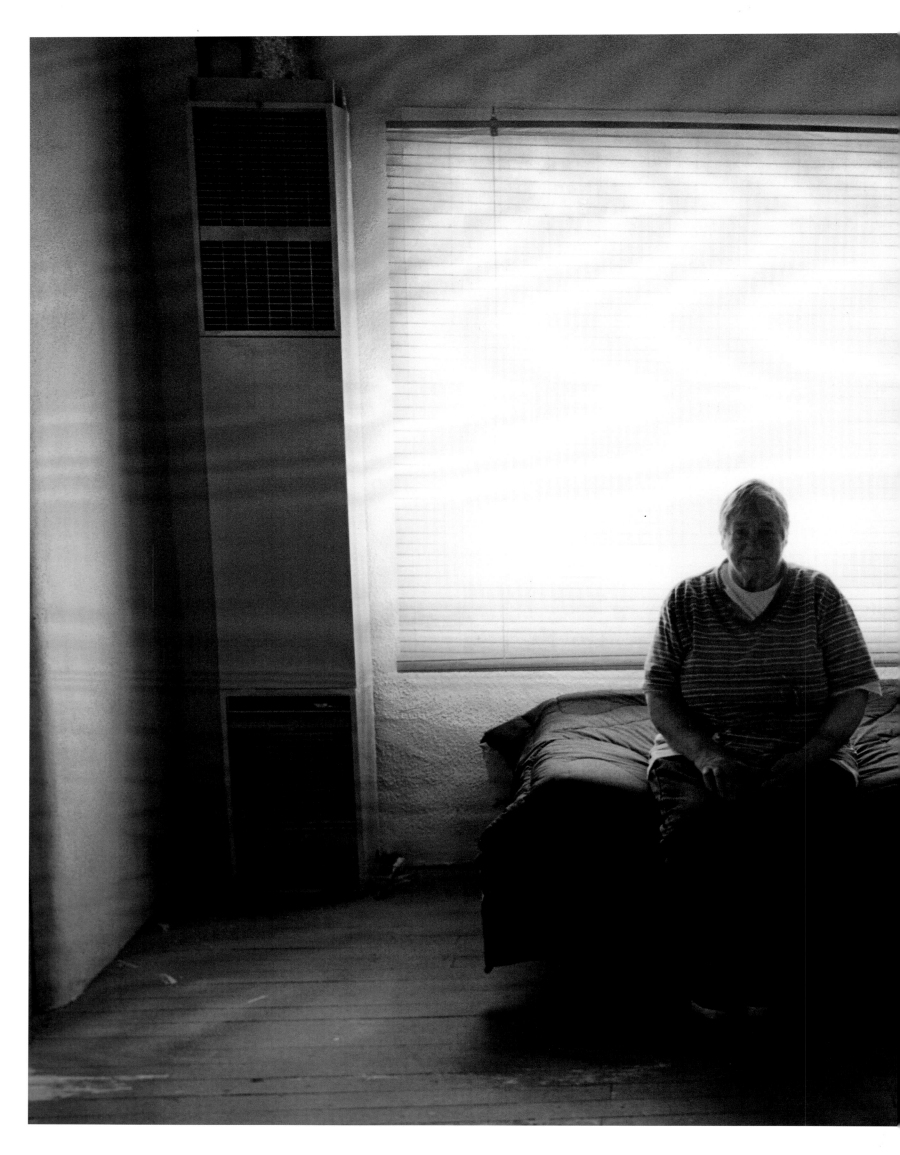

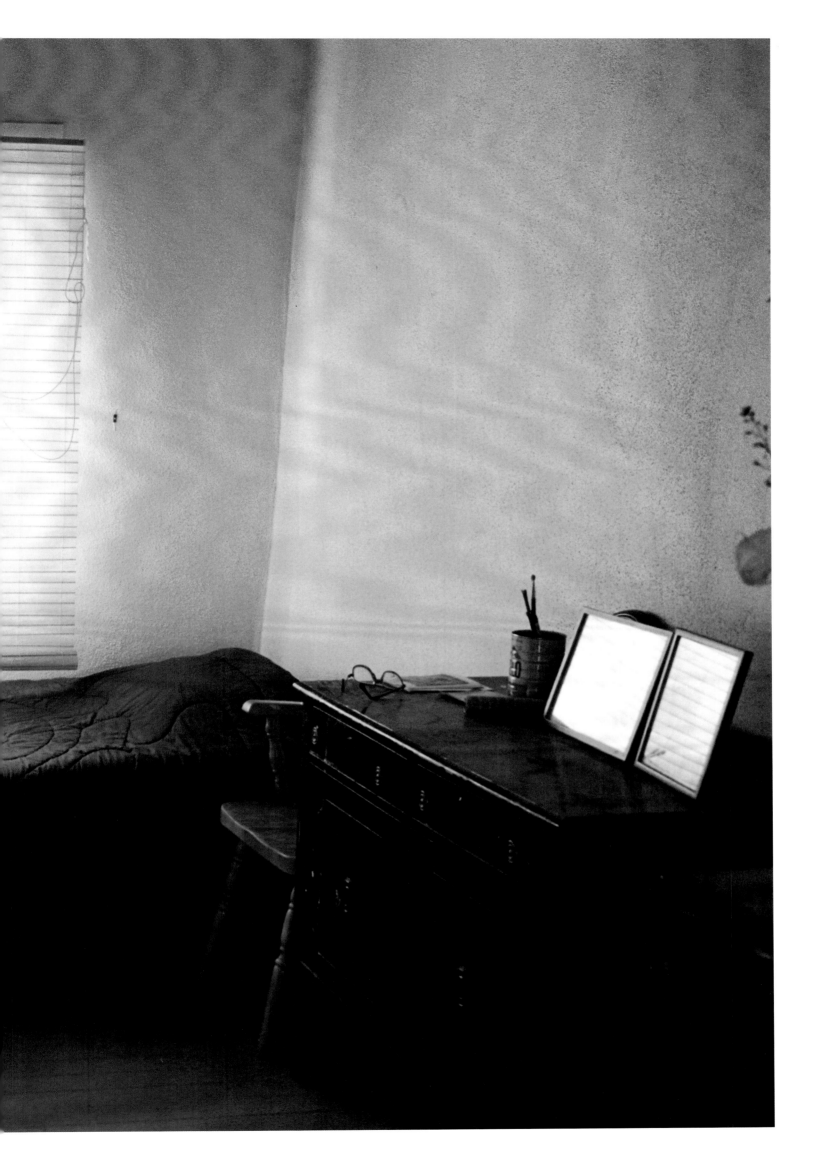

Lucinda Childs
Choreographer, performer
New York City

Preceding pages:

Laurie Anderson
Musician, multimedia performer
Coney Island, Brooklyn, New York

Darci Kistler
Dancer, New York City Ballet
New York City

Agnes Martin
Painter
Taos, New Mexico

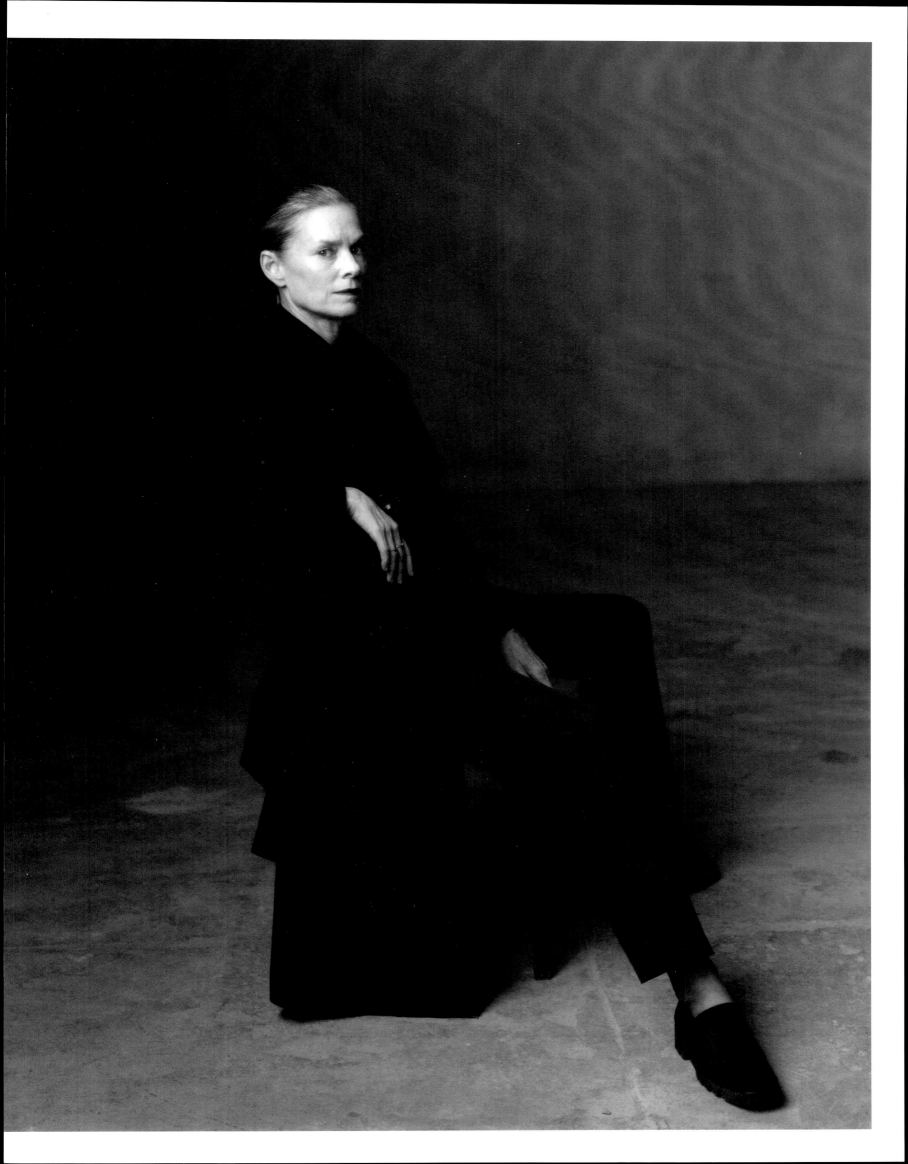

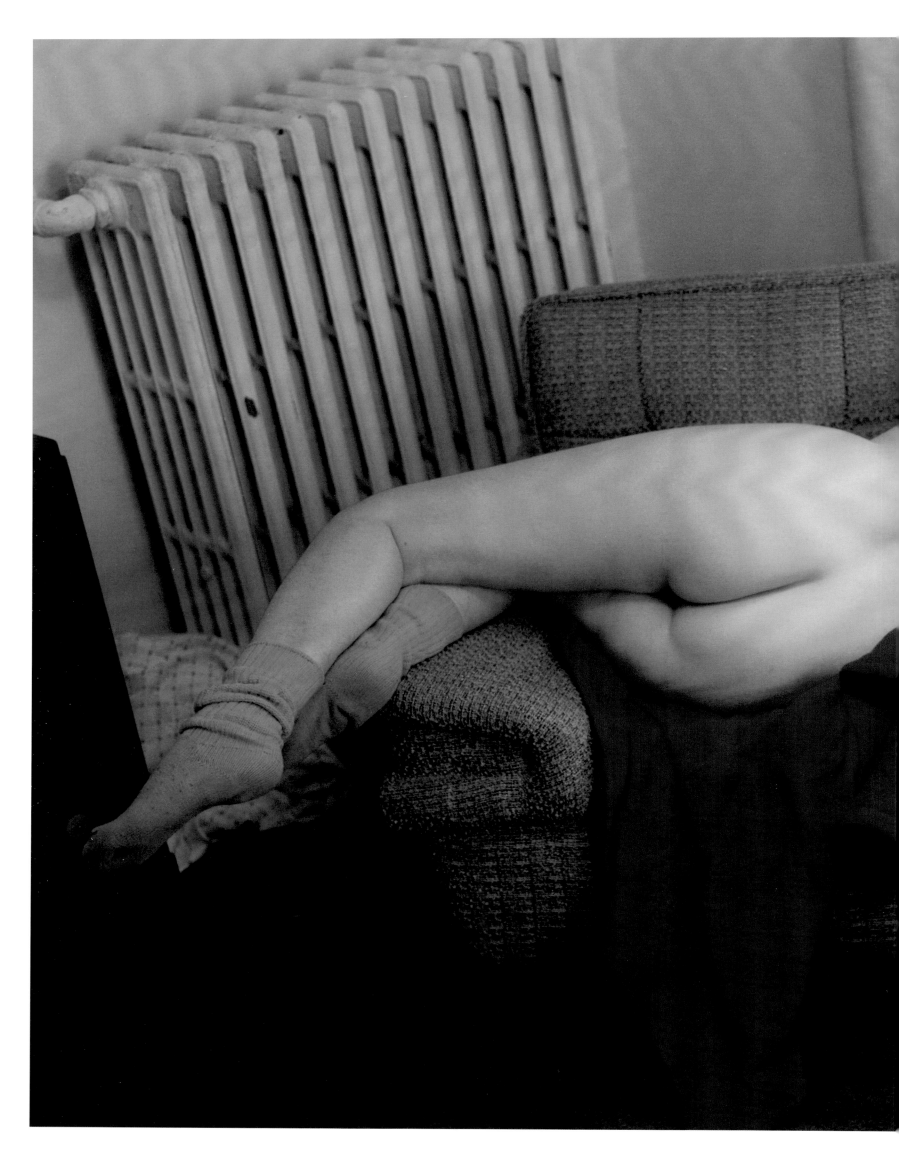

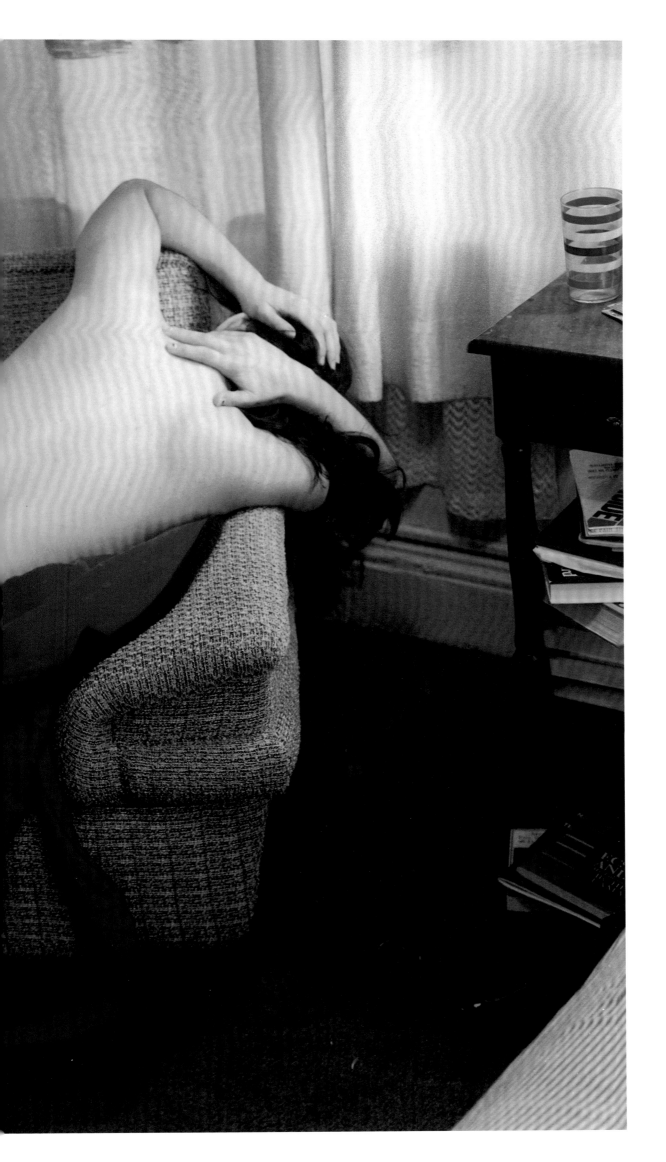

Karen Finley
Performance artist
Nyack, New York

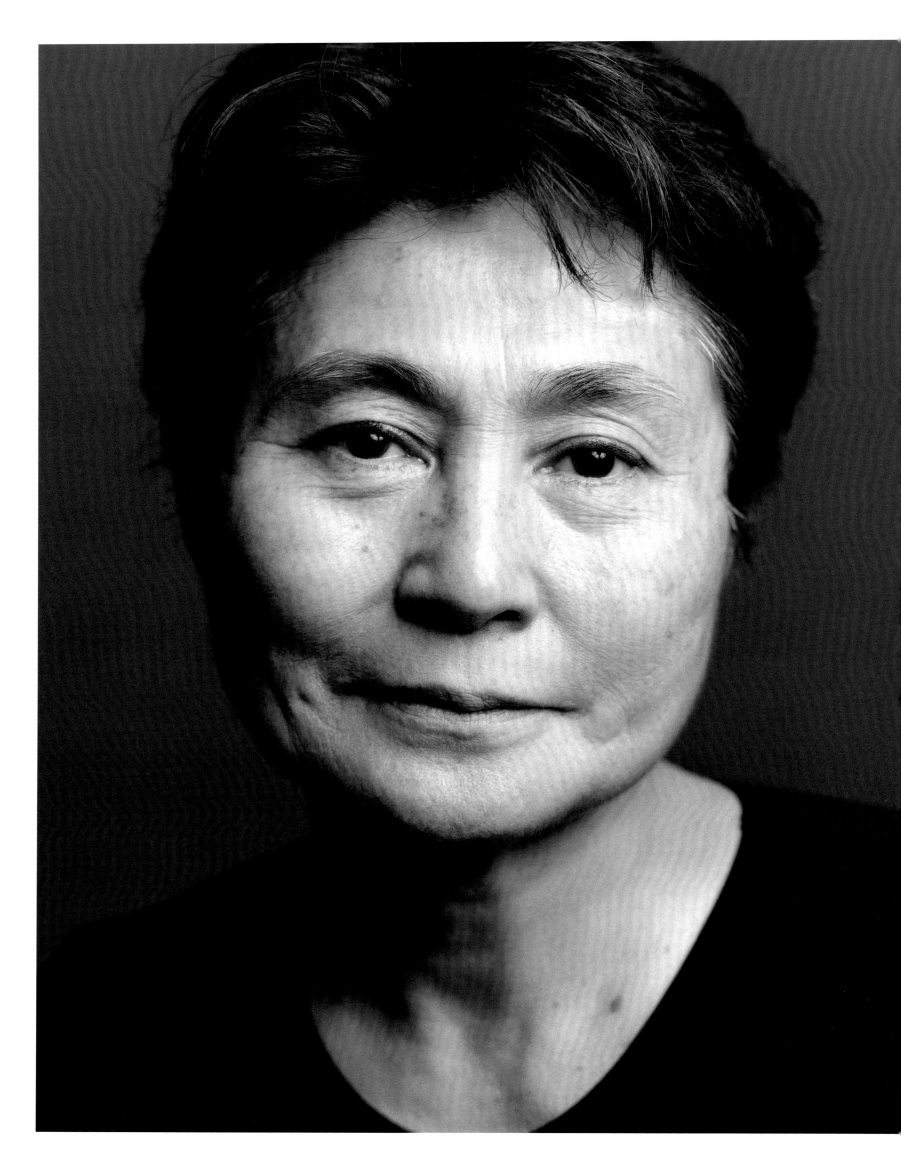

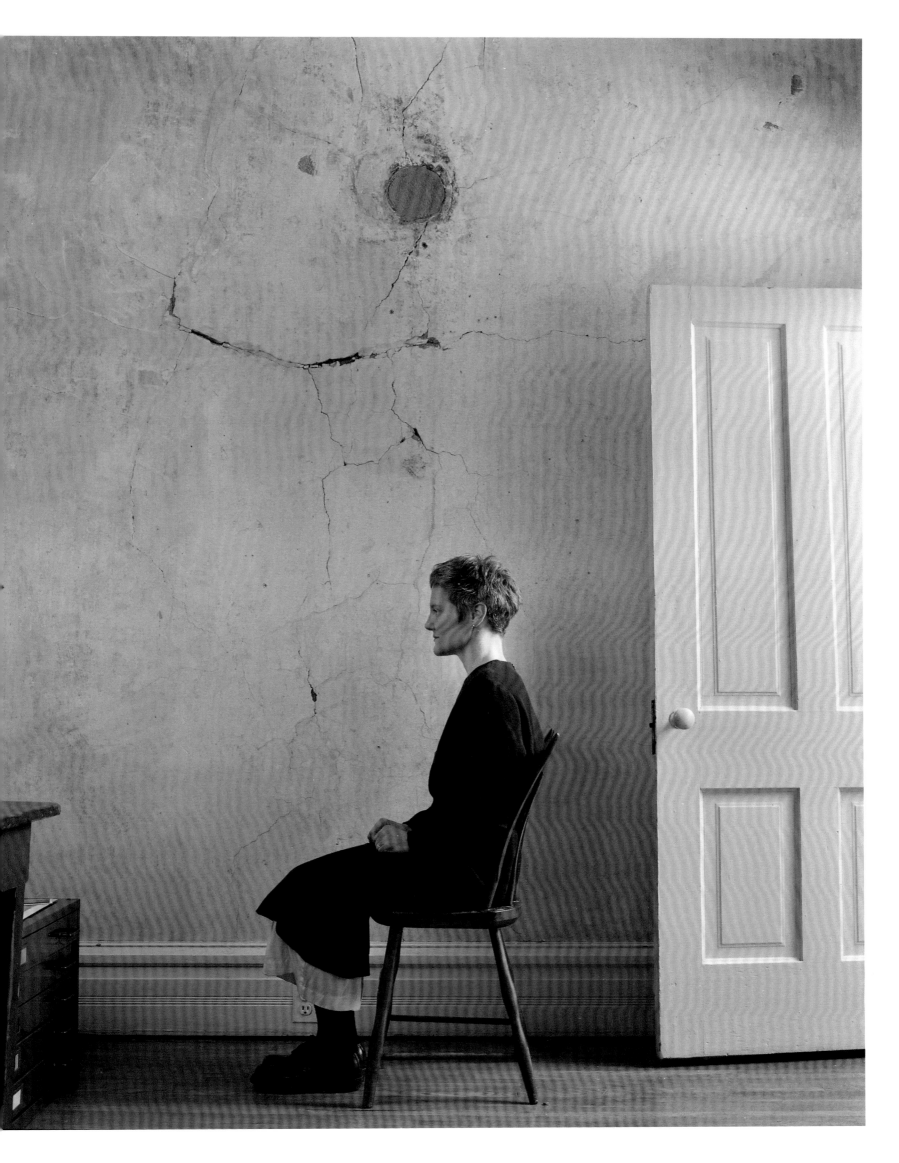

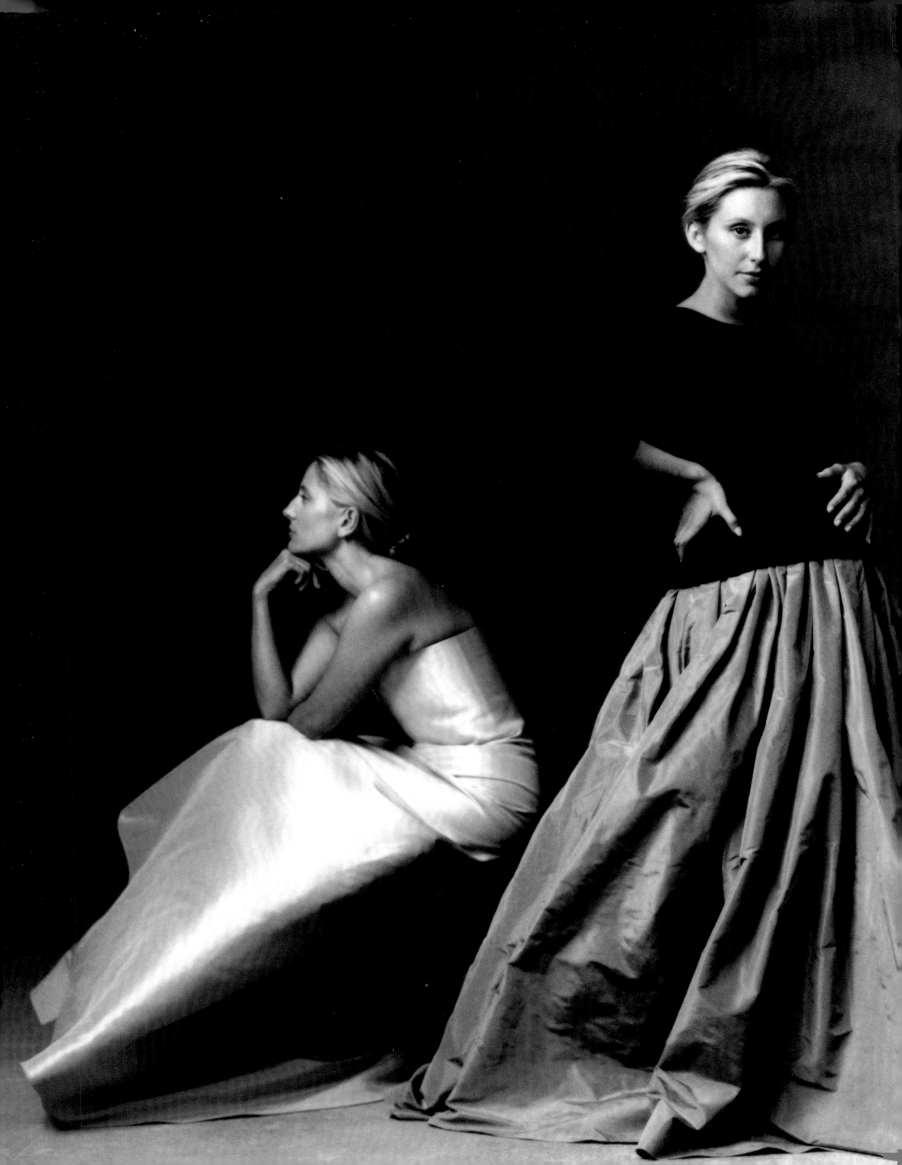

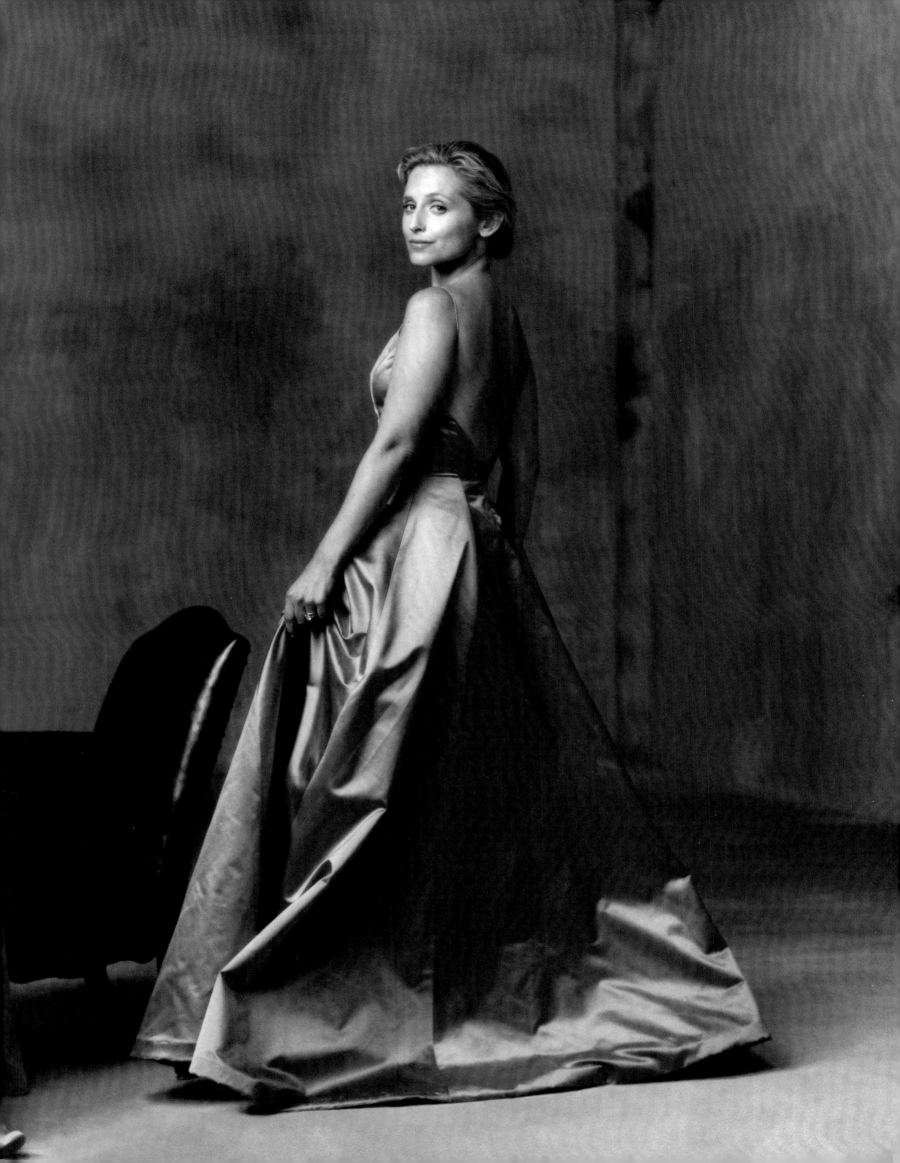

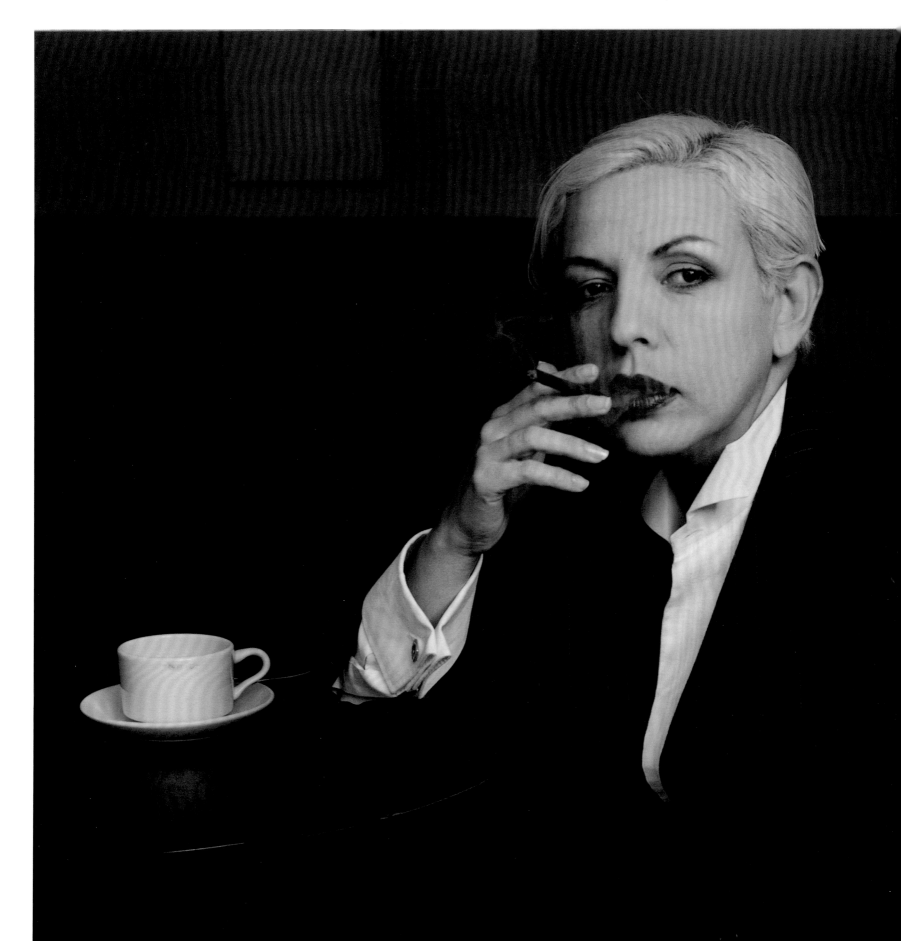

Alida Wallenda Cortes,
Lijana Wallenda Hernandez,
and Delilah Wallenda Troffer
Trapeze artists
Sarasota, Florida

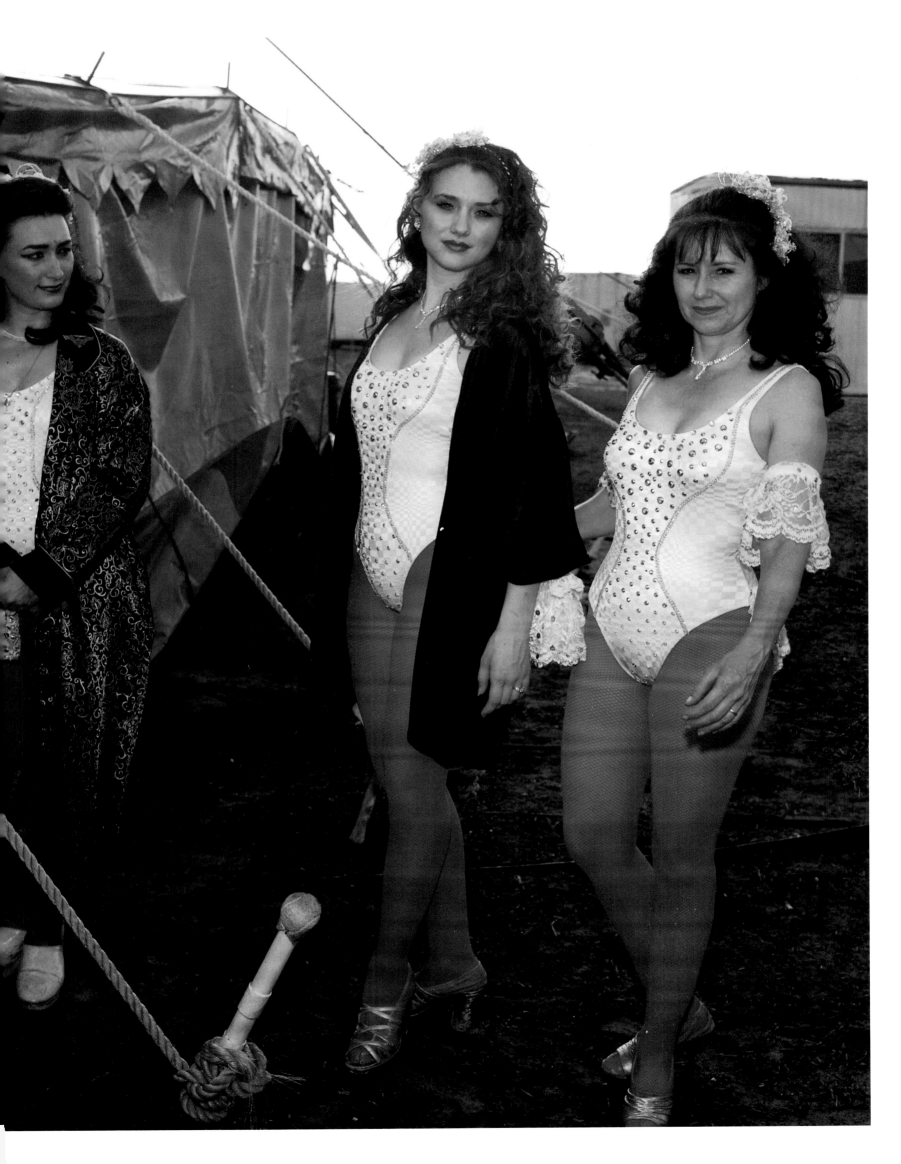

Jerry Hall and Gabriel Jagger
Model and her son
New York City

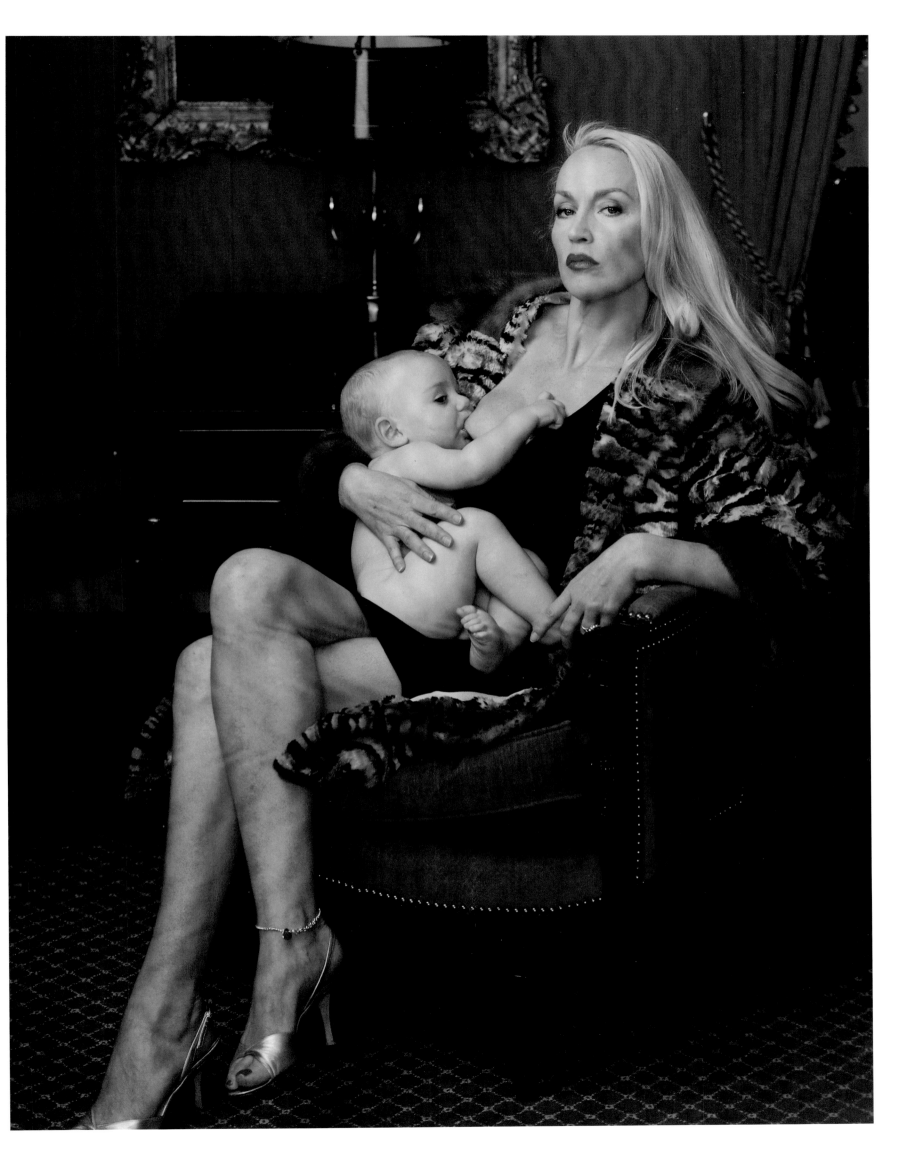

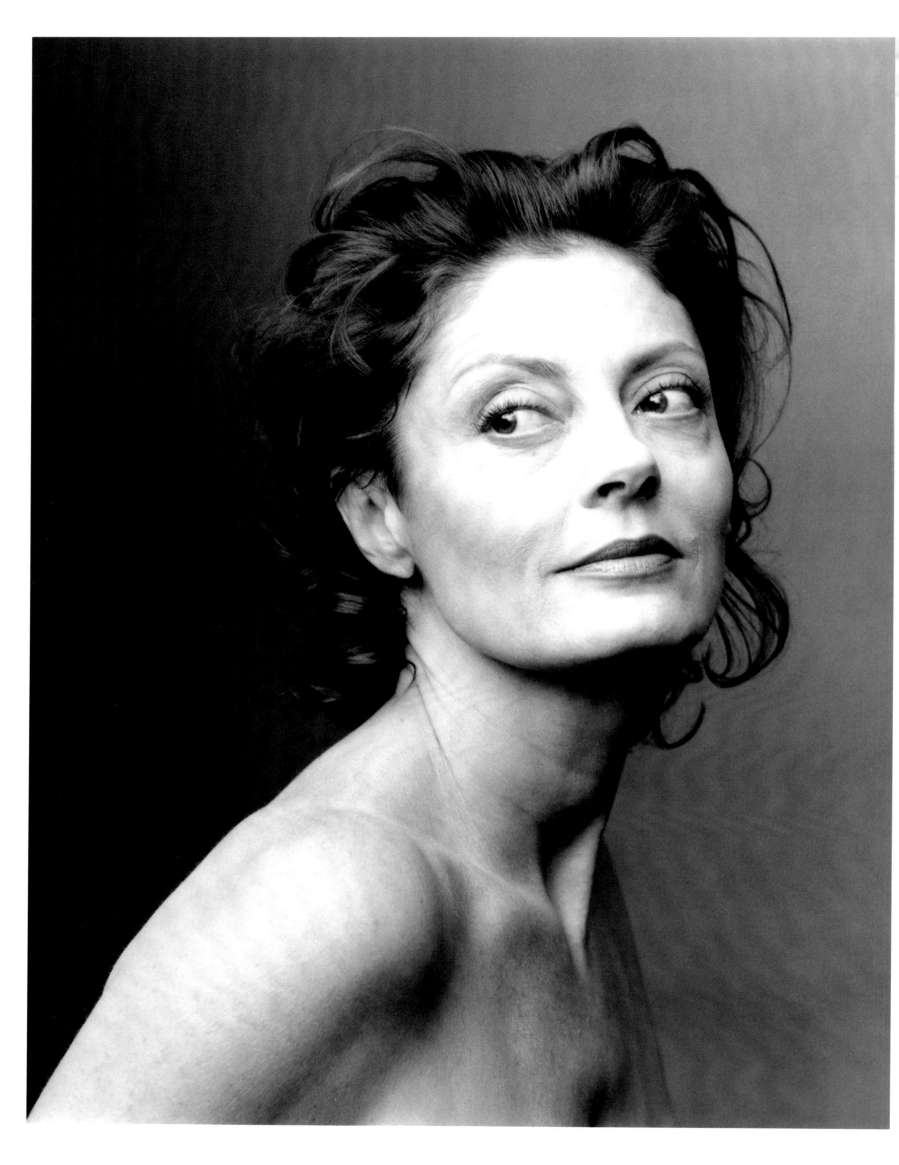

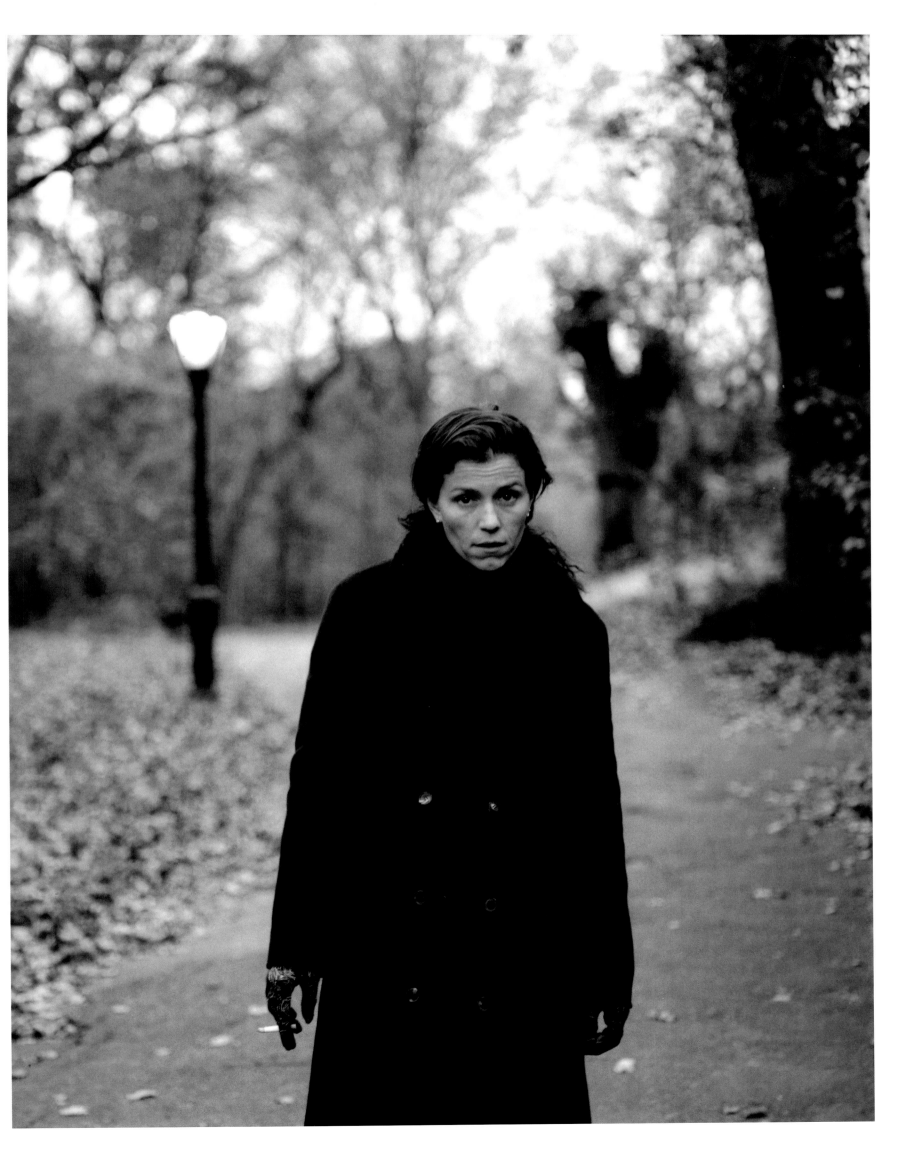

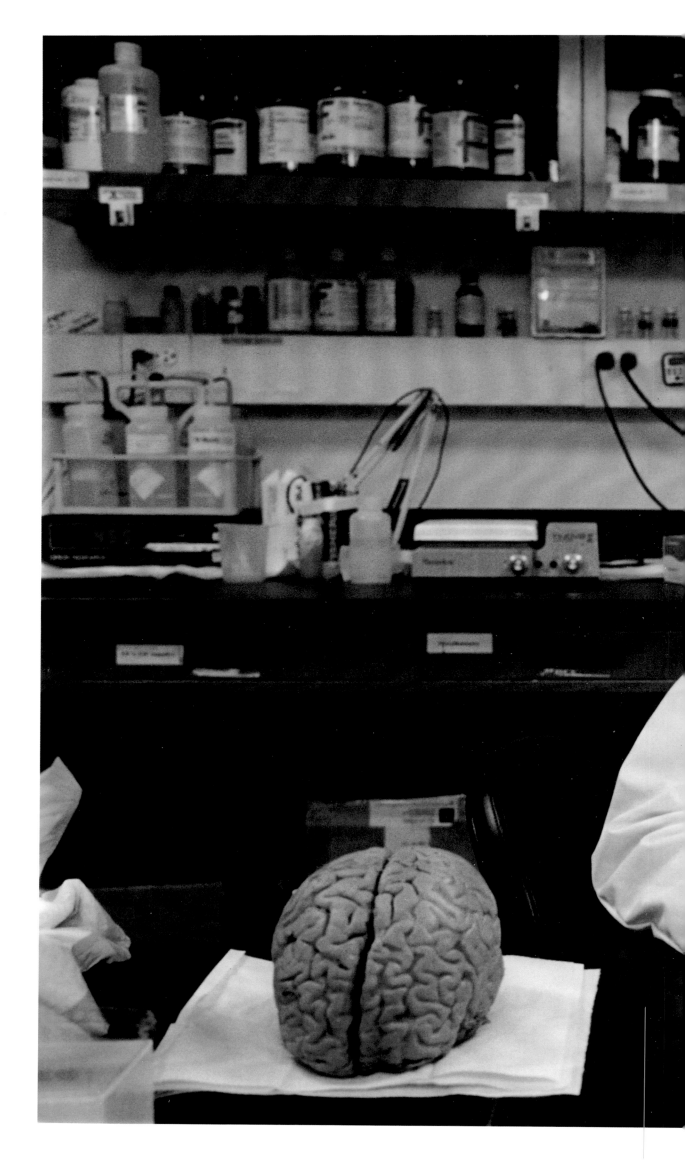

Wendy Suzuki
Research scientist
New York University, New York City

Preceding pages:

Susan Sarandon
Actress
New York City

Frances McDormand
Actress
New York City

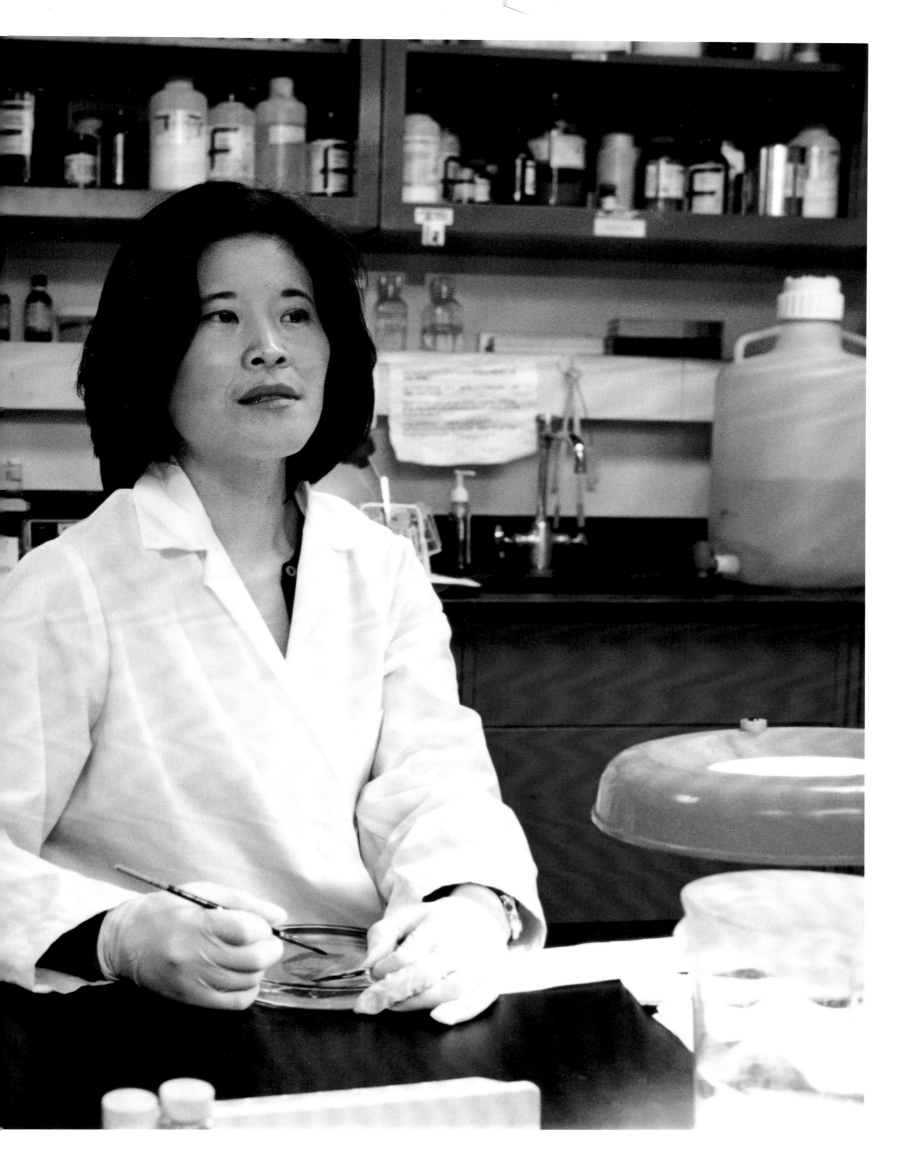

Gwyneth Paltrow and Blythe Danner
Actresses
Vancouver, British Columbia

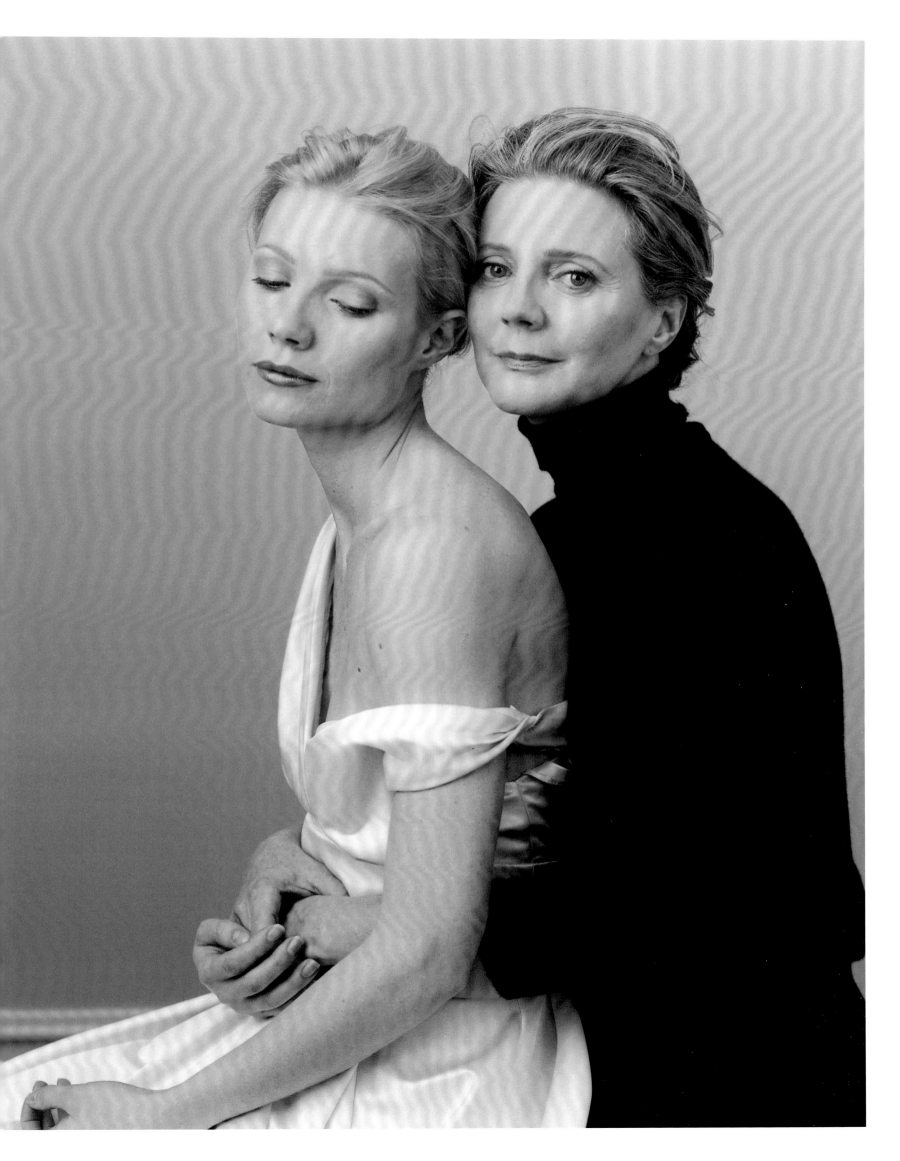

Kathleen M. Sullivan
Dean, Stanford University Law School
Palo Alto, California

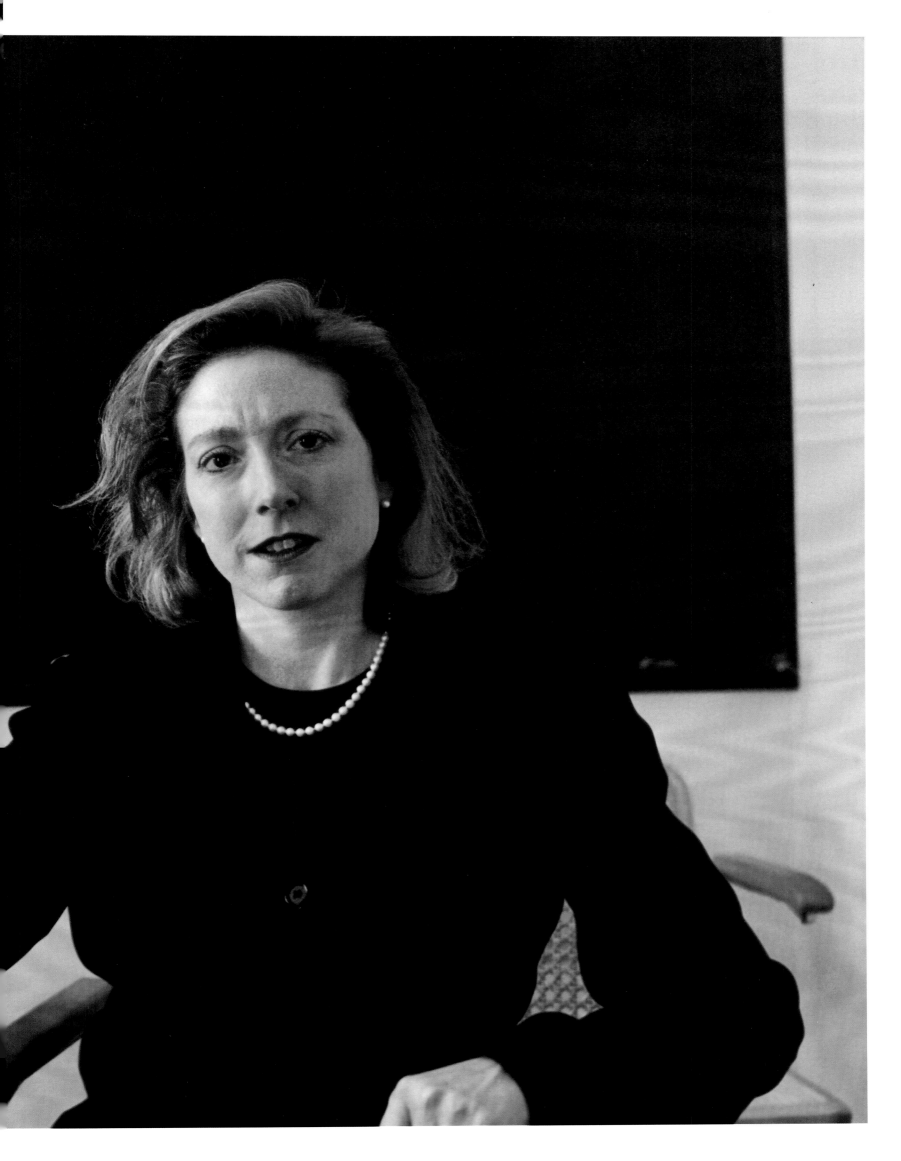

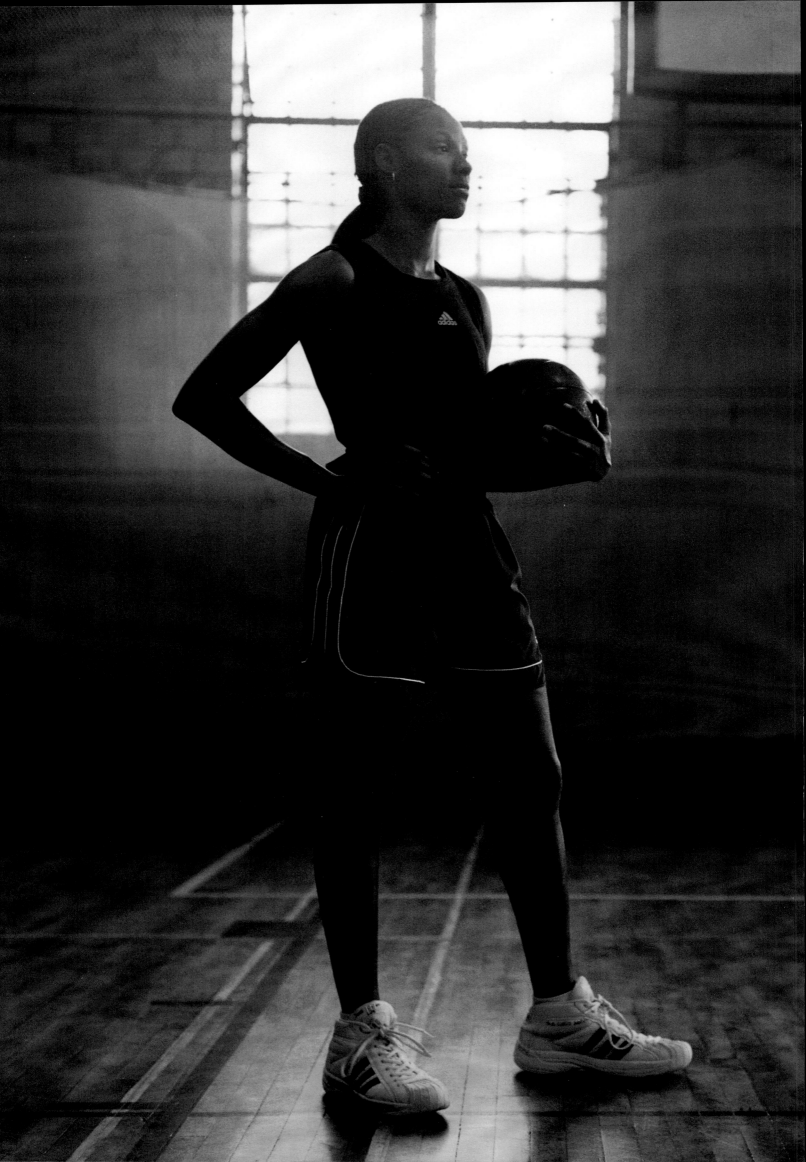

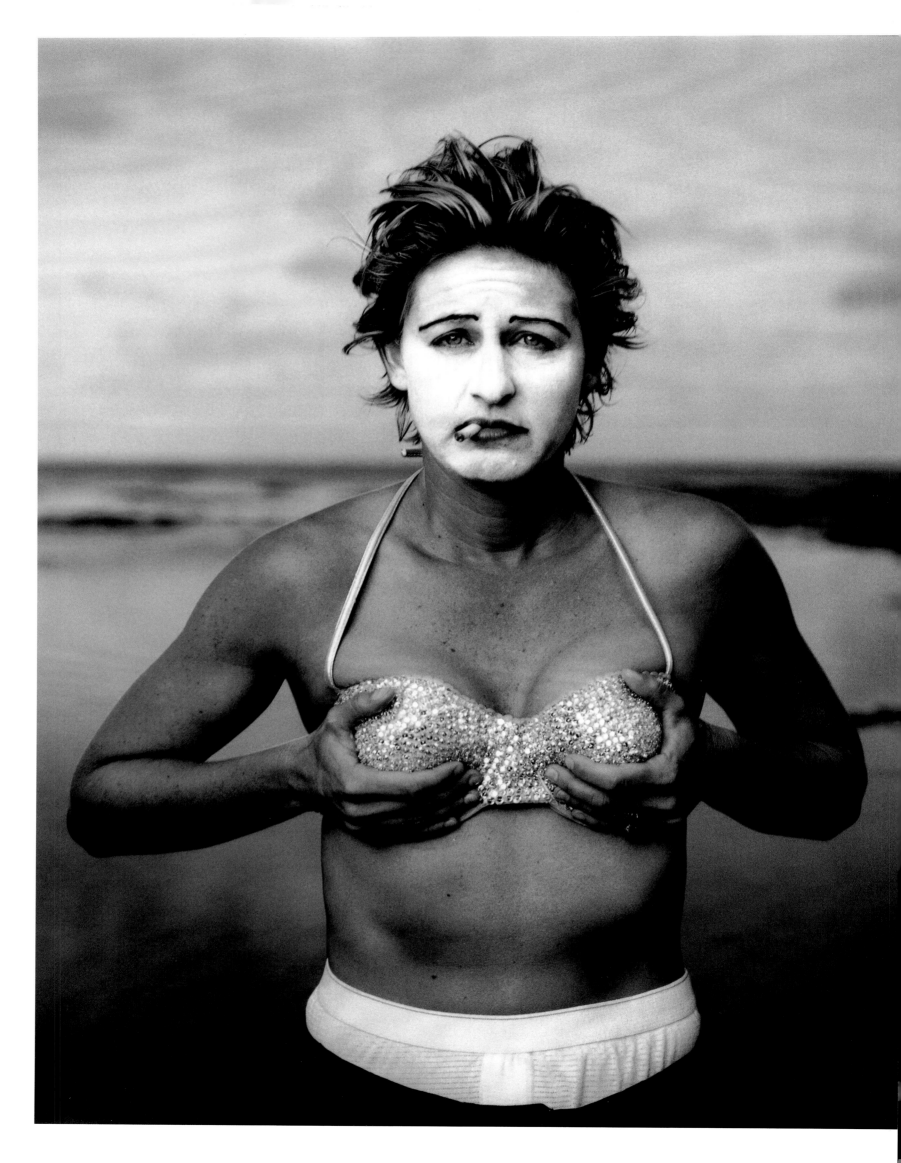

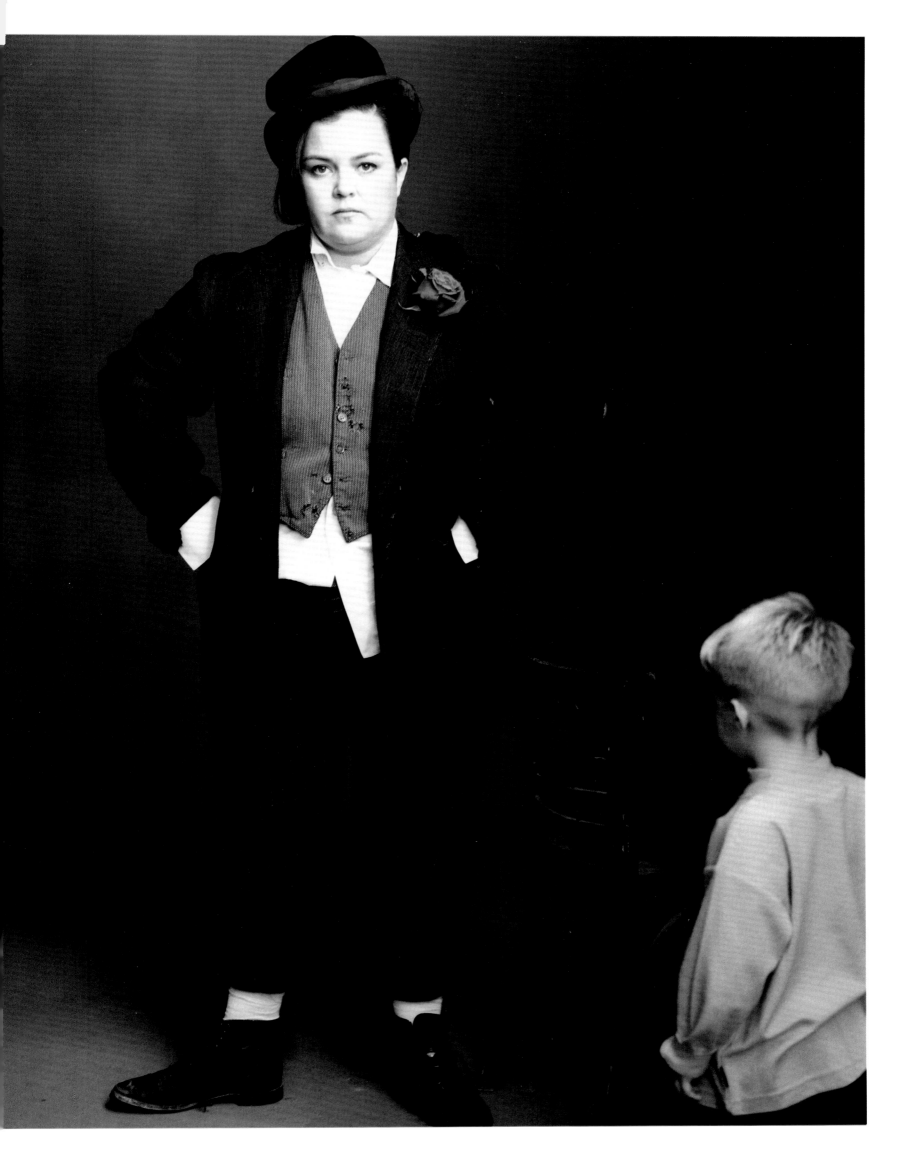

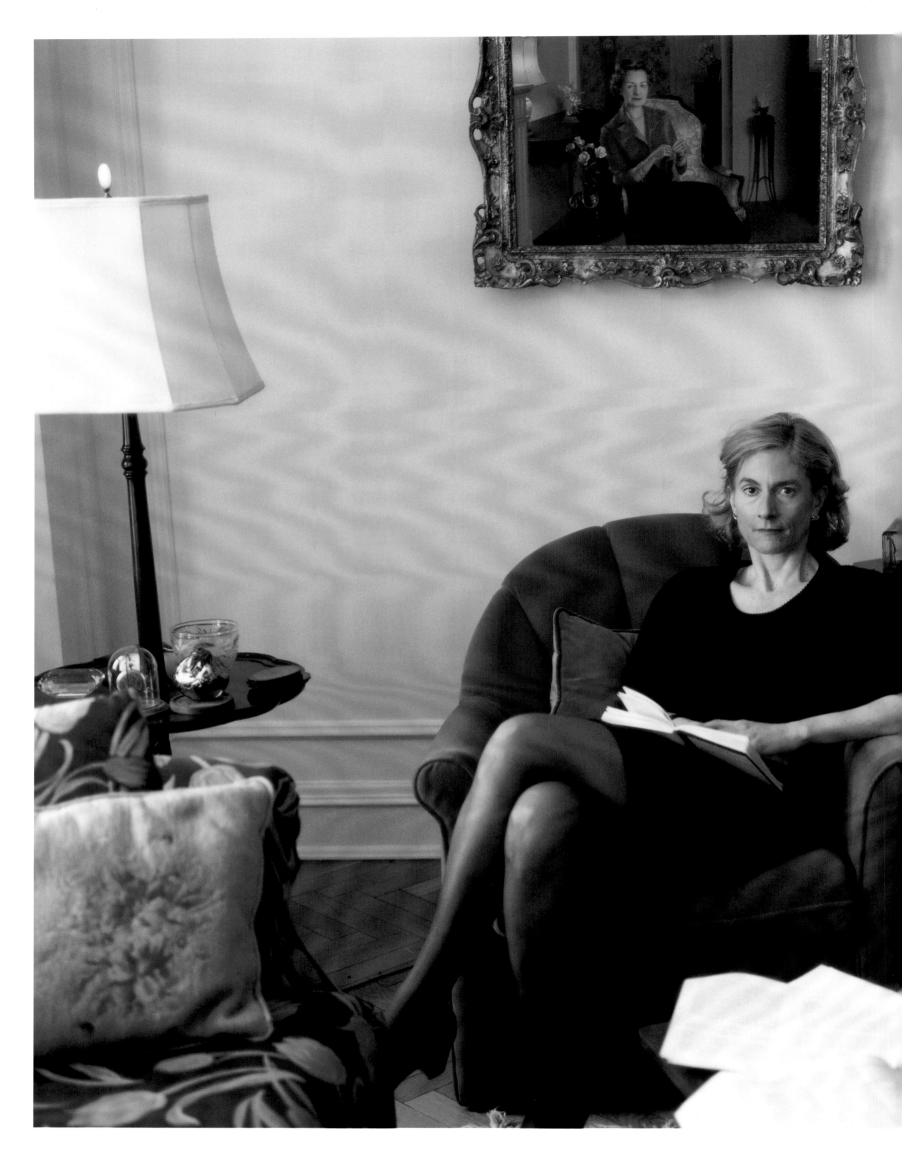

Martha Nussbaum
Professor of law and ethics, University of Chicago
Chicago, Illinois

Preceding pages:

Chamique Holdsclaw
Basketball player
University of Tennessee, Knoxville, Tennessee

Ellen DeGeneres
Comedian
Kauai, Hawaii

Rosie O'Donnell and Parker O'Donnell
Comedian and her son
New York City

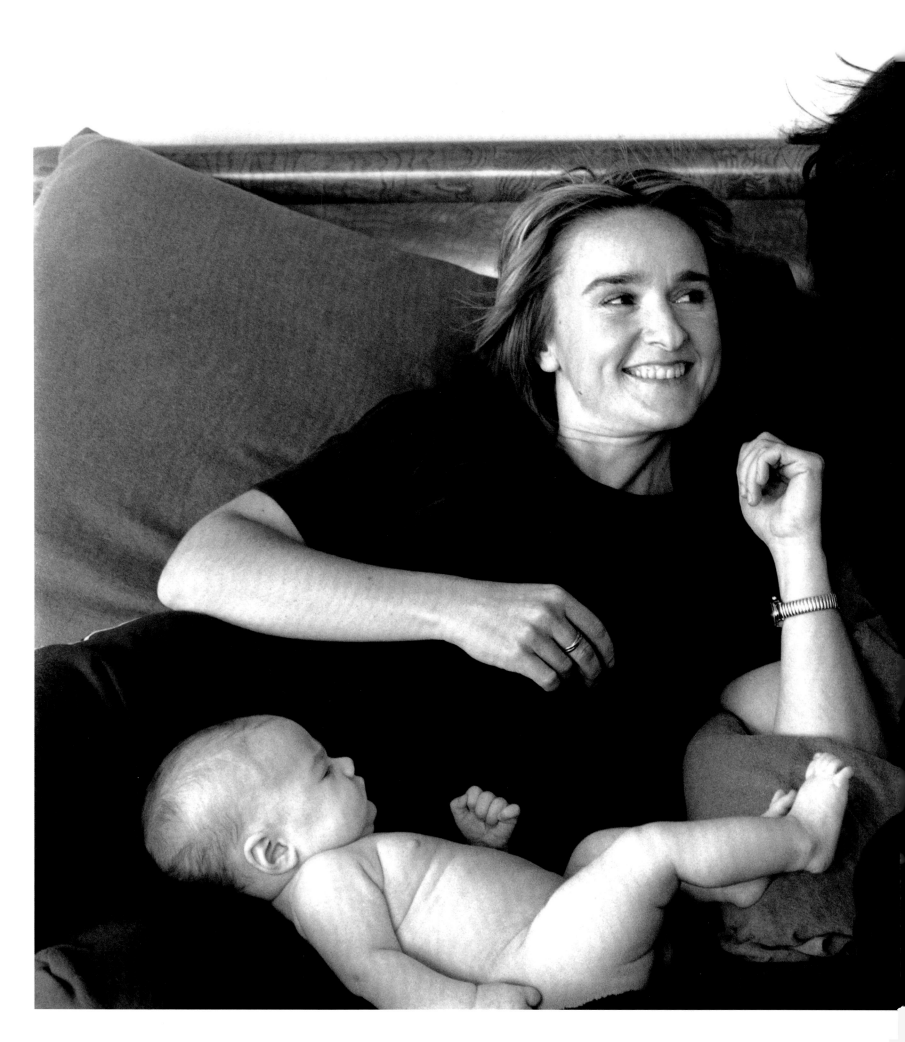

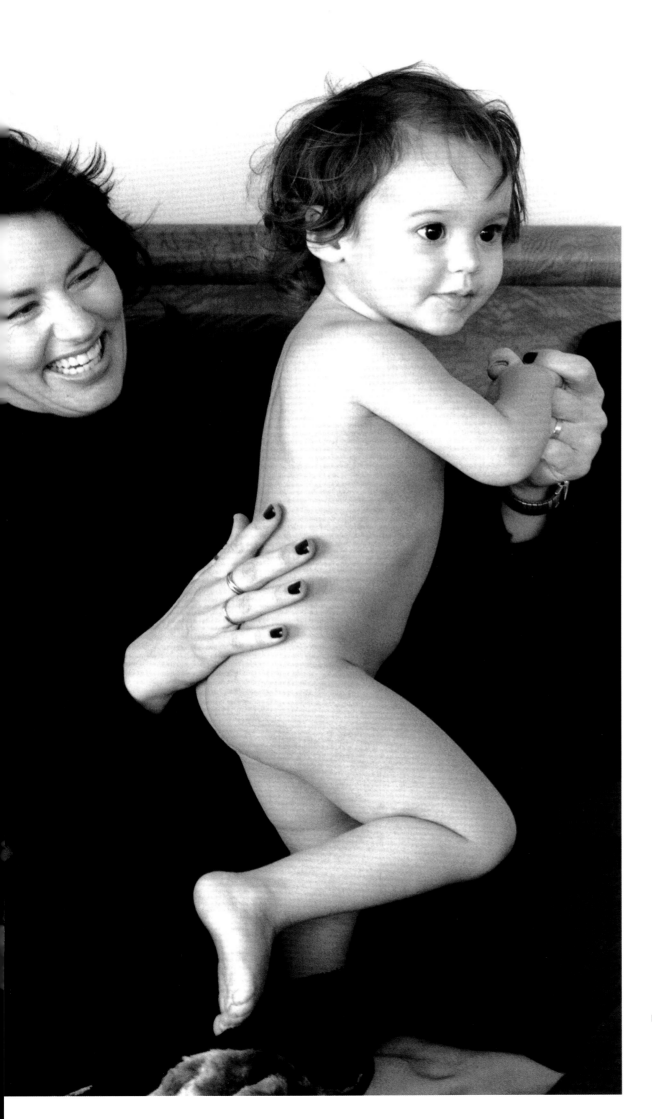

Melissa Etheridge, Julie Cypher,
and Bailey and Beckett Cypheridge
Musician and filmmaker with their children
Brentwood, California

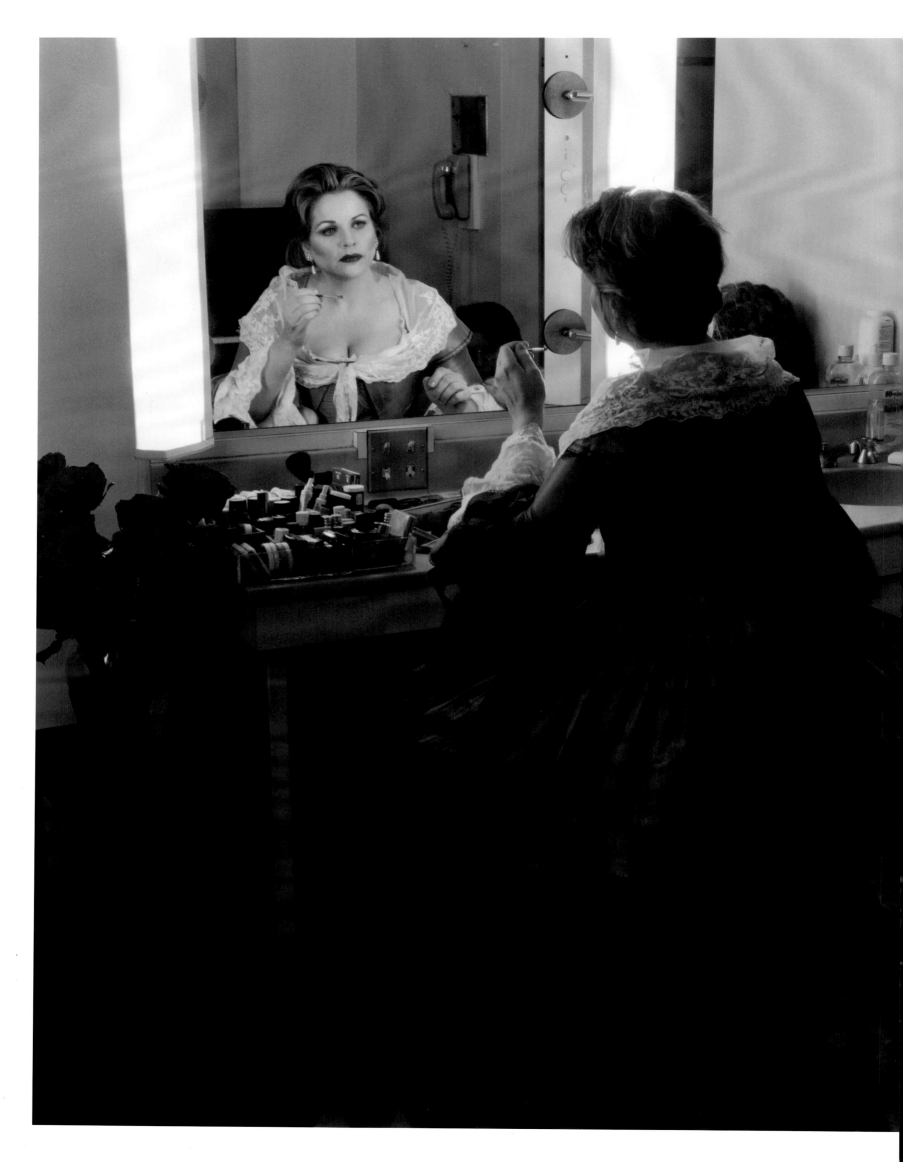

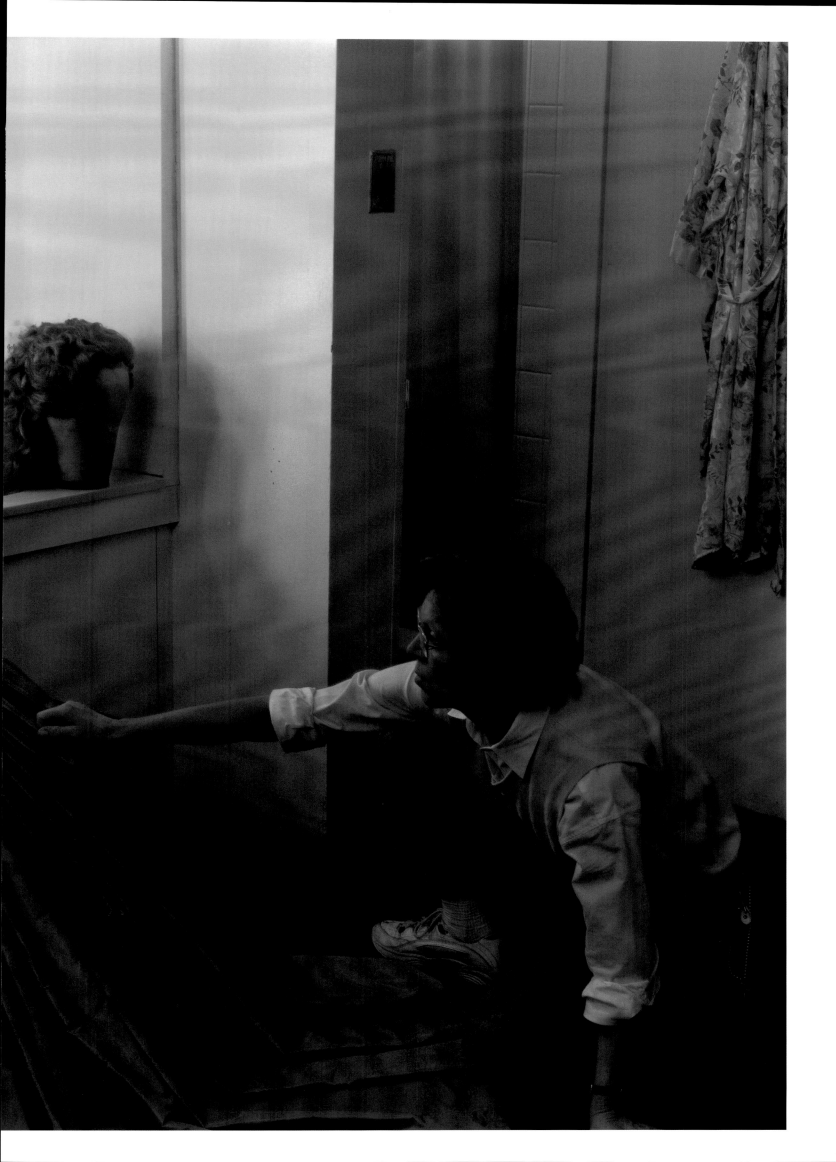

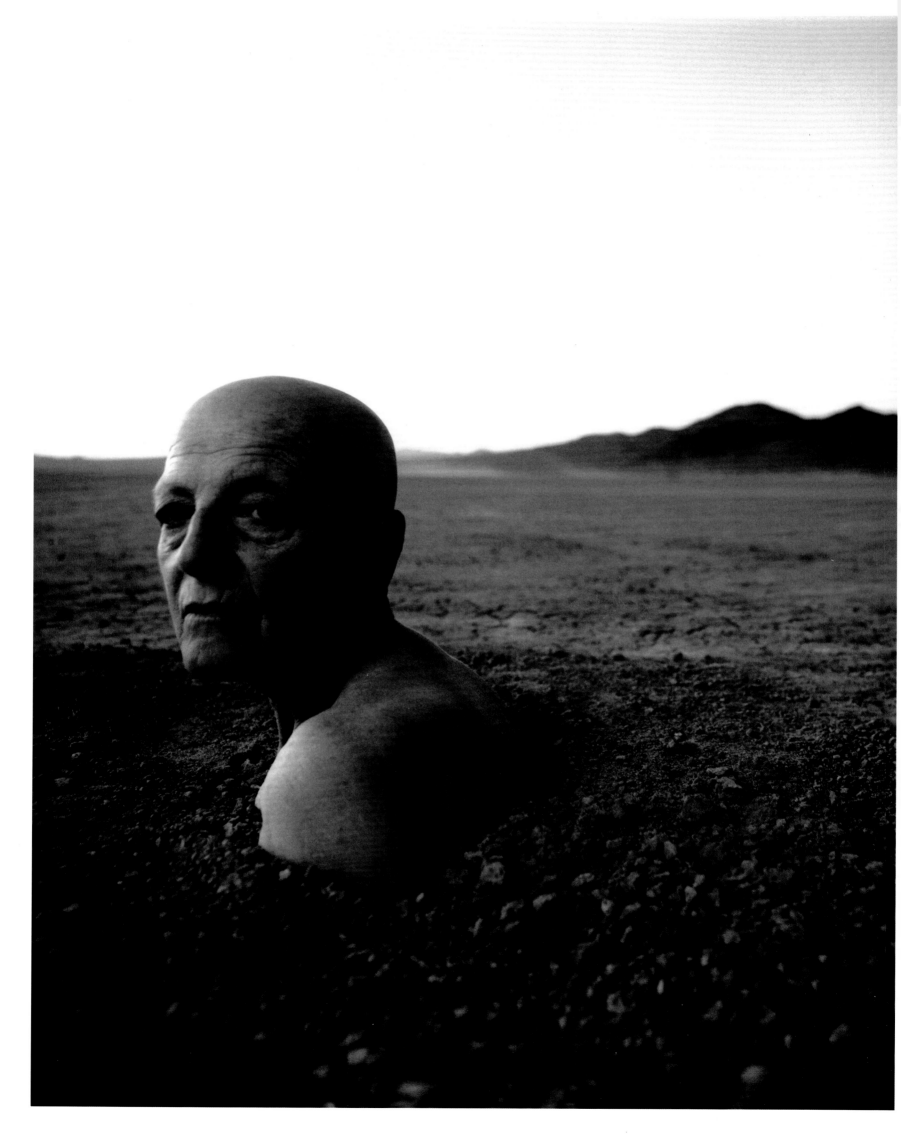

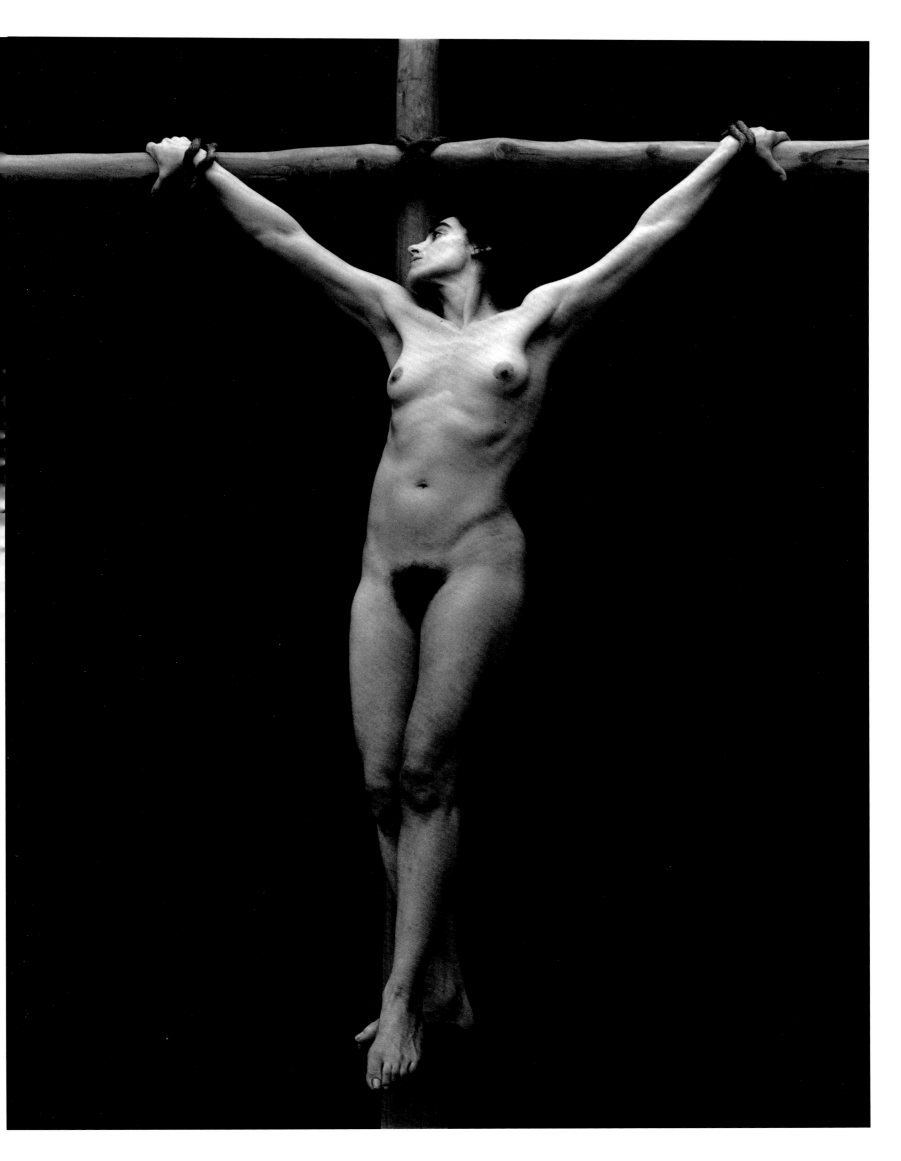

Elizabeth LeCompte
Theater director
New York City

Preceding pages:

Renée Fleming and Vicki Tanner
Opera singer; wardrobe supervisor
Metropolitan Opera House, New York City

Rachel Rosenthal
Performance artist
Soggy Dry Lake, California

Diamanda Galas
Performance artist
New York City

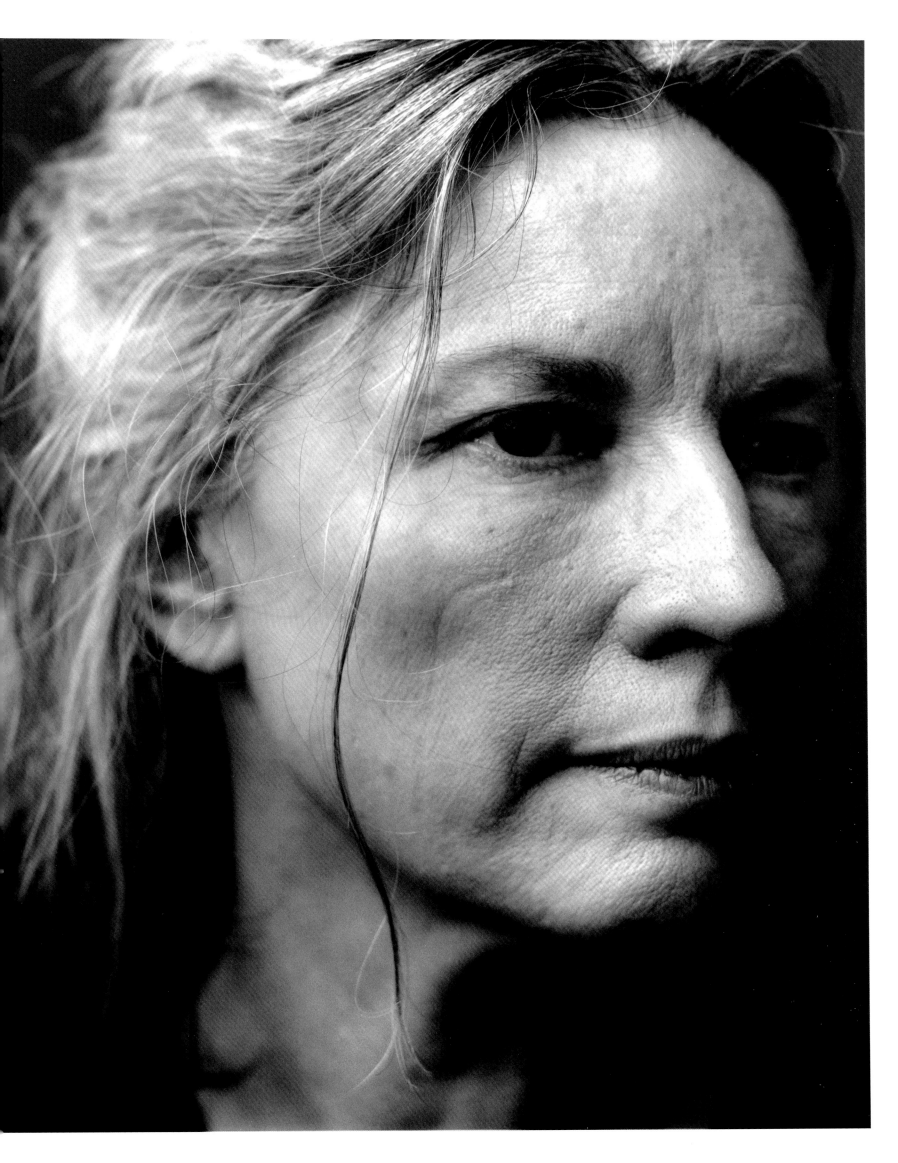

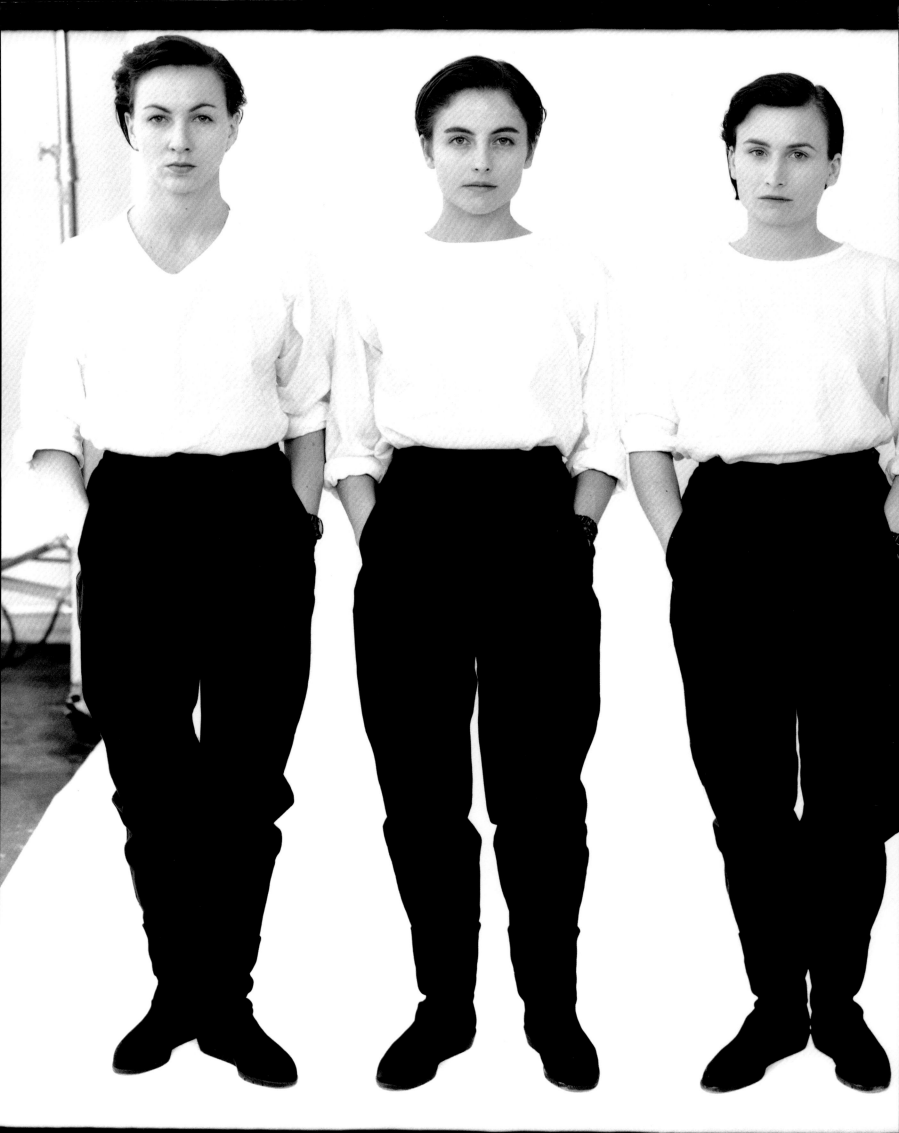

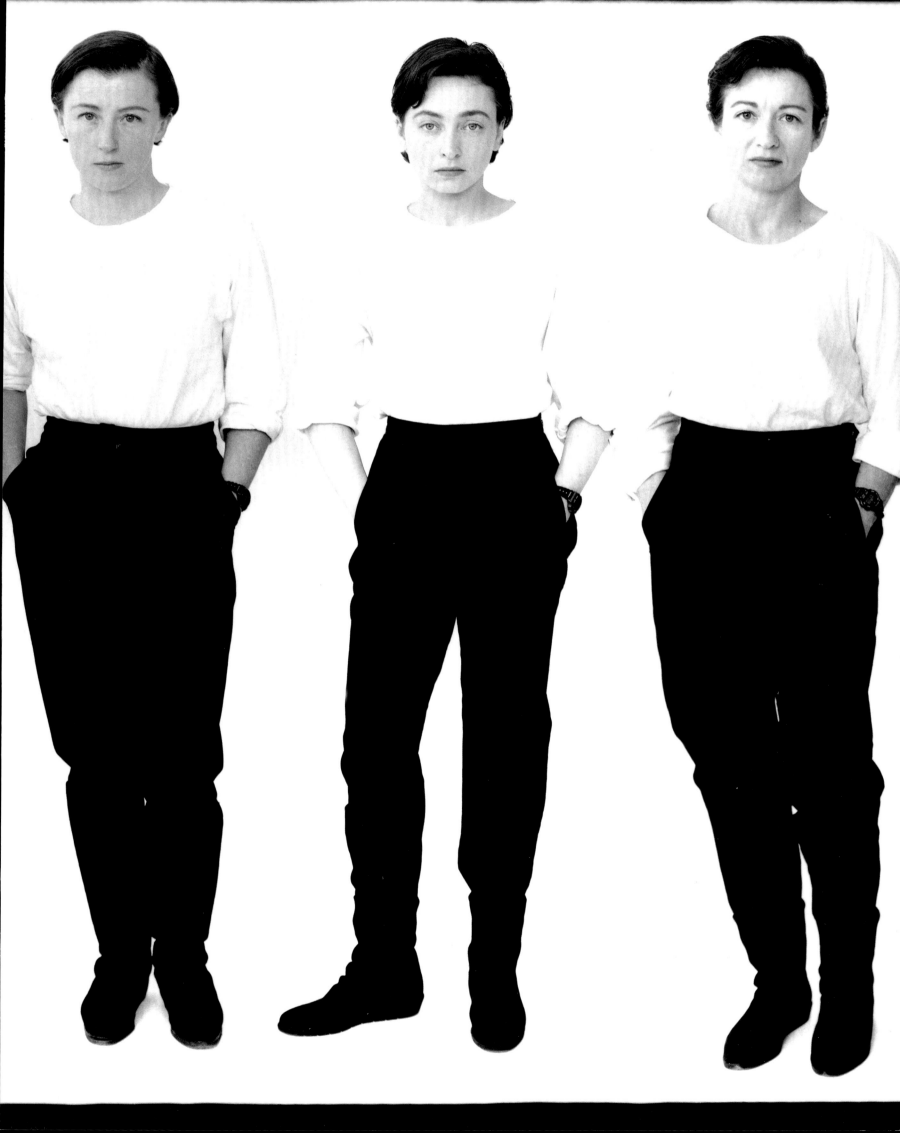

Alexandria Trower
Carnival artist
Houston, Texas

Preceding pages:

Cindy Sherman
Artist
New York City

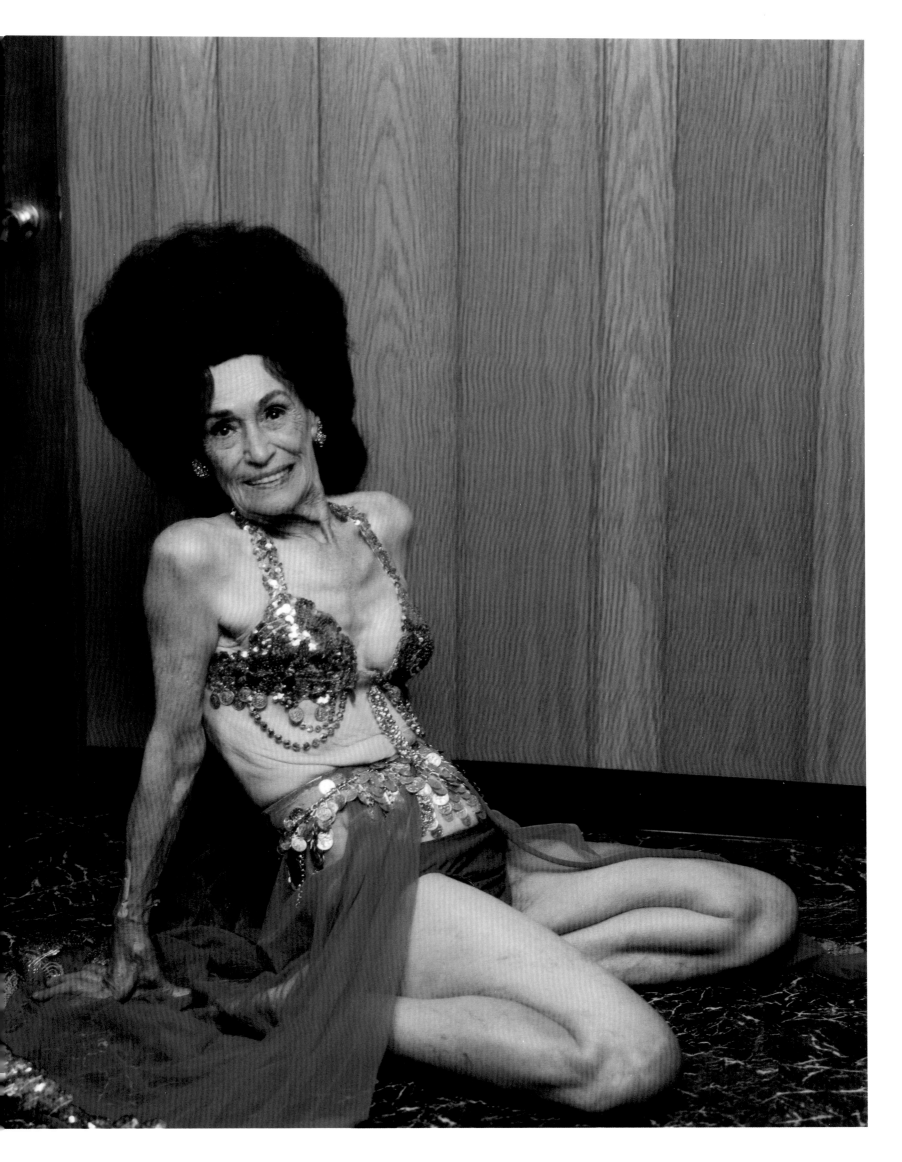

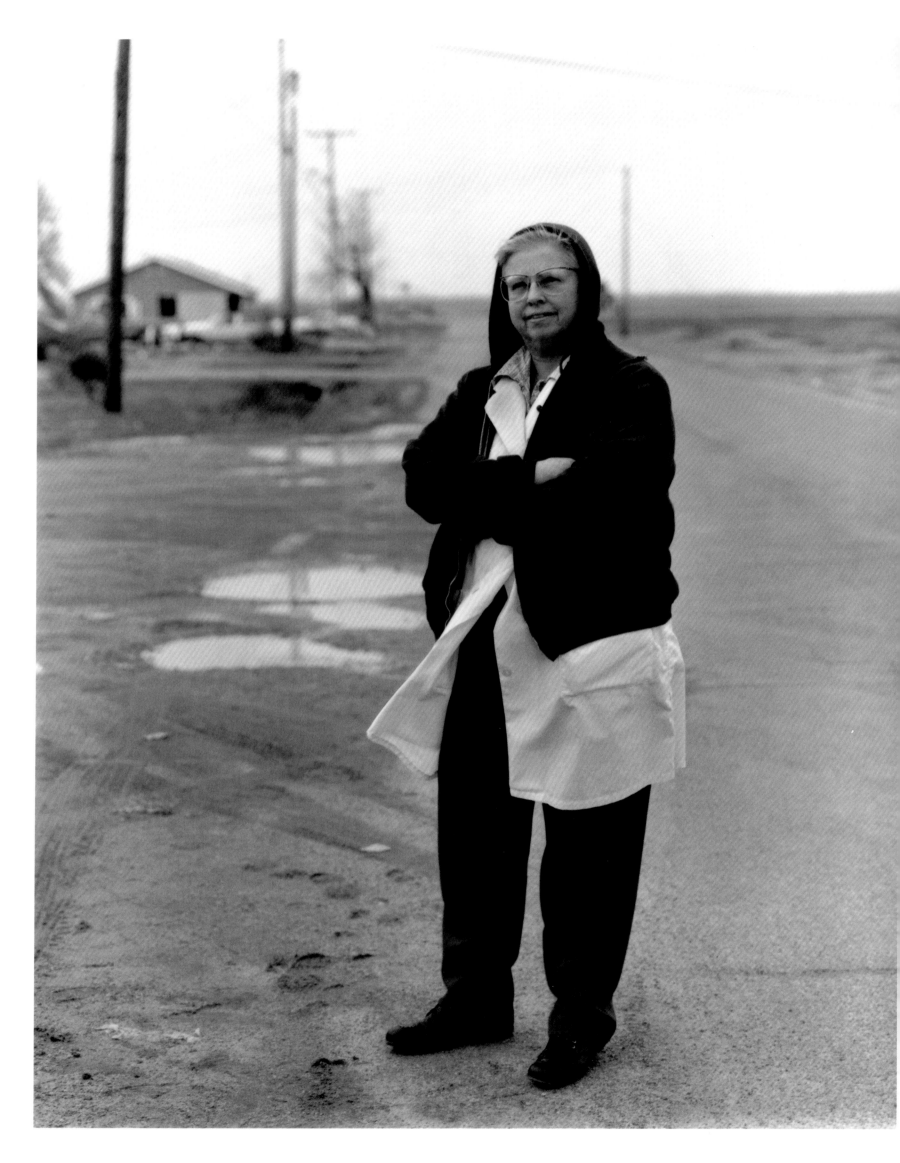

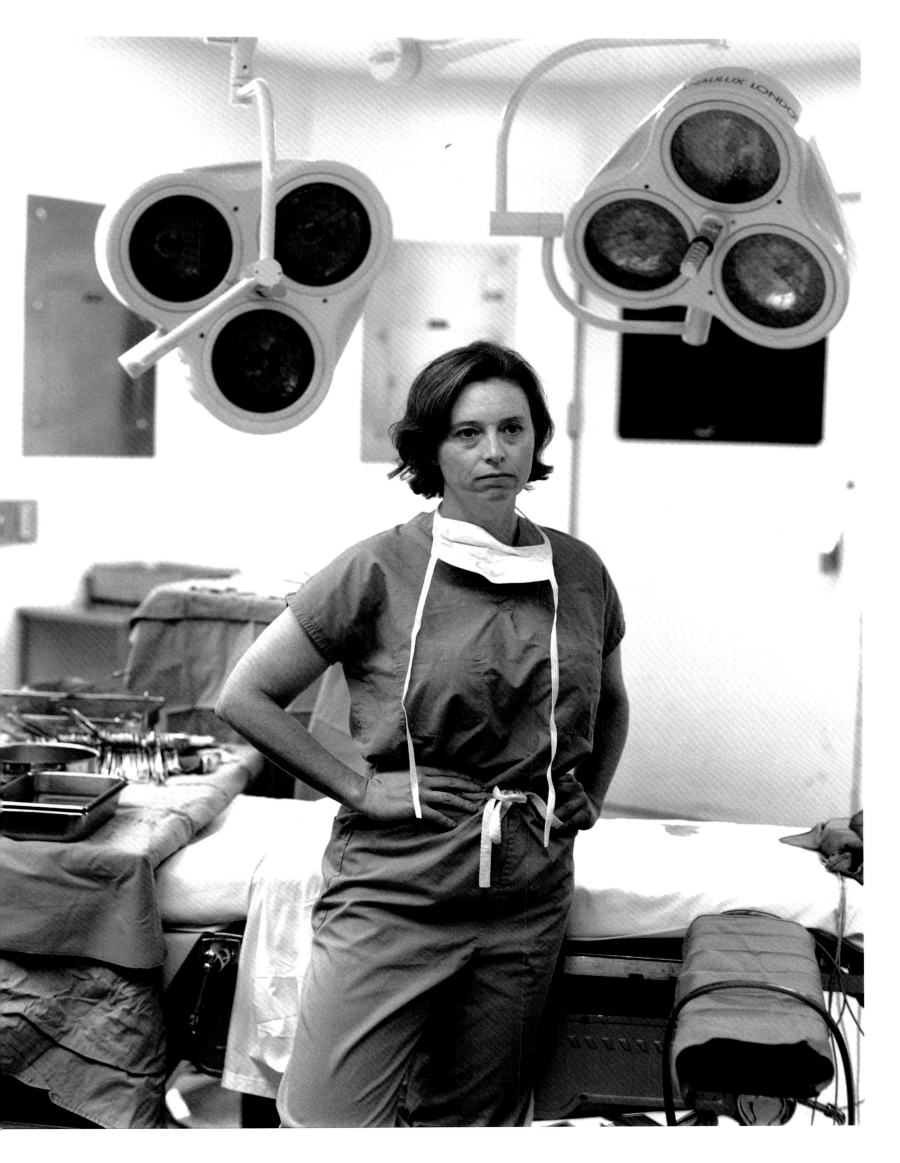

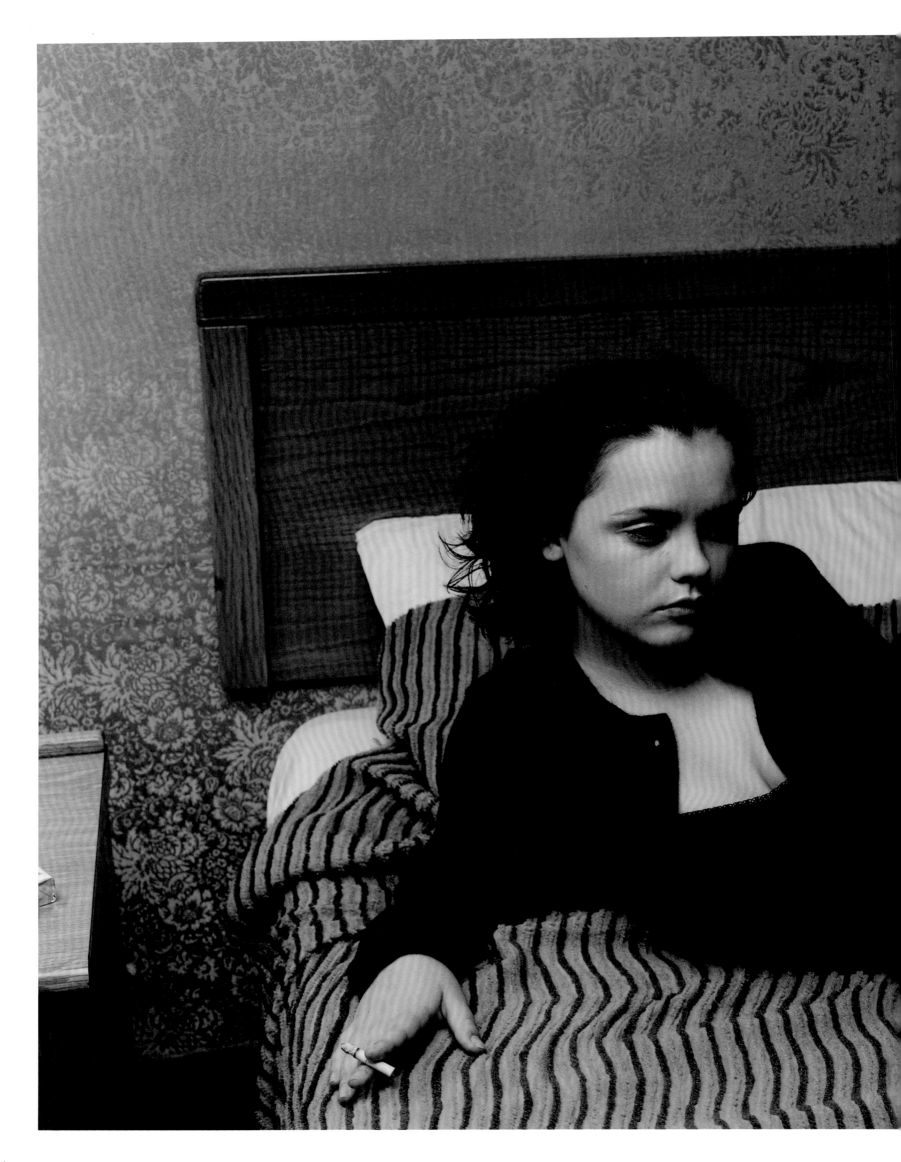

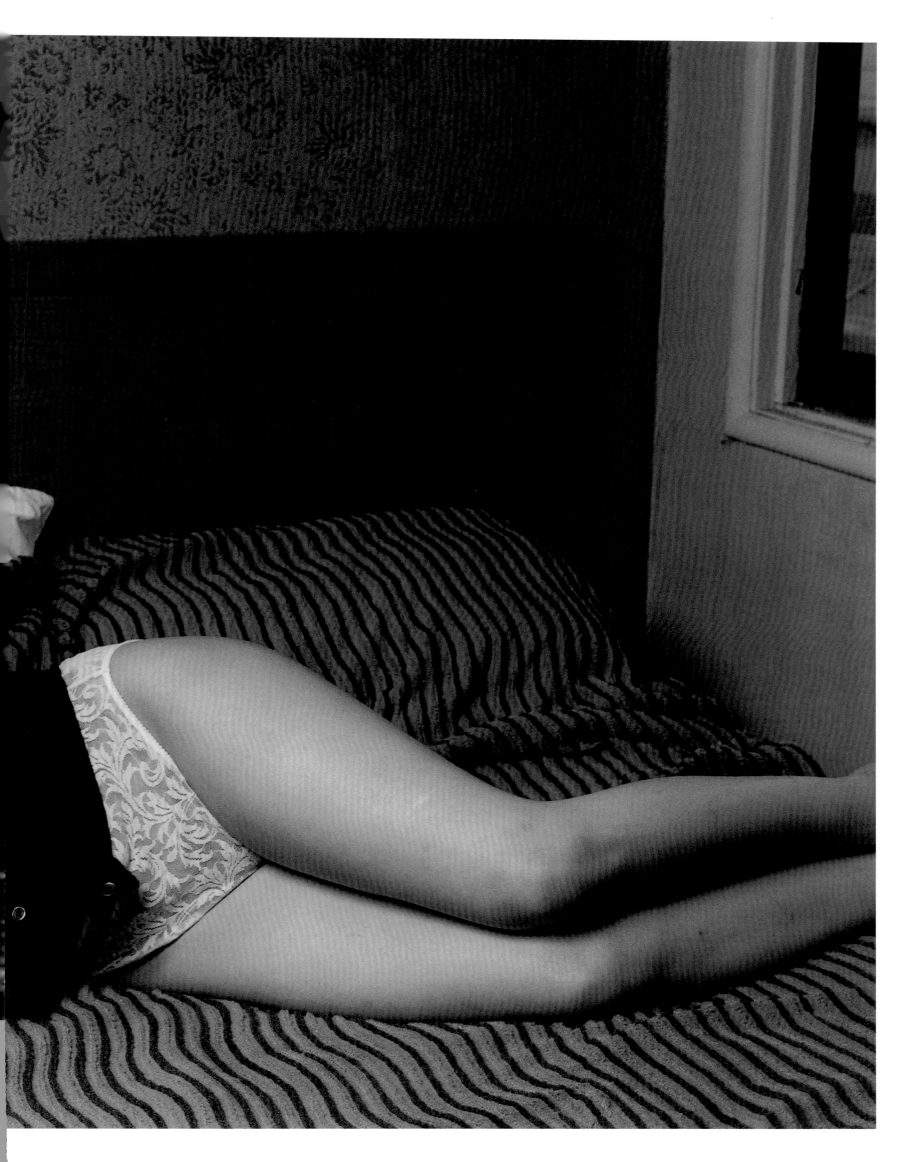

Brooke Astor
Philanthropist
New York City

Preceding pages:

Sister Anne Brooks
Physician
Tutwiler, Mississippi

Alison Estabrook
Breast cancer surgeon
St. Luke's–Roosevelt Hospital, New York City

Christina Ricci
Actress
Hollywood, California

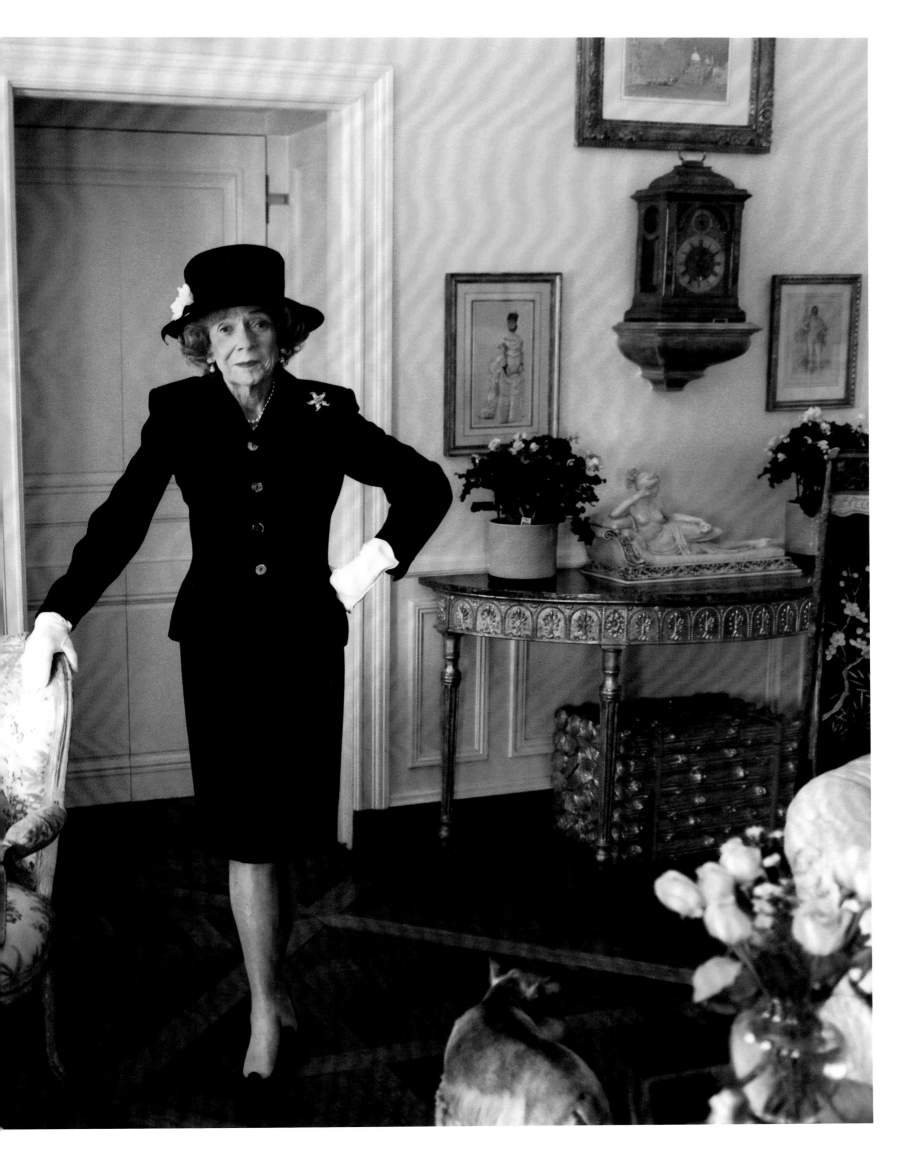

Haydee and Sahara Scull
Painters
Miami Beach, Florida

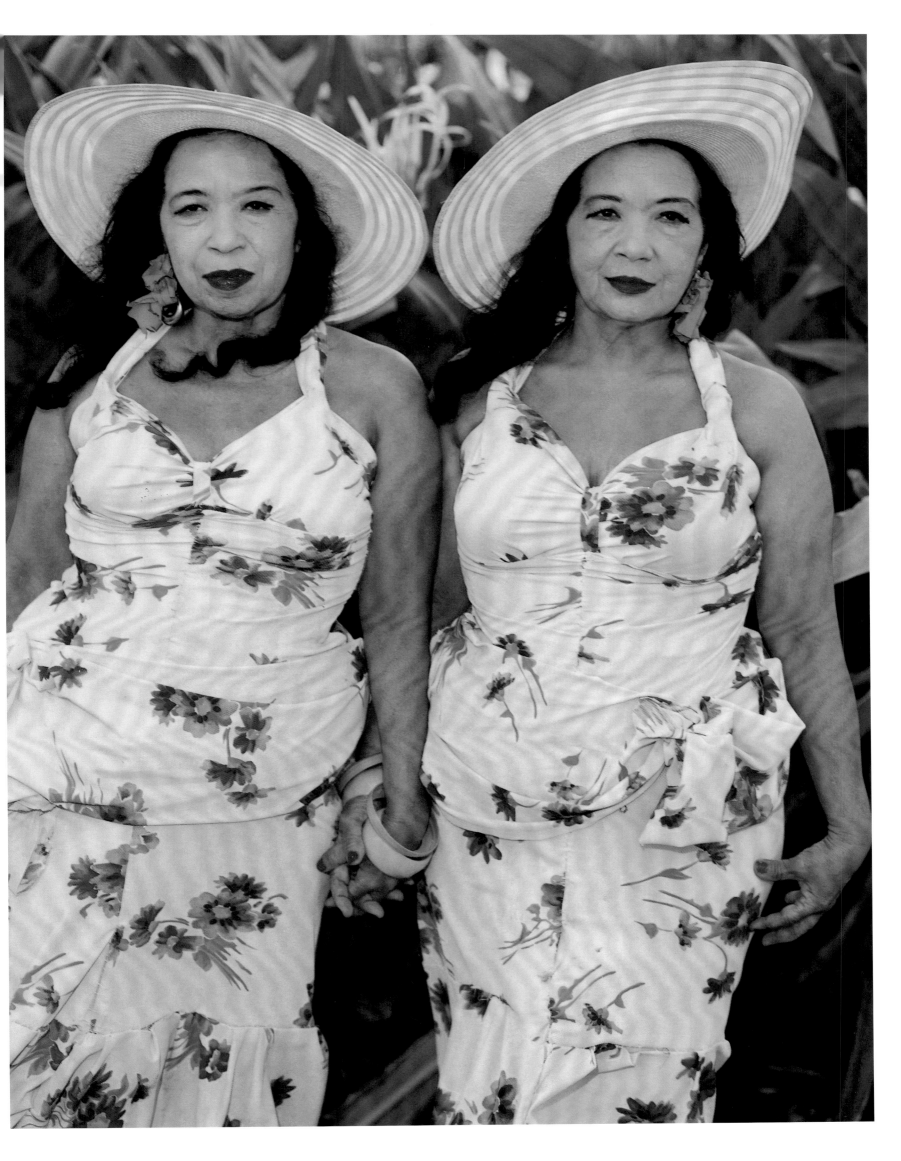

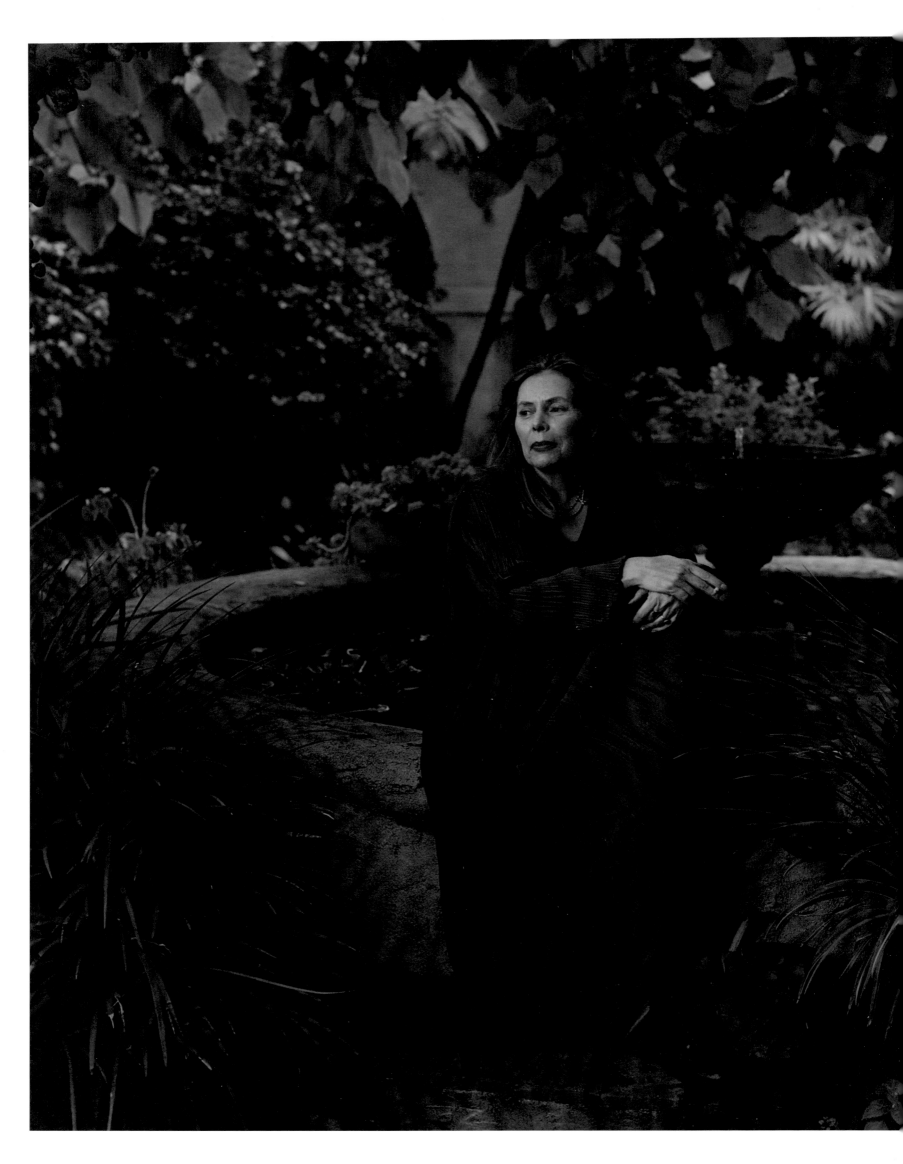

Osceola McCarty
Washerwoman, philanthropist
Hattiesburg, Mississippi

Preceding page:

Joni Mitchell
Musician
Los Angeles, California

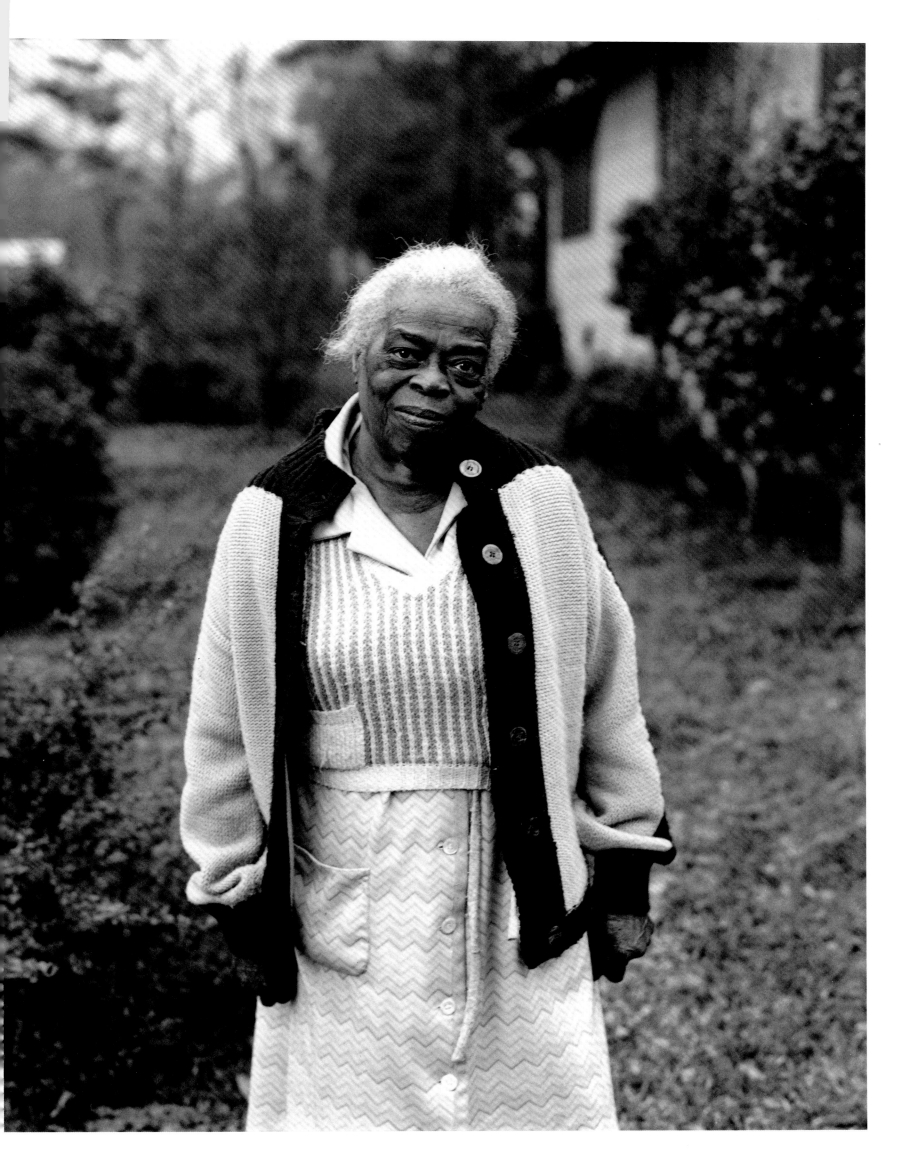

Wilma Mankiller and Gloria Steinem
Former chief of the Cherokee Nation; writer
Tahlequah, Oklahoma

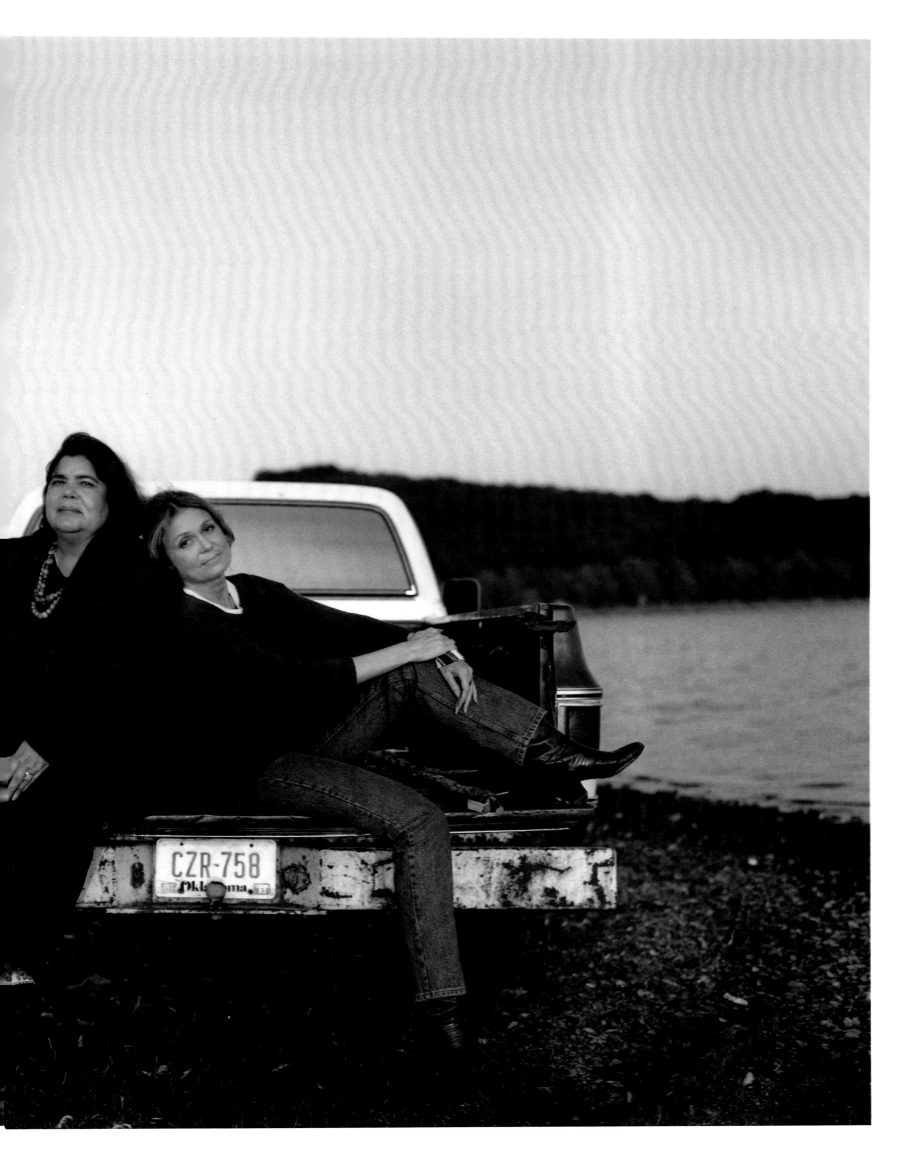

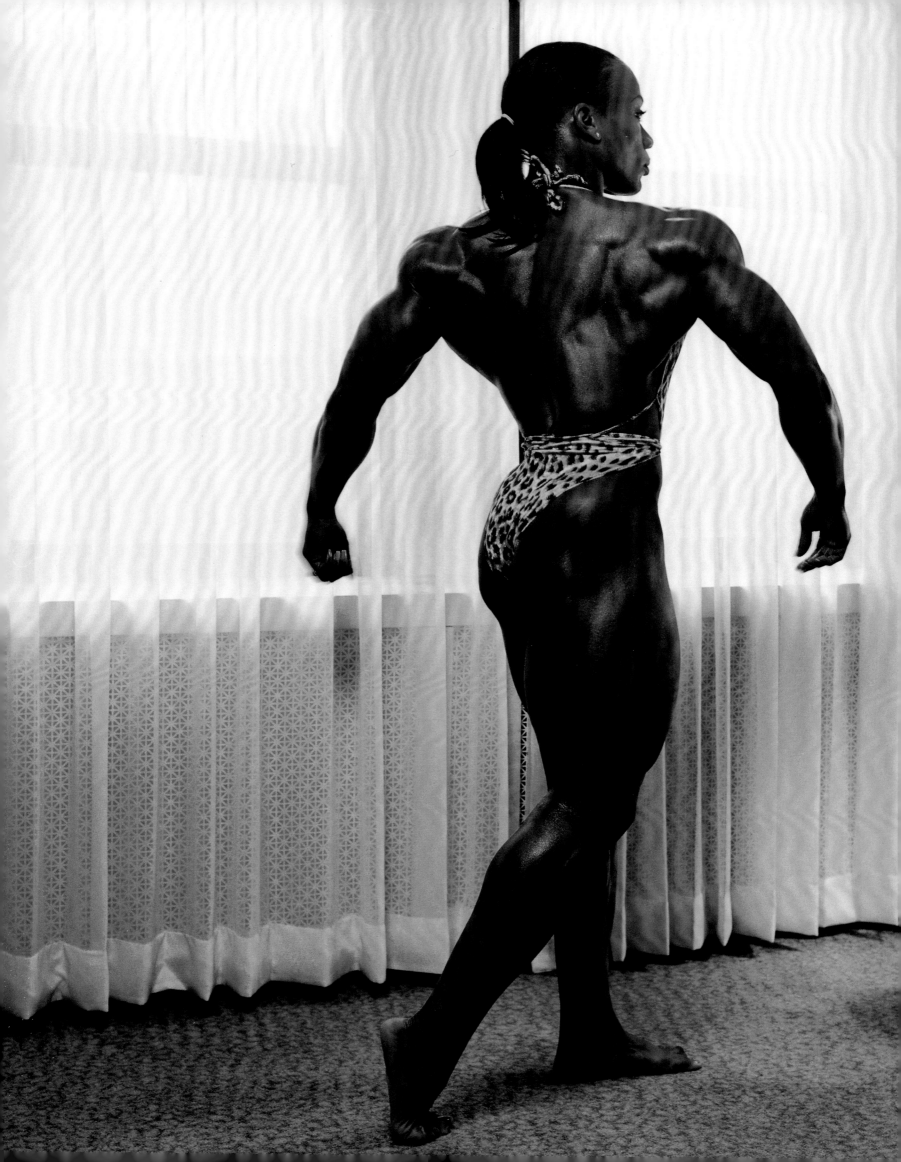

Lenda Murray
Ms. Olympia 1990–1995
New York City

Natalie Portman
Actress
Montgomery, Alabama

Following pages:

Ruth Bader Ginsburg and Sandra Day O'Connor
Supreme Court justices
Lawyer's Lounge, Supreme Court Building, Washington, D.C.

Toni Morrison
Writer
New York City

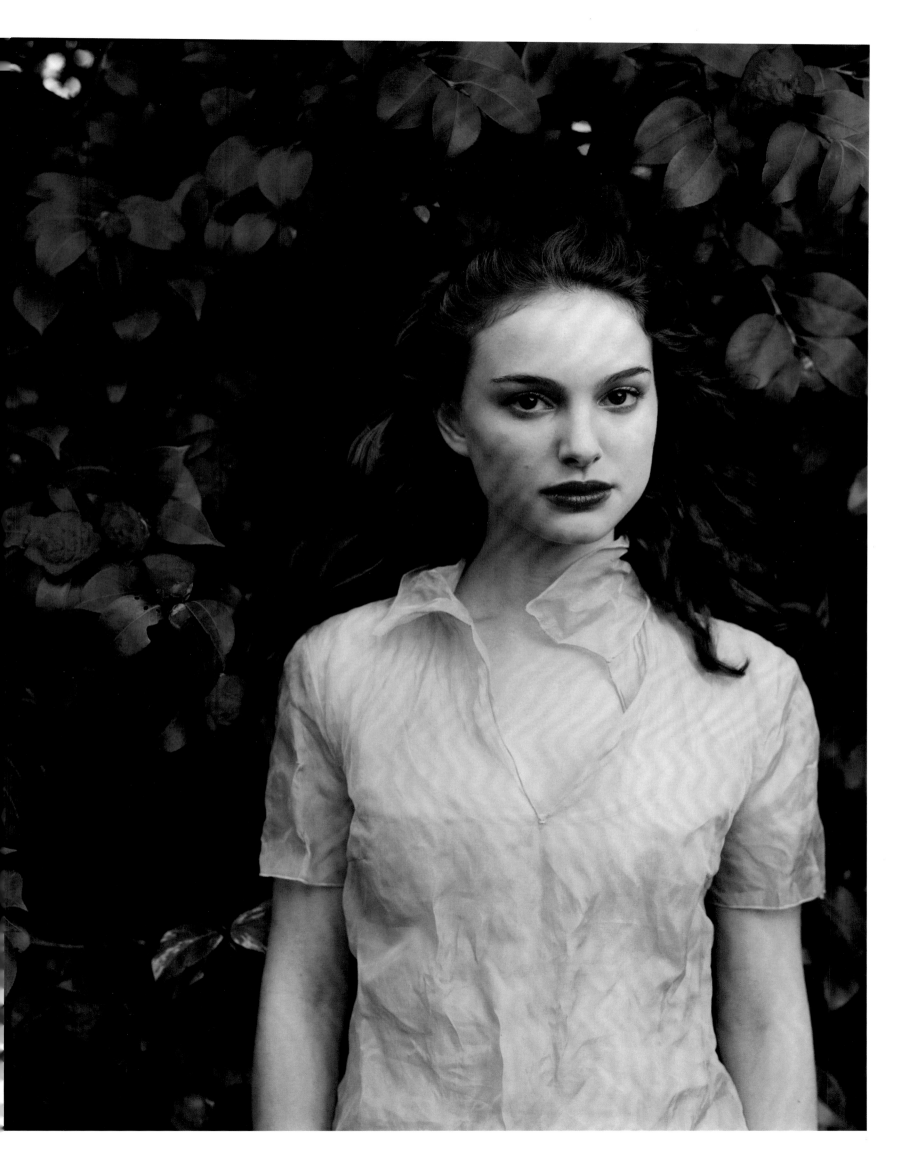

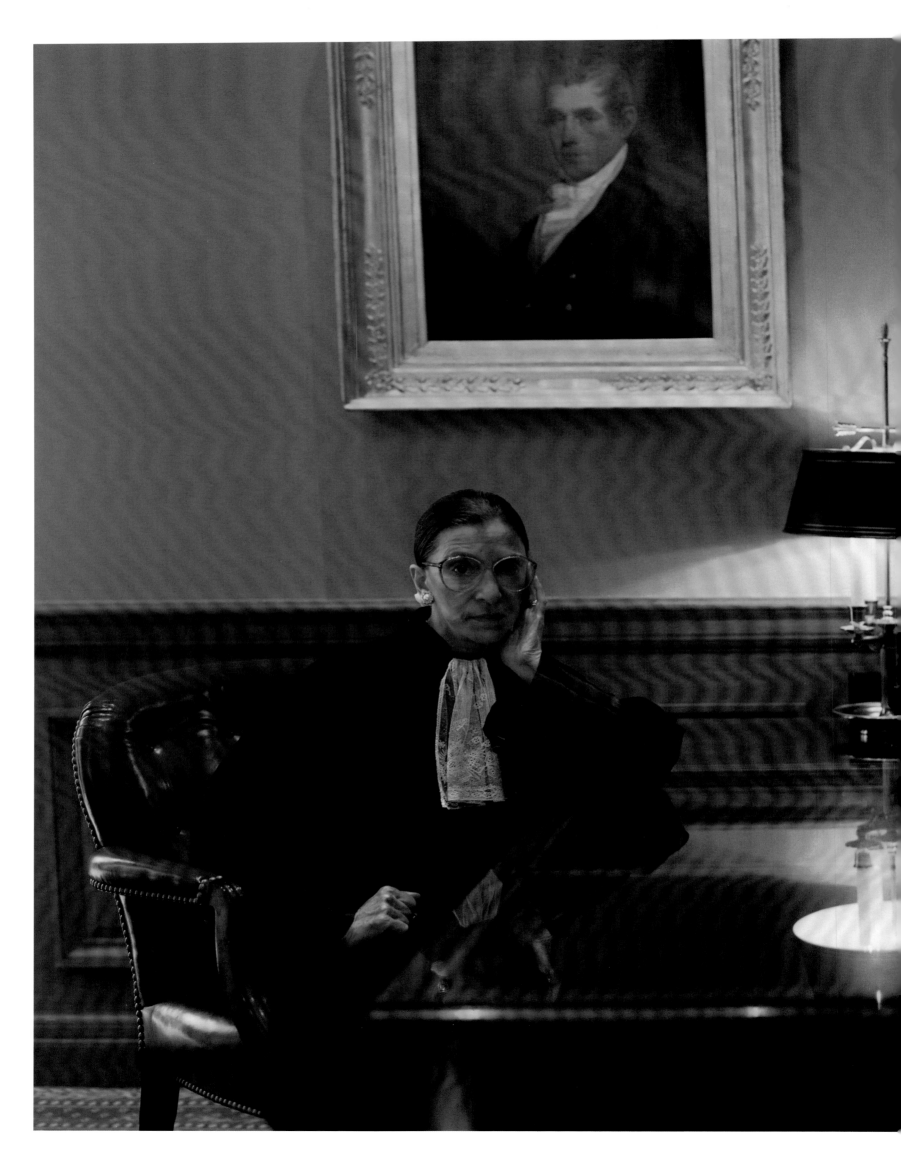

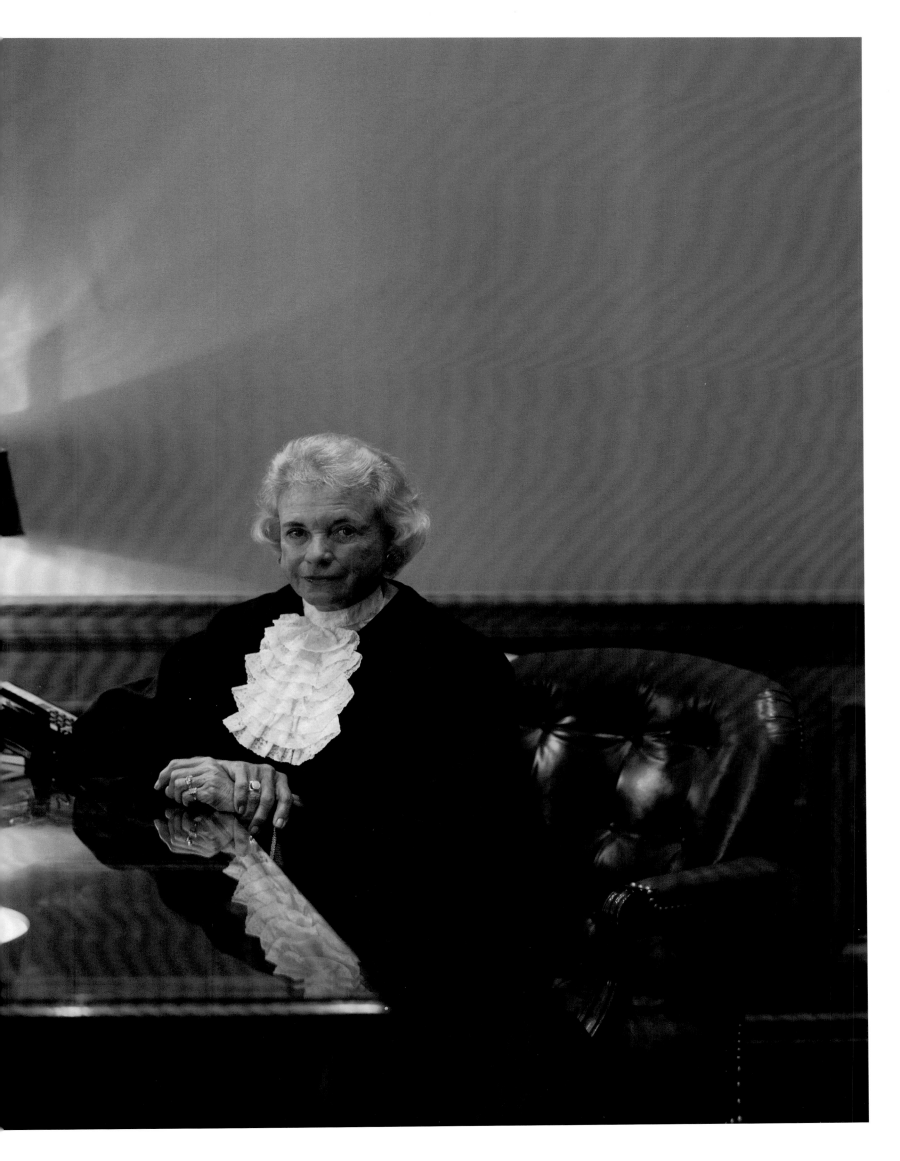

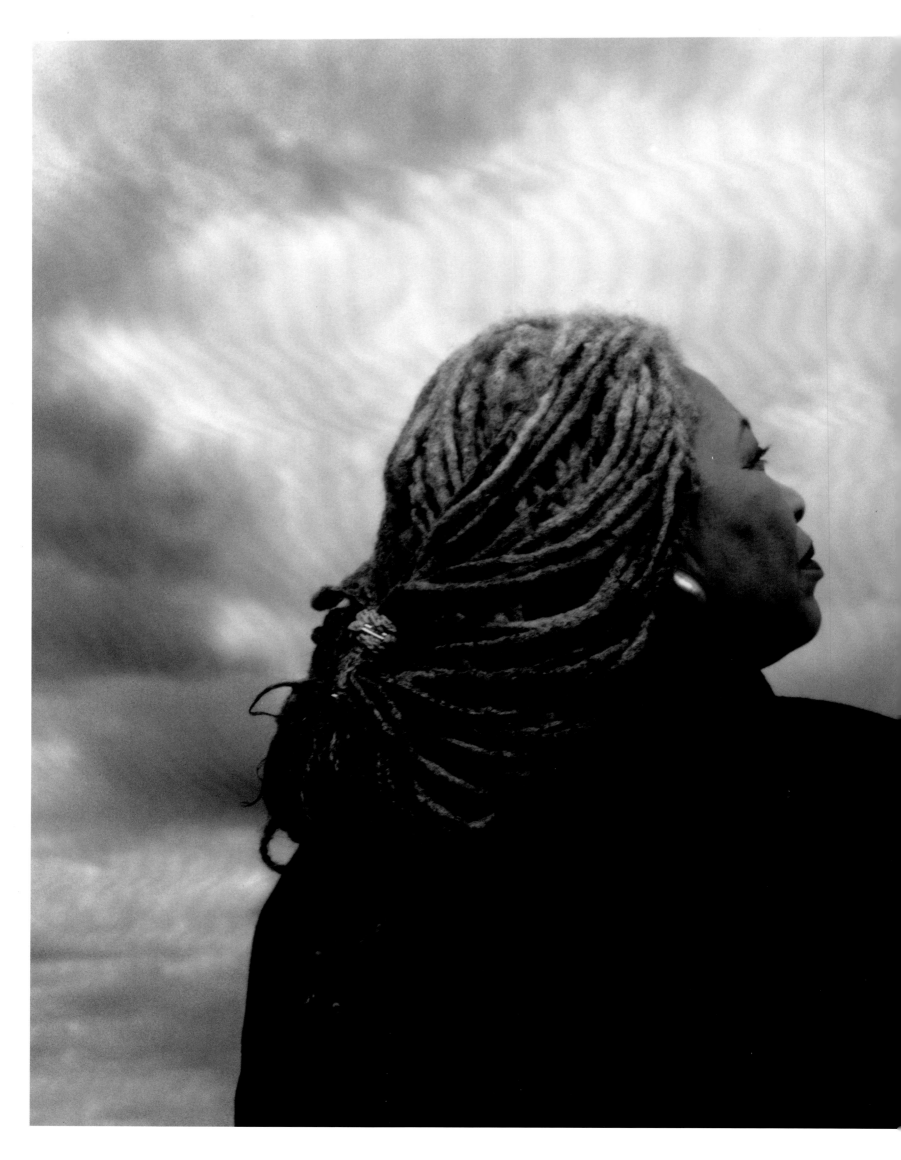

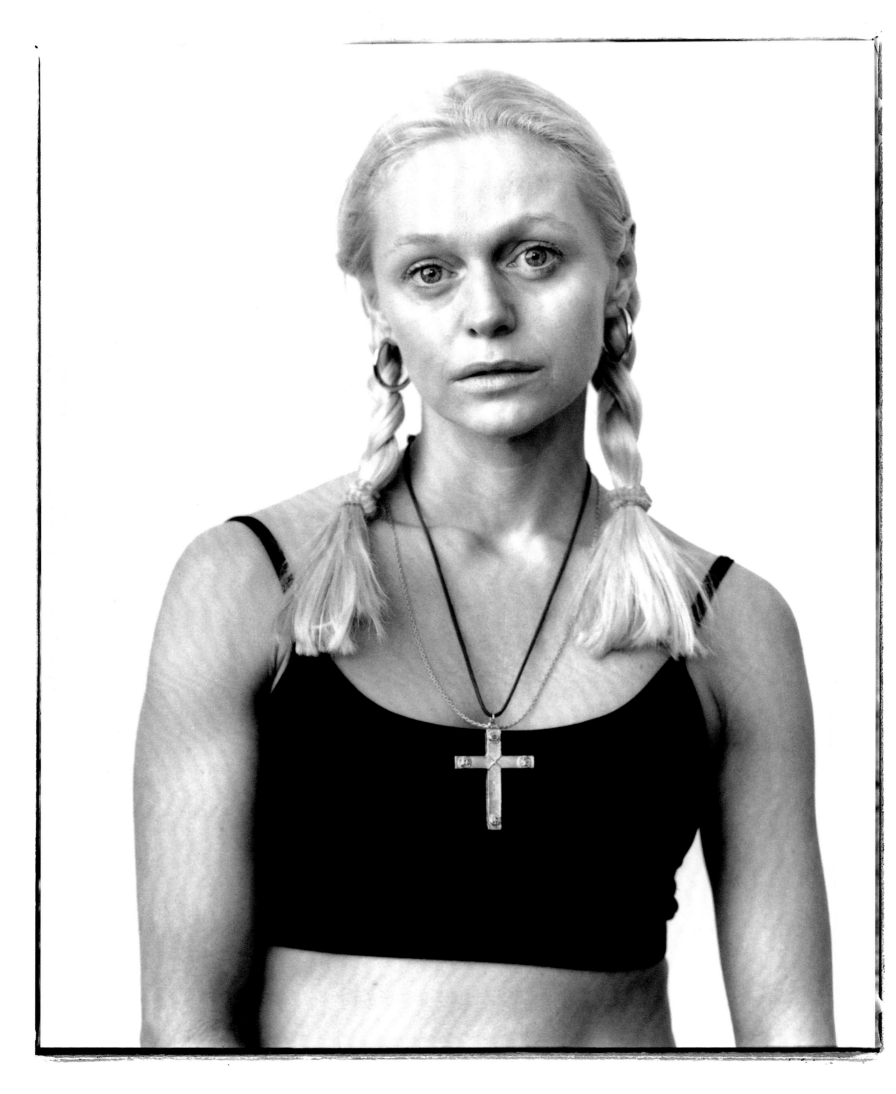

Akke Alma, Las Vegas, Nevada

Akke Alma, showgirl, Stardust Casino, Las Vegas, Nevada

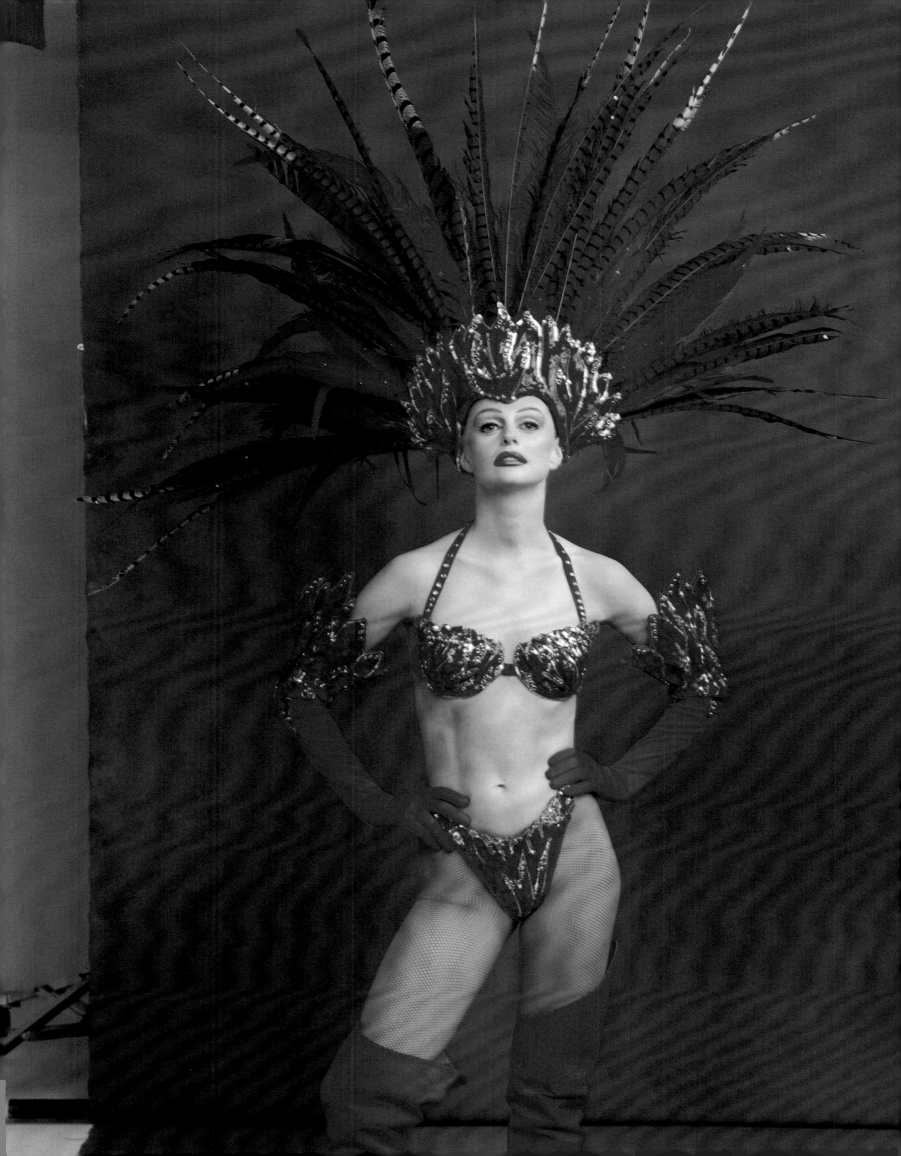

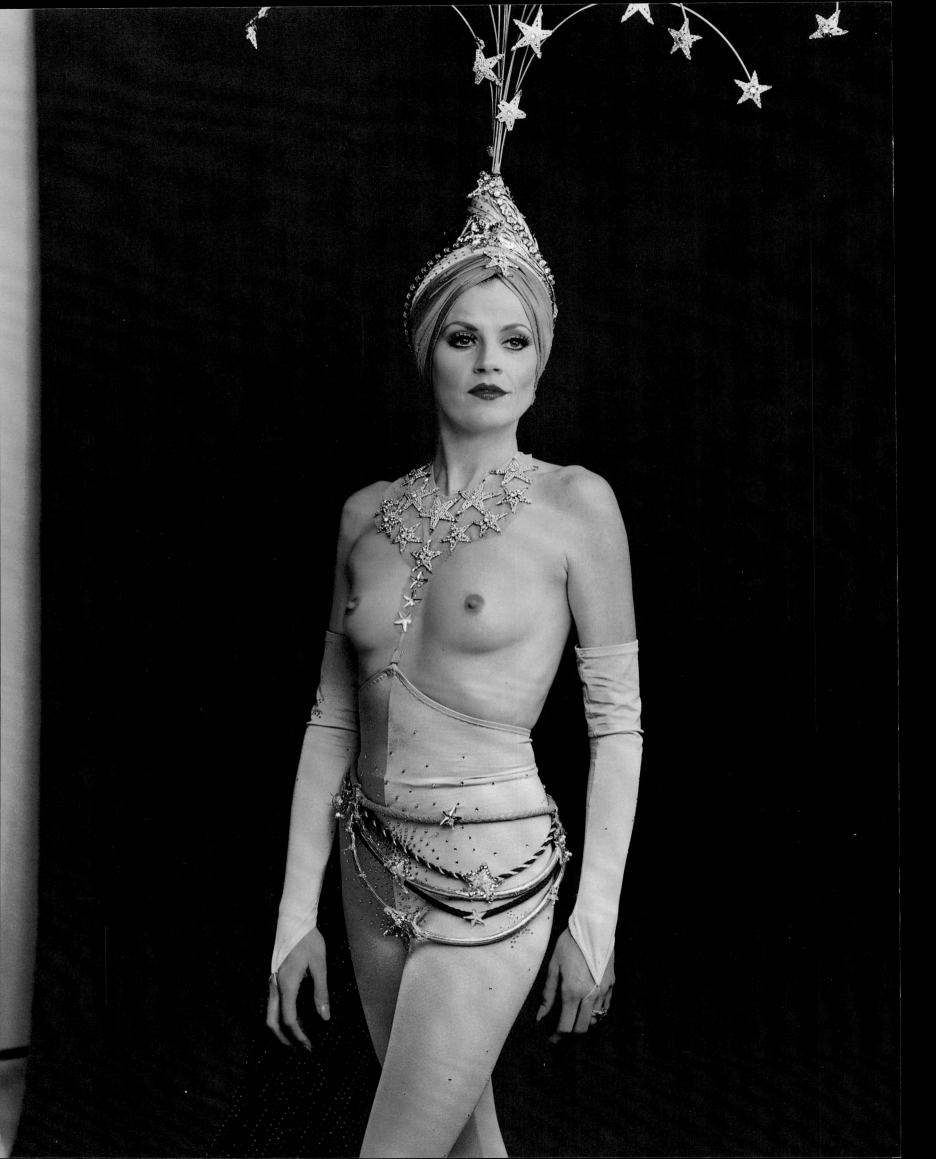

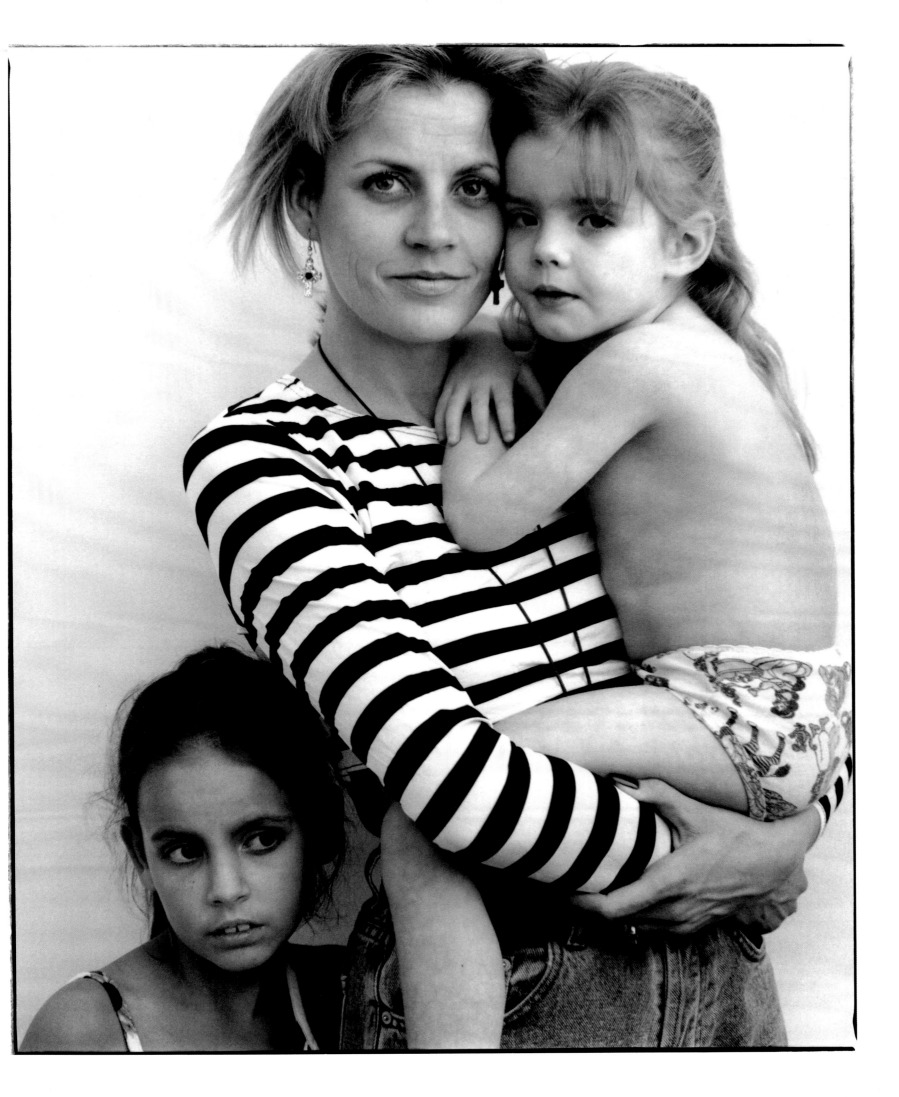

Narelle Brennan, showgirl, Stardust Casino, Las Vegas, Nevada Narelle Brennan and her daughters, Sarah and Briana Brennan, Las Vegas, Nevada

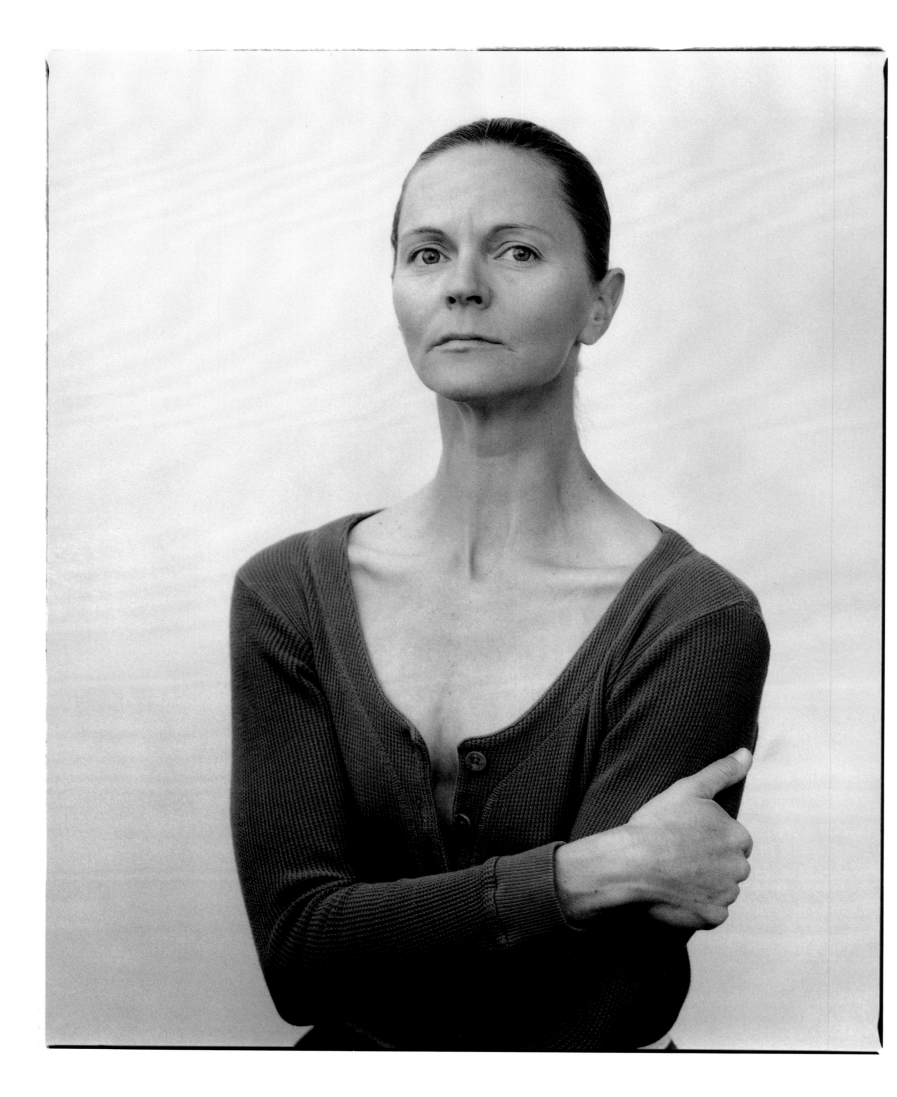

Linda Green, Las Vegas, Nevada

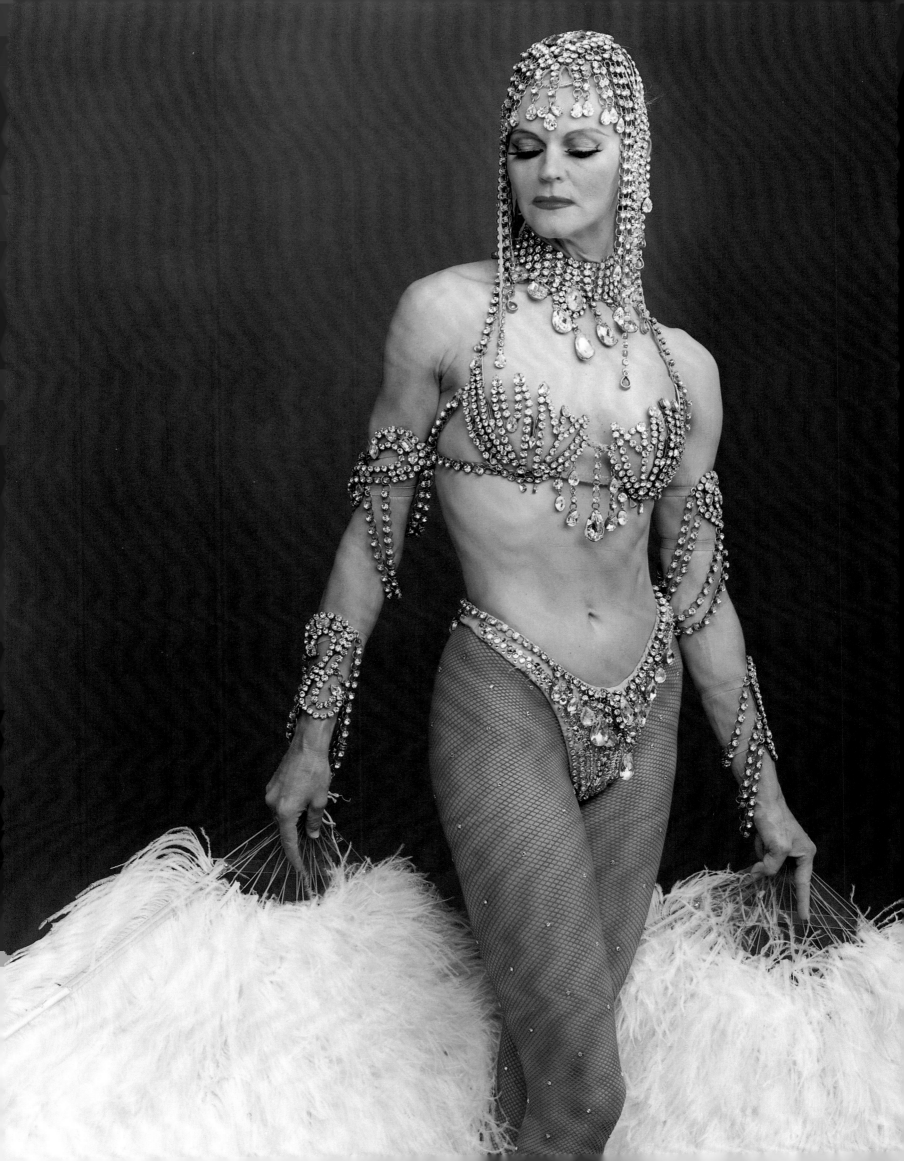

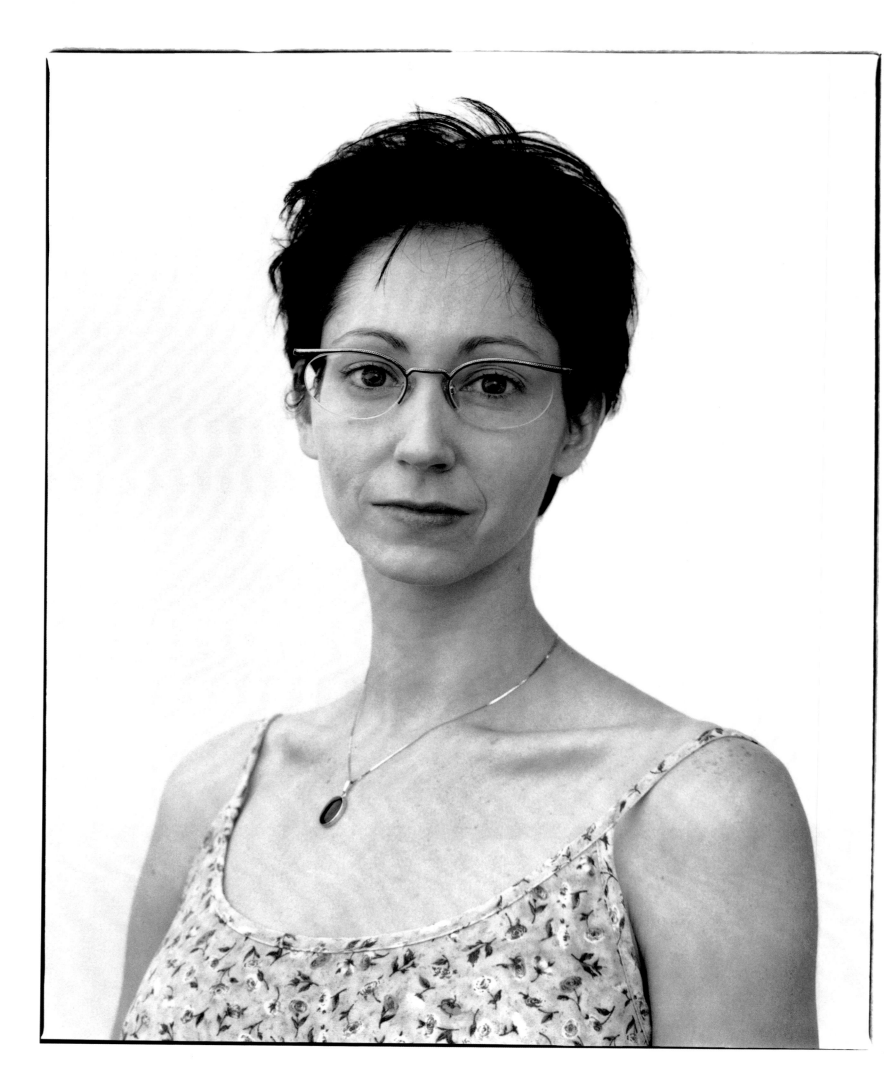

Susan McNamara, Las Vegas, Nevada

Susan McNamara, showgirl, Bally's Casino, Las Vegas, Nevada

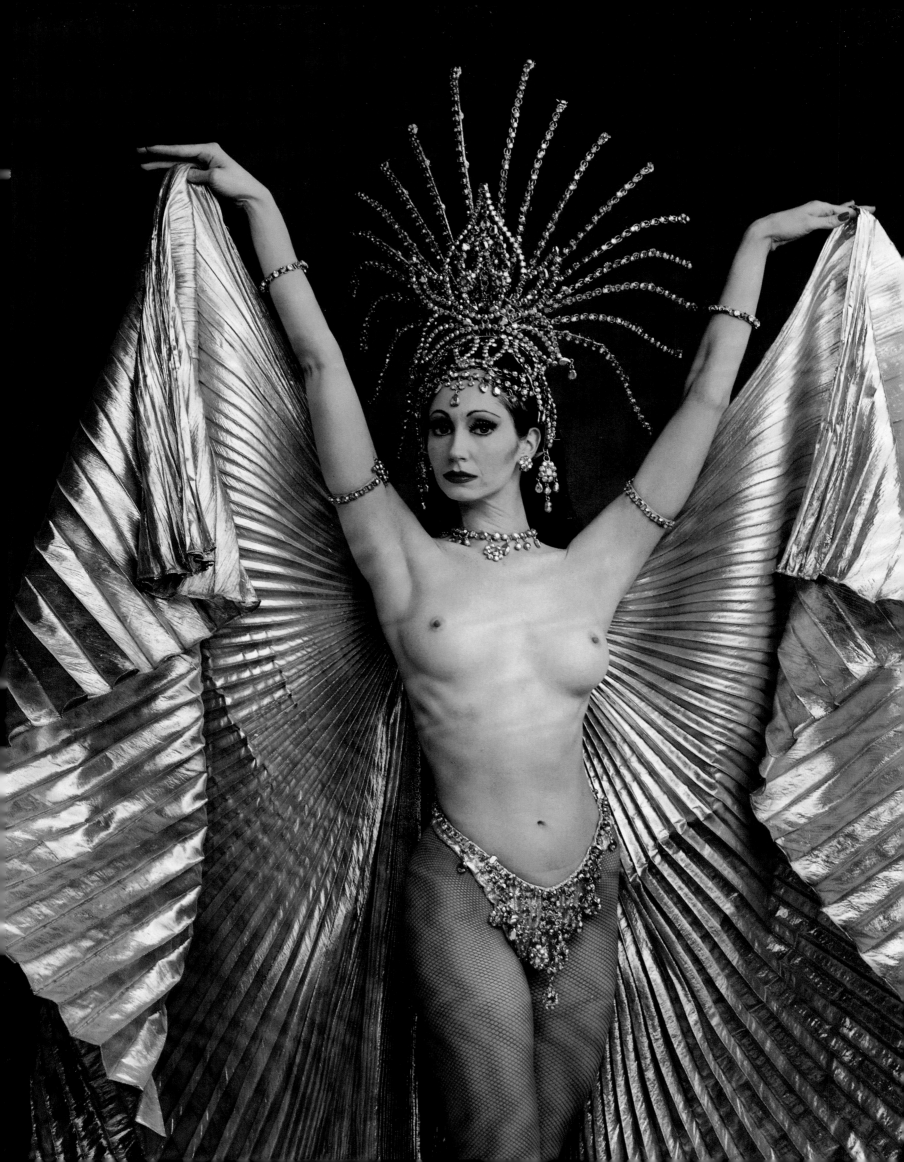

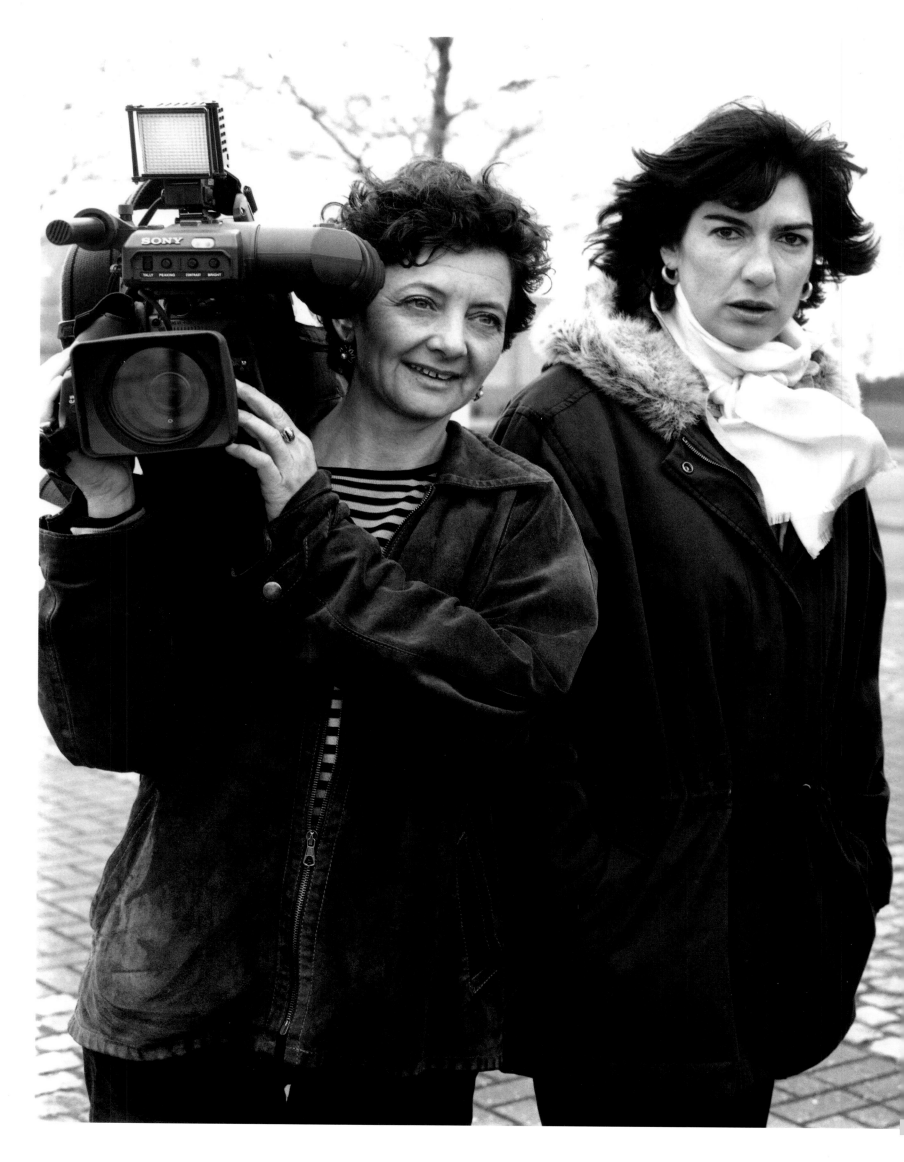

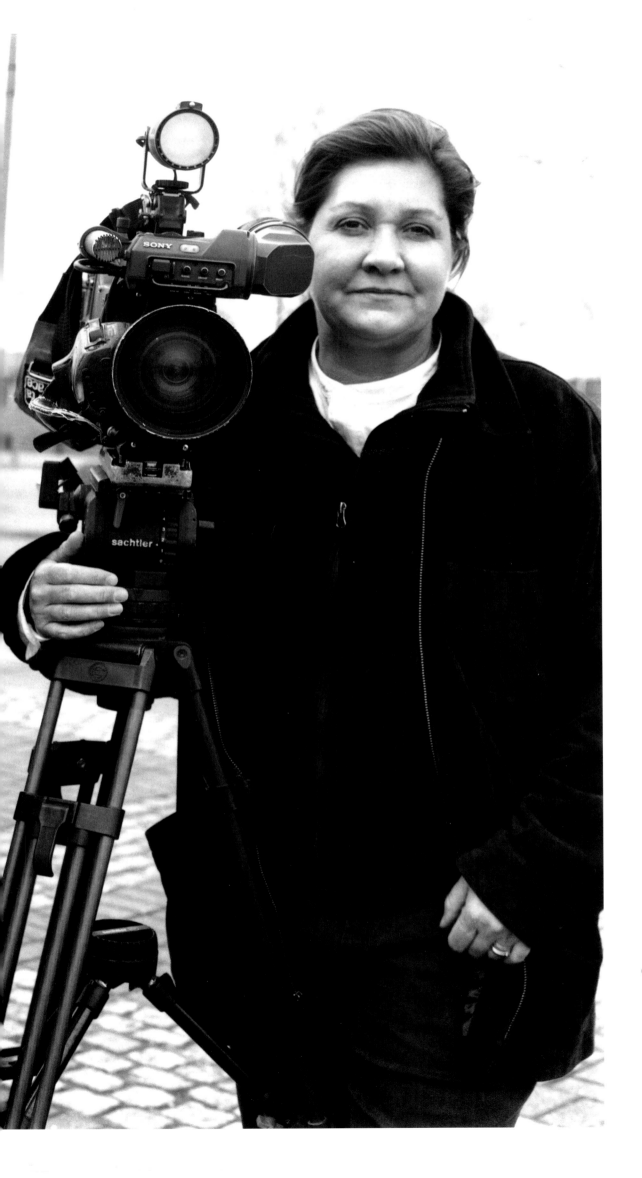

Christiane Amanpour (center),
Maria Fleet (left), and Jane Evans (right)
CNN war correspondent and camerawomen
London, England

Following contents pages:

Susan Sontag
Writer
New York City

form with the Ringling Brothers Circus. He fell to his death during a performance in 1978. Twenty years later, the family re-created his most famous stunt, the seven-person pyramid. ALIDA WALLENDA CORTES (b. 1974) performs as a bareback rider, trapeze artist, unicyclist, and aerialist. She is the first woman to hold the front position on the second level of the seven-person pyramid. LIJANA WALLENDA HERNANDEZ (b. 1977) began performing when she was thirteen. She has held the top position on the seven-person pyramid. DELILAH WALLENDA TROFFER (b. 1952) is Karl Wallenda's granddaughter and the mother of Lijana. She has been performing since she was four and regularly holds the top position on the seven-person pyramid.

180 JERRY HALL (b. 1956) grew up in Mesquite, Texas. She became a model when she was fifteen and was for many years married to Mick Jagger. They have four children, of whom Gabriel is the youngest.

182 SUSAN SARANDON (b. 1946) has appeared in over forty films, including *Pretty Baby* (1978), *Atlantic City* (1980), *Bull Durham* (1988), and *Thelma and Louise* (1991). She received an Academy Award for Best Actress for her performance in *Dead Man Walking* in 1995. She lives with the actor Tim Robbins and has three children.

183 FRANCES McDORMAND (b. 1957) attended Yale Drama School and was a stage actress before making her film debut in *Blood Simple* in 1984. She received an Academy Award nomination for Best Supporting Actress for her role as a Southern wife in *Mississippi Burning* (1988) and won the Best Actress Oscar for her performance as Marge, the Minnesota sheriff in *Fargo* (1996). She and her husband, the director Joel Coen, have a son.

184 WENDY SUZUKI (b. 1965) grew up in Sunnyvale, California. She received a doctorate in neural science from the University of California at San Diego and worked as a postdoctoral fellow at the National Institute of Mental Health before joining the faculty of New York University's Center for Neural Science. She studies the organization of memory function in the brain.

186 GWYNETH PALTROW (b. 1972) grew up in Los Angeles. She first appeared on stage when she was five, with her mother, Blythe Danner, who was performing in a summer-stock production in the Berkshires in Massachusetts. She made her film debut in *Shout* in 1991, and has made several subsequent films, including *Flesh and Bone* (1993), *Emma* (1996), and *Shakespeare in Love* (1998), for which she received an Academy Award for Best Actress. BLYTHE DANNER (b. 1943) received a Tony award for her debut on Broadway in *Butterflies Are Free* in 1969, and has had a long and distinguished stage career. Among the plays she has appeared in are *Betrayal* (1980) and *A Streetcar Named Desire* (1988). Her films include *1776* (1972), *Hearts of the West* (1975), *The Great Santini* (1979), *Brighton Beach Memoirs* (1986), and *Mr. & Mrs. Bridge* (1989). She is married to the producer/writer Bruce Paltrow.

188 KATHLEEN M. SULLIVAN (b. 1955) studied at Cornell and Oxford and received her law degree from Harvard in 1981. Her special field is constitutional law, and she is the co-author of a major textbook on the subject. Since 1993 she has had an active appellate litigation practice and has argued numerous cases before the Supreme Court. She became a member of the faculty of the Harvard Law School in 1984, and taught there until 1993, when she left to join the Stanford Law School faculty. In September 1999 she became dean of the Law School. She is the first woman to hold the position of dean at Stanford.

190 CHAMIQUE HOLDSCLAW (b. 1977) grew up in Astoria, Queens. She attended the University of Tennessee, where she was the forward on the women's basketball team, the Lady Volunteers. She led the team to NCAA championship titles in 1996, 1997, and 1998. In 1999 she was drafted to play with the Washington Mystics.

192 ELLEN DeGENERES (b. 1958) grew up in Louisiana and Texas and began to perform as a stand-up comedian in New Orleans. In 1982, after winning a contest for the Funniest Person in America sponsored by the cable network Showtime, she moved to San Francisco and worked in comedy clubs there. She appeared on the *Tonight Show* and on cable television specials, and had her own show, *Ellen*, for six years.

193 ROSIE O'DONNELL (b. 1962) grew up in Long Island, New York, and began her career in show business as a stand-up comedian. She was the host and producer of a cable television show and acted in several television series and films, including *A League of Their Own* (1992) and *Sleepless in Seattle* (1993). In 1996 she began hosting *The Rosie O'Donnell Show*, for which she has received several Emmys. She is the mother of two children

and the founder of the For All Kids Foundation, which raises funds for children's charities.

194 MARTHA NUSSBAUM (b. 1947) is the Ernst Freund professor of law and ethics at the University of Chicago Law School and Divinity School and an associate member of the classics department. She was previously on the faculties of Brown, Harvard, Princeton, and Wellesley. Among her books are *The Therapy of Desire: Theory and Practice in Hellenistic Ethics* (1994), *Women, Culture, and Development* (1995), *Poetic Justice: The Literary Imagination and Public Life* (1996), and *Sex and Social Justice* (1998).

196 MELISSA ETHERIDGE (b. 1962) grew up in Leavenworth, Kansas, and was singing and playing guitar at dances and the local prison by the time she was thirteen. She moved to Los Angeles when she was twenty-one and played in clubs there for several years before recording her first album in 1988. In 1992 she won a Grammy for her song "Ain't It Heavy." Her fourth album, *Yes I Am* (1993), had three Top Ten hits, including "Come to My Window," for which she received her second Grammy award. She and her companion, JULIE CYPHER (b. 1964), have two children. Cypher was born in Kansas and grew up in Texas. She attended the University of Texas at Austin and in 1986 moved to Los Angeles, where she became a director of music videos and a screenwriter.

198 RENÉE FLEMING (b. 1959) is widely considered to be the greatest American lyric soprano of her generation. She grew up in Rochester, New York. In 1988 she won the Metropolitan Opera National Council auditions and that year debuted at the Houston Grand Opera as the Countess in *The Marriage of Figaro,* which has become her signature role. She is also known for her portrayals of Desdemona, Rusalka, Manon, and the Marschallin in *Der Rosenkavalier,* as well as leading roles in the contemporary American repertoire. In 1997 she collaborated with Sir Georg Solti on a recital album that was the conductor's last vocal recording. She also received the first Solti Prize. In 1999 her album *The Beautiful Voice* won the Grammy for Best Classical Vocal Performance. VICKI TANNER (b. 1942) joined the Metropolitan Opera Company in 1967 as a member of the ballet. In 1985 she began working in the wardrobe department.

200 RACHEL ROSENTHAL (b. 1926) was born in Paris and fled with her family to New York during World War II. In 1955 she moved to Los Angeles, where she performs and directs experimental theater pieces. She was a cofounder of Womanspace, and in 1989 established the Rachel Rosenthal Company, an experimental theater and dance group.

201 DIAMANDA GALAS (b. 1951) is a composer, singer, and performance artist with a three-and-a-half-octave vocal range. She grew up in a Greek Orthodox family in Southern California, and studied music and visual arts at the University of California. In the early eighties in Europe she performed such solo works as *Wild Women with Steak Knives* and *Song from the Blood of Those Murdered.* Her first recording was *The Litanies of Satan* (1982), with a text by Charles Baudelaire. In the mid-eighties she began working on a song cycle about AIDS, the *Masque of the Red Death,* which premiered in London in 1989. The following year, stripped to the waist and covered in blood, she performed a revised version of it at the Cathedral of St. John the Divine in New York.

202 ELIZABETH LeCOMPTE (b. 1944) was born in Summit, New Jersey. She is the director of the Wooster Group, the acclaimed experimental theater company she cofounded in 1975. The productions she designs and directs fuse portions of existing plays with found texts, film, video, and dance. These works—which include *Route 1 & 9* (1981), *Frank Dell's The Temptation of St. Antony* (1987), *Brace Up!* (1991), *The Emperor Jones* (1992), *The Hairy Ape* (1995), *House/Lights* (1998), and *North Atlantic* (1999)—are first seen at the Wooster Group's theater, the Performing Garage, in New York City, and then tour in many European countries. Among her awards are a Distinguished Artists fellowship from the National Endowment for the Arts and a MacArthur Foundation fellowship in 1995. She is married to the actor Willem Dafoe, a longtime member of, and regular performer with, the Wooster Group. They have a son, Jack.

204 CINDY SHERMAN (b. 1954) began photographing herself in costume in 1977. Although she was the model in her photographs, her pictures were not self-portraits. They documented imaginary narratives that explored clichés and the stereotypical roles played by women. She completed a series of sixty-nine of these photographs in 1980. Known as *Untitled Film Stills,* the series was acquired by the Museum of Modern Art. In 1985 she began drawing on fairy tales for her subjects and then on figures from the history of art. In her later work she is no longer the model in the photographs. Plastic dolls and body parts are arranged in complex tableaux that suggest violence and disaster.

206 ALEXANDRIA TROWER and her husband, John Trower, have a carnival act known as the Palace of Wonders. It features fire-eating and knife-throwing, for which she acts as the target. She designs her own costumes.

208 SISTER ANNE BROOKS (b. 1938) entered a convent when she was seventeen. She enrolled in medical school when she was forty, after she was cured of rheumatoid arthritis, which had kept her confined to a wheelchair for seventeen years. In 1983 she took over an abandoned health clinic in Tutwiler, Mississippi, and established a nonprofit practice serving a poor community that had not had a doctor in years. It has since been expanded to incorporate a community education center, youth programs, and prenatal and parenting classes; a satellite clinic has been opened in a nearby town.

209 ALISON ESTABROOK (b. 1951) grew up in Manhattan and graduated from New York University School of Medicine. She completed a residency in general surgery as well as a fellowship in surgical oncology at Presbyterian Hospital. Formerly the chief of breast surgery at Columbia-Presbyterian Medical Center, she has been since 1998 the chief of breast surgery at St. Luke's–Roosevelt Hospital Center, where she established the Comprehensive Breast Center.

210 CHRISTINA RICCI (b. 1980) was born in Santa Monica, California. She made her film debut in *Mermaids* in 1990, when she was nine. Her subsequent films include *The Addams Family* (1991), *Ice Storm* (1997), *The Opposite of Sex* (1998), and *Sleepy Hollow* (1999).

212 BROOKE ASTOR (b. 1902) was born in New York City. She was married when she was seventeen and was divorced eight years later. She enrolled in a playwriting class at Columbia University, wrote book reviews for *Vogue,* and in 1932 married Charles Henry Marshall, a stockbroker with whom she lived for twenty years, during which time she was an editor at *House & Garden.* After he died in 1952 she married Vincent Astor, who created a charitable foundation and asked her to run it after his death. He died in 1959, and she became president of the Vincent Astor Foundation, which has concerned itself with youth services, public housing, and historic preservation. Among the recipients of Mrs. Astor's generosity are the Metropolitan Museum of Art, the New York Public Library, the Wildlife Conservation Society, and Rockefeller University. When she dissolved the foundation in 1998 it had given nearly $200 million to more than a thousand organizations.

214 HAYDEE and SAHARA SCULL (b. 1931) are twins. They graduated in 1952 from the Academia de Belles Artes San Alejandro in Havana and were commissioned to create two hundred and fifty paintings of the city for the Hotel Vedado. In 1969 Haydee defected to the United States, and Sahara followed three years later. Their paintings and murals decorate many hotels and restaurants in Miami.

216 JONI MITCHELL (b. 1943) is one of the most influential singer-songwriters in American popular music. She was born in Fort MacLeod, Saskatchewan, and attended college for a year before moving to Toronto to be a folk singer. In the late sixties she moved to Southern California, a locale that recurs in her lyrics. She was successful early on as a songwriter, but was soon recognized also for her distinctive guitar playing, innovative musicianship, and voice. Her classic albums of the early seventies include *Ladies of the Canyon* (1970), *Blue* (1971), and *Court and Spark* (1974). In 1994 she won two Grammies for *Turbulent Indigo.* In 1997 she was inducted into the Rock and Roll Hall of Fame. That year she was reunited with a daughter whom she had given up for adoption as an infant, and she discovered that she had a grandson.

218 OSCEOLA McCARTY (1908–1999) worked as a washerwoman for over seventy-five years, from the time she left school in the sixth grade until arthritis in her hands forced her to retire in 1994. The following year she donated $150,000 to the University of Southern Mississippi to endow a scholarship for deserving African-American students in need. She had saved the money from her earnings and had invested it carefully. Although she had left Mississippi only once in her life before her donation, she subsequently traveled throughout the United States, received an honorary doctorate from Harvard University, and carried the Olympic torch at the summer games in Atlanta in 1996.

220 WILMA MANKILLER (b. 1945) was born in Oklahoma, but her family was relocated to San Francisco by the Bureau of Indian Affairs when she was a girl. Her last name is derived from a Cherokee military title awarded to her ancestors. During the Native American occupation of Alcatraz Island in 1969, she became a political activist. She moved back to Oklahoma, where she served as the first woman chief of the Cherokee Nation from 1987 to 1995. GLORIA STEINEM (b. 1934) was born in Toledo, Ohio. She is an influential journalist and a longtime activist on women's issues. She first attracted attention in the early 1960s with the article "I Was a Playboy Bunny," an exposé based on her own undercover work in a New York City Playboy Club. In 1968 she published her first overtly feminist piece, "After Black Power, Women's Liberation." In 1971 she helped found the National Women's Political Caucus, and the following year was a founding editor of *Ms.* magazine. Among her books are *Outrageous Acts and Everyday Rebellions* (1983) and *Revolution from Within* (1992).

222 LENDA MURRAY (b. 1962) grew up in Detroit and majored in political science at Western Michigan University. She was a cheerleader for the Michigan Panthers football team, and began bodybuilding in 1984. She entered her first Ms. Olympia event in 1990 and won the competition—the pinnacle of women's bodybuilding—for six consecutive years. She has retired, and she and her husband live in Columbus, Georgia.

224 NATALIE PORTMAN (b. 1981) was born in Jerusalem and moved to the United States when she was three. She became a model when she was eleven and soon began acting as well. She starred on Broadway in *The Diary of Anne Frank* and has appeared in several films, including *Star Wars: Episode 1—The Phantom Menace.* In September 1999 she became a student at Harvard University.

226 RUTH BADER GINSBURG (b. 1933) was born in Brooklyn, where her father was a furrier. She received a law degree from Columbia University Law School in 1959, and in 1972 she became the first woman to receive tenure there. She was the founding counsel of the American Civil Liberties Union Women's Rights Project, and in 1980 she became a judge on the U.S. Circuit Court of Appeals for the District of Columbia. She was appointed to the United States Supreme Court by President Clinton in 1993. SANDRA DAY O'CONNOR (b. 1930) was the first woman on the Supreme Court. She grew up on a cattle ranch on the Arizona–New Mexico border and graduated from Stanford Law School in 1952. She was in private practice for several years. In 1969 she became an Arizona state senator, and three years later became the first woman State Senate majority leader. She was appointed to the Supreme Court by President Reagan in 1981.

228 TONI MORRISON (b. 1931) was born in Lorain, Ohio, and taught English literature at Texas Southern University and Howard University from 1955 until 1964, when she became an editor at Random House. She published her first novel, *The Bluest Eye,* in 1969. *Beloved,* her fifth novel, won the Pulitzer Prize for Fiction in 1987, and in 1993 she won the Nobel Prize for Literature. She is the Robert F. Goheen Professor of the Humanities at Princeton University.

230 AKKE ALMA (b. 1964) was born in Amsterdam and studied ballet in Rotterdam. She lived for seven years in Paris, where she performed at the Crazy Horse nightclub. In 1995 she moved to the United States and became a showgirl at the Stardust Casino in Las Vegas. She speaks five languages and studies civil and corporate law.

232 NARELLE BRENNAN (b. 1960) was born in Sydney, Australia. She studied ballet, jazz, and tap dancing as a child and was recruited by a casino in Reno, Nevada, to perform for a year. She danced in Nevada and Australia, and settled in Las Vegas, where she danced for ten years at Bally's and the Stardust Casino. She retired from the stage in 1998 and moved back to Australia, where she is the cafe chef at a five-star hotel in Queensland.

234 LINDA GREEN (b. 1953) was born in Virginia. She danced for three years with the Harkness Ballet in New York, until it closed in 1974. She then moved to Las Vegas to become a showgirl. She is a featured dancer and the oldest performer in her show at Bally's Casino.

236 SUSAN McNAMARA (b. 1967) was born in Phoenix, Arizona. She began studying ballet when she was four, and performed with dance companies in Florida and Nevada until she became a showgirl in 1993.

238 CHRISTIANE AMANPOUR (b. 1958) was born in London. Her father is Iranian, and they lived in Teheran until the revolution in 1979, when they returned to England. She graduated from the University of Rhode Island and in 1983 went to work for CNN. In 1990 she was assigned to cover the Gulf War and since then has reported from war zones in Bosnia, Rwanda, Algeria, Haiti, and Somalia. Her coverage of the war in the former Yugoslavia has earned several awards. She is also a contributor to *60 Minutes* on CBS. In 1998 she married James Rubin, the United States assistant secretary of state for public affairs. JANE EVANS (b. 1959) was born in Baltimore, Maryland. She graduated from Southern Illinois University and began working for CNN in Atlanta in 1982. She, Christiane Amanpour, and Maria Fleet were the only women who covered the Gulf War. She is now a senior producer and camerawoman for CNN's London bureau. MARIA FLEET (b. 1958) graduated from the University of Georgia in 1980. She went to work for CNN the following year and is now a camerawoman in the Rome bureau.

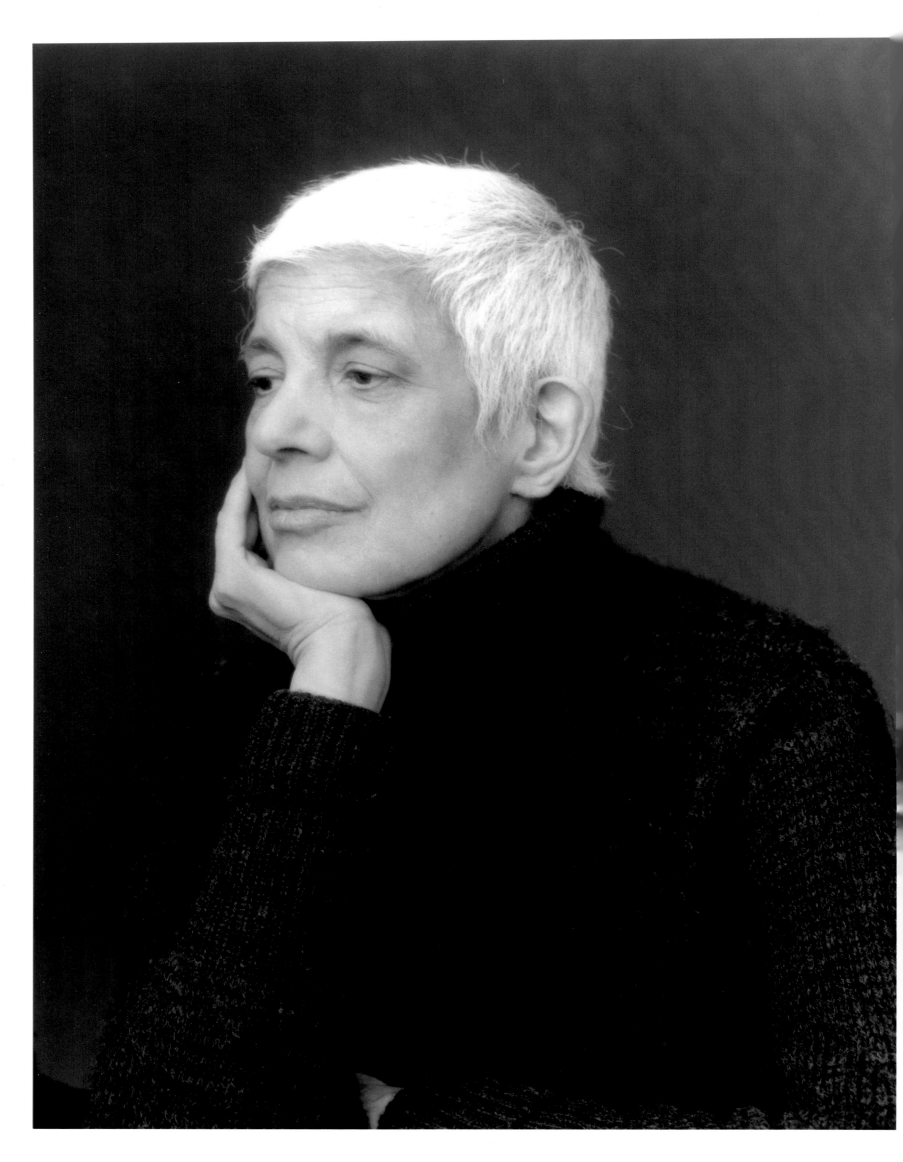

I am grateful to Susan Sontag for the idea of the book. Jim Moffat, once again, gave his active and enthusiastic encouragement. Special thanks to Kara Glynn, my peerless studio manager, and to Karen Mulligan, my wonderful production manager. The book owes a great deal to the ability and dedication of Ruth Ansel, its designer, working with the tireless Tim Hossler, and Michael Fisher, my archivist. Thanks also to Chrissy Persico, Baha Gluhic, David Jacobs, and Briana Blasko in the New York studio. At every stage I counted on the talent, loyalty, and patience of my assistants: Michel Andreo, Paul Gilmore, Nick Rogers, Thanut Singhasuvich, and Wayne Wakino. Warm thanks to Sharon DeLano, my editor. Rick Floyd, Kathryn MacLeod, Leslie Simitch, and Jeffrey Smith contributed indispensably. My thanks to Kim Meehan and Bill Mullen; and, around the country, to Victoria Brynner, Maude Schuyler Clay, Michele Forman, Tom Hoynes, Julie Kahn, Tim Noyes, Christina Patoski, and Amie Williams. Thanks, too, to Linda Atkins, Alexandra Kotur, Doug Lloyd, Mona Talbott, and Andrew Thomas. I relied, as always, on the counsel of Andrew Wylie and Sarah Chalfant. Thank you, thank you: Tina Brown, Graydon Carter, Lucy Danziger, and Jane Sarkin. I am extremely grateful to Anna Wintour and Vogue.

A.L.

Black-and-white photographs printed by:
John DeLaney of Silverworks
Jim Megargee of Megargee/van der Linde

Color photographs printed by:
Chris Beirne of Kelton Labs
Bruce Fizzell of Exhibition Prints

Photo processing by:
Laurent Girad of Lexington Labs
Shazi Hussain of Print Zone
Raja Sethuraman of Color Edge

Random House production director:
Katherine Rosenbloom

Meridian Printing project director:
Daniel Frank

Library of Congress Cataloging-in-Publication Data
Leibovitz, Annie.
Women/Annie Leibovitz, Susan Sontag.
p. cm.
ISBN 0-375-50020-0
1. Photography of women. 2. Leibovitz, Annie.
I. Sontag, Susan. II. Title.
TR681.W6L34 1999
779'.24—dc21 99-24968

Random House website address: www.atrandom.com
Printed by Meridian Printing, East Greenwich, Rhode Island, U.S.A.

2 4 6 8 9 7 5 3

BOOK DESIGN BY RUTH ANSEL
WITH TIM HOSSLER